Contrasts of Form

Magdalena Dabrowski

Introduction by
John Elderfield

Contrasts of Form

Geometric Abstract Art 1910–1980

From the Collection of
The Museum of Modern Art
Including the Riklis Collection of
McCrory Corporation

The Museum of Modern Art, New York

Copyright © 1985 by
The Museum of Modern Art

All rights reserved

Library of Congress Catalog Card Number
85-61418

Clothbound ISBN 0-87070-287-4

Paperbound ISBN 0-87070-289-0

Designed by Katy Homans with Bethany Johns

Production by Tim McDonough

Typeset by Trufont Typographers, Inc.

Printed and bound by Imprimeries Réunies
Lausanne, S.A.

The Museum of Modern Art
11 West 53 Street
New York, N.Y. 10019

Printed in Switzerland

The Museum of Modern Art is deeply honored and pleased to have received the gift of the Riklis Collection of McCrory Corporation, selections from which form the basis of the exhibition documented in this catalog. The 249 works thus donated were selected from the McCrory Corporation Collection, formed over the past fifteen years by Meshulam Riklis and his curator Celia Ascher, and concentrated on geometric abstract art. To have developed such an important, focused collection within a corporate context was itself an extraordinary achievement, evidencing a vision and level of commitment most unusual in collections of this kind. To have further decided to share with the world, in the form of this gift, the outstanding part of the collection is truly an act of patronage of the most enlightened and public-spirited kind. In addition to this gift, the McCrory Corporation has provided the Museum with an endowment for a gallery within the installation of the Painting and Sculpture Collection, which we gratefully name in honor of Mr. Riklis.

On behalf of the Trustees of the Museum of Modern Art, I thank Mr. Riklis most sincerely for his remarkable generosity. With the addition of the Riklis Collection of McCrory Corporation, the Museum has now certainly the largest and most complete representation of Constructivist and geometric abstract art in this country. We are delighted to be able to preserve and foster within the context of our own collection the particular modern tradition that Mr. Riklis and Mrs. Ascher made the focus of theirs.

Meshulam Riklis has taken a keen personal interest in the development of this project from its very beginning; we thank him for his enthusiasm and his attention to detail as well as for his generosity. We also most warmly thank Celia Ascher: for her development of this marvelous collection and for her dedicated professionalism throughout the sometimes complex process of arranging the gift. We are very grateful for the most helpful involvement of Mona Ackerman, Mr. Riklis' daughter and a good friend to this museum. Finally, we offer our warm appreciation and admiration to John Elderfield, Director of the Department of Drawings, who supervised the curatorial aspects of the gift and of this exhibition and catalog, and to Magdalena Dabrowski, Assistant Curator in the same department, who collaborated on the exhibition and is the author of the texts of the catalog. Their own acknowledgments appear at the end of Mr. Elderfield's introduction.

Richard E. Oldenburg
Director, The Museum of Modern Art

I am greatly pleased that the McCrory Corporation was in a position to donate to The Museum of Modern Art a collection that I believe to be of significant aesthetic and educational value. The Museum is the world's leading repository of twentieth-century art and as such is the most appropriate home for a collection of this importance.

M. Riklis

Much has been written about the joys of acquiring and shaping an art collection: the intellectual stimulus of the search, the excitement and exultation of discovery. Over the years, the pursuit can become almost all-absorbing. However, there comes for many collectors that bittersweet moment when logic and practical considerations call for giving up one's acquisitions for public delectation. Though there is a pang of loss, there is also the exhilaration of attaining a goal.

This gift of works from the McCrory Corporation's Collection is largely Constructivist in derivation. It includes not only the pioneeers of this movement, but also a large number of contemporary painters and sculptors whose endeavors reflect Constructivist concepts. The works as brought together represent a carefully developed philosophy which I applied to the art of collecting. It says that collecting should follow a defined path of exploration and scholarship, rather than the willy-nilly road of the eclectic contemporary. Art collecting should expand aesthetic awareness through precision, ultimately making more profound the experience of the collector and the viewer.

No one owns art. It owns us. I speak for Mr. Riklis, the McCrory Corporation, and myself in expressing our delight in seeing the collection in such an auspicious and nurturing setting as The Museum of Modern Art. My formative years in art historical scholarship were influenced greatly by Alfred Barr, the Museum's unparalleled founding director, and this crucial relationship helped sway our choice of a home for the collection. I would personally like to express my most sincere thanks to Mr. M. Riklis for his undaunted backing of my decisions, for his invaluable words of encouragement, and for his generous willingness to share both his time and his thoughts with me.

Celia Ascher

Contents

Introduction

This publication, like the exhibition it accompanies, has two principal purposes: to celebrate the extraordinary gift to The Museum of Modern Art of the 249 works of geometric abstract art which constitute the Riklis Collection of McCrory Corporation, and to present selections from this gift in the context of key works chosen from the Museum's other holdings in this same area, thus to afford an overview of one of the most important and vital traditions within modern art.

Over the past fifteen years or so, the McCrory Corporation has assembled a collection of around a thousand works of art that is exceptional among corporate collections in concentrating on a particular, albeit broadly based, tradition: what is often called Constructivism. The collection encompasses Russian Constructivist art, but also represents a broad range of related geometric and constructed styles from Cubism and Futurism to Minimalist works of the 1960s and even more recent art. In forming this collection, its curator, Celia Ascher, set herself an aim usually associated with museums or other educational institutions: to create a cogent, carefully selected body of work that would be qualitatively important and would serve to inform the public at large about the richness and intellectual force of one aspect of modernism—an aspect, moreover, that was underappreciated when the collection was begun, and even now does not often receive the full attention it deserves.

The collection was formed by Celia Ascher with the support of Meshulam Riklis, Chairman of the Rapid-American Corporation (parent company of the McCrory Corporation). Under Mrs. Ascher's guidance, it became a collection of unusually high quality and coherence—certainly one of the most impressive in its field, indeed rivaling and surpassing the collections of most museums in this particular area. Over the past decade, selections from the collection have been exhibited to great acclaim in museums both in this country and Europe and Japan. Mrs. Ascher suggested to the author of this introduction that the collection might be shown at The Museum of Modern Art, and this suggestion eventually led not only to the exhibition documented by this catalog, but to the extraordinarily generous gift of part of the collection itself.

Wishing to preserve its seminal works in one location, the McCrory Corporation offered the Museum its free selection from the collection, and in addition endowed a gallery of the Museum, located within the installation of the Painting and Sculpture Collection. The 249 works received by the Museum in March 1984 were chosen so that they would enhance and expand the scope of the already significant Museum holdings in this area which, since the early days of the Museum, has been one of its particular strengths. The selection includes paintings, sculptures, three-dimensional and relief constructions, and works on paper by European and American artists who worked in the tradition of Constructivism and geometric abstract art, of whom some were already represented in the Museum collections, while others had not hitherto been represented. With the addition of this remarkable gift, The Museum of Modern Art's representation of this area is certainly without parallel in this country. This catalog and the exhibition it accompanies, in presenting a selection from the gift among examples from the Museum's other comparable holdings, seek both to display the riches of the Museum's now-expanded collection and to describe a particular tradition in modern art.

To talk of a tradition, in any context, is to posit a system of stylistic or ideological resemblance, and usually of causal connection, that links individual works over a reasonably lengthy period. The problem in doing so, of course, is that we derive our definition of tradition from the individual works, but we also establish which works are relevant to the tradition according to the definition we decide upon. In the case of the tradition under examination here, the problem is exacerbated because an extremely ambiguous defining term has become popularly attached to it. "Constructivism," however, as I will argue, does not properly define all that we are examining here—for which reason we have avoided it in our title (whose own defining meaning I will refer to later). Still, it is a useful starting point from which to posit the kind of definition this art requires: something which illuminates the connections that do exist between the often very various works presented here, and something which finds in these connections a way of better understanding the individual works of art themselves.

The term Constructivism has been used at times to refer to virtually all the kinds of art represented in this exhibition. Both semantically and historically, however, this is problematic usage, for it attributes to paintings as well as to constructed sculptures and reliefs the implication of physical assembly, and it implies direct causal connection between those early modern artists who adopted the name of Constructivists and recent artists, some of whom certainly refuse the idea that early modern Constructivism constituted their principal artistic heritage. Allied terms such as "constructive" or "constructional" lessen the historical connection somewhat, and have been used regularly for that reason. They have the benefit of acknowledging the fact that a certain common denominator—art conceived as an additive accumulation of basic formal elements—does link much of the work under consideration here. (For there are, indeed, certain structural constants to be observed in the works in the exhibition: if the direct causal link does eventually break down, some inherited assumptions certainly remain.) But terms like these are, at best, uncomfortable linguistic compromises, and have been so since they were first applied to avant-garde art early in this century.

Such terms had, indeed, already been in currency for some time when, in March 1921, the First Working Group of Constructivists was founded in Moscow by Rodchenko, Stepanova, Medunetsky, and some others. The group's work was strongly influenced by Tatlin's earlier relief constructions, which emphasized the innate characteristic of raw materials and their encroachment into the viewer's space, and some of its members did produce sculptures that used similar principles. However, the First Working Group of Constructivists was basically opposed to the creation of isolated aesthetic objects and ultimately sought an art that was utilitarian—which meant applied art and industrial design.

The term Russian Constructivism (not only Constructivism itself) is now generally understood in a wider sense than this, being taken to include the art objects produced by this group, by Tatlin and his colleagues, and also, at times, by the sculptors Gabo and Pevsner. But neither Constructivism in its original sense nor Russian Constructivism in its wider sense encompasses all that is under consideration here.

In the early 1920s in Germany, another understanding of the term Constructivism emerges: one that comes much closer to defining the art in this exhibition. It was used to describe geometric abstract painting, relief construction, the applied arts associated with these forms, and even the new architecture of that period. Also, and interchangeably, referred to as International Constructivism, this new Constructivism of the 1920s was an amalgam not only of earlier Russian Constructivist ideas and forms, but also of de Stijl and Suprematist art—and, in part, of aspects of Dada too. It was, in effect,

an ecumenical alliance of virtually all the major abstract and constructional styles that had developed from Cubist and Futurist sources during and just after World War I and that had escaped their national boundaries at the beginning of the 1920s. The alliance took various forms, but common to most of them were these three basic ideas: that art based on representation was associable with the old, destroyed prewar order and should be replaced by a purely nonobjective art, emblematic of the new age; that the new art would be both modern and universal by virtue of being composed of purified basic elements of form; and that its vocabulary of basic elements could be used to construct virtually any kind of fabricated object, thus making it possible to dissolve the boundaries between the individual arts, and between them and daily life.

This utopian philosophy, wherein art, ideally at least, was meant to construct a new world, or if not that, to form a blueprint for one, did not survive the social disillusionments of the 1930s. But the idea of composing from basic formal elements did. In the 1920s, the term Elementarism had been coined by van Docsburg to describe this idea. Although it has not survived, Elementarism is, in fact, a more useful term than Constructivism for describing the very broad range of geometric abstract styles that emerged after Cubism, coalesced in the 1920s, and remained the generating force of the most pure forms of abstract art until the emergence of Abstract Expressionism in the 1940s. While some geometric abstract art in the 1930s was affected by the vocabulary of abstract Surrealism, the earlier-established vocabularies continued to dominate, and with them the idea of composing from basic elements of form.

Only after Abstract Expressionism had combined Cubist and Surrealist-based vocabularies in a more radical way than had happened in the 1930s was the thread of the Elementarist tradition broken. While some geometric abstract art, especially in Europe, continued to be conceived within that tradition, the more innovative forms of the new geometric abstraction that emerged after the decay of Abstract Expressionism in the 1950s were significantly different—mainly in refusing the overtly compositional basis of the older art. The alloverness of Abstract Expressionism, though transposed from a painterly to a geometric art, became the new model, and the ultimately Cubist notion of the picture as a container for the play of forms was replaced by a new notion of the picture as a holistic field. Even so, a version of the idea of Elementarism necessarily remains in any art whose components are geometric. Contrasts of form, whether of similar or of unlike form, are basic to the geometric abstract tradition. To see together even the most disparate examples of modern geometric abstract art is to be constantly reminded of this fact—but also, and more important, that this stylistic lowest common denominator allows of astonishingly varied, and contrasting, modes of pictorial expression and emotive meaning.

We have adapted the title of this publication and exhibition from that of a major group of Léger's paintings: not to give Léger himself special prominence here, but in order to stress the fact that a preoccupation with form, in contrasting ways, links the artists represented. This is not to suggest, however, that form, as such, is the ultimate preoccupation of every artist here (nor, of course, that a preoccupation with form is the prerogative only of abstract artists). Indeed, I venture to assume that form, as such, is not the ultimate concern of any of the artists here: "content" presumably is. But form, for almost all of them, is the means through which content is discovered. Not all of them find inspiration purely in form—for many of them, especially in the earlier periods, form was a surrogate for often very specifically definable subject-matter. But nearly all do find in the searching, inventive manipulation of geometric abstract forms a way of generating aesthetic meaning. (The exceptions are the few geometric-realist artists included, for whom representation, as well as their departure from it, fulfills that function.)

The five sections into which this publication and exhibition are divided represent our attempt to give some historical and critical coherence to the wide range of art represented. In reviewing these briefly now, I want to draw attention to the way in which the Riklis Collection of McCrory Corporation has enriched The Museum of Modern Art's holdings in each of these areas.

The first section, "Origins of the Nonobjective—Cubism, Futurism, Cubo-Futurism: 1910–1914," is a prologue. It draws attention especially to two Cubist innovations of crucial importance later: the shift in Analytical Cubism in 1910 from the realization of volumetric form to the creation of a newly frontal art of illusionistically overlapping planes, defined by geometric drawing, which was as significant a step as any in the growth of nonobjective painting; and the invention of collage and constructed relief-sculpture in 1912, which opened the way for Russian Constructivism and subsequent physically constructed abstract art. It also stresses the importance of Futurism as a movement concerned with the abstract evocation of modern life; the pioneering early work of artists like Mondrian, Delaunay, Léger, and Kupka; and the development of Cubo-Futurism in Russia, including Rayonism and the early work of Malevich, which immediately preceded more purely nonobjective styles.

In this section, the great addition to the Museum's collection is Malevich's painting *Samovar* of 1913. The only work of this style in a Western collection, it is a vitally important example of his Cubist-based idiom, which foreshadows his later nonobjective works and reveals the stylistic components that were clarified and refined in subsequent years. Also important here are the Rayonist works, notably Gontcharova's *Rayonism, Blue-Green Forest* of 1913, and the early canvases of Popova and Rozanova. Among the fewer Cubist and Futurist works, Severini's 1912 *Dancer* is a particularly valuable supplement to the Museum's Drawings Collection, while Delaunay's study for the painting *Football: The Cardiff Team* of 1916 adds to the Museum's in-depth representation of this artist's work. This general area, however, was not the central concern of the Riklis Collection of McCrory Corporation. We have therefore added to these, and other, works in this section a larger proportion of the Museum's other holdings than in the following sections—in order to properly represent the contributions of major Cubist and Futurist artists.

The second section, "From Surface to Space—Suprematism, de Stijl, Russian Constructivism: 1915–1921," presents the creation of pure, nonobjective painting in Russia and Holland, with its spiritual-universalist concerns, and the development of relief-construction in Russia, leading to the utilitarian concept of Russian Constructivism. It also includes related work done by a number of independent artists during this period. And here, as elsewhere, we have not hesitated to include some works made outside the precise years indicated in the section title, if they clearly belong to the stylistic concepts under consideration.

This section reflects one of the main areas of strength in the Riklis Collection of McCrory Corporation, which affords a major historical overview of these crucial years through important and previously little-known works by most of the significant artsts of the period. Among the relief constructions, Puni's *Suprematist Relief-Sculpture* of 1915 and Ermilov's *Composition No. 3* of 1923 are invaluable examples of the application of Suprematist and Constructivist principles to the organization of materials in space, while the rare Tatlin *Counter-Relief* drawing of c. 1914–1915 vividly imagines such an application. Other significant Russian works include those by Annenkov, Chashnik, Exter, Kliun, Rodchenko, and especially

by Popova and Lissitzky. These join works from the Museum's existing holdings by Gabo, Klucis, Malevich, Pevsner, and others.

The de Stijl movement is already well represented in the Museum collection, especially by works by Mondrian. The new additions include compositions by van Doesburg, van der Leck, Vantongerloo, and Huszar. Among related works, the drawings by Chris Beekman show how one of the special pleasures of the Riklis Collection of McCrory Corporation is its inclusion of surprisingly fine works by artists still very little known outside specialist circles.

Section three, ''International Constructivism: 1922–1929,'' includes additional, later works by members of the de Stijl group—among them van Doesburg's important *Simultaneous Counter-Composition* of 1929—along with works by artists associated with the Bauhaus, and others active especially in Germany in the 1920s. Among the highlights of this section are two paintings each by Kandinsky, Moholy-Nagy, and Vordemberge-Gildewart. All are especially fine works, and Vordemberge's *Composition No. 23* of 1926 is one of the largest and most compelling of his paintings. Besides these, the paintings, sculptures, and drawings by lesser-known artists of the period, including Béothy, Bortnyik, Buchheister, Dexel, and Kassak, are again evidence of the high standards achieved at times by even minor figures in this richly productive period.

The fourth section, ''The Paris–New York Connection: 1930–1959,'' reflects the geographical shift of geometric abstraction from Germany to Paris and then to New York and the persistence of ideas and forms from the 1930s in both European and American art after World War II. The Riklis Collection of McCrory Corporation is particularly strong in this area. The works shown here that were produced within the context of the Paris-based Abstraction-Création group and the New York–based American Abstract Artists association allow for a particularly instructive evaluation of the diversities of geometric abstraction in the 1930s. These include paintings and relief constructions by the Europeans Freundlich, Gorin, Nicholson, Strzeminski, Taeuber-Arp, and Vantongerloo and the Americans Diller, G.L.K. Morris, and Roszak, among others. Also represented here are geometric-realist paintings by Spencer and Sheeler.

Most accounts of the history of geometric abstract art present the 1930s alone, as a single period. However, since the premises of geometric abstraction were not radically changed after the 1930s until the emergence of Minimal art in the 1960s, we have decided to extend this fourth section to 1959. This has the disadvantage of placing in the fifth section works by artists like Graeser or Lohse, which have more in common with the pre-1960 selection than with Minimalist art, but it has, we believe, the greater advantage of demonstrating the continuity of geometric abstraction before and after World War II, while offering a reminder that Minimalism itself was not by any means the only form of geometric abstraction practiced in the 1960s, and after.

In the fourth section, therefore, will be found not only later sculptures by such pioneers as Arp, Gabo, and Pevsner, but postwar works by Albers, Delaunay-Terk, Gorin, and Herbin, among the Europeans, and by Bolotowsky, Glarner, and von Wiegand, among the Americans. These provide a useful context for the work of those whose geometric styles evolved after the war, among them Baljeu, Biederman, McLaughlin, and Pasmore. Included in this section are a significant group of relief constructions, ranging from Gorin's *Relief-Composition* of 1937 and Roszak's *Pierced Circle* of 1939 to Biederman's *Work*

No. 36, Aix of 1953–1972 and Pasmore's *Transparent Construction in White, Black, and Ocher* of 1959, which demonstrate the revival of this form in the 1930s and its continued importance in postwar geometric art.

The fifth and final section, "Recent Nonfigurative Tendencies: 1960–1980," is necessarily more diverse in its contents, and contains more contrasting styles, than any other. Its major contrast is between the Europeans—among them Bill, Graeser, Lohse, Nicholson, and Riley—who seem close to earlier geometric abstraction, and the Americans—among them Held, Judd, Kelly, Mangold, and Noland—who seem more distant from it. This section is, in one sense, a postscript, in showing what happened to geometric abstraction after the tradition of European modernism that previously carried it was no longer dominant. As noted earlier, the more innovative forms of geometric abstract art that emerged in the 1960s in America were very significantly different from those that had previously existed. The contrast presented in this section is therefore the sharpest in the entire exhibition: that between the old order and what replaced it.

At the same time, however, we should not too firmly separate the American artists shown here from their predecessors in the exhibition. They do draw on other sources than these, in particular the alloverness of Abstract Expressionism. But in doing so, they occupy a position not unlike that of the earliest pioneers of geometric abstraction, who developed their styles from more painterly beginnings. Their achievement, moreover, does not so much involve dismissal of earlier geometric abstraction as enrichment of its possibilities, by adapting that tradition to admit possibilities not previously explored within it, or only tentatively explored: holistic, allover structures, more purely affective color, and more expansive space. Also, as noted earlier, the premise of Elementarist composition necessarily persists in the new modular structures that developed in the 1960s. In this sense, then, this final section is not only a postscript but a demonstration of how a vital tradition undergoes drastic mutation in order to preserve its vitality. And while this exhibition ends with 1980, the vitality of geometric abstract art does not.

It only remains to thank all those who have contributed to the realization of this project. For the gift to the Museum of the Riklis Collection of McCrory Corporation, Meshulam Riklis himself and Celia Ascher deserve our very deepest appreciation. They have paid the most careful and disinterested attention to every detail of this sometimes complicated transaction. What is shown here is largely the result of their willingness to share the fruits of their endeavors. Mona Ackerman, of the Rapid-American Foundation, also took a keen interest in this project and helped in numerous ways. Richard E. Oldenburg, as Director of The Museum of Modern Art, was ultimately responsible for its realization, aided by Beverly Wolff, the Museum's General Counsel. William Rubin, Director of Painting and Sculpture at the Museum, was involved, with me, in the selection of the works for the collection, as was my collaborator in the exhibition, Magdalena Dabrowski, Assistant Curator in the Department of Drawings.

Many individuals at the Museum contributed to the realization of the exhibition itself and of this publication. Within the Department of Drawings, Susan Mason accomplished an extraordinary amount of research under the pressure of imminent deadlines, aided by Kathleen Curry, Mary Jickling, and Pamela Lewis. My assistant, Janet Jones, has been closely involved with the whole project, and deserves special thanks. Mary Sheridan, of the Registrar's Department, made an important contribution, as did other members of that department. Antoinette King, Terry Mahon, Albert Albano, and Patricia Houlihan

of the Department of Conservation helped in numerous ways, as did Richard Tooke, Director of Rights and Reproductions. The text of this publication was edited by Francis Kloeppel, and owes a great deal to his meticulous work. Its production was organized by Tim McDonough; its design is by Katy Homans. The bibliography was prepared by Clive Phillpot; Daniel Starr and Rona Roob assisted with bibliographical research. To all of these go my deepest thanks.

Two people in particular, however, are preeminently to be thanked for their help in realizing the exhibition and publication. First, Magdalena Dabrowski, who assumed the chief burden of work on both these aspects of this project. The catalog which follows is hers. It has been a pleasure to rely on her professionalism and her expertise. Second, Celia Ascher, with whom Mrs. Dabrowski and I discussed every aspect of our work, who played a crucial role in shaping the scope of the exhibition, and who has shown herself a constant, enthusiastic champion of the artists represented here. To her, and to her assistant Barbara Kowaleski, go our special thanks. Her commitment to Constructivist and geometric abstract art was the driving force of the original McCrory Collection, and the source of the exhibition documented in this publication.

John Elderfield
Director, Department of Drawings

In the catalog all the works listed without credit line are from the Riklis Collection of McCrory Corporation, with the exception of the Malevich works on pages 39, 41–45, 90, which are part of the other holdings of The Museum of Modern Art.

Origins of the Nonobjective—

Cubism, Futurism,

Cubo–Futurism

1910–1914

When in 1908 the German philosopher Wilhelm Worringer published in Munich his doctoral dissertation *Abstraction and Empathy*, he introduced into the philosophy of aesthetics the idea of abstraction as a direct opposite of figuration. This idea provided a philosophical justification for the concept of a nonfigurative plastic expression. Worringer's essay declared that "the urge to abstraction stands at the beginning of every art and in the case of certain peoples at a high level of culture remains the dominant tendency," and that this urge is best satisfied through pure geometric abstraction, free of "all external connections with the world."

It seems that such a stage of readiness for the abstract was reached in 1910 when the Analytical Cubism of Picasso and Braque attained its "high" phase. Although Picasso, having done his almost abstract paintings *Woman with a Mandolin*, *Nude Woman*, and *The Rower* (summer 1910), retreated from abstraction through the reintroduction of an illusionistic element, the Cubist transformations provided impetus for other artists to search for a pictorial language no longer based on the imitation of forms observed in the surrounding world and represented in an illusionistic space. Cubist rephrasing of the artistic language, a rephrasing based on fragmentation of form into planar elements dislocated and reassembled as a linear grid in a shallow space, conceptualized the subject and subordinated it to the pictorial structure. Having radically altered the identity of the object and the traditional pictorial relationship between form and space, Cubism provided a formal and theoretical basis for a nonobjective art, devoid of references to the forms existing in reality, and deriving its content from the abstract relations of color, line, form, and texture, organized on the two-dimensional picture surface. Geometric abstraction evolved as the logical conclusion of the process of "purifying" Cubism of the vestiges of visual reality through an emphasis on the two-dimensional features of painting.

An increasing concern with these inherent qualities of painting and their power to convey universal truth, and such "modern" qualities as time and space, became the characteristic of nonobjective expression. The new spirit tending toward the evolution of pure abstract styles, which were predicated upon the recognition of the autonomy of form and the importance of form as the essential carrier of meaning, manifested itself with particular strength around 1912–1913 in France and Russia.

In its development, nonobjective art profited from the different stages of Cubism. While Analytical Cubism—after mid-1910—made available to artists the planarity of overlapping frontal surfaces, it was the Synthetic Cubism of post-1912 works that introduced flatly painted synthesized forms, abstract space, and the "constructional" aspect of the composition, which would become fundamental aspects of abstract art. Further, the invention of collage in 1912 (with Picasso's *Still Life with Chair Caning*) allowed the artist a freedom of experimentation with different materials and different ways of indicating spatial relationships and depth in the two-dimensional composition. It stressed the importance of the flat surface as a carrier of applied elements. It also introduced a new aspect of "reality" to the artwork—that of a "real" material—and allowed textural experimentation. Eventually, collage became a favorite medium of artists as diverse as the Dadaists and Constructivists. Also, Malevich and his followers, such as Liubov Popova, Ivan Puni, and El Lissitzky, explored the possibilities of collage and its "constructional" aspect to create a new purely pictorial reality.

Probably the most far-reaching Cubist influence was that of an openwork Cubist sculpture-construction such as originated with Picasso's *Guitar* of 1912. This three-dimensional transformation of the planar structure of High Analytical Cubist pictures was crucial for the rise of Constructivism, the movement which developed in Russia around 1920 out of the concepts embodied in the 1913–1915 reliefs of Vladimir Tatlin, and which radically altered artists' conceptions of material, facture, construction, and the traditional categories of painting, sculpture, and architecture.

Besides Cubism, a crucial influence on the evolution of geometric abstraction was Italian Futurism, which made its first significant appearance in 1910. The Futurists' preoccupation with the modern, industrial world and their search for new ways of expression compatible with the notion of modernity had an international impact on the young generation of painters. Since there was no single Futurist style of painting, it was mostly the Futurist theories, the subject matter, and at times certain formal devices apparent in the work of Boccioni, Balla, Russolo, and Severini that influenced Léger, Kupka, and Delaunay as well as Larionov, Gontcharova, Popova, Rozanova, and Malevich.

Subsequently, the Cubist principles of composition and fragmentation of the object produced Mondrian's "plus-minus" compositions. The same principles, combined at times with the Futurist interest in movement and speed, resulted in such diverse abstract expressions as Delaunay's Orphism and Kupka's abstractions in France, as well as Cubo-Futurism and Larionov's Rayonism in Russia. All of these marked a transitional phase in the progression toward the purely geometric nonobjective styles of the later teens, such as de Stijl in Holland and Suprematism in Russia.

Almost all the artists regarded dynamism and light as the most exhilarating aspects of modern life and were convinced that they could be effectively expressed through color and/or line. The question of color as dynamic and form-creating became the central issue with Orphism, or "Orphic Cubism," as the movement was named by Apollinaire. Orphism, which took its beginning in the work of Robert Delaunay around 1912 in Paris and was at its height during the following two years, concentrated on the form-evoking capacities of light, which decomposes the subject, "creates" color, and brings about the spatial and temporal interaction of the forms. Reexamining in broader scope an issue explored in the late nineteenth century by Seurat, Delaunay made color the principal carrier of the picture construction and its main subject, as in his 1912 *Window* series and 1913 *Circular Forms* series. In these works simultaneous contrasts of color visually activate the surface of the picture and add dynamic sensation to the abstract pattern of interacting forms of light, while also allowing for the exploration of temporal relationships.

When Delaunay was elaborating his abstractions based on the simultaneous contrasts of color, Kupka, also in Paris, was conducting his own research into the realm of pure painting. His studies of nature and physiology convinced him that nature is "inimitable." The artist should therefore create his own plastic forms and patterns of color and light, without depending on external reality, if he intends to render adequately his thoughts and visions. Kupka thus rejected the "false" reality of the perceptual experience in favor of the "true" reality of the known. He studied the scientific discoveries of the time, seeking the means that would allow him to express the dynamism of the universe and the "motor-force" of human beings. Stimulated by the Symbolist theory of correspondences with regard to the nonrepresentational nature of music and that of painting, he experimented with the interaction of color and form, and in 1912 produced totally nonobjective works such as the *Amorpha: Fugue in Two Colors* series based on the rhythmic pattern of interlocking circular forms and the interaction of two basic

colors, blue and red. Delaunay's and Kupka's theories of color and its ability to create space and movement later provided the basis for a more objective attitude to color developed at the Bauhaus by Johannes Itten in his theory of color art.

Equally important for the later development of nonfigurative expression were the efforts of Léger. In his search for a means of conveying the physicality of objects, he created forms born out of tension between linear Cubist flatness of form and generalized shapes abstracted from reality. The forms, composed of a limited repertoire of interlocking cylinders, cubes, and wedges in roughly painted patches of color, highlighted with white areas, created a dense surface structure, well exemplified in his *Contraste de formes* paintings (1912–1914). The structure was held together by the rhythm of the linear elements and the flatness of the color areas. Through the manipulation of painted areas and white highlights, Léger created the impression of volume while retaining an abstract, flat configuration.

The conclusion that geometric form is the best and most objective expression of universal truth and the absolute was also reached by Mondrian (first working in Paris and then in Holland). Mondrian's abstract style, which made its appearance around 1914 in his "plus-minus" compositions, evolved on the basis of Cubism—or more specifically, out of his dissatisfaction with the Cubist retreat from the inevitable nonobjective form. As he later explained in his essay "Toward the True Vision of Reality" (1942), "Cubism did not accept the logical consequences of its own discoveries; it was not developing abstraction toward its ultimate goal, the expression of pure reality." Mondrian's utopian vision assigned to art a role-model for the social relations of the modern era. The linear structure of his compositions,.based on carefully calculated relation- ships of the vertical and horizontal which directly derived from his experimentation with the Cubist grid, was conceived as the only viable expression of spiritual needs and harmonious relations within modern society—which he described as the "new reality." The reduced formal vocabulary and the resultant austerity of composition made Mondrian's geometric idiom one of the most radical transformations of Cubism, rivaled only by the Suprematism of Kasimir Malevich in Russia.

During the first decades of the century, Russia suddenly appeared on the map of avant-garde art. Stimulated by the changes in its social and political makeup and by the increasing contacts with the Western world, there emerged an avant-garde whose formal and conceptual innovations fundamentally influenced the course of geometric abstract art. A number of new styles evolved, based on both native Russian and Western sources, and often fostering a close collaboration of painters and poets. The Futurist poetry of Khlebnikov, Guro, and Kruchenykh, and even early poems of Mayakovsky, made use of formal devices—sound patterns, syntax, form and texture of the verse—that find their equivalents in the structure and composi- tional principles of Cubist and Futurist paintings. The Russian Futurist anthologies (published between 1912 and 1914) which made use of free verse and a new creation, the transrational language "Zaoum" (based on the use of words devoid of their associative meaning and proper syntax and explored for their sonoric value), expressed principles related to those of Marinetti's *Technical Manifesto of Futurist Literature* (May 1912) and his poetic concept of "free words," *parole in libertà*.

Cubism and Futurism were catalysts for the development of quite diverse versions of Russian avant-garde Cubo-Futurist styles beginning around 1910. Assimilation of Cubism into the pictorial idiom of Russian artists occurred under the influence of their increasing exposure to Cubist works through their trips to the West. Artists such as Exter, Popova, Udaltsova, and Puni spent the crucial Cubist years in Paris. Exter, during 1909–1914, traveled frequently between Paris, Italy, and Russia and played an important part in the dissemination of Cubist and Futurist ideas in her native country. Both Udaltsova, in

1911–1913, and Popova, in the winter of 1912–1913, studied at La Palette, the studio of Metzinger and Le Fauconnier in Paris. Puni was closely involved with the French avant-garde during 1910–1912 and also visited Italy, where he familiarized himself with Futurist ideas. In Moscow the artists also had direct contact with Cubist pictures in the collections of Morozov and Shchukin. By 1914, Shchukin's collection included twelve Cubist paintings by Picasso and one by Braque, and Morozov owned Picasso's 1910 *Portrait of Vollard* (purchased by the collector in 1913); both collections were regularly accessible to the public. The awareness of new Western developments was also heightened through the numerous exhibitions organized periodically by the avant-garde groups, the Union of Youth in St. Petersburg and the Jack of Diamonds in Moscow, that presented works of the Russian and Western vanguard artists. Further, art journals such as *The Golden Fleece* and *Apollon* discussed the new art styles in France and Germany and included reviews of their most important exhibitions, the Salon des Indépendants and the Salon d'Automne.

Added to indigenous sources, Russian folk art, and the icon, where two-dimensional form and conceptualized space are the fundamental aspects of composition, Cubism released creative energies that produced diverse personal versions of the Cubist idiom, exemplified in works by Popova *(Early Morning),* Rozanova *(Factory and the Bridge),* and Udaltsova. The influences absorbed by the Russians stemmed mostly from the works of Gleizes, Metzinger, Le Fauconnier, Léger, and the artists of the Section d'Or group, rather than the mature High Analytic Cubist works of Picasso and Braque. The Russian Cubist works generally show less fragmentation of form and less commitment to the rectilinear grid, and vestiges of figuration are more visible. The Russian works also show greater interest in color, which is never muted to the use of greens and ochers (as in Picasso and Braque) and is often quite vivid; and rhythm is used as a decorative rather than structural element.

The influences absorbed by the Russians stemmed mostly from the works of Gleizes, Metzinger, Le Fauconnier, Léger, and the artists of the Section d'Or group, rather than the mature High Analytic Cubist works of Picasso and Braque. The Russian Cubist works generally show less fragmentation of form and less commitment to the rectilinear grid, and vestiges of figuration are more visible. The Russian works also show greater interest in color, which is never muted to the use of greens and ochers (as in Picasso and Braque) and is often quite vivid; and rhythm is used as a decorative rather than structural element.

The most successful explorations based on different aspects of Cubism, Futurism, or elements of both movements combined appear in the Cubo-Futurist works of Malevich executed between 1912 and 1915. Searching for new means to revitalize art, Malevich began to assimilate Cubism into his own pictorial vocabulary around 1912. As early as 1910 his work had shown a tendency toward planar organization; volumetric forms were increasingly replaced with flat color surfaces and forms made up of sets of basic shapes such as tubes, truncated cones, and trapezoidal planes that superficially showed a certain resemblance to the contemporaneous work of Léger. After 1910 the entire plastic structure of Malevich's painting underwent change, indicating a growing dependence on the relationship of the verticals and horizontals, descended from the linear Cubist armature. And during 1912–1913 he produced some of the most interesting of his more truly Cubist pictures, such as *Samovar*, and Cubo-Futurist works, such as *Knifegrinder* (Yale Art Gallery). The transformation of plastic structure signified an altered relationship between its essential components: color, form, space, and content. Forms and colors were disposed clearly around the verticals and horizontals, retaining stress on symmetry and balance of color areas but eliminating the distinction between foreground and background, which became integrated into a surface pattern. The color areas were increasingly treated as flat, unmodulated frontal surfaces, and in such 1914 paintings as *Woman at the Poster Column*

(Stedelijk Musem, Amsterdam) and *Private of the First Division* they almost dominate the composition. The placement of flat color planes overwhelming the juxtaposed smaller and more fragmented forms produced the effect of spatial interaction, and foreshadowed compositional structures of his later nonobjective style.

Among the more personal, original expressions—and in fact the first truly nonobjective style evolved at the time—was the Rayonism of Larionov, initiated by him in 1912 and propounded mainly by him and Natalia Gontcharova until 1914. It was most directly indebted to Italian Futurism but also drew on the discoveries of Cubism and Orphism and the Impressionist interest in *matière*. Although no Futurist pictures had been exhibited in Russia, Larionov and other vanguard artists were familiar with Futurist ideas from the moment of the first publication of Marinetti's Futurist Manifesto in February 1909. By 1910 many excerpts of the Italian manifestos were translated into Russian, and from 1912 on the ideas of Marinetti and the Futurist painters were widely disseminated; also, at the invitation of the Russian Futurists, Marinetti visited Russia in January 1914. Larionov's Rayonism, although conceptually predicated on different precepts, was in its use of overlaid multiple images and repetitive directional lines pictorially close to the works of Boccioni, Carrà, Balla, and Russolo, with which it shared a preoccupation with the dynamic quality of light and form. Pictorial form in Rayonism resulted, according to Larionov's theory, from the physical phenomenon of vision—our perception of light. His basic premise was that the human eye does not perceive objects of the surrounding world but the light rays reflected from them, which through their interaction create a shimmering image. Since painting has to operate within its inherent means of expression (color, line, and texture), the pictorial representation of such perceptual experience would take the form of a two-dimensional composition of crisscrossing lines of color (devoid of specific representation), conveying dynamic and temporal interaction of light and matter, and in fact producing an abstract composition, such as his *Rayonism: Domination of Red* (1912–1913) and Gontcharova's *Rayonism: Blue-Green Forest* (1913).

By emphasizing the new approach whereby painting was considered a self-referential entity, an end in itself, Rayonism created the conceptual frame for the future nonobjective movements, and its discoveries were shortly after brought to a logical conclusion in Malevich's Suprematism. On the other hand, Rayonism focused attention on material or physical aspects of painting—the texture of the painted surface itself—and this helped to open up further surface explorations and liberate material from its descriptive role. It created an additional dimension for the surface investigations introduced by Synthetic Cubism and the Cubist collage, and enriched the repertoire of artistic vocabulary, which would later be explored in ''laboratory'' research in the early phase of Constructivism.

Chronology

1910–1914

Berlin

Herwarth Walden's weekly journal *Der Sturm* founded in March as a forum of exchange on avant-garde music, literature, drama, and the visual arts (highlighting German Expressionist, French, and French-influenced artists). Intent upon fostering the international spirit of modernism. Journal continued until 1932.

Budapest

April–May. Picasso shows four works in group exhibition at gallery Müvészház, among them *Woman with Mandolin* of 1909, later bought by the Moscow collector Sergei Shchukin.

Darmstadt

El Lissitzky at the Technische Hochschule, where he remains until 1914.

Milan

Publication of Filippo Tommaso Marinetti's novel *Mafarka le futurista* (French translation published later that year by Sansot in Paris).

February 11. Publication of the *Manifesto of Futurist Painters* as a leaflet by *Poesia*; later proclaimed from the stage at Politeama Chiaretta in Turin (March 8) during a Futurist presentation with participation of the artists Umberto Boccioni, Aroldo Bonzagni, Carlo Carrà, Romolo Romani, Luigi Russolo.

March 19–April 3. The first exhibition of Futurist works "Famiglia Artistica," presenting prints and drawings by Boccioni, Bonzagni, Carrà, Russolo.

April 11. *Technical Manifesto of Futurist Painting*, signed by Balla, Boccioni, Carrà, Russolo, and Severini, published by *Poesia*.

December 20–21. Boccioni, Carrà, and Russolo exhibit in the "Intimate Exhibition" of Famiglia Artistica.

Moscow

Vladimir Tatlin at the Moscow Institute of Painting, Sculpture, and Architecture, from which he is subsequently expelled.

October–December. Kandinsky arrives for a visit from Munich and travels also to Odessa and St. Petersburg.

December. The first exhibition of the society Bubnovyi Valet (Jack of Diamonds); includes Alexandra Exter, Natalie Gontcharova, Kandinsky, Mikhail Larionov, Kasimir Malevich, et al. Subsequently, until 1917, the society holds annual exhibitions, which show works by the members of the Russian avant-garde and progressive Western artists: Braque, Delaunay, Le Fauconnier, Léger, Marc, Matisse.

December. First exhibition of Moscow Salon, including Gontcharova, Malevich, Larionov, et al. Exhibitions held regularly until 1918.

Munich

Naum Gabo begins medical studies at Munich University, but transfers in 1912 to the Polytechnic Engineering School.

September. Neue Künstler Vereinigung International Exhibition, including David Burliuk, Vladimir Burliuk, Vasily Kandinsky.

Odessa

January. The International Exhibition of Painting, Sculpture, Engraving, and Drawing, the so-called first Izdebsky Salon (organized by sculptor Vladimir Izdebsky in collaboration with French critic Alexandre Mercereau), enters its second month. Includes Russian and Western sections with contributions by Natan Altman, the Burliuks, Exter, Gontcharova, Kandinsky, Aristarkh Lentulov, Mikhail Matiushin, Giacomo Balla, Georges Braque,

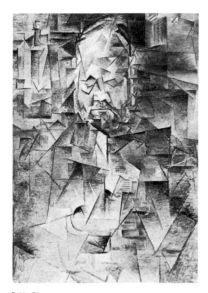

Pablo Picasso.
Portrait of Ambroise Vollard. 1910.
The Pushkin State Museum of Fine
Arts, Moscow

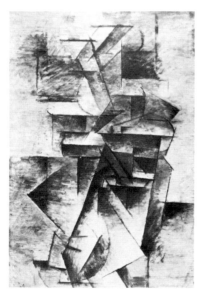

Pablo Picasso. *Woman with a
Mandolin*. 1910. Museum Ludwig,
Sammlung Ludwig, Cologne

Maurice Denis, Marie Laurencin, Henri Le
Fauconnier, Jean Metzinger, Odilon Redon,
Henri Rousseau, et al.; also a section of
children's drawings. In the course of 1910
the exhibition travels to Kiev, St. Petersburg,
and Riga.

December. Second Izdebsky Salon, with con-
tributions of mainly Russian artists, such as
Gontcharova, Larionov, Tatlin, and some
members of the Western avant-garde; the
catalog contains essays by Kandinsky and
Arnold Schönberg.

Padua and Venice

Summer. Several Futurist events.

Paris

Picasso's exhibition at Galerie Notre-Dame-
des-Champs includes *Bowls of Fruit with
Wine Glass*, 1908; *Factory at Horta*, 1909,
later bought by Shchukin.

Spring. Picasso completes *Portrait of Am-
broise Vollard*, bought by Ivan Morozov for
his Moscow collection in 1913.

May 18. The *Technical Manifesto of Futurist
Painting* is published; stresses the "dynamic
sensation of life" and a need to "put the
spectator in the center of the picture."

June. Diaghilev's Ballets Russes—in their
second season—perform Rimski-Korsakov's
Scheherazade and Stravinsky's *Firebird*. (The
first Diaghilev production was in 1909, with
other performances in 1911, 1913, 1914,
1917, 1926, and 1927.)

High Analytic Cubism announced with Picas-
so's *Woman with a Mandolin*, *Nude Woman*,
and *The Rower*.

October–December. A lecture on Russian
poetry, organized by Alexandre Mercereau and
sponsored by the Salon d'Automne, includes
examples of contemporary verse in original
Russian and in French translation. Apollinaire
writes of the Russian artists of the Société
Artistique et Littéraire Russe and their current
show.

St. Petersburg

Anton Pevsner enters his second year at
St. Petersburg Academy of the Arts (having
previously studied painting from 1902 to 1909
at the School of Fine Arts in Kiev).

March. Exhibition "Triangle" (Treugolnik)
organized by Nikolai Kulbin; presents contri-
butions by Exter (also Burliuks and Pavel
Filonov), et al. Later this year exhibition
travels to Riga.

May. Publication of the first Russian Futurist
collection of experimental literature and art,
A Trap for Judges (*Sadok sudei*).

Trieste

January. The first "Futurist Evening," at
Politeama Rossetti, presenting the *Futurist
Manifesto* and Futurist poetry.

1911

Mondrian moves to Paris from the
Netherlands. Braque (in the spring) and later
Picasso (in the fall) introduce lettering into
their Cubist compositions.

Spring–summer. Numerous Futurist presen-
tations in Mantua, Parma, Como, Milan,
Rome, Treviso, Florence.

Moscow

Tatlin designs set and costumes for the play
Czar Maximilian and His Unruly Son Adolfe,
staged in Moscow at the Literary-Artistic
Circle.

Fall. Larionov graduates from the Moscow
School of Painting, Sculpture, and Architec-
ture.

Larionov and Gontcharova break with Jack of
Diamonds group and create a new associa-
tion, Oslinyi khvost (Donkey's Tail).

Winter. Tatlin organizes teaching studio (active until 1915) called The Tower; attended by, among others, Aleksandr Vesnin, Liubov Popova, Nadezhda Udaltsova.

December. One-day exhibition of Larionov's work at Society of Free Aesthetics.

E. Gordon Craig's production of *Hamlet* at the Moscow Art Theater uses spare, geometric sets and props; it is attended by David Burliuk and Vladimir Mayakovsky.

Exter returns from Paris with photos of Picasso's latest Cubist paintings.

Munich

December. Founding of Der Blaue Reiter (Blue Rider) group by Kandinsky and Franz Marc.

The first exhibition of the Editorial Board of the Blue Rider takes place at Thannhauser's Moderne Galerie.

Kandinsky's *On the Spiritual in Art* published by Piper.

Paris

Anton Pevsner moves definitively to Paris (where he remains until outbreak of war); keeps contact with Alexander Archipenko, Amedeo Modigliani, and other artists of La Ruche.

Lentulov and Udaltsova study at the studio La Palette, run by Metzinger, Le Fauconnier, and Segonzac, where they become closely acquainted with the principles of Cubism.

Georges Annenkov studies with Maurice Denis and Félix Vallotton.

Marcel Duchamp exhibits at the Indépendants, Salon d'Automne, and the Société Normande de Peintres Modernes.

Sunday gatherings at Raymond Duchamp-Villon's studio (in Puteaux) include the writers Apollinaire and Henri-Martin Barzon, painters Le Fauconnier, Gleizes, Léger, Metzinger, Pach, and Ribemont-Dessaignes.

March. Marinetti lectures on Futurism.

April 21. Salon des Indépendants opens with Cubist demonstration; includes Delaunay, Gleizes, Laurencin, La Fresnaye, Léger, Metzinger, Picabia, Le Fauconnier, Archipenko, and Duchamp.

Summer. Lissitzky visits his friend, sculptor Ossip Zadkine.

October 1. Opening of Salon d'Automne, with a large Cubist section (but without Picasso and Braque).

October–November. Boccioni and Carrà (and possibly Russolo) visit Paris briefly with Severini; visit studios of Braque and Picasso and other advanced painters whose work was shown at the 1911 Salon d'Automne. Study work of Metzinger, Gleizes, Duchamp, Léger. Introduced to Gertrude Stein by Picasso.

Marinetti's *Le Futurisme* published in Paris by Sansot—a compendium of lectures, proclamations, and manifestos (translated into Russian in 1914 and published on occasion of Marinetti's trip to Russia).

November. Apollinaire publishes "Peintres futuristes," *Mercure de France*.

St. Petersburg

Spring. Exhibition of the Union of the Youth, with contributions by Tatlin, Varst (Varvara Stepanova), the Burliuks, Gontcharova, Larionov, Malevich, Rozanova.

September. Blaise Cendrars visits St. Petersburg.

December. The Second All-Russian Congress of Artists opens; a shortened version of Kandinsky's essay *On the Spiritual in Art* is read by Kulbin.

1912

Duchamp travels (June–October) in central and eastern Europe and spends two months in Munich.

Lissitzky travels in the summer through northern Italy.

Barcelona

Spring. Duchamp's *Nude Descending a Staircase* exhibited.

Berlin

March. Der Sturm gallery opens with an exhibition on the Blue Rider, Oskar Kokoschka, and the Expressionists. The second exhibition (in April) features Italian Futurists, and on this occasion *Der Sturm* journal publishes Futurist manifestos. For the next decade the gallery is the German outpost of the international avant-garde. (Gallery will close in 1932.)

Bologna

Publication of Balilla Pratella's "Musica futurista per orchestra, riduzione per pianoforte," with his manifesto of Futurist Musicians, written October 1910.

London

March. Marinetti's lecture in Bernstein Hall.

October 5–December 31. Grafton Galleries, Second Post-Impressionist Exhibition, organized by Roger Fry, with a section of Russian art organized by Boris Anrep; includes works by Larionov, Gontcharova.

Milan

April 11. Publication of Boccioni's *Technical Manifesto of Futurist Sculpture*, as a leaflet by *Poesia*.

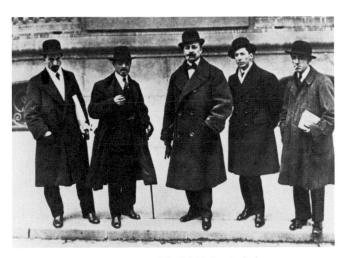

Italian Futurists Russolo, Carrà,
Marinetti, Boccioni, and Severini
in Paris, February 1912, at the
time of their exhibition at
Bernheim-Jeune

May 11. *Technical Manifesto of Futurist Literature* by Marinetti, announcing the principle of "free words" (*parole in libertà*). On August 11, he adds a further statement in answer to objections.

Moscow

January. The second Jack of Diamonds exhibition opens, including works by the Burliuks, Exter, Kandinsky, Lentulov, Braque, Delaunay, Le Fauconnier, Léger, Marc, Matisse, and Picasso.

February. Debate on Cubism and other contemporary movements organized by the Jack of Diamonds group; David Burliuk and Gontcharova deliver speeches on the subject.

March. Exhibition "The Donkey's Tail" organized by Larionov and Gontcharova, with contributions by them and also Malevich and Tatlin, among others.

Summer–fall. The first of many Futurist books of poetry carrying illustrations by members of the avant-garde appear: Kruchenykh's book of poetry *Starinnaia liubov* (Old-Time Love) with illustrations by Larionov; Kruchenykh and Khlebnikov's long poem *Igra/v/adu* (Game in Hell) with illustrations by Gontcharova and Larionov; Kruchenykh and Khlebnikov's book of poetry *Mirskontsa* (World Backward) with illustrations by Gontcharova and Larionov.

December. First of the series of "Contemporary Painting" exhibitions; includes Tatlin, Malevich.

Publication of an anthology of poems, prose, and articles—*A Slap in the Face of Public Taste*—the most famous manifesto of the Russian literary Futurist group Hylea; includes the first important text on Cubism signed by Nikolai Burliuk, but written by him in collaboration with his brother David.

Creation of "Zaoum," a transrational language invented by Kruchenykh and Khlebnikov—a self-contained tongue stripped of historical and associative descriptive connotations, devoid of established syntactical conventions, making use of words composed of syllables valued for their sonoric quality.

Munich

February. Second Blaue Reiter exhibition at the Galerie Goltz; includes works by Picasso, Braque, Delaunay, Kandinsky, Klee, Gontcharova, Larionov, Malevich.

David Burliuk travels to Germany; in Munich he visits Kandinsky, who has just published (in May) the *Blaue Reiter Almanach*.

Paris

Jean Puni and Xenia Boguslavskaia study at the Académie de la Grande Chaumière.

Les Soirées de Paris and *Poème et Drame*, French periodicals, are founded; they last until 1914.

Mondrian in Paris until mid-1914.

Popova joins Udaltsova at La Palette.

February 5–24. Exhibition by the Futurist painters at Bernheim-Jeune: Boccioni, Carrà, Russolo, and Severini. The catalog contains illustrations, the "Technical Manifesto," and a new theoretical preface entitled "The Exhibitors to the Public." The exhibition goes on to London, Sackville Gallery, March 1912; Berlin, Der Sturm at the Tiergartenstrasse Galerie, April–May 1912; Brussels, Galerie Georges Giroux, May–June 1912. A subsequent tour includes The Hague, Amsterdam, Cologne, Munich, and Budapest.

Spring. Picasso creates *Guitar*, the first open-construction sculpture, which represents radical break with the traditional approaches of modeling and carving and opens way to twentieth-century constructed sculpture.

May. Picasso's first collage, *Still Life with Chair Caning*, incorporating ordinary materials.

May–August. Apollinaire writes *Les Peintres cubistes: Méditations esthétiques* (published March 1913).

Summer–fall. Delaunay writes his two major essays on art: "Light" (published in German translation in *Der Sturm* in February 1913 in Berlin) and "Notes on the Construction of the Reality of Pure Painting."

Early September. Braque's first *papier collé*.

Autumn. Picasso makes his first *papiers collés*, which include newsprint and flat painted planes in linear scaffolding, as in *Violin*. (Continues into following spring or summer, as in *Head*, Museum of Modern Art collection.)

October. At the Salon d'Automne Kupka exhibits two large works without specific subject-matter: *Amorpha: Fugue in Two Colors* and *Amorpha: Warm Chromatics* (examples of his "pure painting" as defined by Apollinaire); Boccioni exhibits some sculpture.

"Salon de la Section d'Or" exhibition of the Puteaux Cubists is mounted at the Galerie La Boétie.

November. André Salmon publishes *La Jeune Peinture française*.

Winter. High Analytic Cubism at its zenith with works such as Picasso's *Ma Jolie*.

November. Apollinaire lecture in which he invents the term "Orphic Cubism."

December. Gleizes and Metzinger publish *Du cubisme*.

Rome

Exhibition of Futurist Photodynamism at the Sala Pichetti.

St. Petersburg

February. Puni returns from Paris and through his friend Kulbin meets the members of the Russian avant-garde, with whom he develops closer ties in 1913.

April. First issue of journal *The Union of Youth*, carrying Vladimir Markov's essay "The Principles of the New Art" (continued in the June issue).

First issue of Bolshevik writers' paper *Pravda* (Truth).

June. Second issue of *The Union of Youth*, containing a Russian translation of Le Fauconnier's catalog statement from the second *Neue Künstlervereiningung*, Munich, 1910; the Italian Futurist manifesto to the public; Russian translation of Boccioni's introduction to his Paris exhibition catalog; and the second part of Markov's "Principles of the New Art."

December. The private gallery Dobychina Bureau opens; presents regular exhibitions of modern Russian art until 1918.

Opening of the fourth exhibition of the Union of Youth, including both the Larionov group and the Burliuks; first examples of Larionov's Rayonist painting are included (e.g., *The Rayonist Sausage and Mackerel*, 1912, Museum Ludwig, Cologne).

Fifth Union of Youth exhibition, including works by Gontcharova, Larionov, Malevich, Matiushin, Puni, Rozanova, Tatlin.

1913

Spring. Publication in Russian translation of Signac's *From Eugène Delacroix to Neo-Impressionism* and of *Du Cubisme* by Gleizes and Metzinger.

October 11. "The Futurist Political Program" signed by Marinetti, Boccioni, Carrà, and Russolo.

December. Russian Futurist tour, in which David Burliuk, Vladimir Mayakovsky, and Vasily Kamensky give evenings of poetry and lectures on the new art in seventeen cities.

Berlin

Exhibition of works by Archipenko at Galerie Der Sturm with catalog by Apollinaire.

Publication of "Die moderne Malerei" by Apollinaire in *Der Sturm*. Essay describes Picasso's collages and mentions cardboard reliefs.

September. First exhibition of Sonia Delaunay-Terk and Blaise Cendrar's simultaneous book, *La Prose du Transsibérien*.

Herwarth Walden's "Erster deutscher Herbstsalon" opens at Galerie Der Sturm, showing remarkable cross-section of avant-garde artists. Represented were the Delaunays; recent Futurist works and Balla; Léger, Picabia, Gleizes, Metzinger, Mondrian, Marc, Kandinsky, Chagall; and Larionov, Gontcharova, and the Burliuk brothers. Apollinaire called this the "first salon of Orphism."

Brighton

November–January. "Exhibition of English Post-Impressionists, Cubists and Others" at Public Art Galleries. Wyndham Lewis publishes an article on it entitled "Room III: The Cubist Room."

Ceret

Summer. Picasso's *Man with a Guitar* completed, showing well-developed Synthetic Cubist style.

Florence

January. First issue of the experimental Futurist newspaper *Lacerba*, edited by Giovanni Papini and Ardengo Soffici. (Last issue May 22, 1915.)

June 15. Publication in *Lacerba* of Marinetti's manifesto "Destruction of Syntax, Imagination without Strings; Words in Freedom."

September 1. Carrà's manifesto "The Paintings of Sounds, Noises, and Smells" published in *Lacerba*.

September 15. Apollinaire's "Futurist Anti-Tradition" manifesto published in *Lacerba*.

October 1. Marinetti's manifesto "The Variety Theater" published in *Lacerba*.

November 30–January 15. Futurist exhibition sponsored by *Lacerba* at the gallery of Ferrante Gonelli.

London

Spring. Wyndham Lewis founds Rebel Art Center in opposition to Roger Fry. It includes Edward Wadsworth, Lawrence Atkinson, Frederick Etchells, and Christopher Nevinson.

April. Exhibition of Severini's paintings and drawings at the Marlborough Gallery.

Milan

March 11. *The Art of Noises*, manifesto by Russolo addressed to Pratella; published as a booklet July 1 by Direzione del Movimento Futurista.

Moscow

Publication of the *Word as Such*, a manifesto of the "self-sufficient word," by Kruchenykh and Khlebnikov.

February. Jack of Diamonds organizes a debate on modern art and literature. One of the many Futurist encounters with the public.

Jack of Diamonds publishes a collection of articles and reproductions including Aksenov's "On the Problem of the Contemporary State of Russian Painting."

March. Larionov organizes the Target (Mishen) exhibition in Moscow. Includes Gontcharova, Malevich, Chagall, et al.; also children's art. The catalog includes Larionov's

text "Rayonist Painting," expounding his theory of new pictorial style.

Ilya Zdanevich lectures on "Marinetti's Futurism."

Spring. Aleksei Grishchenko publishes his book *On the Links of Russian Painting with Byzantium and the West*, dedicated to Sergei Shchukin.

Midyear. Founding of the journal of art and literature *Sofiia*, edited by P. P. Muratov.

Yakov Tugendkhold, art critic for the St. Petersburg journal *Apollon*, delivers a series of lectures on French art of the nineteenth and twentieth centuries.

June. Publication of Alexandr Schevchenko's *Principles of Cubism and Other Contemporary Trends in Painting of All Ages and Nations*.

July. Publication of the first monograph on Gontcharova and Larionov by Eli Eganbury (Ilia Zdanevich).

Publication of a miscellany, *Donkey's Tail and Target*, containing Larionov and Gontcharova's "Rayonism and Futurism: A Manifesto."

August. Gontcharova's one-artist exhibition includes 768 works; a slightly smaller version opens in St. Petersburg the following year.

November. Schevchenko publishes his booklet *Neo-Primitivism: Its Theory, Its Potentials, Its Achievements*.

Munich

Kandinsky continues preparations for a second volume (never realized) of the *Blaue Reiter* with contributions from Larionov and others.

June. Synchromist movement announced with exhibition at Neue Kunstsalon of the work of Morgan Russell and Stanton Macdonald-Wright.

New York

February 17–March 15. "International Exhibition of Modern Art" at the 69th Regiment Armory (known as the Armory Show) opens, including works by numerous Western European avant-garde artists. Also travels to Chicago and Boston.

Paris

Gabo visits his brother Antoine Pevsner and remains in Paris until 1914.

March 17. Publication of Apollinaire's *Les Peintres cubistes: Méditations esthétiques* (Eugène Figuière).

June 20–July 16. Exhibition of Boccioni's sculpture at the Galerie La Boétie. Marinetti (June 21) and Boccioni (June 27) give talks on Futurism at the gallery.

Spring or summer. Tatlin, after a brief trip to Berlin, arrives in Paris. Visits Picasso's studio at 242 Boulevard Raspail and sees his open constructions such as *Guitar*, which will provide stimuli for creation of Tatlin's counter-reliefs upon his return to Moscow—and subsequently lead to Constructivism.

October. Salon d'Automne includes a section of Russian folk arts.

Synchromist exhibitions at Bernheim-Jeune gallery, including the first abstract works by the Americans Stanton Macdonald-Wright and Morgan Russell.

November 15. Apollinaire publishes photographs of four Picasso constructions, including *Guitar and Bottle of Bass*, in periodical *Les Soirées de Paris*, of which he has become editor.

Russian collector Ivan Morozov acquires Picasso's *Portrait of Ambroise Vollard* (1910) directly from Vollard, for his Moscow collection.

Russolo gives concerts in Paris, Italy, and London with the first "noise organ."

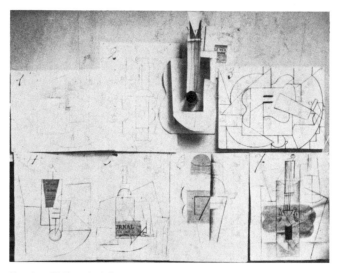

View of a wall in Picasso's studio at 242 Boulevard Raspail in Paris (1912), with cardboard maquette for *Guitar*, drawings, and series of papiers collés—possibly seen by Tatlin

View of Picasso's studio at 242 Boulevard Raspail in Paris, with a three-dimensional object, a guitar player (now lost)—possibly seen by Tatlin

Kasimir Malevich. Sketch for a backdrop for Act 2, Scene 1, of the Futurist opera *Victory over the Sun*, 1913

Rome

February 21. Tumultuous Futurist presentation at the Teatro Costanzi. A second presentation March 9 ends in a riot. An exhibition of Futurist paintings including works by Balla and Soffici is held in the theater from February 21 to March 21.

December 6–January 15. Boccioni exhibition of sculpture and drawings at the Galleria Permanente d'Arte Futurista established in Rome by Giuseppe Sprovieri.

Rotterdam

May 18–June 15. Exhibition of Futurist painting and sculpture at Rotterdamsche Kunstkring.

St. Petersburg

March. Under the auspices of the Union of Youth, Malevich lectures on Cubo-Futurism.

December. The Futurist opera *Victory over the Sun*, with music by Matiushin, texts by Khlebnikov and Kruchenykh, and designs by Malevich, is produced in Luna Park Theater. Malevich later identifies this production as an important step in his move toward Suprematism; the backdrop design shows the famous divided black square on white ground.

At the cabaret The Stray Dog, Alexandr A. Smirnov lectures on simultaneism and Robert Delaunay, and exhibits *La Prose du Transsibérien* by Cendrars, with ornamentation by Sonia Delaunay-Terk.

Larionov and Zdanevich publish Futurist manifesto "Why We Paint Ourselves" in the Christmas issue of the journal *Argus*.

Venice

Midyear. The Russian pavilion at the Venice exposition, designed by Shchusev (later to design Lenin's mausoleum).

January. Marinetti visits Russia at the invitation of Kulbin and lectures in Moscow and St. Petersburg; remains until mid-February. Meets Russian Futurists but is rather coldly received. He invites Exter, Kulbin, and Rozanova to contribute to the Futurist exhibition at Galleria Sprovieri in Rome that April.

First of several Futurist tours (begun in December 1913) in provincial cities in Russia by David Burliuk and Vladimir Mayakovsky. Joined by Kamensky in March, they continue a grand Futurist tour in southern Russia.

July. Declaration of war on Russia by Germany.

Summer. Mondrian returns to Holland because of father's illness. Outbreak of war prevents return to Paris.

Florence

March 15. Publication of Marinetti's manifesto "Geometric and Mechanical Splendor and the New Numerical Sensibility," in *Lacerba*. An English translation appears in *The New Age*, London, May 7, 1914.

Publication of Boccioni's book *Pittura, scultura futuriste*, written in 1913.

July 15. Marinetti and C. R. W. Nevinson publish the manifesto "Vital English Art," in Italian and English in *Lacerba*.

August 1. Publication of Sant'Elia's "Manifesto of Futurist Architecture" in *Lacerba*.

London

Publication of Clive Bell's *Art*, partly in reaction against Tolstoi's *What Is Art?* originally published in 1895.

April–May. Exhibition of the Italian Futurists at the Doré Galleries, with contribution by Balla, Boccioni, Carrà, Russolo, Severini, and Soffici.

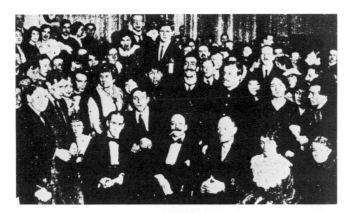

Marinetti with the Russian Futurists during his trip to Russia, winter 1914

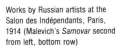

Vladimir Tatlin. Painterly Relief. *Selection of materials*. 1914. Iron, plaster, glass, asphalt. Whereabouts unknown

Works by Russian artists at the Salon des Indépendants, Paris, 1914 (Malevich's *Samovar* second from left, bottom row)

July. Wyndham Lewis announces Vorticism in the first issue of *Blast* in response to Marinetti and Nevinson's "Vital English Art." Signed by Ezra Pound, Henri Gaudier-Brzeska, Lawrence Atkinson, Edward Wadsworth.

Moscow

Publication of the Russian translation of Marinetti's book *Futurism* (published in Paris in 1911), containing texts of his lectures, proclamations, and manifestos.

Publication by critic G. Tastevin of his essay on Futurism along with five manifestos by Marinetti (two concerning literature) and the "Manifesto of Luxury" by Valentine de Saint-Point.

January. Publication of the second edition of Kruchenykh/Khlebnikov booklet *Game in Hell*; includes illustrations by Malevich and Rozanova.

March. Publication of *The Futurists: The First Journal of the Russian Futurists*.

An exhibition, "No. 4," organized by Larionov; includes works by him, Gontcharova, Kamensky, Schevchenko, Exter, Kiryl Zdanevich.

The fourth exhibition of the Jack of Diamonds group, with contributions by Exter, Lentulov, Malevich, Popova, Udaltsova, Braque, Picasso.

May 10–14. Tatlin holds "First Exhibition of Painterly Reliefs" in his studio, where he displays his three-dimensional works of 1913–1914.

November. Publication of Gontcharova's album of lithographs, *The Mystical Images of War*.

Munich

March. Hugo Ball plans a book on the new theater with the participation of Kandinsky, Marc, von Hartmann, Fokine, Bekhteev, and Klee (the venture interrupted by the war).

Paris

Apollinaire reports on Léger's lecture at the Académie Russe de Marie Vassilieff and announces the forthcoming exhibition of Larionov and Gontcharova's works at the Galerie Paul Guillaume. Catalog includes preface by Apollinaire and French translation of Larionov's Rayonist theory.

July. Publication of Apollinaire's calligrammes in *Les Soirées de Paris*.

Rome

February 11. Exhibition of Futurist works opens at Sprovieri's gallery (from then on often called the Futurist Gallery).

April–May. "Free Exhibition of Futurist Art" at the Sprovieri Gallery, including the work of many younger painters. Marinetti, Cangiullo, and Balla exhibit their "object sculptures"— assemblages (some of joint authorship) of various materials.

May. "First Free International Exhibition of Futurist Art" at the Sprovieri, with contributions by artists from Italy, Russia, England, Belgium, North America. The Russian artists represented were Archipenko, Exter, Kulbin, Rozanova.

St. Petersburg

January. Publication of the booklet *Futurists: Roaring Parnassus (Futuristy Rykaiushchii Parnas)*, including contributions by David Burliuk, Filonov, Puni, Rozanova, and Igor Severianin.

April–May 3. One-person exhibition of paintings by Gontcharova (including 249 works) at the Dobychina Bureau.

Balla, Giacomo
Speeding Automobile. 1912
Oil on wood
21⅞ × 27⅛″ (55.6 × 68.9 cm)
Purchase

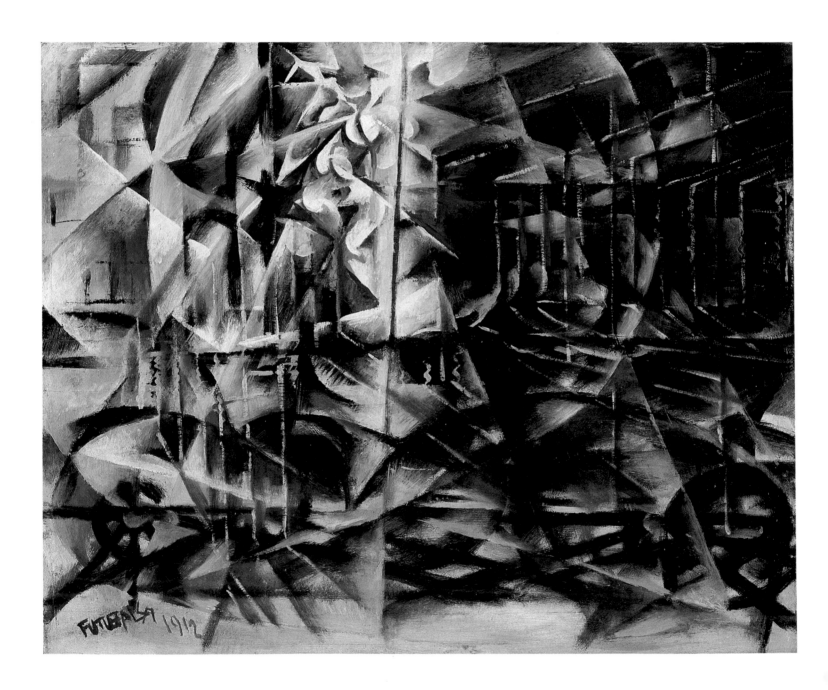

Braque, Georges
Clarinet. 1913
Cut-and-pasted papers, charcoal, chalk, and oil on canvas
37½ × 47⅜″ (95.2 × 120.3 cm)
Nelson A. Rockefeller Bequest

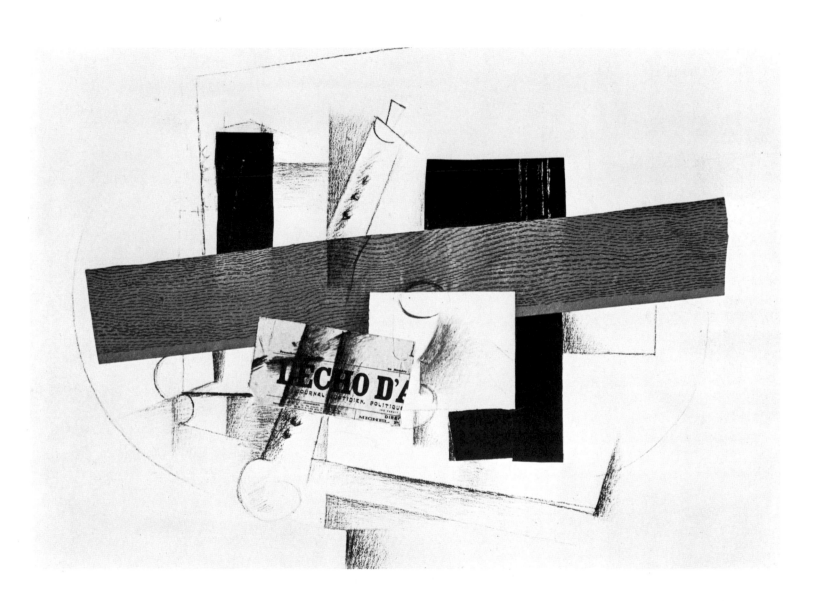

Delaunay, Robert

Simultaneous Contrasts: Sun and Moon. 1913, dated on painting 1912

Oil on canvas

53″ (134.5 cm) diameter

Mrs. Simon Guggenheim Fund

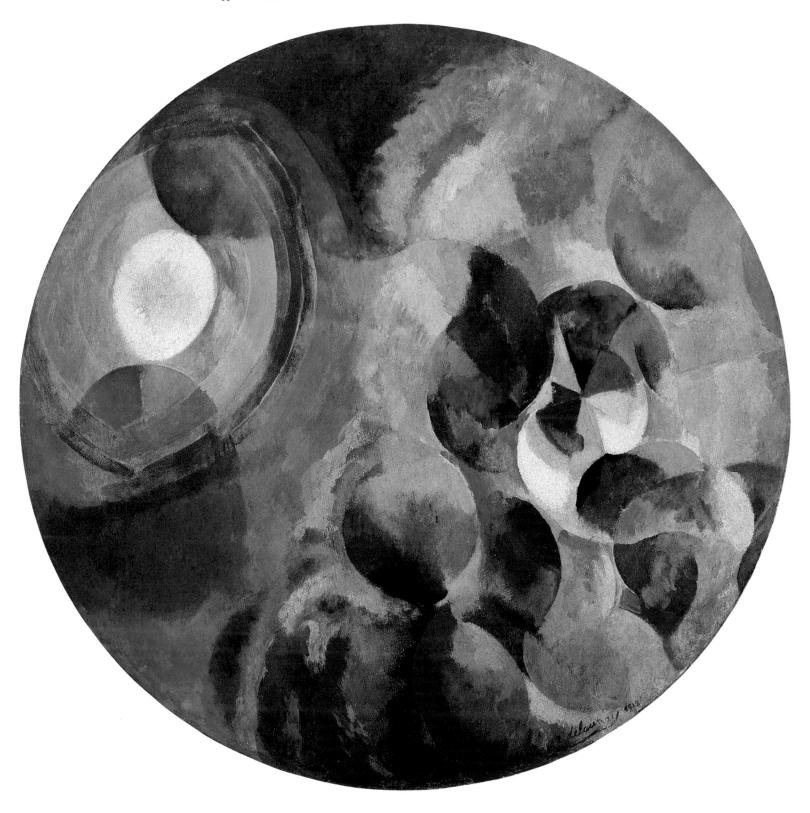

Delaunay, Robert
Football. The Cardiff Team. 1916
Oil on paper on wood
24½ × 18½″ (62.3 × 47 cm)

Gontcharova, Natalia
Rayonism, Blue-Green Forest. 1913
Oil on canvas
21½ × 19½″ (54 × 49.5 cm)

Kupka, František
Vertical and Diagonal Planes. 1913–1914
Oil on canvas
22 × 15¾″ (56 × 40 cm)

Larionov, Mikhail
Rayonist Composition: Domination of Red. 1912–1913, dated on painting 1911
Oil on canvas
20¾ × 28½″ (52.7 × 72.4 cm)
Gift of the artist

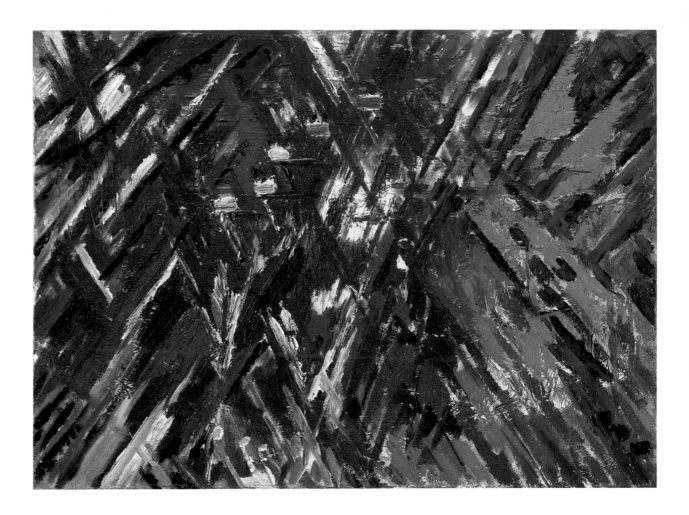

Léger, Fernand

Exit the Ballets Russes. 1914

Oil on canvas

53¾ × 39½″ (136.5 × 100.3 cm)

Gift of Mr. and Mrs. Peter A. Rübel (partly by exchange)

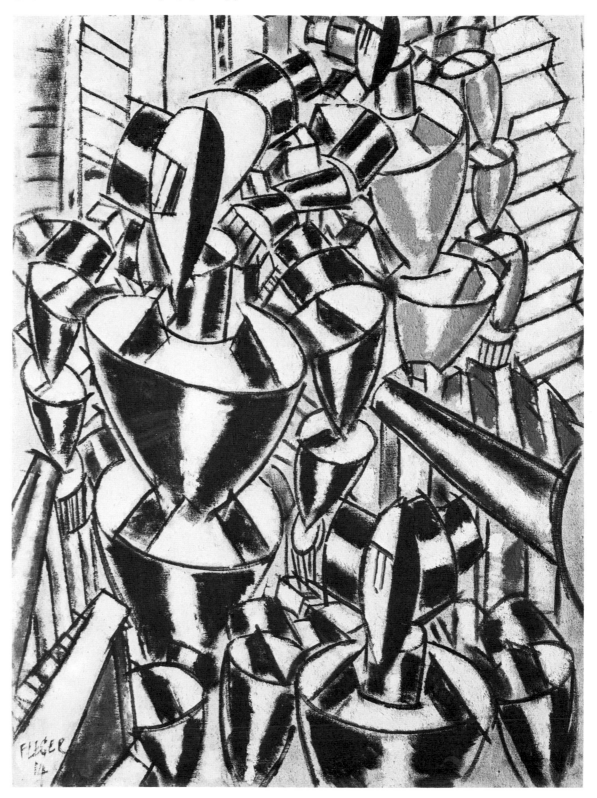

Malevich, Kasimir
Samovar. c. 1913
Oil on canvas
34¾ × 24½" (88 × 62 cm)

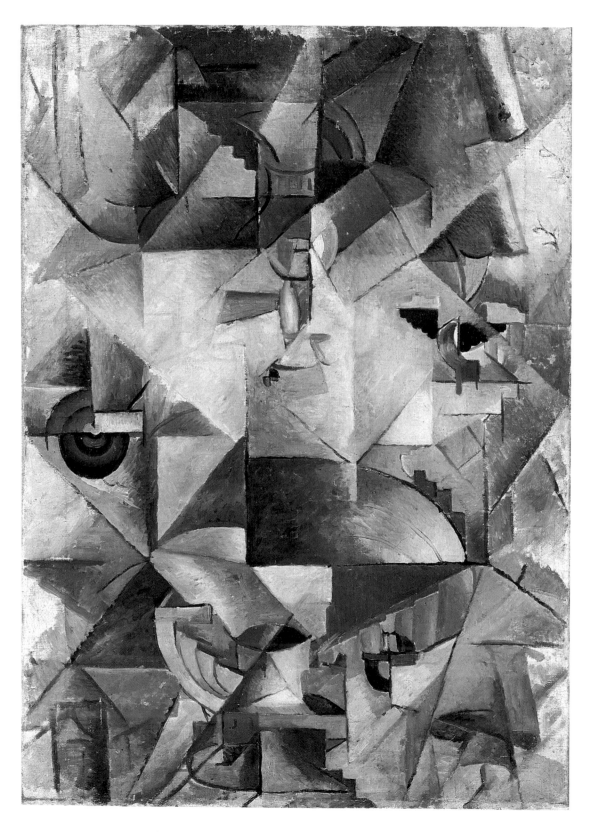

Malevich, Kasimir
Private of the First Division. 1914
Oil on canvas with collage of postage stamp, thermometer, etc.
21⅛ × 17⅝" (53.7 × 44.8 cm)

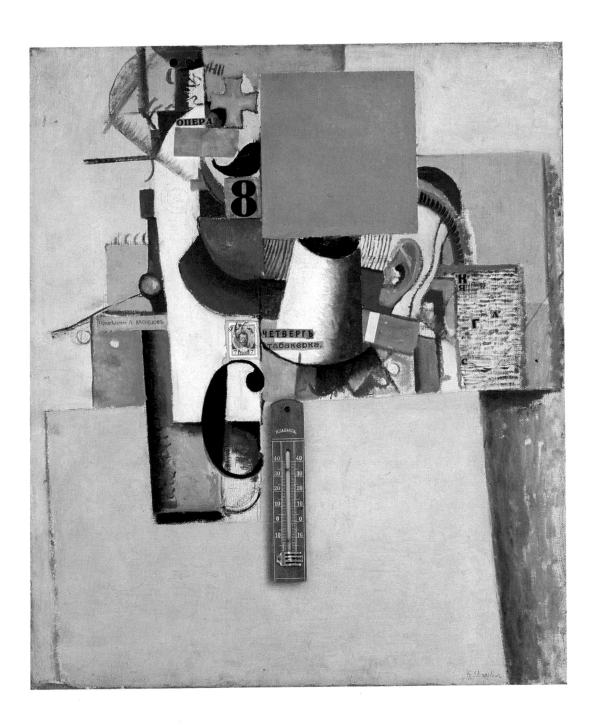

Malevich, Kasimir
Pedagogical Designs. 1919
Lithographs

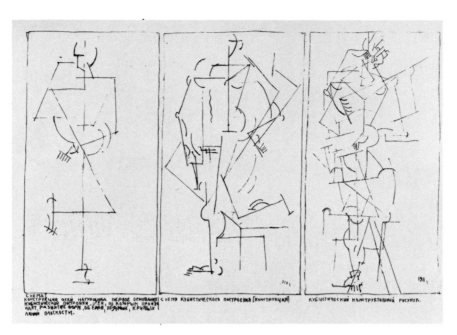

Three Explanatory Schemes of Dynamic Cubism
6¼ × 8¾" (16 × 22 cm)

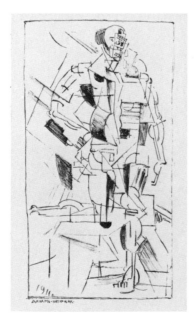

Dynamic Figure
8¼ × 5¼" (21 × 13.5 cm)

Alogism: Cow and Violin
8¼ × 5¾" (21 × 14.5 cm)

Malevich, Kasimir
Analytical Chart. c. 1925
Collage, pencil, pen and ink, ink wash
23 × 22″ (58.4 × 81.1 cm)

BEISPIEL DER FORMENANALYSE DER 4 ELEMENTE DES KUBISMUS ERHALTEN DER FRAGMEN TE, VERBINDUNGEN UND LINIEN.

Malevich, Kasimir
Analytical Chart. c. 1925
Watercolor, collage, pencil, pen and ink
21⅞ × 31⅛″ (55.6 × 78.9 cm)

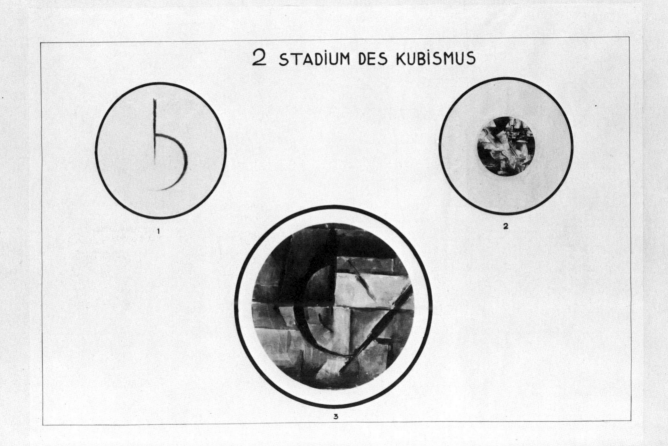

Malevich, Kasimir
Analytical Chart. c. 1925
Collage, pencil, pen and ink
21⅝ × 33″ (55 × 78.6 cm)

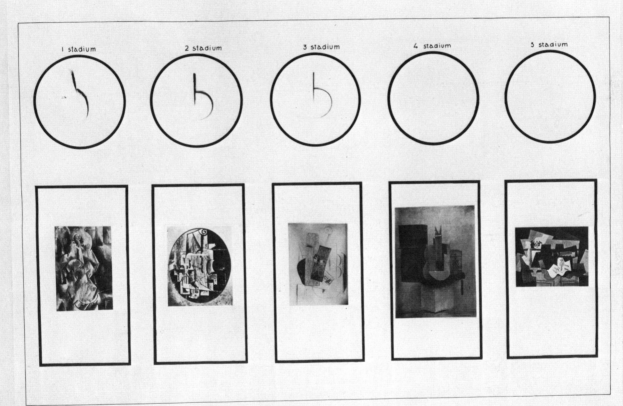

Malevich, Kasimir
Analytical Chart. c. 1925
Collage, pen and ink
21⅝ × 31″ (54.7 × 78.6 cm)

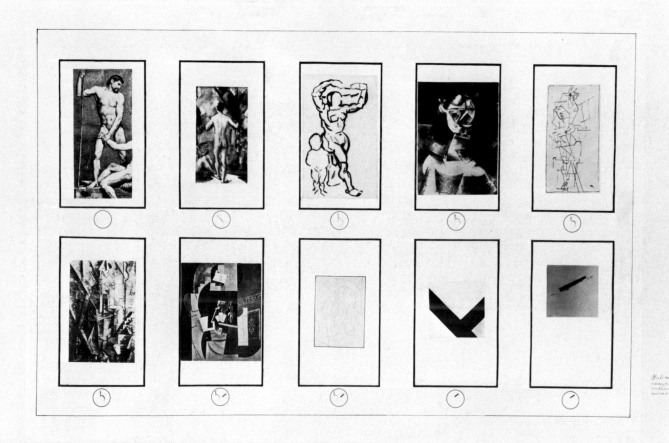

DIE MALERISCHE NATURVERÄNDERUNG UNTER DEM EINFLUSSE DES ERGÄNZUNGSELEMENTS.

Malevich, Kasimir
Analytical Chart. c. 1925
Collage with pencil on transparent paper, pen and ink
25 × 32½″ (63.5 × 82.6 cm)

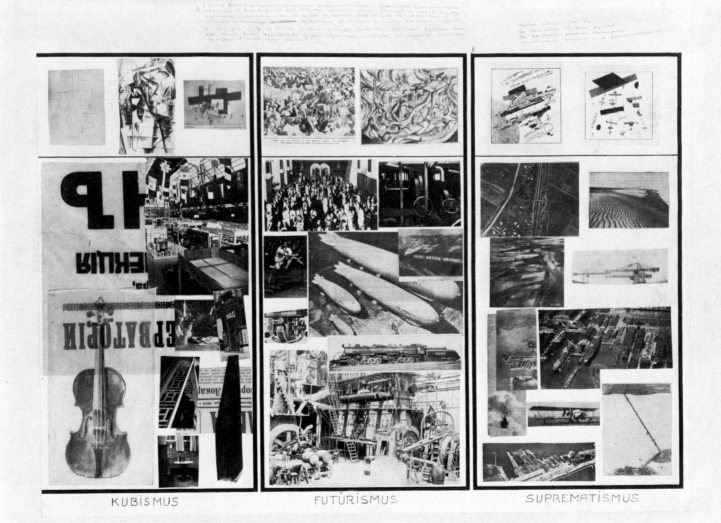

Marinetti, Filippo Tommaso
Vive la France. 1914
Brush and ink, crayon, cut-and-pasted papers
12⅛ × 12¾″ (30.9 × 32.6 cm)
Gift of the Benjamin and Frances Benenson Foundation

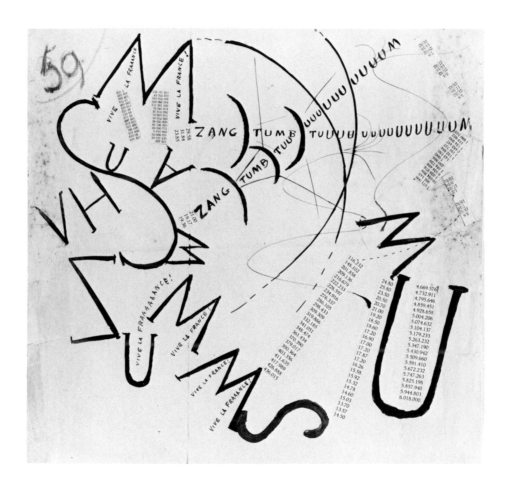

del Marle, Félix
Looping. 1914
Charcoal and ink on paper
24½ × 18¾″ (62 × 47.5 cm)

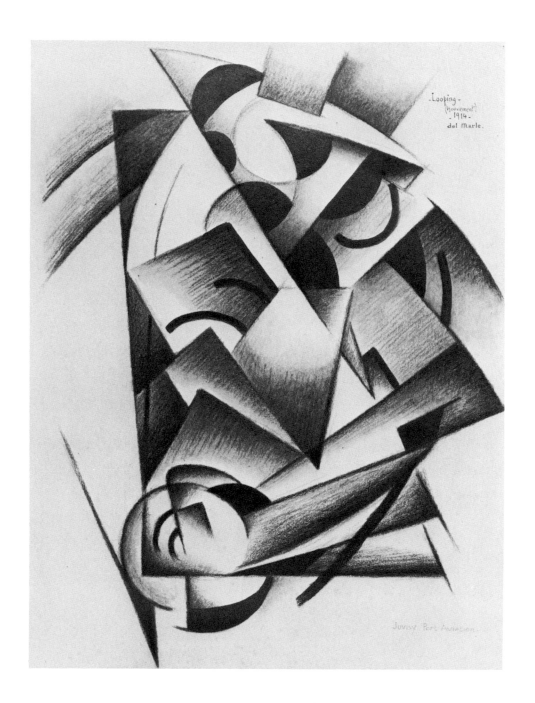

Mondrian, Piet
Pier and Ocean. 1914
Charcoal and white watercolor on buff paper
34⅝ × 44″ (87.9 × 111.2 cm)
Mrs. Simon Guggenheim Fund

Picasso, Pablo
Guitar. 1912
Sheet metal and wire
30½ × 13⅛ × 7⅝″ (77.5 × 35 × 19.3 cm)
Gift of the artist

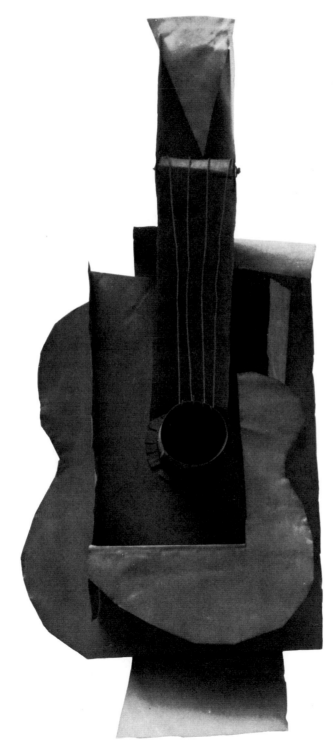

Picasso, Pablo
The Architect's Table. 1912
Oil on canvas mounted on panel
28⅝ × 23½″ (72.6 × 59.7 cm)
Gift of William S. Paley

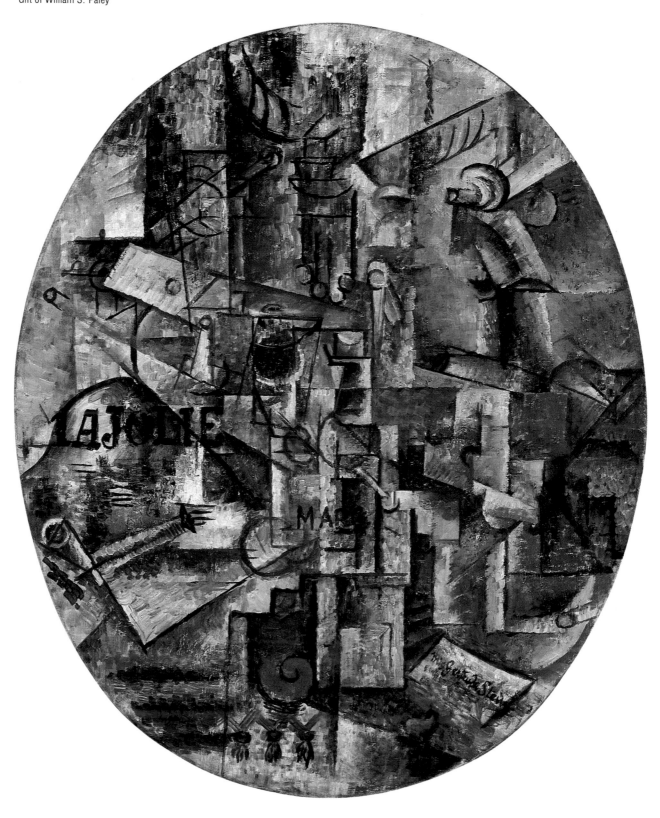

Popova, Liubov
Early Morning. 1914
Oil on canvas
28 × 35″ (71 × 89 cm)

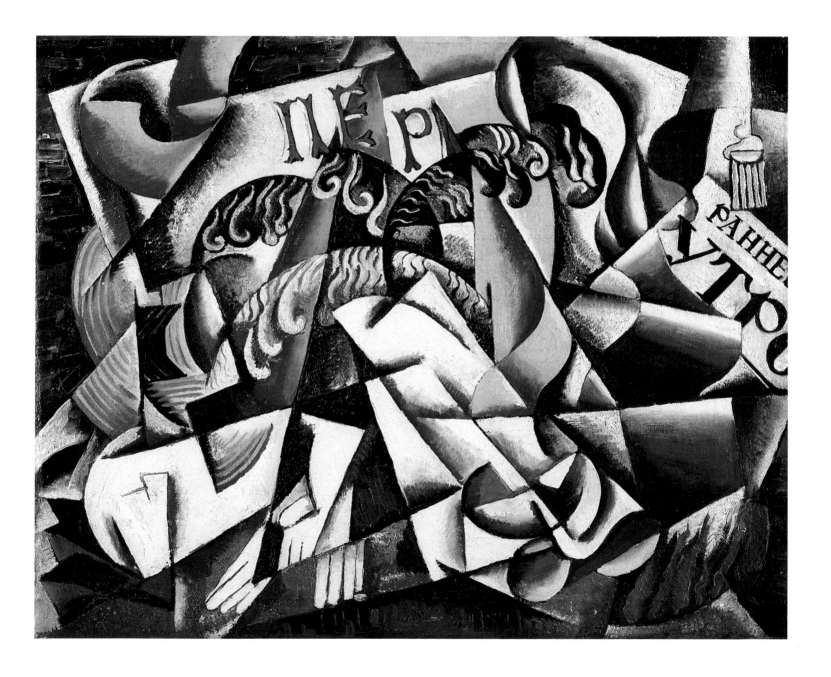

Rozanova, Olga
The Factory and the Bridge. 1913
Oil on canvas
32¾ × 24¼″ (83 × 61.5 cm)

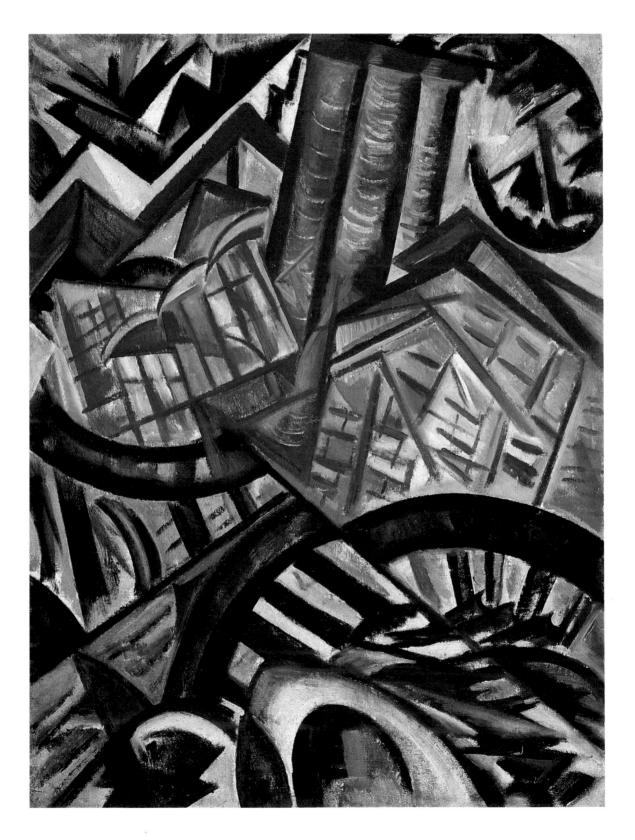

Severini, Gino
Dancer. 1912
Pastel on paper
19¼ × 12½″ (49 × 32 cm)

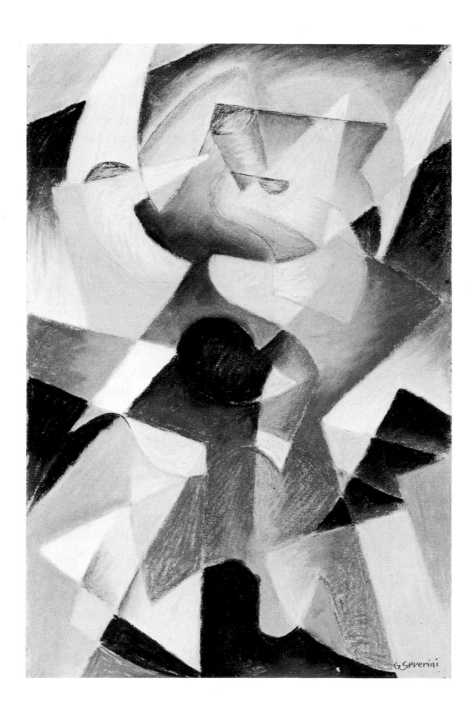

From Surface to Space—

Suprematism,

de Stijl, Russian Constructivism

1915–1921

In the second half of the 1910s two radical transformations in artistic expression took place. First, the search for an expression of "absolute" artistic creation that would be compatible with the values of modernity resulted in the formulation of nonobjective geometric styles—Suprematism in Russia and de Stijl in Holland—as the most advanced pictorial idiom. Second, the fundamental rethinking of the function of art within society and the emphasis on its utilitarian importance, prompted by social and political revolution, entailed a transition from two-dimensional pictorial form (easel painting) to a spatial one (three-dimensional construction). The second phenomenon, which had its roots in Russia and initiated a new movement, Constructivism, was of great consequence for design, architecture, and decorative and graphic arts in later decades, through the 1960s and even into the present.

In December 1915 at the exhibition "0.10: The Last Futurist Exhibition of Paintings," in Petrograd, Kasimir Malevich astonished his avant-garde colleagues with nonobjective paintings done in a new style that he called Suprematism (the Latin word *supremus* means "ultimate," "absolute"). His canvases were austere compositions of basic geometric forms of unmodulated color organized in free, unstructured space, and these works (e.g., *Airplane Flying,* 1915) conveyed dynamic sensation through the compositional arrangement of forms and the interaction of colors. Through the new language that he had devised, Malevich intended to achieve an expression of sensitivity extending beyond the perceptual world and conveying the universal truth of spiritual order. His aim was to create "pure art" that would symbolize the order and harmony of the new age, for he felt that the old art forms, tied to representation of visible reality, had lost their relevance to the ideals of a society changed by industrial technology, by Einstein's physics, and by social upheavals. The concept of painting as an "absolute," self-referential construct composed of such fundamental formal elements as the square, rectangle, circle, and cross, free of the artist's subjective intervention and governed only by its own universal laws, implied a new ideal harmony between modern man and his environment.

Suprematism—as Malevich explained in his booklet *From Cubism and Futurism to Suprematism: The New Realism in Painting*, published at the time of the "0.10" exhibition—had evolved as a result of his search for a way out of the constraints of Cubism and Futurism. These movements, he felt, in spite of their formal and conceptual innovations, were still tied to the depiction of perceptual reality and therefore did not satisfy the requirements of the pictorial language needed to render the modern world of speed and motion. Cubist and Futurist devices had to be replaced by new means of constructing pictures, based on forms cerebral in origin that would introduce "new realism" in painting—the "new realism" of independent artistic creation. Such means were afforded by Suprematism, conceived as a system of autonomous pure creation constructed in time and space from planar elements of concentrated color.

The nucleus of the Suprematist concept first appeared in Malevich's work in Moscow in 1913 in the set and costume designs for the first Russian Futurist opera, *Victory over the Sun*. Specifically, a backdrop design representing a diagonally bisected black and white square on a white ground was the announcement of the new mode.

Suprematist ideas came to full maturity between mid-1913 (the time of the *Victory over the Sun* designs) and mid-1915 (the date given on the text of *From Cubism and Futurism to Suprematism*). Pictorially, Malevich's Suprematist works were "prepared for" by his Cubo-Futurist pictures, such as *Private of the First Division* (1914). Here, into a formal structure deriving from Synthetic Cubism and including elements of collage and lettering as space-defining elements, Malevich introduced large flat areas of color. Subsequently, these areas of pure color became the subject of his compositions—the signs of pure color generating a metaphysical space of his "absolute nonobjective creation." *Black Square on White Ground* (1915) and *White on White* (1918) were the quintessential Suprematist paintings; their economy of means and structure defined the parameters of Malevich's Suprematist philosophy, the substance of which was created by the interrelationships between color, form, space, and content. Suprematism introduced a new concept of universal space and color as purified, metaphysical essence. This space differed from traditional pictorial space (whose purpose was to divide objects) in that it was devoid of materiality and weight of forms; it was unstructured, infinite, all-encompassing, cosmic. To convey this, Malevich, in *Black Square on White Ground*, proposed an ultimately radical solution achieved through the exploration of flatness of form and support, without help of representational devices. Perception of space implies a notion of distance and movement, or dynamics, which is evoked in Suprematism through the compositional arrangement of shapes of flat color, falling, ascending, and moving along diagonal axes.

The concept of dynamic space, which grew out of the Futurist interest in movement and its depiction, was closely related to the general interest in time and space awakened by Einstein's theory of relativity, non-Euclidean geometry, and the contemporaneous philosophical preoccupations with the fourth dimension and the possibilities of measuring time and space. Theories of Minkowsky, Hinton, Poincaré, Lobachevsky, Rieman, Bouché, and particularly the theories of hyperspace philosophy expounded in the treatise on the fourth dimension *Tertium Organum* by the Russian philosopher and mystic P. D. Ouspenski (first published in St. Petersburg in 1912), were then widely known and discussed by the Russians, as evidenced by Malevich's 1913 correspondence with Matiushin, his close friend and collaborator on *Victory over the Sun*.

Malevich envisioned Suprematism as a system allowing the artist to depict fourth-dimensional space pictorially on a two-dimensional support fusing spatial and temporal qualities. Color, contained within basic geometric forms, and the relational structure of the forms within the composition were the expressive means of that system. The ultimate goal of Suprematism was to achieve the "absolute" creation, and *White on White* is the embodiment of this aspiration. Through the most economical use of form in a single color, symbolic of infinity and purity, Malevich attained the infinite extensibility of pictorial space and reached the "higher spiritual plane."

Malevich's Suprematist ideas promptly found followers among avant-garde artists. In 1916 they formed a group, Supremus, intended to prepare the publication of a Suprematist journal. The group included, among others, Ivan Kliun, Liubov Popova, Ivan Puni, Olga Rozanova, and Nadezhda Udaltsova. They all used the Suprematist vocabulary of form and its compositional principles based on dynamics of form and color to develop individual styles related to but independent of Malevich's idiom. Popova, for instance, explored the possibilities offered by collage; making use of experience gained in her 1915 collage-constructions based on the Cubist formulation of form and space (e.g., *Jug on the Table* and *Relief*, both in the Tretiakov Gallery, Moscow), she executed a number of Suprematist collages. Puni was interested in the "constructional" aspect of collage technique; in 1915–1916 he created numerous Suprematist reliefs composed of planar elements—essentially three-

dimensional counterparts of the pictorial Suprematist compositions. Rozanova created two astonishing series of Suprematist collages for the portfolios *War* and *Universal War* (1916), using free-floating triangles, circles, and rectangles of colored paper.

Suprematism aspired to be not only a style and an aesthetic theory of pure art, but a philosophical system—a world view, designed to encompass other aspects of life, applied arts and theater and especially architecture and environment. After 1918, Malevich concentrated on drawings for idealized architecture and on his Suprematist teaching method. His 1920 retrospective in Moscow and the publication of *Suprematism: 34 Drawings* in Vitebsk ended the period of planar Suprematism. From then on he was committed to architecture and three-dimensional objects—the theoretical architectural models, initiated in the autum of 1919. The focus on architecture reflected the theoretical concerns being debated in Russia and bearing a marked resemblance to the European ideas viewing architecture as a synthesizing art form (the ideas best exemplified in the precepts of de Stijl and the Bauhaus). Starting in 1919 Malevich transposed the pictorial principles governing his Suprematist pictures into their three-dimensional counterparts, and in the late 1920s he worked almost exclusively at Suprematist architecture, considering it "*the* contemporary art form." His Planits (drawings for new architecture) and his Arkhitektons (models of Suprematist architecture) embodied experimental conceptions of architecture and urban design—the new vision of modern human environment.

Malevich's views were elaborated by his pupils, who in 1919–1920 had formed the Unovis group (or Suprematist Academy) at the Vitebsk Institute of Art and Practical Work. The group included Lissitzky, Ilya Chashnik, Nikolai Suetin, Anna Leporskaia, Nina Kogan, Lazar Khidekel, Vera Ermolaeva, Gustav Klucis, et al. Later two of his pupils, Chashnik and Suetin, who followed him to the Petrograd Inkhuk in 1922, carried their Suprematist theories into applied arts, making designs for porcelains and book covers. Between 1924 and 1927 Malevich and his students at the Formal Theoretical Department of the Leningrad Inkhuk prepared a group of twenty-two pedagogical charts illuminating Malevich's theory of historical development in art from Cubism-Futurism to Suprematism, his theory of basic and additional elements in painting, and his color theory.

Malevich's Suprematist theories were a catalyst for the development of the personal idiom that El Lissitzky evolved in 1919–1921 as a "transitional stage between painting and architecture." Initially educated as an architect, Lissitzky considered architecture to be an ultimate synthesis of artistic endeavors, and his spatial concepts were to a large degree conditioned by his architectural training. The works called Prouns—an acronym for Projects for the Affirmation of the New (in Art)—which were executed in the years from 1919 to 1927, demonstrated Lissitzky's new conception of plastic form, cosmic space, and their dynamic relationship. They originally combined Malevich-inspired flat color planes and three-dimensional geometric figures, floating in space, that were subsequently enriched by real materials attached to the pictorial surface, as in *Proun 19 D*. The addition of real materials mediated the extension of the Prouns into the third dimension and into the virtual space of the viewer; ultimately the works were transformed into environmental spaces, such as the Proun Room for the Grosse Berliner Kunstausstellung in 1923, the Kabinett der Abstrakten in the Niedersächsisches Landesmuseum in Hannover in 1927, and the Russian pavilion for the Pressa exhibition in Cologne in 1928.

At the time when Malevich was developing his abstract idiom, concerns similar to those of Suprematism—how to create a universal pictorial counterpart of the harmonious relations within the ideal modern society—arose among the Dutch painters

Mondrian, van Doesburg, and van der Leck, who, together with the architect J. J. P. Oud and the poet Anton Kok, founded the de Stijl group in 1917. The group subsequently included also the Hungarian painter Huszar, architects Jan Wills and Vant'Hoff, and the sculptor Vantongerloo, as well as the architect Rietveld and others. Ideologically, it was probably the purest and most idealistic among the abstract movements, imbued with the sense of ethical and spiritual mission, in search of a "new plastic reality." Since it evolved at the end of World War I, when the need for a new order and a new man was acutely felt, the new art invoked a sense of social destiny. The essential premise of de Stijl was a belief in a universal harmony wherein man could be an integral part if he freed himself from his individuality and from the burden of objects from the visible world. Art was to be a model for such a harmonious new reality. These artistic conceptions were a combination of the Dutch Protestant philosophy of idealism and the intellectual tradition of logic and clarity. In addition, certain aspects of Marinetti's Futurist ideology and Boccioni's ideas about line as the best means of spiritual expression for the man of the future were of relevance to the formation of de Stijl concepts. Such views were fostered in the periodical *De Stijl*, which appeared from October 1917 until the death of van Doesburg in 1931.

The pictorial transposition of these idealistic conceptions of the universe was reached through the reduction of plastic means to the essential elements of pictorial vocabulary: line, space, and color organized into the most rigorous compositions. Elemental geometric forms of pure primary colors (red, yellow, and blue, and noncolors, black and white and gray) in austere linear relationships became the essence of de Stijl's visual language—which Mondrian called Neoplasticism.

Although de Stijl's professed goal was the objectivity of artistic expression and a search for "pure art" based only on perfect relationships according to the laws of geometry, the works by Mondrian, van Doesburg, van der Leck, and Huszar represent a diversity within the Neoplastic idiom. While Mondrian and (until 1924) van Doesburg adhere to the strict vertical-horizontal organization of forms, both van der Leck and Huszar make use of diamond-shaped and triangular forms, thus introducing a diagonal into the composition, which as a result is less dependent on the grid structure and hence less rigid in expression.

De Stijl tenets were envisioned as a life-governing philosophy that was to encompass painting, architecture, and the entire environment. Participating in the group were architects who shared the painters' concern for transposing the pictorial principles of de Stijl into the third dimension. An extension into space, that is, architecture and environment, was the logical next stage in the evolution of geometric abstract theories. Mondrian's attempts at creating a Neoplastic environment in his own studios in Paris and later in New York; van Doesburg's architectural projects and drawings, done in collaboration with van Eesteren, for a private house designed according to de Stijl principles; Rietveld's red/blue chair (1918) and his Schröder House (1924); Huszar's interiors; van der Leck's designs for tapestries and carpets—all reflected a commitment to applying the de Stijl pictorial philosophy to a new "pure plastic reality."

The artists' ambition to create a modus vivendi for man of the future through the redefinition of the vocabulary and syntax of plastic arts was an aim partially akin to the objectives of the Russian Constructivists. Constructivism was the last of numerous avant-garde "isms" that sprang up in Russia during the 1910s. Its emergence was closely related to the political and social changes brought about by the October Revolution in 1917. Its goal was to transform the consciousness of society, to promote a new understanding of the notion of a work of art and the role that art ought to play within society.

The initial impulse for the evolution of Constructivist ideas came from the three-dimensional creations of Tatlin, shown at the "0.10" exhibition in December 1915 in Petrograd, concurrently with Malevich's first Suprematist canvases. Tatlin's constructions—the painterly reliefs of 1913–1914 and the counter-reliefs of 1914–1915—were assemblages of ordinary industrial materials, whose inherent properties determined the forms of compositional elements. These works were originally stimulated by Tatlin's discovery of Picasso's open Cubist constructions, such as *Guitar* (spring 1912), seen at Picasso's studio in Paris during Tatlin's visit there in the spring or early summer of 1913. Tatlin's works, as well as Gabo's constructions of 1915–1917, such as *Head*, represented the first step in the work of Russian artists in the evolution of form from an enclosed sculptured mass to an open, dynamically integrated construction, where real space played an active compositional part. Tatlin's counter-reliefs and corner counter-reliefs of 1915 (named so possibly because their building process into the viewer's space was in direct opposition to traditional relief technique) embodied concepts similar to those involved in Picasso's constructions; the essential difference (and innovation) was Tatlin's approach to materials. Their natural properties were, to him, crucial for the form and expressive power of the work. In order to achieve their expressive potential, materials had to be used according to their "true nature," which was the essential determinant of form. Based on this principle of the "culture of materials," the counter-reliefs were arrangements of planar elements assembled in front of a wall or tautly stretched in a corner between two walls in the virtual space of the viewer, and as a result became part of his environment.

The formulation of other concepts of Constructivism also began to take shape around 1918–1920 in the work of such artists as Popova, Rozanova, Exter, Stepanova, and Rodchenko. The tenets were further developed and consciously defined in 1920–1921 through the theoretical preoccupations and actual practice of these artists, members of the Institute of Artistic Culture (Inkhuk) in Moscow. Created in May 1920, Inkhuk united all of the leftist artists who shared political sympathies and artistic ideology. It set out to develop a theoretical approach and specific pedagogical program and method for the educational and artistic institutions of the new Communist society. The Vkhutemas (Higher Artistic Studios), the central pedagogical institution—created in the autumn of 1920—also played a very active part in elaborating the Constructivist theory, particularly since many of the Inkhuk artists taught there: Exter, Kliun, Popova, Rodchenko, Stepanova, and Babichev. Constructivist ideas became the dominant philosophy at the Inkhuk at the end of 1920, after Kandinsky's original artistic program, based on the concept of art as a spiritual activity in search of "pure art," was rejected and the administration was reorganized under the leadership of the sculptor Aleksei Babichev, with the collaboration of Rodchenko, Popova, and others. The designation of the movement as "Constructivism" came into usage in late 1920 and was formalized in March 1921 when a group of avant-garde artists at the Inkhuk—Rodchenko, Stepanova, Gan, Medunetsky, Ioganson, and the brothers Stenberg—established the First Working Group of Constructivists. The name first appeared in print in the catalog for the exhibition "Constructivists," organized at the Poets' Café in Moscow in January 1921 by the younger generation of the artists at the Vkhutemas (who in 1919 had formed the Society for Young Artists—Obmokhu). In "Constructivists," the three participants, Konstantin Medunetsky and the Stenberg brothers, showed their three-dimensional free-standing structures assembled from industrial materials according to the Tatlinian concept of the "culture of materials," devoid of pedestal and interacting with space through their placement vis-à-vis the enclosure, that is walls, floor, and ceiling.

As it subsequently developed, Constructivism was a global philosophy that expounded materialism over idealism and postulated integration of life and art; art had to fulfill a social function and be expressive of the ideological aspirations of the

new system. Essentially, Constructivism initiated an antiaesthetic concept of art. Art had to be *engagé* and utilitarian. This premise eliminated easel painting as an old-fashioned bourgeois art form and introduced three-dimensional "construction" as the only form of expression that could answer the requirements of the new industrial society and mass culture. "Construction" in this context was to be understood on two levels: as a description of the process of creation and as a metaphorical representation of the order of the created three-dimensional object. Ultimately, the functional and economic objects "constructively" formed by artists and the utilitarian mass product whose aesthetic value was raised to the status of a cultural product by virtue of its creation by an artist-engineer were to best embody the tenets of Constructivism.

Focusing upon the creation of form as resulting solely from the treatment of material, Constructivism was the movement of the third dimension and subsequently of applied arts. A limited part of Constructivist history—the more theoretical phase and "the laboratory period" of 1919–1921—included pictorial experimentation by Rodchenko, Popova, Stepanova. These artists, although subscribing to the utilitarian philosophy of art, concentrated on investigating the formal attributes of painting—color, line, texture (*faktura*), and their relations and expressive values—as the preparatory stage for the three-dimensional constructions. Their pictorial research was justified by the uniquely Russian concept of paint and painted surface (*faktura*) understood as "material," which originated in Cubo-Futurism and was elaborated by Vladimir Markov in his book, *Principles of Creation in the Visual Arts: Faktura* (St. Petersburg, 1914).

Having arrived at the nonobjective geometric form in painting, as in Rodchenko's *Black on Black* (where the interaction of analogous forms in close-valued colors is the subject of the work) or Exter's *Construction* (which expresses a group preoccupation with the role of composition, plane, line, space, and dynamics), the Constructivists then rejected painting as obsolete. They formally denounced it in their "last" exhibition of paintings, "5 x 5 = 25" (Moscow, September 1921), to which Exter, Popova, Rodchenko, Stepanova, and Aleksandr Vesnin contributed five works each, and the "dead end" of painting was marked with Rodchenko's three monochrome canvases in pure color: red, blue, and yellow. By then the focus had shifted from an abstract arrangement on a two-dimensional surface to three-dimensional construction, as in Rodchenko's Hanging Constructions of 1920, which were three-dimensional translations of his concepts of the role of line, essentially studies in spatial and dynamic relationships of forms based on line.

Line, plane-surface, *faktura*, composition versus materials and construction were the subjects of analysis and debate at the Inkhuk throughout 1921. A compendium of theoretical essays on these themes entitled "From Figurativeness to Construction" was planned in the autumn of 1921, and a series of lectures was organized to continue polemical discussion on questions of art: the idea of the artist-engineer, the role of space, the dialectics of art. The theoretical discussions at the Inkhuk that extolled the superiority of "construction" as the active process of creation over "composition," the passive and contemplative one, led to a schism among the Constructivists in January 1922. Later that year, in November, the most doctrinaire of them proclaimed the supremacy of industry and turned decisively from painting to areas that lent themselves better to the fusion of the artistic and the technical and were closely linked to the propagandistic ends of the new regime. Constructivism entered a new phase, Productivism—the period of artists' active involvement with industrial production— which continued during the 1920s. Viewing their work in a political light, as a synthesis of the functional, technological, and social aspects of art, they developed new approaches to industrial and graphic design, typography and layout, which were treated as direct and powerful means of communication (in a way foreshadowing modern advertising techniques).

Thus Rodchenko introduced innovative photographic and typographical conceptions. Popova and Stepanova turned to textile design, and also to theater design, where along with Aleksandr Vesnin they produced revolutionary stage sets for Meyerhold's productions. Lissitzky, the Vesnin brothers, and Klucis designed various structures serving propagandistic purposes—Lenin's podium, projects for the decoration of city squares and civic monuments, as well as kiosks and giant loudspeakers for the streets. But the domain where the synthesis of art and life could best be fulfilled was architecture; it produced such excellent modernist examples as Vesnin's Leningrad Pravda Building (1922), Melnikov's Workers' Club in Moscow, and the latter's Soviet pavilion at the Paris Exhibition of Decorative Arts (1925). The most ambitious and most utopian attempt to use the skills of the artist-engineer to construct a symbol of the new society was Tatlin's unrealized project for the Monument to the Third International, of 1920. But with the "Productivist" phase of Constructivism, the innovative experimentation quickly ended, and in 1929, with the removal of Anatoli Lunacharsky as the arts commissar, the period of liberalism in the arts ended. It was followed by a return to traditional easel painting, with Socialist Realism as the official style, better suited to the popularization of an ideological and political message than nonfigurative art.

The irony of the rejection of Constructivism by the very system and the very consumer for whom it was essentially intended is clearly apparent. That rejection was the result of contradictions inherent within the conception itself. The artists' emphasis on the utilitarian aspect of art and their fascination with industrial materials (for the most part scarcely available in Russia at that time) were the consequence of recent industrialization in Russia and initially became a stimulating factor for formal and aesthetic innovations (Tatlin's reliefs, Rodchenko's hanging constructions, the Obmokhu members' sculpture). On the other hand, the nonobjective geometric form was not aesthetically appealing or even understandable for the mass audience or for officialdom, and in reality it was little suited to achieving propagandistic objectives. Besides, the Constructivist artists themselves, within their claustrophobic circle, stiffened in their doctrinaire approach. By the mid-1930s Constructivism had definitely fallen out of favor with official organizations, and the First All-Union Congress of Soviet Writers, in August–September 1934, hailed Socialist Realism as the high style of the proletarian state, in fact sanctioning the movement, which had been in existence alongside Constructivism since the mid-1920s and was increasingly gaining in importance. But by the time of the official ban on Constructivism in the Soviet Union, Constructivist ideas had gained popularity in Western Europe, finding expression in the philosophy of the Bauhaus and later in various aspects of the modernist trends of the 1950s and 1960s.

Chronology

1915–1921

Mondrian moves to Laren. Begins correspondence with van Doesburg.
Gabo in Norway makes his first constructions.

London

June. Exhibition of Vorticism, at Doré Galleries.

Milan

January 11–February 18. *Manifesto of the Futurist Synthetic Theater,* by Marinetti, Bruno Corra, and Emilio Settimelli.

March 11. Balla and Fortunato Depero sign the manifesto *The Futurist Reconstruction of the Universe.* Balla at this time is experimenting with "plastic complexities," constructions combining various materials.

Moscow

Kandinsky returns to Russia, where he remains until December 1921 (except for short trip to Stockholm December 1915–March 1916).

End March–April. "Exhibition of Painting: 1915" organized by Kandaurov, with contributions by the Burliuks, Gontcharova, Kandinsky, Larionov, Malevich, Mayakovsky, Tatlin (last three not in catalog); includes Rayonism, Tatlin's reliefs and "counter-reliefs," and his "constructions of materials."

July. Gontcharova and Larionov leave Moscow and join Diaghilev in Lausanne.

New York

Stieglitz publishes the monthly *291,* dedicated to modern art and satire.

August. Duchamp arrives in New York and becomes part of the Arensberg circle, which includes Hartley, Sheeler, Stella, William Carlos Williams. He also shares in the émigré community with the Picabias, Roche, Gleizes, Crotti, etc. He meets Man Ray and the Stettheimer sisters and uses the term "Readymade" for his found objects.

Petrograd

"Exhibition of Leftist Trends," at the Dobychina Bureau, includes contributions by Larionov, Malevich, Puni, Rozanova, Udaltsova, Vladimir and David Burliuk, Kulbin, Kandinsky.

March. Exhibition "Tramway V," subtitled "The First Futurist Exhibition of Paintings," includes Exter, Kliun, Malevich, Popova, Puni, Rozanova, Tatlin, Udaltsova. (Malevich shows "alogic" paintings, and Tatlin shows his "painterly reliefs.")

December. "The Last Futurist Exhibition of Pictures: 0.10" includes contributions by Kliun, Malevich, Popova, Puni, Rozanova, Tatlin, Udaltsova, and others, and one room of reliefs by Tatlin. Malevich's Suprematist room is first public showing of Suprematist works like the famous *Black Square.* On the occasion of this exhibition Malevich, Kliun, Menkov, Boguslavskaia, and Puni edit a Suprematist manifesto, containing their statements on new art.

Malevich's book *From Cubism to Suprematism: The New Painterly Realism* is published in two editions. The third edition, *From Cubism and Futurism to Suprematism: The New Painterly Realism,* is published in 1916 in Moscow.

San Francisco

May. Forty-eight Futurist drawings and paintings and Boccioni's sculptures *Development of a Bottle in Space* and *Muscles in Quick Movement* are shown through the summer at Panama-Pacific International Exposition. Boccioni's essay "The Exhibitors to the Public" is published in the catalog.

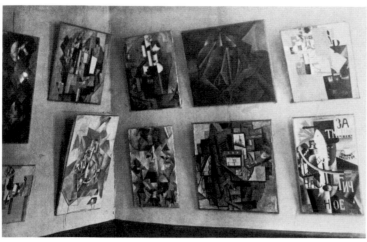

Works by Malevich at the "Tramway V" exhibition, Petrograd, 1915, including *Private of the First Division* (first from left, bottom row), *Samovar* (third from right, bottom row)

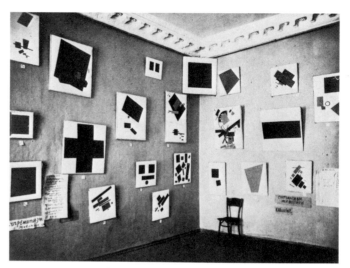

Works by Malevich at the "0.10" exhibition, Petrograd, 1915

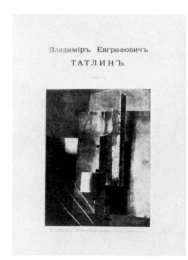 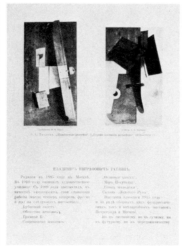 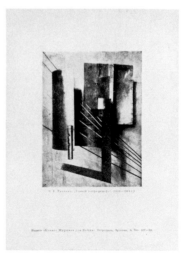

Pamphlet on Tatlin's reliefs published by him in connection with the "0.10" exhibition

1916

August 17. Death of Boccioni.

Milan

December 28–January 14. Comprehensive exhibition of Boccioni's work at the Galleria Centrale d'Arte, Palazzo Covo.

Moscow

Malevich plans publication of a Suprematist journal, *Supremus,* in collaboration with Kliun, Popova, Rozanova, Udaltsova, and Pestel.

March. "The Store" (Magazin) exhibition organized by Tatlin, with contributions by Exter, Kliun, Malevich, Popova, Rodchenko, Tatlin, Udaltsova. (Malevich refuses to show Suprematist canvases; Rodchenko shows geometric drawings; Tatlin, reliefs, among them two corner-reliefs.)

November. Malevich represented by sixty Suprematist paintings in the fifth Jack of Diamonds exhibition. Popova shows her first "painterly architectonics"; other contributors are David Burliuk, Chagall, Exter, Kliun, Puni, Rozanova, Udaltsova.

Naples

January. Boccioni, on leave from the army, lectures on "Plastic Dynamism."

New York

Katherine S. Dreier becomes director and guarantor of the Society of Independent Artists and comes into contact with Duchamp and the Arensberg circle.

Paris

January 15–February 1. Severini holds an exhibition, "1re Exposition Futuriste d'Art Plastique de la Guerre," in the Galerie Boutet de Monvel.

Petrograd

January. Publication of the portfolio *Universal War,* with geometric abstract collages by Rozanova, words by Kruchenykh (who also published another booklet, *War,* around the same time).

April. "Exhibition of Contemporary Russian Painting" at Dobychina Bureau, including works by Popova, Puni, Rozanova, Kandinsky, Kulbin.

1917

Mondrian develops a new style which he calls Neoplasticism (new plastic art). Formulates its principles in his writings, "Die Nieuve Beeldung in de Schilderkunst" (The New Plasticism in Painting), published in the periodical *De Stijl.*

October 25. Outbreak of the Russian Revolution.

November. Lunacharsky appointed head of the Ministry of Enlightenment. Under his jurisdiction, establishment of Narkompros (People's Commissariat for Enlightenment), an institution which is to reorganize the cultural and educational life of post-Revolutionary Russia.

At Brest-Litovsk, Lenin signs the armistice ending Russian participation in the war.

Leiden

De Stijl movement and periodical founded by van Doesburg, Mondrian, Vilmos Huszar, van der Leck, architect J. J. P. Oud, and poet Anton Kok.

Moscow

Georgii Yakulov, Tatlin, and Rodchenko decorate the interior of the Café Pittoresque, the first attempt to synthesize "art and life"—architectonic, plastic and painterly and technical forms.

Publication of Ivan Aksenov's *Pikasso i okrestnosti* (Picasso and Environs); the work was written largely before the war, while Aksenov was still in Paris.

Gabo returns to Russia, settles in Moscow, and works in the studio of his brother, Pevsner, at the Svomas (Free State Art Studios).

December. Exhibition of the "World of Art" (Mir Iskusstva), with contributions by Lissitzky, Yakulov, and others.

New York

Macdonald-Wright exhibits at Stieglitz Gallery.

Early in the year, international debut of Vorticism in New York.

Paris

May. Ballets Russes perform *Les Contes russes* (Larionov, Massine) and *Parade* (Cocteau, Satie, Picasso, Massine), the first "Cubist Ballet." The program contains an essay by Apollinaire which uses the word *surréalisme* for the first time.

Petrograd

Critic Nikolai Punin is made Commissar of the Russian Museum, and formulates his radical ideas about the destruction of the old bourgeois art.

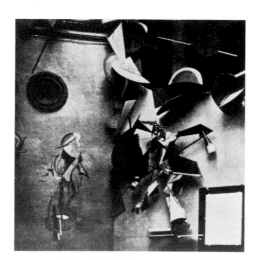

Interior of the Café Pittoresque,
Moscow, 1918

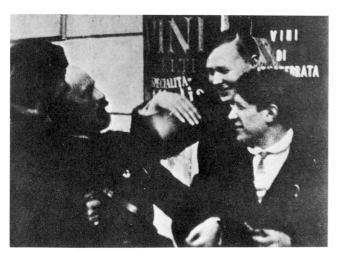

Marinetti, with Gontcharova,
Larionov, and Picasso in Rome,
winter 1916–1917

Rome

April. Balla creates scenery for Stravinsky's ballet *Fireworks*, presented by Diaghilev at Teatro Costanzi.

1918

January. Special visual-arts section IZO established within Narkompros. Many avant-garde artists and critics take up administrative, pedagogical, or research positions within various branches of IZO. (Tatlin heads the Petrograd section, David Shterenberg the Moscow division.)

The Western calendar replaces the Old Style of dating.

March. Russian capital moved from Petrograd to Moscow.

October. Apollinaire dies.

November. Publication of the first manifesto of de Stijl, signed by van Doesburg, Mondrian, van der Leck, Huszar, architects van't Hoff and Wils, the poet Kok, and Belgian sculptor Vantongerloo; intended to promote de Stijl concepts beyond the Dutch borders and calling for "Formation of the international unity in life, art, and culture."

Moscow

Kandinsky a professor at the Moscow Svomas and editor of journal *Visual Art*.

November. Death of Olga Rozanova. Shchukin collection of modern French art is nationalized.

December. Morozov's collection of modern French art is nationalized.

Petrograd

April. Academy of Arts abolished and replaced by Svomas (Free State Art Studios).

Old art schools in Moscow and provincial centers also replaced by Svomas.

Lenin inaugurates his Plan of Monumental Propaganda, intended among other things to replace Czarist monuments.

November. Meyerhold's production of Mayakovsky's "Mystery-Bouffe," with designs by Malevich.

December. First issue of journal *Iskusstvo komuny* (Art of the Commune) published. Issues appear regularly until April 1919. Creates forum for discussions of innovative issues relating to art and revolution; contributors include Puni, Punin, Vera Ermolaeva.

Museum of Painterly Culture (also known as Artistic Culture) established in Petrograd, Moscow, and other cities.

Vitebsk

August. Marc Chagall becomes director of Popular Art Institute (the Vitebsk Svomas).

1919

Lissitzky begins to work on his Prouns (Projects for the Affirmation of the New in Art).

Tatlin is appointed to a professorship at the Free Art Schools (Svomas).

August–December. Katherine S. Dreier in Europe. In Berlin she is impressed with Herwarth Walden's Der Sturm gallery.

Berlin

The first photomontages of Raoul Hausmann, George Grosz, and Hannah Höch are made. Mies van der Rohe embarks on first projects for glass skyscrapers.

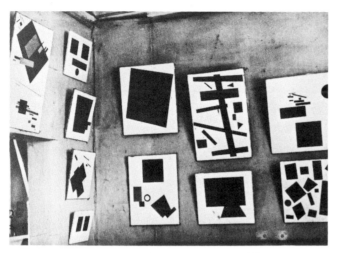

Part of Malevich's one-man exhibition, Moscow, 1919–1920

Budapest

Kassak founds the review *MA*, eventually published in Vienna and appearing until 1925.

Leiden

"Dialog over de nieuwe Beeldung" by Mondrian appears in two issues of *De Stijl*.

Mondrian publishes "Natuurlijke en abstracte realiteit" in thirteen installments in *De Stijl* (1919–1920).

Moscow

Kandinsky helps to reorganize the Russian Museum and found the Museum of Painterly Culture. He teaches at the Moscow Svomas and at the University of Moscow.

January. Komfut, an alliance of Communists and Futurists, publishes its manifesto in *Iskusstvo komuny*.

February. "First State Exhibition," a posthumous show of Rozanova's work. This is the first of twenty-one State Exhibitions organized during 1919–1921. The most important among these are the "Fifth State Exhibition of the Trade Union of Artist-Painters of the New Art: From Impressionism to Nonobjectivity," 1919; "Tenth State Exhibition: Nonobjective Creation and Suprematism," 1919; "Sixteenth State Exhibition: One-Man Exhibition of K. Malevich (His Path from Impressionism to Suprematism)," 1919; and "Nineteenth State Exhibition," 1920.

Spring. "Tenth State Exhibition: Nonobjective Creation and Suprematism" includes 220 works (all purportedly abstract) by nine contributors. Malevich exhibits his *White on White* (1918) and Rodchenko his *Black on Black* paintings. The event was one of the last major collective vanguard exhibitions; it possibly inspired Lissitzky to create his first Prouns.

March. Congress of the Third Communist International.

May. First exhibition of newly founded Society of Young Artists (Obmokhu), who will hold exhibitions until 1923. Includes contributions by Medunetsky, the Stenberg brothers, and others.

Sinskulptarkh (Commission for the Elaboration of Questions of Sculptural-Architectural Synthesis); changed to Zhivskulptarkh (Commission of Painterly-Sculptural-Architectural Synthesis) at the end of 1919, when it attracts Rodchenko.

New York

Max Eastman's *Education and Art in Soviet Russia in Light of Official Decrees and Documents* is published.

Paris

March. The first issue of *Littérature* appears; edited by Louis Aragon, André Breton, and Philippe Soupault.

July. Mondrian returns from Holland.

Vitebsk

Lissitzky, working on book illustrations with Chagall, meets Malevich.

Malevich publishes *On New Systems in Art*, which will be revised and republished by Narkompros in 1921 in Moscow as *From Cézanne to Suprematism;* both books continue his polemic against the official materialism of the young nation.

September. Malevich replaces Chagall as director of Vitebsk Popular Art Institute.

Weimar

Bauhaus formed by Walter Gropius from the Saxon State School of Arts and Crafts and the Academy of Fine Arts.

First Bauhaus proclamation: "A Guild of Craftsmen without Class Distinction."

Zurich

Hans Richter forms a short-lived Association of Revolutionary Artists, attempting to bring avant-garde artists into the political revolution. The group includes Hans Arp, Willi Baumeister, Viking Eggeling, Giacometti, Walter Helbig, and Marcel Janco.

1920

April. Publication of the second de Stijl manifesto, "On Literature," signed by van Doesburg, Kok, and Mondrian.

Berlin

Berlin Dada Fair, where poster celebrates Tatlin.

October. Puni arrives; remains in Berlin until 1923; moves to Paris in 1924.

November. Van Doesburg journeys abroad in order to spread de Stijl ideas. In Berlin meets Richter and Eggeling, views their abstract films, and suggests founding of a journal dedicated to "the new art" (which eventually emerges in 1923 as *G*).

Moholy-Nagy moves to Berlin from Vienna.

Moscow

Lissitzky begins work on the designs for *Victory over the Sun*, intended as part of a plan for a completely mechanical theater—one of the most radical attempts to introduce Constructivist ideas into staging.

The second exhibition of Obmokhu; at the Inkhuk, formation of the nucleus of the First Working Group of Constructivists, consisting of Gan, Stepanova, Rodchenko (group formally established in March 1921).

May. The Institute of Artistic Culture (Inkhuk) established as the official institution concerned with formulating a role for art in a Communist society. It was committed to developing both a theoretical and practical program for teaching art at the new artistic institutions, focused on analytical research and experimentation with the formal aspects of painting and the evolution of a new vision in art based on utilitarian principles. Affiliates were soon established in Petrograd (under Tatlin and Puni), Vitebsk (under Malevich), and other cities.

August. Open-air exhibition of Gabo and Pevsner on Tverskoi Boulevard and publication of their *Realist Manifesto,* opposing the aesthetics of Cubists and Futurists and highlighting a new role for art and artists. Postulated an art constructed in time and space according to "constructive" technique (for this reason the *Realist Manifesto* was for many years mistakenly considered to mark the beginning of Constructivism).

The Constructivist group begins to split into two factions, Gabo and Pevsner on one hand and Rodchenko and his close associates on the other.

October. Rodchenko exhibits fifty-five paintings, constructions, and linocuts at the Nineteenth State Exhibition; his wife Stepanova exhibits seventy-six works.

First All-Russian Congress of Proletkult opens.

November. Svomas renamed Vkhutemas (Higher State Art-Technical Studios). Rodchenko named dean.

December. Tatlin and others publish statement, *The Work Ahead of Us,* on uniting art with utilitarian intentions.

End 1920. Kandinsky leaves Inkhuk after his educational program, based on an idealistic psychological and subjective concept of art, is rejected. The administration is reorganized by Rodchenko, Stepanova, the sculptor Aleksei Babichev, and the musician Nadezhda Briusova, on theoretical, objective "laboratory" principles.

Munich

Publication of *New Art in Russia 1914–1919* by Konstantin Umanskii, which discussed broad range of Russian avant-garde developments, including Malevich's Suprematism and Tatlin's counter-reliefs, and the role of Russian art within the European modern-art context.

New York

Under new ownership, *The Dial* magazine is transformed into an illustrated monthly of arts and letters. Henry McBride becomes art critic, remaining through 1929.

Paris

Publication of Mondrian's *Le Néoplasticisme* by the art dealer Léonce Rosenberg. Mondrian begins to apply his Neoplastic principles to the environment (in his own studio).

November. Ozenfant and Le Corbusier begin monthly magazine, *L'Esprit nouveau,* in which are articulated the principles of Purism.

Petrograd

Publication of the *First Series of Lectures* by the art historian and critic Nikolai Punin, based on his lectures on art delivered to workers in 1919 while he was in the Petrograd Soviet of Peasant, Soldier, and Worker Deputies.

November. Tatlin's model for his *Monument to the Third International* (which he began to design in March 1919) displayed in Petrograd. In December transferred to Moscow.

Venice

Twelfth International Art Exhibition includes work of Gontcharova, Larionov, Jawlensky, and other Soviet artists.

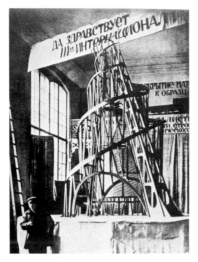

Tatlin and the model of his *Monument to the Third International*, Petrograd, 1920

Vitebsk

January. Malevich and students establish the Posnovis (Followers of the New Art), a group of Suprematist enthusiasts. The name changes to Unovis (Affirmers of the New Art) in April. Among the members of Unovis are Vera Ermolaeva, Ilya Chashnik, Lazar Khidekel, Anna Kagan, Nikolai Suetin.

1921

August. Third de Stijl manifesto, "Toward a New Formation of the World."

Fall. Rome, Berlin, New York: *Broom* begins publication under Harold Loeb; the review continues until 1924.

December. Kandinsky emigrates to Germany.

Berlin

October. Manifesto "Call for Elementarist Art" is signed by Raoul Hausmann, Hans Arp, Ivan Puni, and László Moholy-Nagy. To be published in 1922 in *De Stijl*, foreshadowing the international extension of Constructivist ideas.

Moscow

Lunacharsky begins to organize educational and art institutions according to Lenin's New Economic Policy.

Lissitzky becomes head of the faculty of architecture of the Vkhutemas.

Inkhuk is attached to the Russian Academy of Artistic Sciences, established in October 1921.

January. Medunetsky and the Stenberg brothers organize an exhibition at the Poets' Café called "The Constructivists." It is the first instance when the word *Constructivist* appears in print—on the cover of the catalog, which gives the first published declaration of the principles of Constructivism. The contributions include sixty-one nonutilitarian constructions.

March 18. Official establishment of the First Working Group of Constructivists, which includes Rodchenko, Medunetsky, Stepanova, Ioganson, Gan, the brothers Stenberg.

May. The third Obmokhu exhibition, with contributions by Ioganson, Lentulov, Medunetsky, Rodchenko, the Stenberg brothers, Yakoulov.

September. Exhibition "5 × 5 = 25" opens with contributions by Exter, Popova, Rodchenko, Stepanova, and Vesnin.

In conjunction with the "5 × 5 = 25" exhibition, a series of lectures are presented at Inkhuk. The first lecture is presented by El Lissitzky and is entitled "Prouns—Changing Trains between Painting and Architecture."

October. Russian Academy of Artistic Sciences (RAKhN) opens with the assistance of Kandinsky.

November. Plenary session of the Inkhuk, when a majority of the group condemn easel painting as outmoded and advocate industrial art and construction. A group of artists including Rodchenko and Popova leave Inkhuk in order to work in industry and applied art. Beginning of the Productivist phase of Constructivism.

December. Varvara Stepanova's lecture on Constructivism at the Inkhuk.

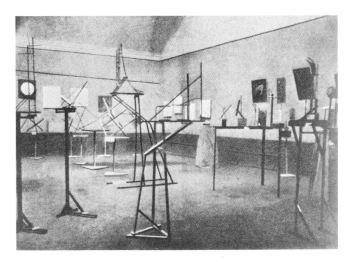

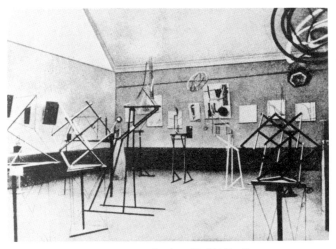

Two views of the third Obmokhu exhibition, Moscow, 1921, with constructions by Rodchenko (hanging) and the Stenberg brothers (center)

New York

April. The Civic Club has an exhibition of Soviet Russian posters.

Paris

Mondrian develops his style of heavy black lines defining rectangles in primary colors. His *Composition* is included in a group exhibition at L'Effort Moderne.

February. Exhibition of Purist canvases of Ozenfant and Le Corbusier is held at the Druet gallery. Léonce Rosenberg purchases several canvases and, by midyear, Purism has become closely associated with his gallery.

Petrograd

The critic Nikolai Punin publishes the first monograph on Tatlin, *Tatlin (Against Cubism)* [Tatlin (Protiv Kubizma)], and becomes the first commentator on Tatlin's *Monument to the Third International.*

Founding of the Museum of Artistic Culture (with Punin as founder-organizer).

Restoration of the Academy of Fine Arts.

Vitebsk

January. Malevich publishes his book of lithographs *Suprematism: 34 risunka*. Though dated 1920, the book is not published until January 1921.

Weimar

Van Doesburg visits Bauhaus, lectures to the students on de Stijl.

Schlemmer joins the Bauhaus faculty.

Annenkov, Yuri
Relief-Collage. 1919
Assemblage: burlap and cardboard painted with india ink on board
13 × 9½″ (33 × 24 cm)

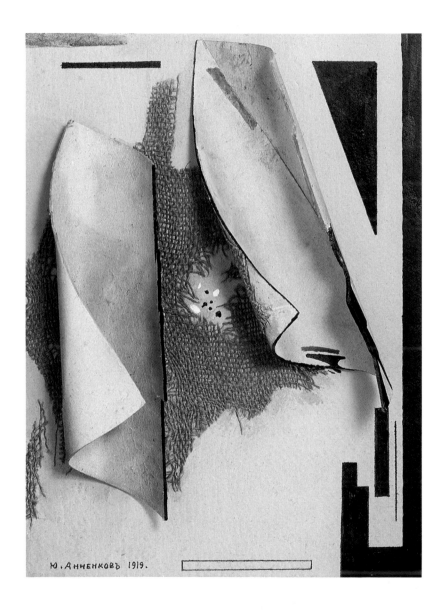

Beekman, Chris
Composition. 1916
Pastel on paper
28 × 11¾″ (71 × 29.5 cm)

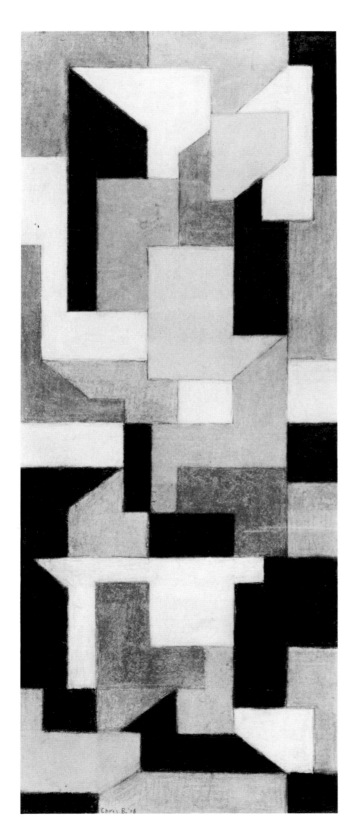

Beekman, Chris
Composition. 1920
Watercolor on paper
6 × 6½″ (15 × 16.5 cm)

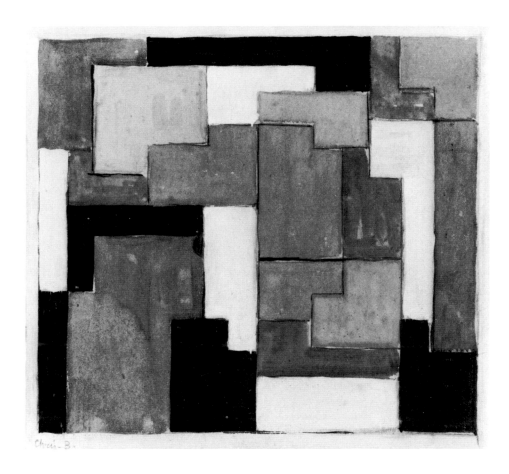

Chashnik, Ilya
Suprematist Composition. c. 1924
Watercolor and pencil on paper
7¾ × 11½" (19.5 × 29 cm)

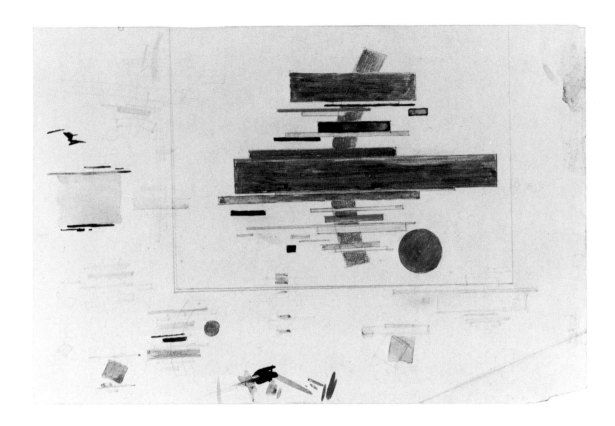

Chashnik, Ilya
Suprematist Composition. c. 1924
Watercolor and pencil on paper
5½ × 4″ (14 × 10 cm)

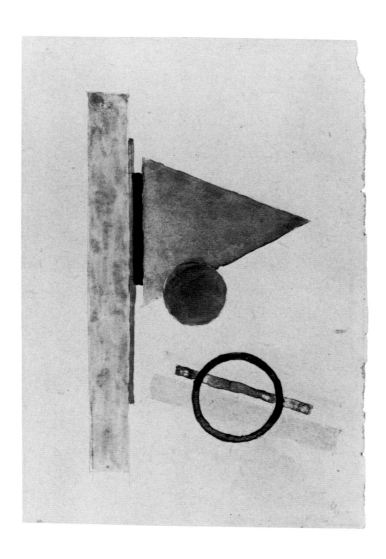

Le Corbusier
Cup, Pipes, and Paper Rolls. 1919
Pencil studies
17½ × 21½″ (44.5 × 54.5 cm)

van Doesburg, Theo
Composition (The Cow). 1916–1917
Oil on canvas
14¾ × 25″ (37.5 × 63.5 cm)
Purchase

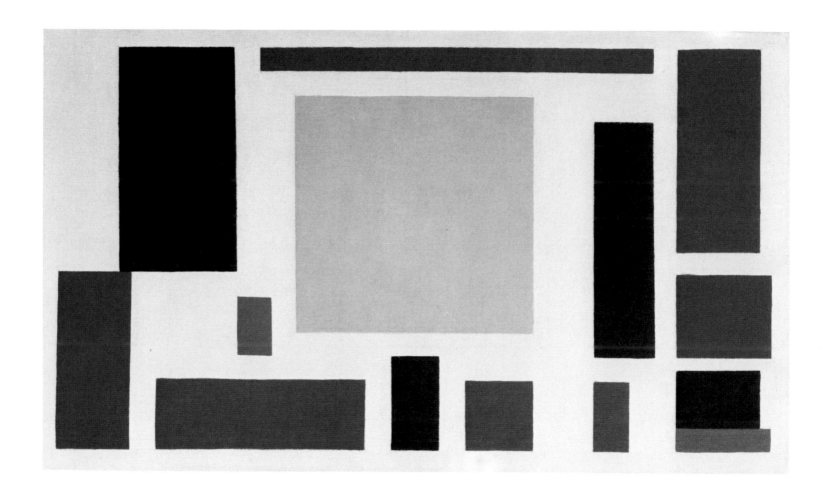

van Doesburg, Theo
Study for a Composition. 1923
Watercolor and india ink on paper
6¾ × 6⅞" (17 × 17.5 cm)

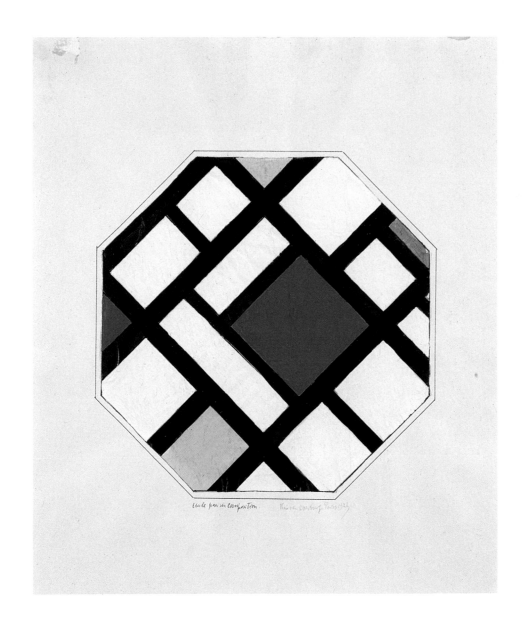

Ermilov, Vasily

Composition No. 3. 1923

Wood, brass, varnish, and paint

$32 \times 17 \times 3''$ ($81 \times 43 \times 7.5$ cm)

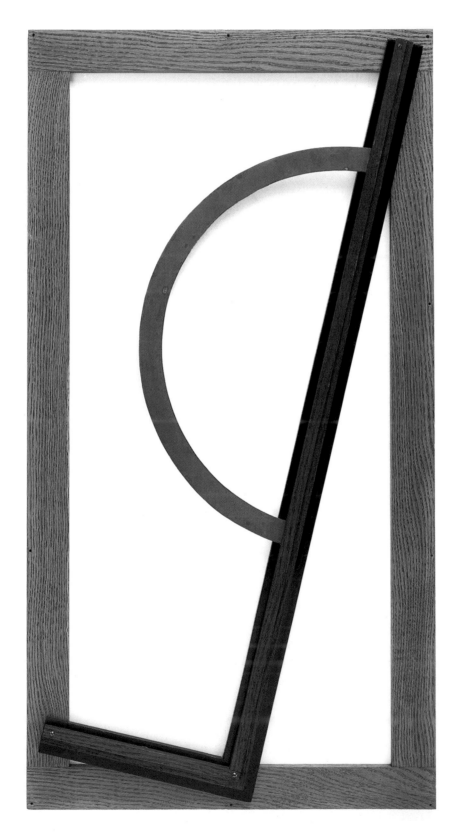

Exter, Alexandra
Construction. 1922–1923
Oil on canvas
35¼ × 35¼″ (89.5 × 89.5 cm)

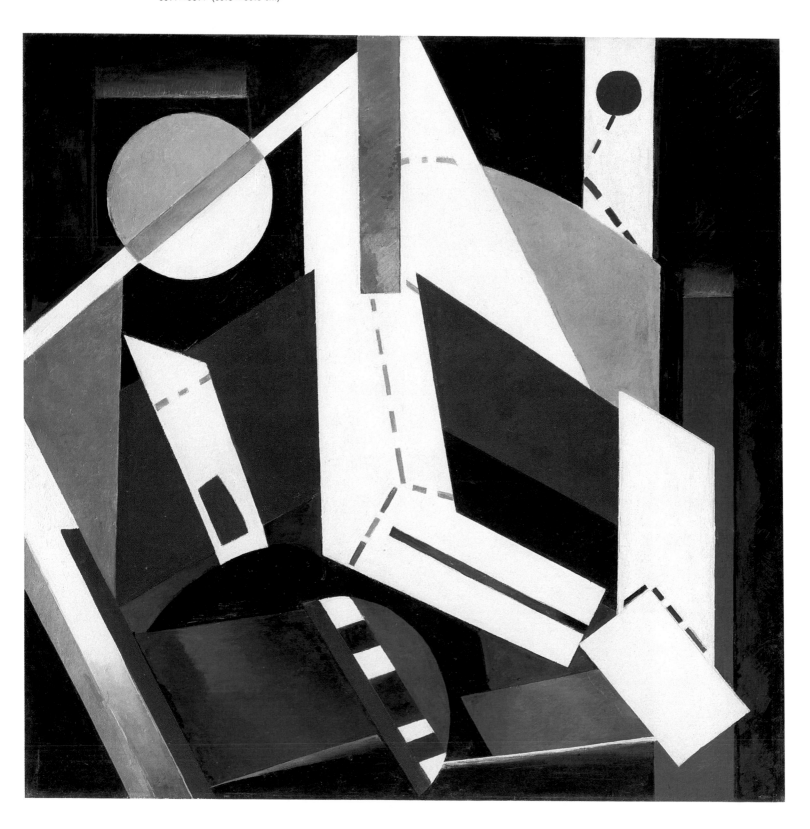

Gabo, Naum
Head of a Woman.
c. 1917–1920, after a work of 1916
Construction in celluloid and metal
24¼ × 19¼″ (62.2 × 48.9 cm)
Purchase

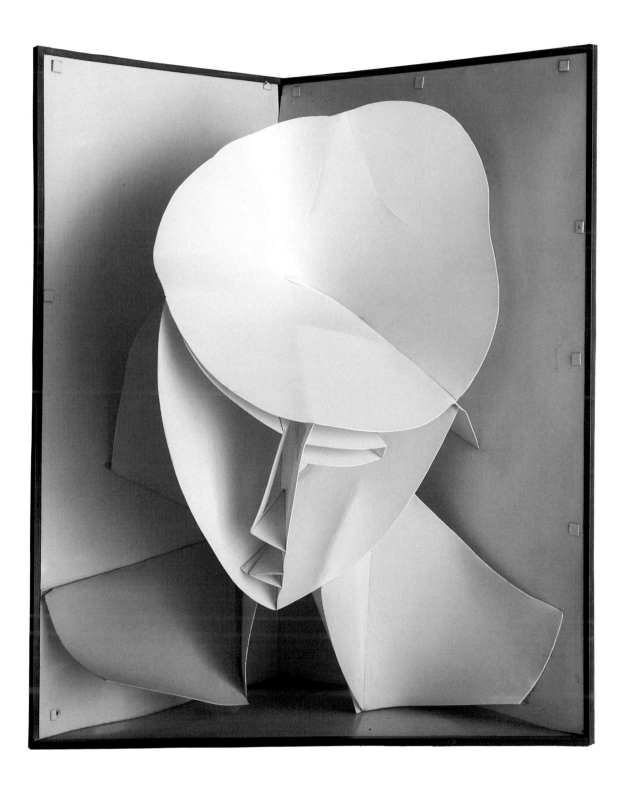

Huszar, Vilmos
Composition with Female Figure. 1918
Oil on canvas
31½ × 23¾″ (80 × 60.5 cm)

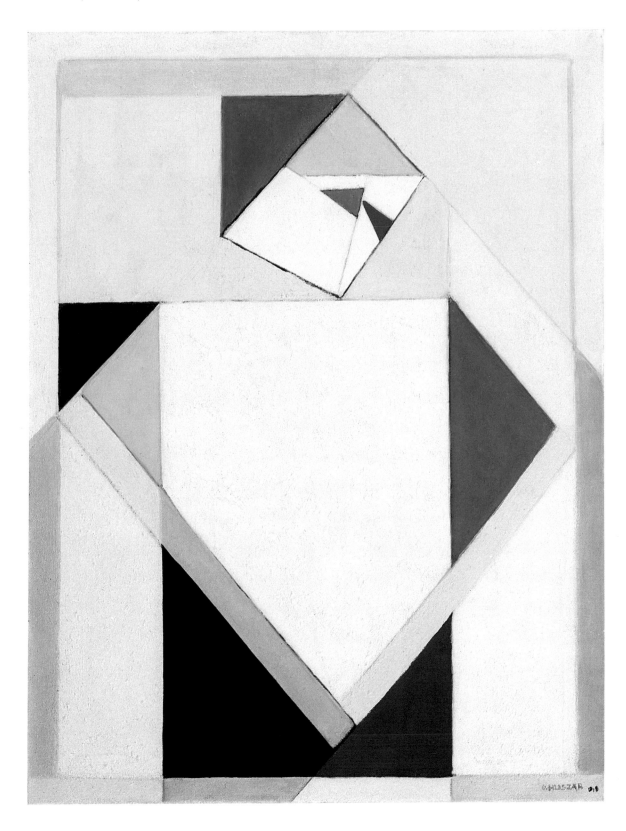

Kliun, Ivan
Suprematism. 1916
Oil on wood
10 × 14½″ (25.5 × 37 cm)

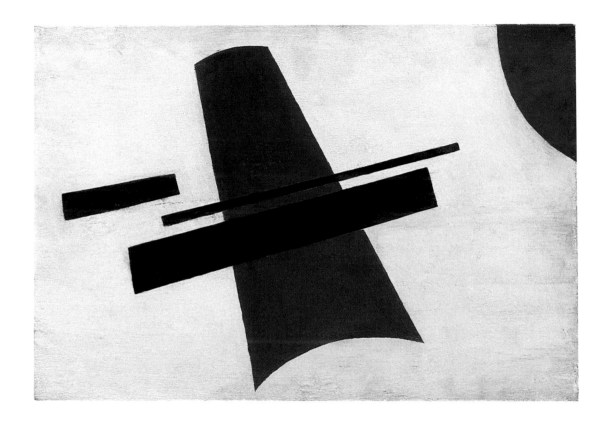

Klucis, Gustav
Radio Announcer. 1922
Construction of painted cardboard, paper, wood, thread, and metal brad
42 × 14¼ × 14¼" (106.5 × 36 × 36 cm)
Sidney and Harriet Janis Collection Fund

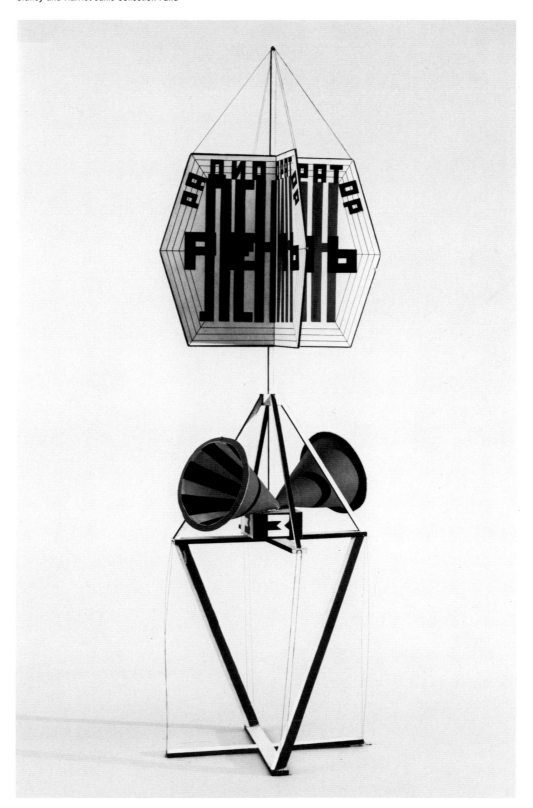

Kudriashev, Ivan
Suprematist Composition. 1921
Pencil and watercolor on paper
11¾ × 9¾″ (30 × 25 cm)

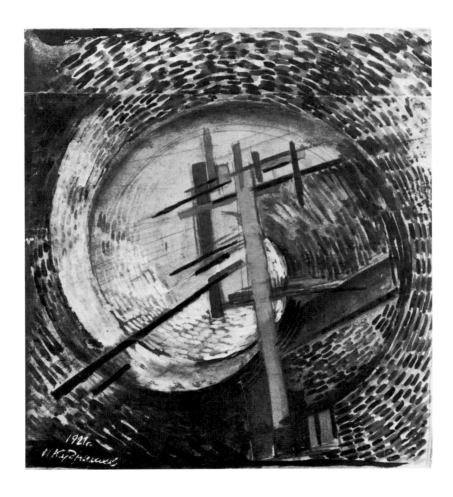

van der Leck, Bart
Untitled. 1917
Gouache and pencil
17⅝ × 22½″ (44.7 × 57.1 cm)
Gift of Constance B. Cartwright

van Leusden, Willem
Abstraction of Figure. 1920
Pencil on paper
21¼ × 14″ (54 × 35.5 cm)

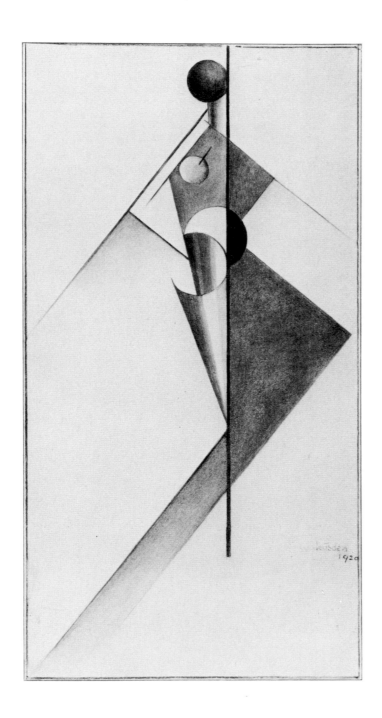

Lissitzky, El (Lazar)
Study for Proun 30T. 1920
Gouache, pencil, and ink on brown paper
8⅝ × 9⅞″ (22 × 25 cm)

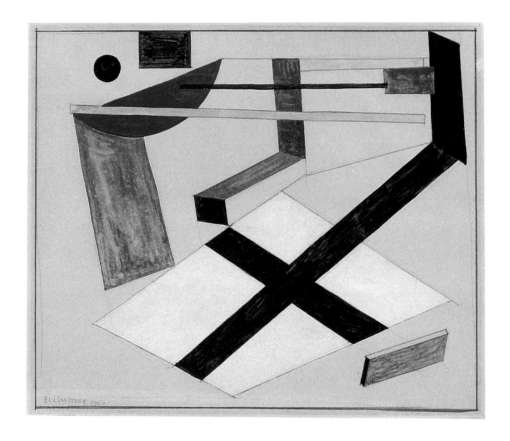

Lissitzky, El (Lazar)
Composition. 1922
Oil and tempera on wood
28 × 24¾″ (71 × 63 cm)

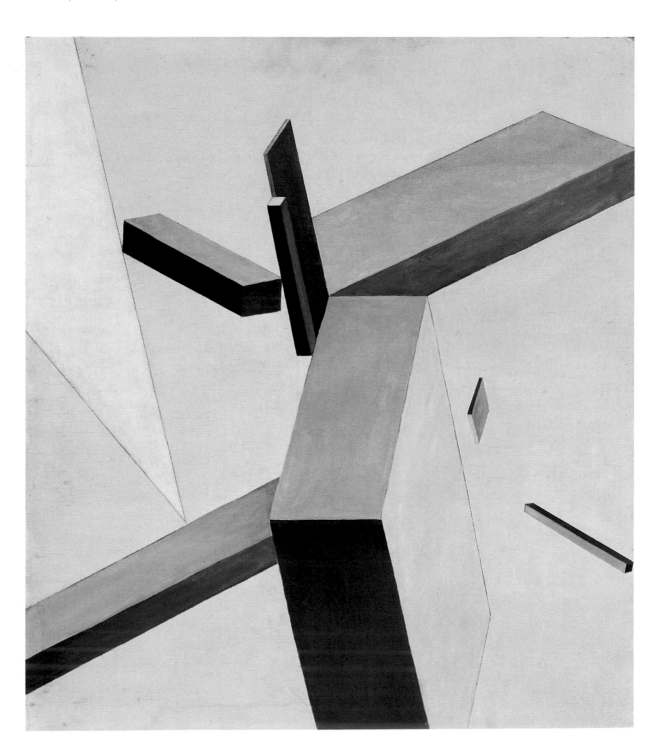

Malevich, Kasimir
Suprematist Composition: Airplane Flying. 1915
Oil on canvas
22⅞ × 19″ (58.1 × 48.3 cm)
Purchase

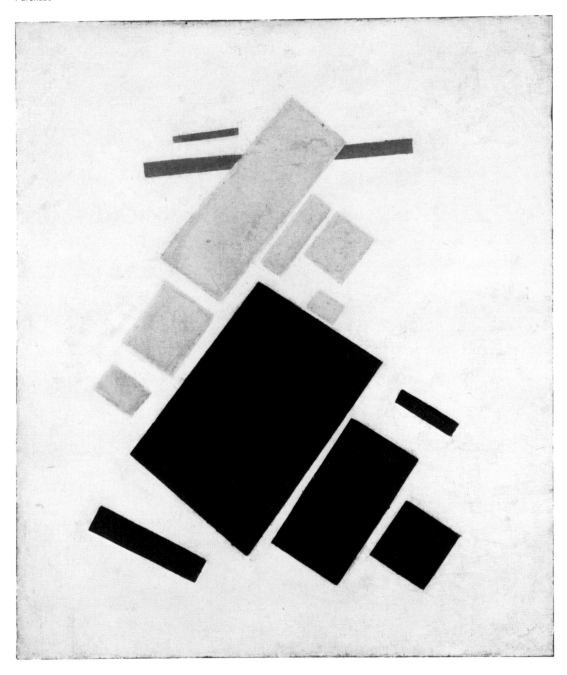

Malevich, Kasimir

Suprematist Composition: White on White. 1918

Oil on canvas

31¼ × 31¼″ (79.4 × 79.4 cm)

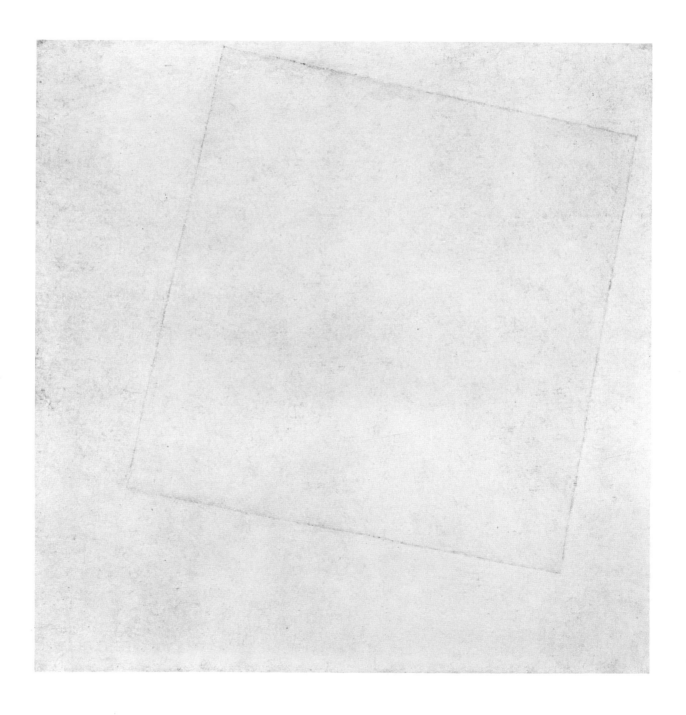

Mansurov, Pavel
Composition 191. 1918
Oil on wood
9¼ × 13¾ × 1″ (23.5 × 34.9 × 2.6 cm)

Matiushin, Mikhail
Color in Movement. c. 1920
Oil on canvas
12½ × 13″ (32 × 33 cm)

Mondrian, Piet
Composition with Color Planes, V. 1917
Oil on canvas
19⅜ × 24⅛″ (49 × 61.2 cm)
The Sidney and Harriet Janis Collection (fractional gift)

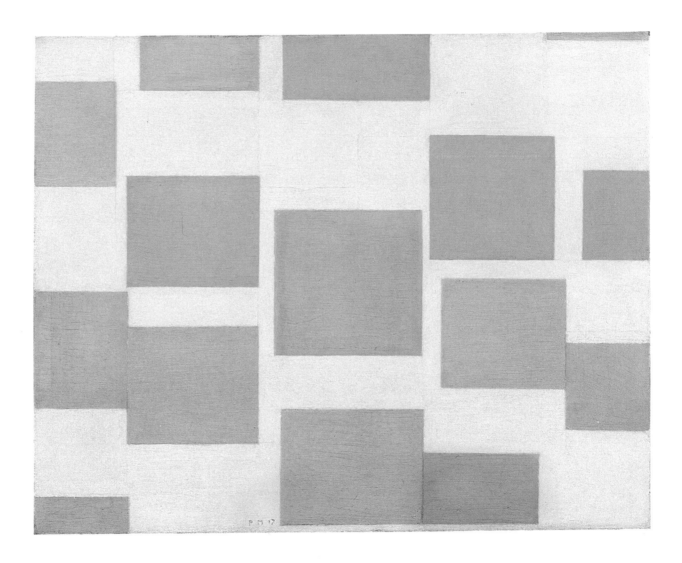

Pevsner, Antoine
Torso. 1924–1926
Construction in plastic and copper
29½ × 11⅝″ (74.9 × 29.4 cm)
Katherine S. Dreier Bequest

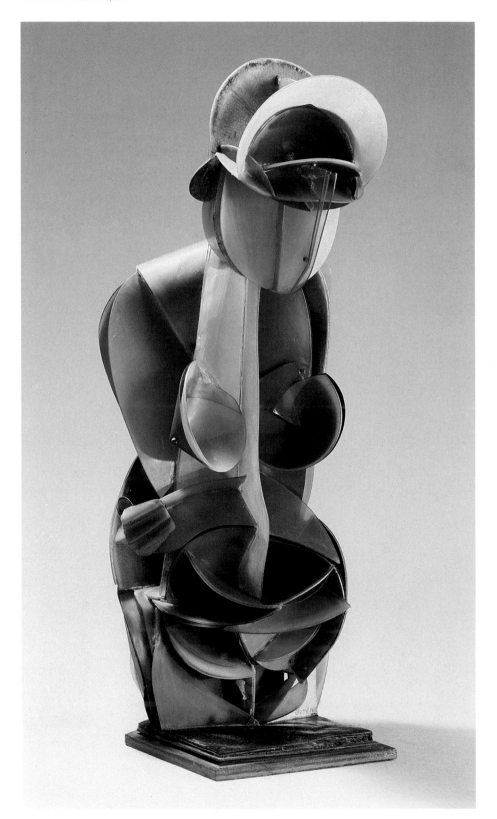

Popova, Liubov
Untitled. c. 1916–1917
Gouache on cardboard
19½ × 15½″ (49.5 × 39.5 cm)

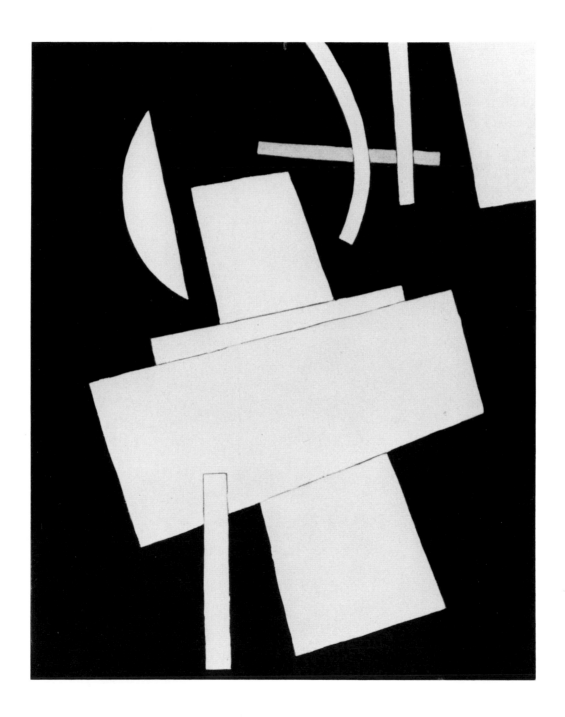

Popova, Liubov
Architectonic Painting. 1917
Oil on canvas
31½ × 38⅝" (80 × 98 cm)
Philip Johnson Fund

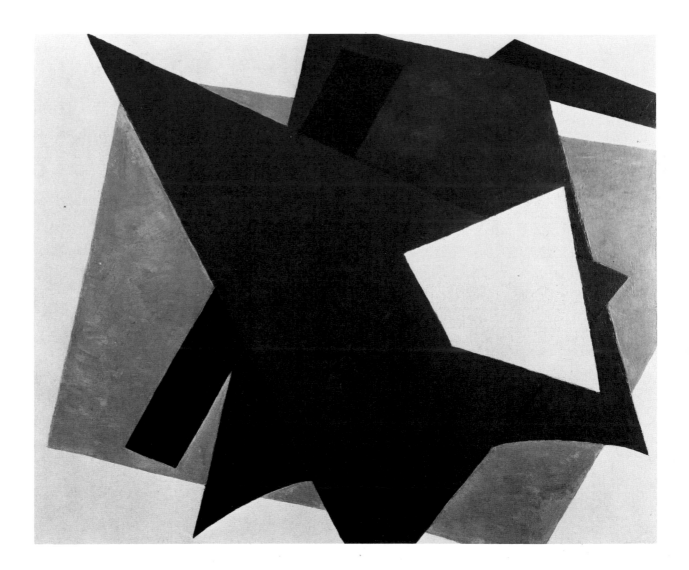

Popova, Liubov
Composition. 1920
Mixed media on wrapping paper
13¼ × 9¾″ (33.5 × 25 cm)

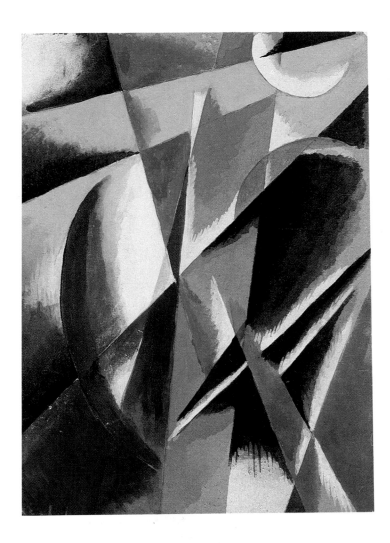

Puni, Ivan

Suprematist Relief-Sculpture. 1920s reconstruction of 1915 original

Painted wood, metal, and cardboard, mounted on panel

19¾ × 15½ × 4″ (50 × 39.5 × 10 cm)

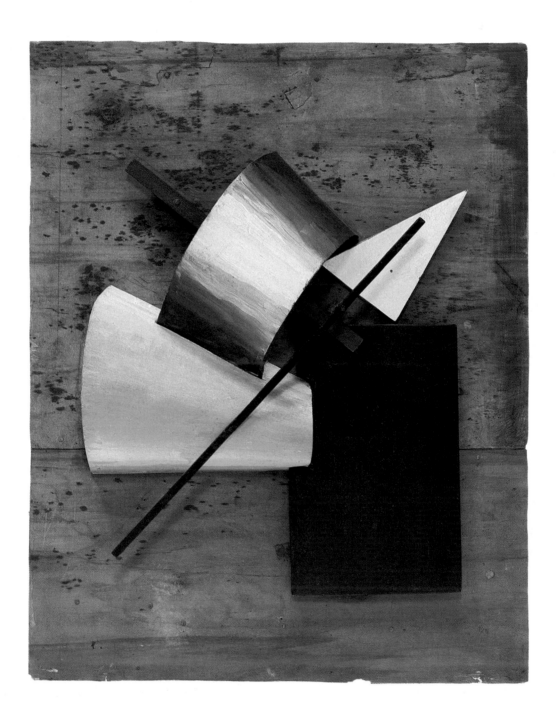

Rodchenko, Aleksandr
Nonobjective Painting: Black on Black. 1918
Oil on canvas
32¼ × 31¼" (81.9 × 79.4 cm)
Gift of the artist, through Jay Leyda

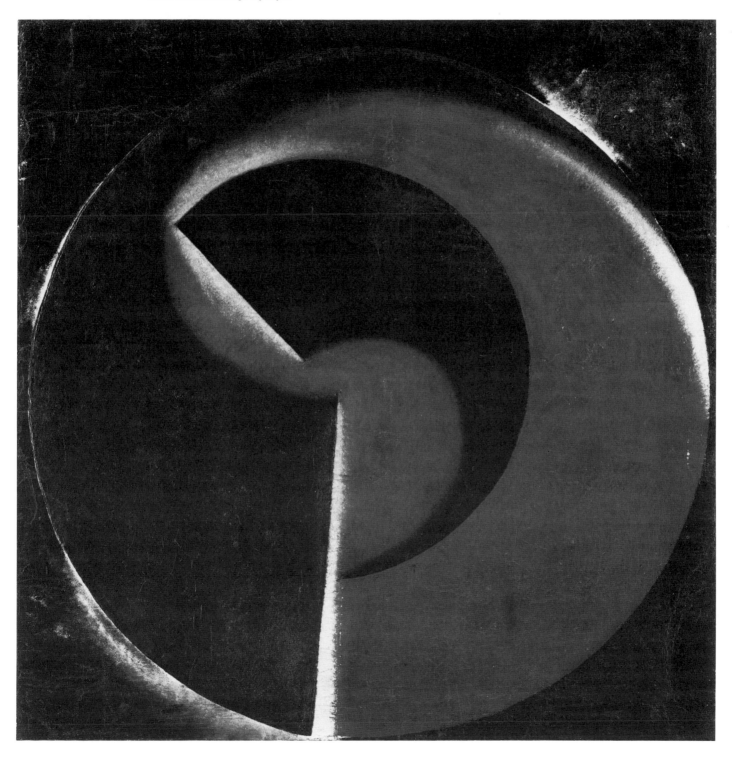

Rodchenko, Aleksandr
Line Construction. 1920
Colored ink on paper
14¾ × 9″

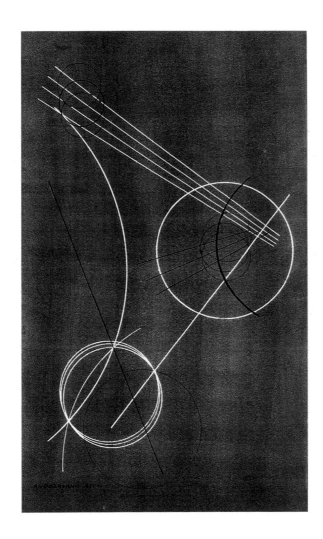

Rozanova, Olga
The War. 1916
Cut-and-pasted papers on gray paper
12¼ × 16″ (31.1 × 40.7 cm)
Purchase

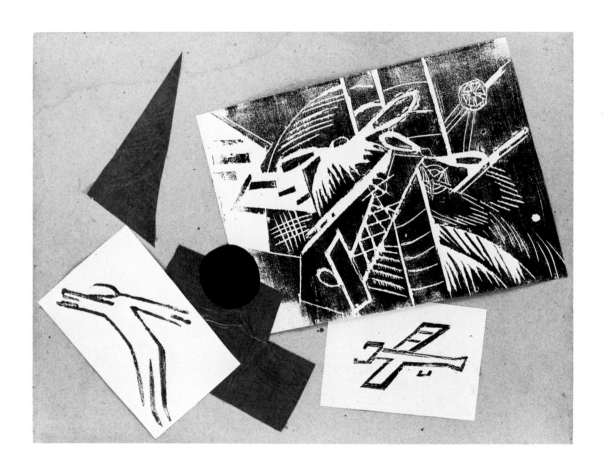

Stepanova, Varvara
Untitled. 1919
Ink on paper
13¾ × 10½″ (35 × 26.5 cm)

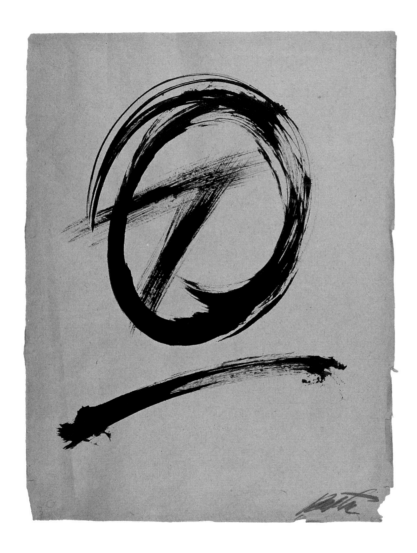

Tatlin, Vladimir
Counter-Relief. c. 1914–1915
Charcoal on paper
12½ × 9½″ (32 × 24 cm)

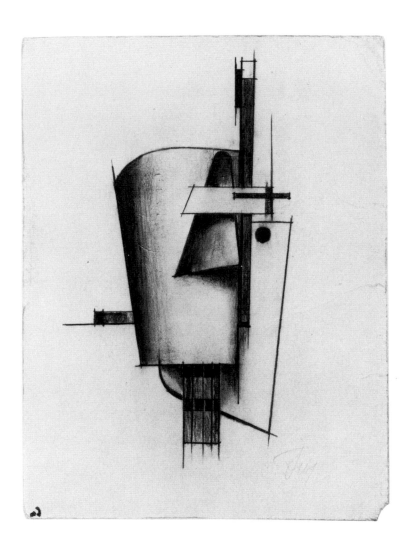

Tatlin, Vladimir
Study for *Board, No. 1*. 1917
Watercolor, metallic paint, gouache, traces of pencil
17¼ × 11⅝″ (43.9 × 29.6 cm)
Gift of The Lauder Foundation

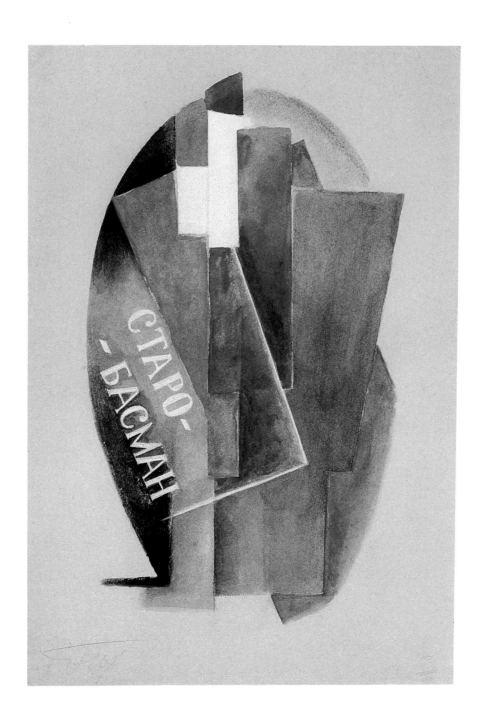

Udaltsova, Nadezhda
Untitled. 1916
Gouache on paper
8 × 8″ (20.2 × 20.2 cm)

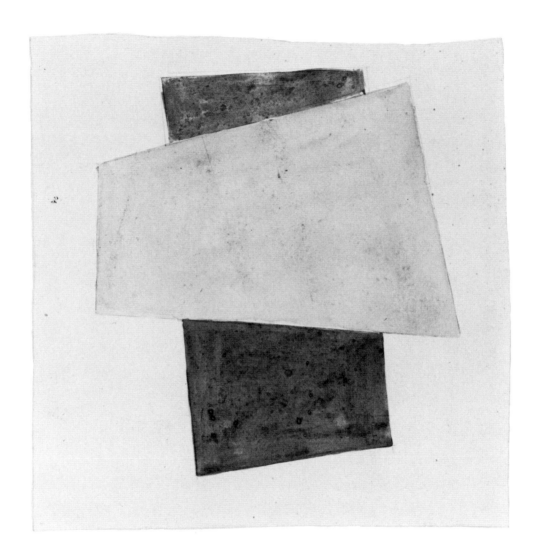

Vantongerloo, Georges
Composition II, Indigo Violet Derived from
Equilateral Triangle. 1921
Oil on cardboard
12¼ × 14⅛″ (31.5 × 36 cm)

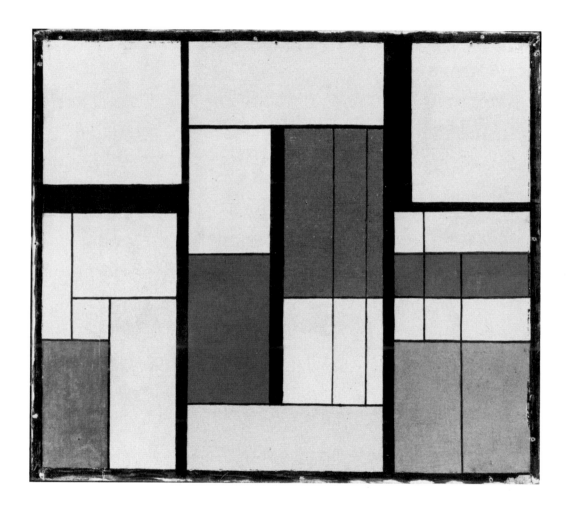

Vesnin, Aleksandr

Proposal for a *Monument to the Third Congress of*
the Communist International. 1921

Gouache

20¾ × 27¾" (53 × 70.5 cm)

Acquired through the Mrs. Harry Lynde Bradley and the

Katherine S. Dreier Bequests

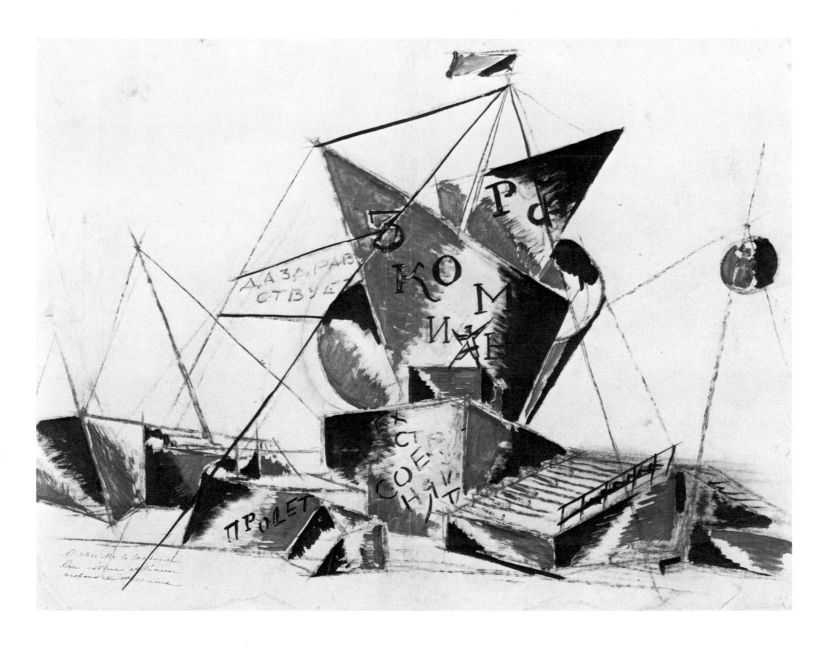

International Constructivism

1922–1929

The 1920s were marked by aesthetic pluralism. Contradictory tendencies coexisted and interacted: de Stijl, Constructivism, Dada, Purism, Surrealism. Constructivism, among the geometric movements, seemed to have the strongest impact.

The year 1922 was a turning point in the course of Constructivism. In Russia, as already noted, it marked the beginning of the ''Productivist'' phase. Outside Russia, Constructivist ideas gained broader adherence, particularly in Germany, Hungary, Poland, and Czechoslovakia. Constructivism stood for order and structure; for universalism and utilitarianism in art; for the use of ordinary, contemporary materials to artistic ends; for the rejection of individualism in favor of a collective style. These goals were irresistibly appealing to many artists searching for a modern idiom. The practical application of Constructivist precepts created diverse artistic expressions. Moholy-Nagy made dynamic paintings composed of interpenetrating linear and flat color elements floating in space, such as *Yellow Circle* (1921), and experimented with new materials, as in the freestanding dynamic *Nickel Sculpture* (1922). Kassak's compositions combined planar and stereometric forms. Bortnyik's Pictorial Architecture series also juxtaposed flat and stereometric elements. In Strzeminski's ''unistic'' compositions— monochromatic canvases uniformly textured—the thickly covered relieflike surface translates his idea of the texture of the paint understood as ''material.''

At that point the characteristics of the work of Mondrian, van Doesburg, Malevich, and Tatlin, as well as their philosophical convictions concerning the social and political role of art and artist, became intertwined and relaxed, creating less-radical pictorial expressions and an ideology with less emphasis on materialism and material production and greater concern with aesthetic issues. Thus the geometric abstract idiom of the 1920s was a composite of Dutch and Russian movements: de Stijl, Suprematism, and Constructivism, catalyzed in Germany through the Dada movement. Dada, although basically a subjective philosophy, already contained in itself interests tangent to Constructivism, notably the antiart position and the desire for a new order, as well as a fascination with the machine aesthetic. France, less affected by Constructivist ideas than was Central Europe, remained more in the orbit of de Stijl, whose influence was strengthened by Mondrian's return to Paris in 1919 and van Doesburg's arrival in 1923.

The exchanges of ideas leading to International Constructivism developed with particular strength toward the end of 1921. The theories of de Stijl, disseminated through the group's periodical and through exhibitions, became widely known. Van Doesburg made numerous trips to Italy, Belgium, and especially Germany, where he established contacts with the Dadaists (through Hans Richter) and also with the Bauhaus, where he gave several lectures. The innovative concepts and works of the Russian Constructivists came to attention in the West in part through Lissitzky's travels, which put him in touch with German artists and with de Stijl members (especially van Doesburg). Also influential were the Russians then settled in Berlin, among them Puni, Gabo, Pevsner, Archipenko, along with the writers Mayakovsky, Ehrenburg, Pasternak, and Shklovsky. Another factor was the trilingual Constructivist journal *Veshch/Gegenstand/Objet*, founded in Berlin by Lissitzky and Ehrenburg in March of 1922. Important exchanges took place at the International Congress of Progressive Artists in Düsseldorf in May of 1922. There proponents of the Constructivist movement joined forces against the Expressionist majority of the Congress, and

the most committed—van Doesburg, Richter, and Lissitzky—established the Internationale Fraktion der Konstruktivisten (International Section of Constructivists) and signed a joint proclamation. Further, the Weimar Dada-Constructivist Congress, organized in September of 1922 on the initiative of van Doesburg and Walter Dexel in response to the failure of the Düsseldorf Congress to formalize Constructivism, represented a concerted effort to unite different ideologies, to ratify the International Section of Constructivists and acclaim Constructivism as a leading international movement.

The objectives and formal innovations of Russian Constructivism came again into focus through the First Russian Art Exhibition at the Galerie van Diemen, held in Berlin in October 1922 and later shown in Amsterdam. Of the 594 entries in the exhibition a large part represented nonobjective and Constructivist works, and the predominant among them were "constructions," not "compositions."

The spread of Constructivist ideals was also helped by little magazines, published both in Russia and Europe. Among them were Richter's *G* (for *Gestaltung*), published in 1923 in Berlin; Moscow-published *Lef*, edited by Mayakovsky and Ossip Brik (1923–1928); the Polish *Blok* (1924); and the Czech *Disk* (1924). They promoted Constructivism not only through their content, but also through innovative typography based on strict vertical-horizontal relationships, use of block lettering, and division of the page into large rectangular blocks of text, as best exemplified in Lissitzky's designs for *Veshch/Gegenstand/ Objet* and Rodchenko's covers for *Lef*.

Among the institutions where the Constructivist canon exercised a vital influence was the Bauhaus, which during the 1920s became the center for propagation and development of geometric abstraction and experimental architecture. Founded by Walter Gropius in Weimar in 1919, it set out to achieve a unity of art and technology through the teaching of painting, sculpture, and architecture on the basis of craftsmanship. Gropius as an architect believed that "all the arts culminate in architecture" and that the natural balance of the arts should be restored through the collaboration of artists and architects. This philosophy essentially paralleled the ideas of merging art and life propounded by the Russian Constructivists, although it did not contain equally strong overtones of functionalism and active ideological involvement with the political left. It was therefore natural that the ideas of the Bauhaus members should take on a more Constructivist cast with broader exposure to Constructivism. To achieve his goal of unifying architect-artist and craftsman, Gropius recruited his faculty from among the important painters of the time; Itten, Kandinsky, Klee, Feininger, Schlemmer taught painting, graphic arts, and stage design, and were later joined by Moholy-Nagy and Albers.

The change in the philosophy of the Bauhaus toward a Constructivist alignment and away from the more Expressionist program originally implemented by Itten occurred when Moholy-Nagy joined the faculty in 1923. Painter, photographer, theater and graphic designer, he significantly influenced the Bauhaus profile through his teaching and writings. His own art had been strongly influenced by Tatlin's ideas as well as those of Malevich and Lissitzky. He shared the Constructivist interest in new materials and in art as process, and championed the view of the world as a product of the machine. His concern with light as form-revealing, apparent in his 1921 studies of transparency, proved conducive to experiments with new materials and techniques. In 1922 he began exploring the plastic possibilities of wood, glass, copper, zinc, steel, and plated metals. An example of his work at this point is *Nickel Sculpture*—formally a homage to Tatlin's Tower. This and his other static sculptures recalled the Russian Constructivist works first shown in Moscow in 1920 by the Obmokhu generation and also presented in 1922 at the First Russian Art Exhibition at the Galerie van Diemen in Berlin.

A geometricizing trend could also be observed among the lyrical-abstractionist members of the Bauhaus faculty, Kandinsky and Klee. Their works of the period show a tendency toward more sharply defined geometric forms and more rigid organization of the composition. In Kandinsky's work one can detect the influence of Russian nonobjective trends, specifically Malevich's Suprematism and Rodchenko's dynamic works—the compass-and-ruler compositions of 1915–1916 as well as his later line compositions of around 1920—with which Kandinsky came into contact during his years in Russia. Although his concept of art as a spiritual activity differed diametrically from the utilitarian ideals of the Russian Constructivists (one of the reasons for his departure from Russia), Kandinsky nevertheless adopted into his idiom their characteristic clarity of composition while retaining his own multiplicity of formal vocabulary.

Klee, through contact with Bauhaus colleagues who were influenced by Constructivist and de Stijl ideas, increased the diversity of his pictorial means and introduced into his compositions stronger horizontal and vertical organization and later a preoccupation with space and its simultaneous perception in time, as in the works of the late 1920s, for example, *Fire in the Evening,* in which bands of colors interact dynamically.

But the main objective of the Bauhaus was a synthesis of all the arts—crafts and the machine, painting and environment, painting and theater. This goal was, in a unique way, achieved in the work of Oskar Schlemmer and his conception of total theater. A member of the Bauhaus faculty since 1921, Schlemmer centered his attention on the interpretation of space as experienced through the human figure in motion. This he explored in drawings and in paintings such as *Bauhaus Staircase* (1932). He saw theater as the best arena for such experimentation—a synthesis of form and color in motion which permitted the investigation of the planimetric and stereometric relationships at work within a given space. These preoccupations were fully developed in his set and costume designs for the production of his *Triadic Ballet* (1922).

At the time when Constructivist influences were affecting the Bauhaus program, they were also attracting artists such as van Doesburg, who in his efforts to further the cause of de Stijl initiated contacts with the Russians and particularly befriended Lissitzky. He shared Lissitzky's views on architecture and, like him, sought a practical application of pure plastic means to create a new environment. These views were proclaimed in a statement signed jointly by van Doesburg and Cornelis van Eesteren. This statement, "Toward Collective Construction"—often referred to as the fifth de Stijl manifesto—was published on the occasion of van Doesburg's and van Eesteren's exhibition of de Stijl architectural models at the Galerie de l'Effort Moderne in Paris in 1923.

Van Doesburg's works during the 1920s show the evolution of his conceptions from Neoplasticism to the Concrete Art of 1930. They illustrate his search for means to convey dynamic quality in art, a quest aligned with the spirit of the contemporaneous theories of the fourth dimension and the space-time relationship, which were so important to Malevich in his search for a new idiom. This interest led van Doesburg to his projects for private houses designed according to de Stijl principles and shown in Léonce Rosenberg's gallery, L'Effort Moderne, in 1923. These projects helped him to develop the dynamic principle of Elementarism in his two-dimensional work, as shown in *Simultaneous Counter-Composition* (1929). Evolved in late 1924 and early 1925 and announced in 1926 in *De Stijl,* the Elementarist approach, which introduced a diagonal into the vertical-horizontal linear structure of Neoplastic painting, revealed a search for a novel form of expression, appropriate to the scientific concepts of matter in motion and denial of the laws of gravity. This initiated the "counter-constructions," the axonometric drawings or spatial projections at a 45° angle of the architectural models, from which

evolved his Elementarist pictures—the "counter-compositions," arrived at through the process of "reverse translation" of a three-dimensional work into a two-dimensional one that combined the orthogonals with the visual oblique symbolic of dynamic quality. The Elementarist precepts were put into practice in the project executed in collaboration with Jean Arp and Sophie Taeuber-Arp for the reconstruction of the Café de l'Aubette in Strasbourg in 1926–1928, one of the few environmental projects actually realized. There the ceiling and side walls were treated as large-scale Elementarist pictures based on a compositional arrangement of diagonally related flat color planes, interacting spatially and intended to convey "repose and movement, time and space."

The Dada movement, because of its reliance on chance in art, was dedicated to a subjective approach to artistic creation—and thus was basically opposed to the goals of geometric abstraction. But around 1922 even Dadaism was affected by Constructivist rigor and logic. It shared with Constructivism an interest in the machine aesthetic and in the practice of collage and photomontage as well as object-construction—and for that reason may have been receptive to the influence of Constructivist ideas. Van Doesburg, although opposed to its formal expression, considered Dada a positive factor from the philosophical point of view, and he himself, under the pseudonym I. K. Bonset, founded the Dada magazine *Mécano* (1922) as if to counterbalance the views of the Bauhaus. He saw Dada as the force which, by destroying the old order, accomplished the necessary preparation for implementing the goals of de Stijl—the creation of a New Man and the realization of a New Vision.

An example of Dada elements altering under the influence of Constructivist ideas is provided by the work of Kurt Schwitters, particularly some of his collages done after 1922. The representative of Hannover Dada, Schwitters made collage a very personal expressive idiom. His collages —compositions, including bits of found papers, discarded train tickets, cigarette and candy wrappers—begun in the winter of 1918, evolved in the 1920s into more rigorously organized geometric abstractions where, to all appearances, greater attention to vertical-horizontal axes and greater regularity of forms reflect influences from de Stijl and Constructivism.

In France geometric abstraction in the 1920s developed initially on the basis of Synthetic Cubism, which had made available to artists an anti-illusionistic abstract space through schematic representation of objects and flatness of form, so that the entire canvas became available as a compositional field. From 1920 on, the de Stijl influence exercised an increased impact in Paris through the presence of Mondrian and the publication of his fundamental text, *Le Néoplasticisme*, by Léonce Rosenberg—who also published van Doesburg's essay *Classique, baroque, moderne.*

During 1923–1925 French geometric abstraction began to be affected by International Constructivism. In France, however, International Constructivism never became a dominant current, and events relating to it, such as the 1923 exhibition of de Stijl architecture, went largely unnoticed. One major event popularized a modified form of geometric abstraction; the 1925 Exposition des Arts Décoratifs in Paris initiated the broad use of geometric form for ornamental purposes in the applied and decorative arts—the Art Deco style.

Toward the end of the 1920s geometric abstraction became an increasingly eclectic style, foreshadowing the art of the 1930s. Throughout the decade to come it would gradually lose its ideological certainties and give up its ambitions for establishing a new social, political, and aesthetic order.

Chronology

1922–1929

Amsterdam

Large retrospective of Mondrian at Stedelijk Museum organized on the occasion of his fiftieth birthday by his friends Peter Alma, J. J. P. Oud, S. B. Slijper. Submits entry to exhibition "From Cubism to a Plastic Renaissance," at Léonce Rosenberg's.

Berlin

Lissitzky publishes his book *About 2 Squares* (designed in Vitebsk in 1920).

Lissitzky and Gabo leave Russia for Berlin. Gabo stays until 1933, with frequent visits to Paris.

Dreier visits Russian exhibition at Galerie van Diemen and purchases some Cubo-Futurist works, among them Malevich's *Knifegrinder* (1912), Udaltsova's *At the Piano* (1915), two nonobjective gouaches by Popova, a sculpture by Medunetsky of 1919.

Van Doesburg meets architects Bruno Taut and Mies van der Rohe. He publishes magazine *Mécano* under the pseudonym I. K. Bonset.

Also in Berlin at this time: Mayakovsky, in contact with George Grosz, Raoul Hausmann, John Heartfield, Diaghilev, who helps obtain a visa for Mayakovsky to visit France.

George Grosz breaks with the Dada artists and makes a six-month trip to Russia (briefly meets Lenin).

March. Ehrenburg and Lissitzky publish first issue of the trilingual journal *Veshch/Gegenstand/Objet,* one of the most important Constructivist magazines.

October. "The First Russian Art Exhibition" (Erste Russische Kunstausstellung) opens at Galerie van Diemen and is the first showing of Constructivist works outside Russia. Many members of the avant-garde are represented. Gabo accompanies the exhibition, never to return to Russia.

Lissitsky, through George Grosz, meets many members of Western avant-garde.

Düsseldorf

Lissitzky meets Moholy-Nagy.

May. "The First International Congress of Progressive Artists," sponsored by the Artist's Union of the Rhineland; unites the advanced members of the Constructivist groups in opposition to the Expressionist majority of the Congress. The German, Swiss, Scandinavian, and Rumanian Constructivists are led by Richter, the Hungarian group by Moholy-Nagy, and the Russians by Lissitzky. Van Doesburg, Richter, and Lissitzky issue joint statement against the individualistic tenor of the Congress and in favor of collective activity by progressive artists and establish themselves as the International Section of Constructivists in an attempt to formalize the International Constructivists movement.

Hannover

Lissitzky admitted to the Kestner Gesellschaft through the efforts of Kurt Schwitters.

Lodz

Blok nonobjective artists group founded, propounding Constructivist ideas.

Moscow

Constructivism is kept alive in the theater. Popova and Stepanova design Constructivist sets for the Meyerhold Theater.

Aleksandr Vesnin designs the Constructivist set for the production of *The Man Who Was Thursday* at the Kamernyi Theater.

Group portrait of the participants in the First International Congress of Progressive Artists in Düsseldorf, 1922, including van Doesburg (third from left) and Lissitzky (seated on fence)

Theo van Doesburg and friends in Weimar, September 1922

The Productivist faction of the Constructivists, promoting artists' active involvement with industrial production, gains official support.

January. Exhibition of the resurrected World of Art (Mir Iskusstva), including Drevin, Konchalovsky, Lentulov, Udaltsova, Falk.

April. Meyerhold's production of Crommelynck's *The Magnanimous Cuckold,* with set designs by Popova.

May. First exhibition of the Makovets group. Group will remain active until about 1925.

The "Exhibition of Paintings by Artists of the Realist Tendency in Aid of the Starving" opens in Moscow and inaugurates the activities of AKhRR (Association of Artists of Revolutionary Russia), a group ideologically opposed to the avant-garde.

November. First exhibition of NOZh (New Society of Painters), former pupils of Exter, Malevich, and Tatlin, which helps reverse the trend away from easel art.

Meyerhold's production of Sukhovo-Kobylin's play *Death of Tarelkin,* with stage designs by Stepanova.

New York

Gontcharova and Larionov exhibit at the Kingore Gallery.

February. Wanamaker's presents exhibition of paintings by Gontcharova, Larionov, Rivera, Metzinger, Gleizes, and Marcoussis.

Paris

Mary Knoblauch translates Apollinaire's *Les Peintres cubistes* for three successive issues of *The Little Review.*

Man Ray develops his Rayograms, independently of Moholy-Nagy's similar technique.

Petrograd

April. Malevich moves from Vitebsk to Petrograd. Shortly thereafter followed by Chashnik, Suetin, and others, and joins Inkhuk on the initiative of Tatlin.

June. Exhibition of the Association of New Trends in Art (Malevich, Senkin, Tatlin, et al.).

Stuttgart

September. Schlemmer's *Triadic Ballet* is first performed in its entirety in the Stuttgart Landestheater.

Tver

December. Gan publishes his book *Konstruktivizm*—the first attempt to present the new movement as a coherent artistic ideology.

Vienna

July. Group of Hungarian artists including Kassak and Moholy-Nagy sign a statement in support of IFdK, later published in *De Stijl.*

Weimar

Van Doesburg organizes a Weimar section of de Stijl and gives unofficial series of lectures at the Bauhaus, but his influence conflicts with Bauhaus principles and soon wanes.

Van Doesburg meets Mies van der Rohe and Le Corbusier.

Kandinsky appointed to the Bauhaus faculty as Form Master for the wall-painting workshop.

Spring. First performance of Schlemmer's *The Figural Cabinet* (second performance during the Bauhaus week, 1923).

September. Constructivist Congress also known as Dada-Constructivist Congress, organized by Van Doesburg and Walter Dexel

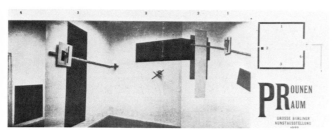

Lissitzky's Proun Room Space designed for the Grosse Berliner Kunstausstellung, 1923

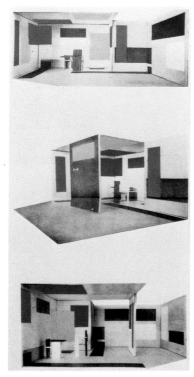

De Stijl environment project by Vilmos Huszar and Gerrit Rietveld, *Spatial Color Composition,* presented at the Grosse Berliner Kunstausstellung, 1923

with participation of Tzara, Arp, Lissitzky, and Moholy-Nagy, the principal goal being to ratify the International Section of Constructivists (IFdK) and establish Constructivism formally as an international movement; the effort fails. The enlarged IFdK publishes *Manifesto of International Constructivism.*

1923

Berlin

Karel Capek's play *R.U.R.* is produced at the Theater am Kurfürstendamm with sets by Frederick Kiesler. The designs incorporate films for backdrops. Images of actors in diminished scale are reflected by mirrors on a panel as on a television screen. After the second performance, van Doesburg introduces himself to Kiesler, who then meets Schwitters, Moholy-Nagy, Lissitzky, and Werner Graeff, and joins de Stijl.

Richter, Mies van der Rohe, and Graeff publish magazine *G* (Material zur elementaren Gestaltung).

Grosse Berliner Kunstausstellung, including Lissitzky's Proun Room and de Stijl exhibition space designed by Huszar in collaboration with Rietveld.

Hannover

Publication of two Kestner Geschellschaft portfolios of Lissitzky's works: the first, *Proun* (1919–1923); the second (summer), *Victory over the Sun,* ten costume designs for the mechanical production of the Kruchenykh/Matiushin opera first presented with costumes and sets by Malevich in 1913.

Moscow

Critic Nikolai Tarabukin publishes his two important essays on art: *From Easel to the Machine* and *For a theory of Painting*—a thorough analysis of the avant-garde painting theories.

The Vesnin brothers complete the design for the Palace of Labor.

The All-Russian Agricultural Exhibition— where Exter, Aleksandr Vesnin, the brothers Stenberg contribute the Constructivist decorations to the exhibition pavilions (e.g., Izvestia pavilion decorated by Exter).

March. Mayakovsky, Ossip Brik, and others found the journal *Lef* (Left Front of the Arts), which will appear regularly through 1925. Favors a strongly ideological interpretation of art and also champions Constructivism and the formalist method in literary criticism.

New York

Société Anonyme presents Kandinsky's first U.S. one-man exhibition.

Dreier publishes *Western Art* and the *New Era*.

Dreier meets David Burliuk, who eventually becomes her chief link with many Russian émigrés.

Archipenko arrives in the U.S.A.

January. The Brooklyn Museum organizes the exhibition "Contemporary Russian Paintings and Sculpture" with the Société Anonyme.

Paris

October 15. Exhibition "The Architects of the de Stijl Group, Holland," at the Galerie L'Effort Moderne, where van Doesburg and van Eesteren exhibit their architectural models, Mies van der Rohe his design for a glass

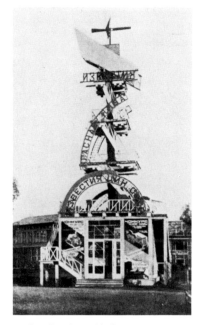

Izvestia pavilion, decorated by Exter, at the All-Russian Agricultural Exhibition, Moscow, 1923

Van Doesburg and van Eesteren with an architectural model at their exhibition at the Galerie L'Effort Moderne, Paris, 1923

skyscraper. Other contributors include Huszar, Rietveld, Oud, Wils, W. van Leusden. On occasion of the exhibition, van Doesburg and van Eesteren issue their text "Toward a Collective Construction" (published the following year in *De Stijl*)—the fifth de Stijl manifesto.

Petrograd

"Exhibition of Paintings by Artists of All Tendencies"—the last Russian presentation to include nonobjective art (including numerous works by Malevich, who on this occasion publishes his manifesto "Suprematist Mirror."

Prague

May. Publication of *Disk* by the Czech artist Karel Teige, with the goal of popularizing Constructivist ideas.

Warsaw

Publication of the magazine *BLOK*, an organ of Polish Constructivism.

Weimar

At Gropius's invitation, Moholy-Nagy joins the Bauhaus as head of the metal workshop and is also in charge of the introductory course.

Itten leaves the Bauhaus; replaced by Moholy-Nagy, who introduces Constructivist concerns into the preliminary course: Problems of Materials, Transparency, Light, Typography.

Albers joins Bauhaus staff at invitation of Gropius and begins teaching the preliminary course in materials and design.

Lissitzky comes into close contact with van Doesburg and Moholy-Nagy, increasing the Constructivist influence on Bauhaus.

During the summer the Bauhaus exhibition devoted to the achievements of the first four years includes work from the preliminary course and the workshops and an international survey of architecture.

Zurich

Founding of the review *G* by Richter, which combines elements of both Constructivism and Dada and includes contributions by such diverse artists as Gabo, Pevsner, Malevich, Lissitzky, Mies van der Rohe, Schwitters, Hausmann, Grosz. The July issue of *G* publishes van Doesburg's text "Toward Elementary Plastic Expression."

1924

Founding of the Blue Four Group (Kandinsky, Klee, Jawlensky, and Feininger).

Publication of Trotsky's *Literature and Revolution*.

Exter and Puni emigrate to Paris.

Vordemberge-Gildewart joins de Stijl.

Toward the end of the year (and early in 1925) van Doesburg begins to develop his concept of Elementarism, which introduces the use of the diagonal in painting to express its dynamic quality.

Leningrad

Ginkhuk (State Institute of Painterly Culture) founded. Lasts only until December 1926.

Moscow

Exter designs sets and costumes for the science-fiction film *Aelita* (begun in 1923).

January. Lenin's mausoleum in Red Square is designed in a Constructivist vein by Shchusev.

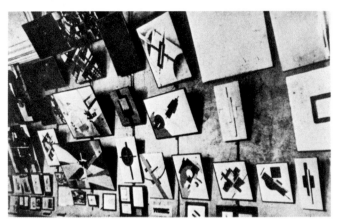

View of the "Exhibition of Paintings by Artists of All Tendencies," Petrograd, 1923

May. "First Discussional Exhibition of the Associations of Active Revolutionary Art"; eight sections, including Concretists, Projectionists, and the First Working Group of Constructivists.

May 25. Death of Popova. Shortly thereafter she is given an important retrospective.

Late spring. Publication of Lunacharsky's *Theater and Revolution.*

New York

Exhibition of "Modern Russian Artists" at the galleries of the Société Anonyme.

March. "Russian Art Exhibition" at Grand Central Palace.

Paris

Publication of van Doesburg's architectural program, on occasion of the second exhibition of de Stijl architecture—a sixteen-point manifesto entitled "Toward Plastic Architecture," which summarized his notion of architecture as synthesis of Neoplasticism at the expense of painting and sculpture as independent categories.

June 19–July 5. Galerie Percier holds exhibition "Constructivistes russes: Gabo et Pevsner."

Utrecht

Rietveld's Schröder House is the first house built according to de Stijl principles.

Venice

Fourteenth Biennale, with a Russian section including Exter, Malevich (*Suprematist Square, Suprematist Cross, Suprematist Circle*), Udaltsova, Vesnin.

1925

RAPP (Russian Association of Proletarian Writers) is established in Moscow. Its members call for increased ideological awareness on the part of writers.

Lissitzky returns to Russia from Switzerland.

Die neue Gestaltung (a translation of Mondrian's 1920 pamphlet *Le Néoplasticisme*) published by Bauhaus.

Grundbegriffe der neuen gestaltenden Kunst (Foundation of New Plastic Art) by van Doesburg published by Bauhaus.

The Staatliche Bauhaus moves to Dessau into new buildings designed by Gropius. Albers, Breuer named Junior Masters on the teaching staff. The Bauhaus publishes eight of its fourteen Bauhaus books, largely designed by Moholy-Nagy and printed in Munich.

Oud designs Café De Unie in Rotterdam (according to de Stijl principles).

Kiev

Tatlin heads, until 1927, the Department of Theater and Cinema and Photography within the painting department at the Kiev Art School. Begins to teach "the culture of materials."

Moscow

The Vesnin brothers and Moïse Ginzburg initiate the group of architectural Constructivists OSA (Society of Contemporary Architecture), intended to implement the principles of the First Working Group of Constructivists in architecture. OSA's official organ, *SA* (Sovremennya Architektura—Contemporary Architecture), will be edited by Ginzburg and Aleksander Vesnin, beginning January 1926.

July. The Communist Party Central Committee's resolution "On the Party's Policy in the Field of Artistic Literature" calls for a style "comprehensible to the millions" while also advocating continued open competition among different artistic tendencies.

September. Exhibition "Leftists Trends in Russian Painting of the Last Fifteen Years."

New York

The publication of Louis Lozowick's *Modern Russian Art* (by the Société Anonyme) and Huntley Carter's *The New Theater and Cinema of Soviet Russia*.

November. The Société Anonyme holds an exhibition of Léger's recent work at the Anderson Galleries.

Paris

Mondrian dissociates himself from de Stijl because of van Doesburg's insistence on the diagonal.

April. The "Exposition Internationale des Arts Décoratifs et Industriels Modernes" opens with a Constructivist Soviet pavilion by Melnikov. Soviet design movement is well represented. Le Corbusier's Pavillon de L'Esprit Nouveau is constructed for the exposition and decorated with paintings by Ozenfant, Le Corbusier, and Léger. Rodchenko makes trip to Paris for the occasion. For the Austrian section, Kiesler designs "The City in Space," a suspended framework constructed on a tension system without foundations or walls, and without a static axis, indicating the influence of both the Russian Constructivists and de Stijl. De Stijl itself is not represented. Germany is excluded from the exhibition. The U.S. declines to participate because there is no "modern design" in America.

December. The exhibition "Art d'Aujourd'hui," organized by Polish painter C. Poznanski, unites French and foreign abstract directions. It includes nearly 250 works, with de Stijl represented by Mondrian, van Doesburg, Domela, and Vordemberge-Gildewart, the Paris school by Gris, Léger, Ozenfant, Villon, and Picasso. Willi Baumeister, Gontcharova, Klee, and Moholy-Nagy also are represented.

Zurich

Publication of *Kunstismen/Les Ismes de l'art/ The Isms of Art: 1914–1924* by Lissitzky and Arp, an overview of the avant-garde tendencies from Cubism to abstraction and Constructivism.

1926

Eisenstein releases his film *The Battleship Potemkin*, and Pudovkin his film version of Gorky's *Mother*.

The review *Asnova* (Association of New Architects) is founded, edited by Lissitzky and Ladovsky.

Mondrian designs his Neoplastic interior, *Salon de Mme B . . .* , in Dresden (never executed) and stage set for Michel Seuphor's play *L'Ephémère est éternel*.

March. French periodical *Vouloir* (edited in Lille by A. F. del Mare) publishes Mondrian's article "Art, Purity, and Abstraction" (his crucial criticism of Elementarism versus Neoplasticism) and van Doesburg's "Toward Elementary Art."

Berlin

Mies van der Rohe appointed first vice-president of the Deutsche Werkbund. The Ring, an association of progressive German architects, organized with, among the members, Gropius, Mies van der Rohe, Bruno and Max Taut, and Ludwig Hilbersheimer.

Dessau

Kandinsky's *Punkt und Linie zu Fläche* and Oud's *Hollandische Architektur* are published as Bauhaus books nos. 9 and 10.

December 4–5. Bauhaus moves to Dessau and into Gropius's new buildings, whose design shows the influence of de Stijl and Constructivism.

Dresden

June–September. The International Art Exhibition. Lissitzky goes to Dresden to design a room for the display of the nonobjective work of Léger, Mondrian, Moholy-Nagy, Picabia, and Gabo.

Hannover

1926–1928. Lissitzky at Kestner-Gesellschaft, where he is commissioned by Alexander Dorner to design an "Abstract Gallery," the first in Europe, in the Provinzial Museum.

Leiden

Van Doesburg publishes in *De Stijl* his fragmentary manifesto on Elementarism entitled "Painting and Plastic Art: On Counter-Composition and Counter-Plastic Elementarism."

Moscow

January. Architectural journal *SA* (Contemporary Architecture), edited by A. Vesnin and M. Ginzburg, begins to appear in Moscow. It serves as a key propagator of Constructivism until it ceases publication in 1930.

September. Vkhutemas transformed into Vkhutein (Higher State Art-Technical Institute).

Members of the Bauhaus in Dessau, 1928, at a farewell evening for Gropius

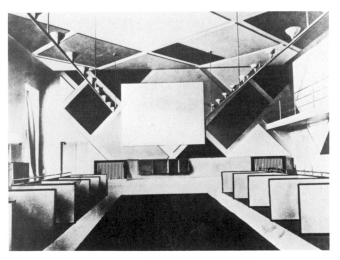

Interior of the Café de l'Aubette, designed by van Doesburg, Arp, and Sophie Taeuber-Arp, Strasbourg, 1926–1928

New York

Mondrian is exhibited in U.S. through Dreier at "Société Anonyme International."

Brooklyn Museum exhibition of the Société Anonyme opens, showing 300 works by 106 artists from 19 countries. Nearly all works done since 1920. Widespread reviews pay most attention to Constructivist abstraction.

November–December. In its winter issue, *The Little Review* announces the opening of The Little Review Gallery at its offices at 66 Fifth Avenue. It is dedicated to "the new movements in the arts," and exhibits artists such as van Doesburg, Léger, Brancusi, Gabo, and Pevsner.

Philadelphia

June–December. The Société Anonyme cooperates with loans for the Russian and German sections of the Sesquicentennial Exposition; Malevich and Kandinsky are included. Russian section organized by Christian Brinton.

Strasbourg

Van Doesburg collaborates with Jean Arp and Sophie Taeuber-Arp on the rebuilding and decorating of the Café de l'Aubette, designed according to Elementarist principles.

1927

Publication of the German edition of Malevich's *The Nonobjective World,* as a Bauhaus book.

March. Malevich begins trip to Poland and Germany for an exhibition of his work. He leaves a large number of works with a friend in Germany and returns to Soviet Union in June. Travels to Warsaw, Berlin, Dessau.

Berlin

April–May. Malevich in Berlin, where he meets Arp and Gabo (also visits the Bauhaus, meeting Gropius and le Corbusier).

May 7–September 30. Retrospective exhibition of the work of Malevich at the Grosse Berliner Kunstaustellung includes seventy of his paintings and gouaches.

Dessau

Max Bill studies architecture at Bauhaus from 1927 to 1929.

Hannover

Lissitzky designs Room of Abstracts (Kabinett der Abstrakten) for the display of nonobjective art in the collection of the Landesmuseum, at the invitation of Alexander Dorner, director of the Niedersächsisches Landesmuseum. The walls are lined with metal strips painted white, gray, and black that change color with the position of the viewer.

Malevich meets Schwitters.

Leiden

In commemoration of the tenth anniversary of de Stijl, issues no. 79–84 are devoted to surveying events of the past ten years with articles by the original members of de Stijl.

Brancusi joins de Stijl.

Leningrad

Constructivist critic Nikolai Punin publishes his two essays on the *New Directions in Russian Art.*

November. Exhibition of the "Newest Trends in Art."

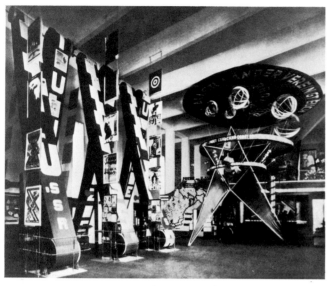

Entrance to the Soviet pavilion, designed by Lissitzky, at the "Pressa" exhibition, Cologne, 1928

Moscow

Tatlin back home from Kiev at Vkhutein (until 1931); exhibits at the Russian Museum his project for a man-propelled glider called Letatlin.

Architectural periodical *SA* (Contemporary Architecture) sponsors the "First Exhibition of Contemporary Architecture," with participation of the de Stijl and Bauhaus architects.

Leonidov completes his design for a Lenin Institute in Moscow—a tour de force of Constructivist architecture.

January. Journal *Novyi lef* (New Left Front of the Arts) begins publication. Issues appear regularly through 1928.

September. The "All Union Printing Exhibition" opens in Moscow with contributions by Klucis, Lissitzky, Senkin, Shterenberg, et al.

New York

May. The "Machine-Age Exposition," May 16–28, organized by *The Little Review,* exhibits machines and industrial products with photography, painting, sculpture, and architecture. Artists include Archipenko, Man Ray, Lipchitz, Demuth, van Doesburg, Pevsner, Gabo, and Arp. The Russian section arrived too late for documentation in the catalog. The catalog appears in *The Little Review.*

December. The Gallery of Living Art, N.Y.U., the collection of A. E. Gallatin, opens with an exhibition of about seventy paintings, including Picasso, Braque, Gris, Léger. Its tenure lasts from 1927 to 1943 (In 1933 Gallatin changes its name to the Museum of Living Art.)

Alfred Barr travels to Russia; spends winter of 1927–1928 in Moscow and Leningrad, forming a high regard for such innovators as Rodchenko, Lissitzky, Shterenberg, Tatlin.

Paris

Diaghilev's ballet *La Chatte* is produced with settings by Pevsner and Gabo, which are later shown in New York.

Stuttgart

"Die Wohnung," an international exhibition of architecture sponsored by the Deutsche Werkbund. The project brings together older (German) architects such as Peter Behrens with Le Corbusier, Oud, Gropius, Hilbersheimer, Bruno Taut, and Mies van der Rohe. The exhibition initiates public acceptance of the International Style.

1928

Basel

April–May. The Kunsthalle holds exhibition "Bauhaus Dessau," with the work of Albers, Feininger, Kandinsky, Klee, and Schlemmer.

Berlin

During the summer, Gropius and Moholy-Nagy design housing exhibition "Open-Air Life" in suburb, displaying new building techniques and materials.

Brussels

An exhibition of "Old and New Russian Art" opens.

Cologne

May–October. "Pressa," the International Press Exhibition. Lissitzky, in charge of the Soviet pavilion, comes to Cologne, designs the catalog and photo-supplement for the

Russian section. Later travels to Vienna, Frankfurt, Stuttgart, and Paris; visits Mondrian, Le Corbusier, and Léger.

Dessau

Moholy-Nagy and Breuer leave the Bauhaus for Berlin.

February 4. Gropius resigns as director of the Bauhaus. Succeeded by Hannes Meyer, an orthodox Marxist and propagator of pure functionalism of design, under whose directorship free creative activity in the Bauhaus is curtailed.

La Sarraz, Switzerland

June. The Congrès Internationaux d'Architecture Moderne (CIAM), organized by Le Corbusier and Siegfried Giedion as a three-day series of meetings, with participation of the avant-garde architects throughout Europe, to plan a program for new directions.

Leiden

De Stijl publishes van Doesburg's essay "Elementarism and Its Origin," and the entire issue is devoted to the elementarist architecture of the Café de l'Aubette in Strasbourg.

Moscow

May. The fourth exhibition of OST opens in Moscow with contributions by Labas, Liushin, Shterenberg, Vialov, et al.

1929

Le Corbusier again visits Russia; completes his design for the Centrosoyuz Building in Moscow.

September. *Manifesto of Futurist Aeropainting* signed by Balla, Marinetti, and others.

Barcelona

Summer. The World's Fair, representing Germany, France, the Scandinavian countries, and Italy. The German pavilion, designed by Mies van der Rohe, establishes his reputation on an international scale.

Dessau

Schlemmer leaves the Bauhaus.

Moscow

Malevich has a one-artist exhibition at Tretiakov Gallery.

Dziga Vertov completes his film *Man with a Movie Camera*.

August. Establishment of the All-Russian Union of Proletarian Architects (Vopra), representing an opposition against Constructivist and modernist architecture.

New York

February. "Exhibition of Contemporary Art of Soviet Russia" opens.

Stuttgart

May 18–July 7. "Film und Foto," the first international exhibition of film photography and photomontage, organized by the Deutsche Werkbund. The Russian section is designed by Lissitzky and includes photographs and stills by Eisenstein, Rodchenko, and Klucis. Among the Germans are Grosz, Schwitters, and Höch.

Wellesley College, Massachusetts

April–May. Alfred Barr delivers a series of five lectures at Farnsworth Museum of Modern Art and discusses subjects such as "Modern Painting: The Ideal of Pure Art," "The Bauhaus at Dessau," and "The LEF Group of Moscow," among others.

Zurich

March–April. Exhibition of Russian art at the Kunstgewerbemuseum. The poster is designed by Lissitzky.

Balla, Giacomo
Circolpiani. 1924
Oil on canvas
30½ × 30½″ (77.5 × 77.5 cm)

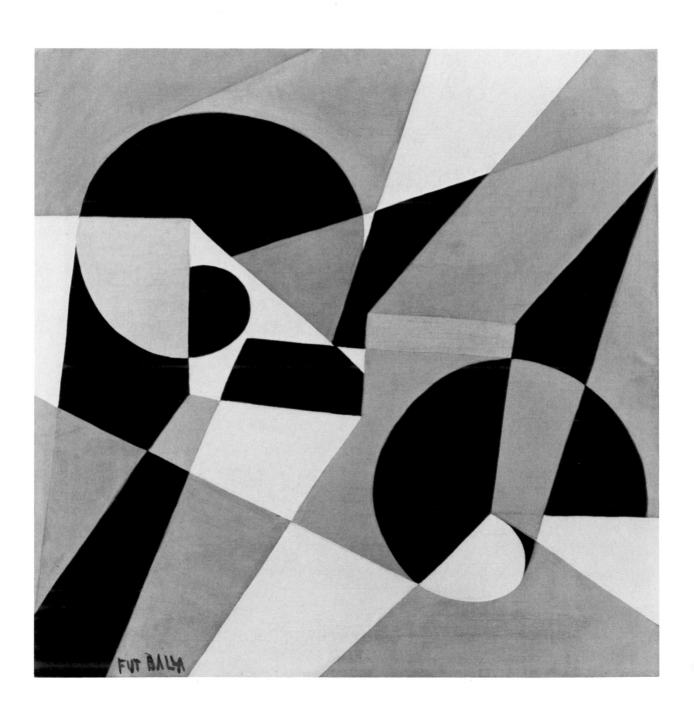

Baumeister, Willi
Figurate with Red Ellipse. 1920
Oil on canvas with sand
25½ × 19¾″ (65 × 50 cm)

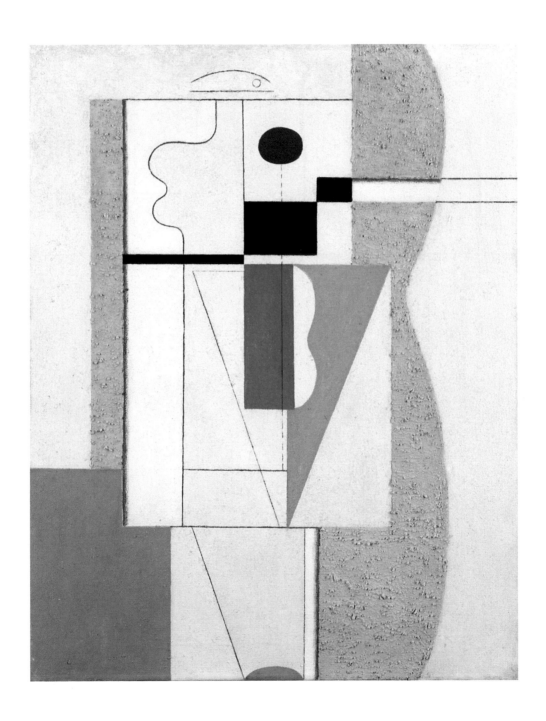

Béothy, Etienne (Istvan)
Project for a Monument ''Aranysor'' (Golden Row). 1919
Brass and copper
18 × 5 × 5″ (including base) (46 × 12.5 × 12.5 cm)

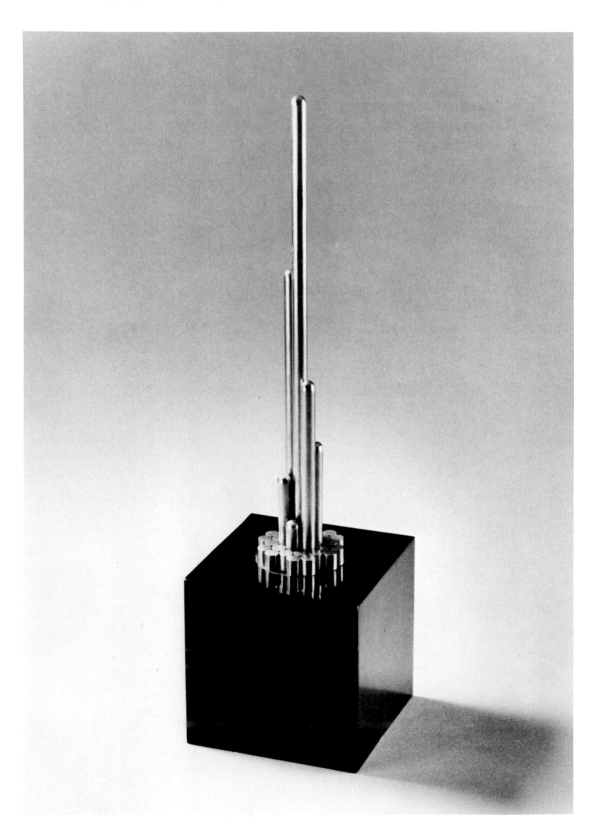

Berlewi, Henryk
First State of the Mechano-Faktura. 1923
Gouache on paper
21¾ × 17½″ (55 × 44.5 cm)

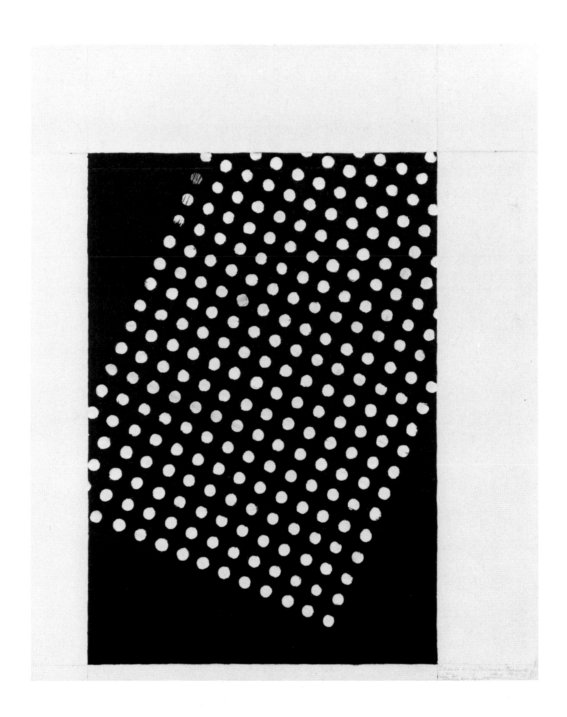

Bortnyik, Alexander (Sandor)
Pictorial Architecture 31. 1921
Watercolor on paper
10¼ × 8½″ (26 × 21.5 cm)

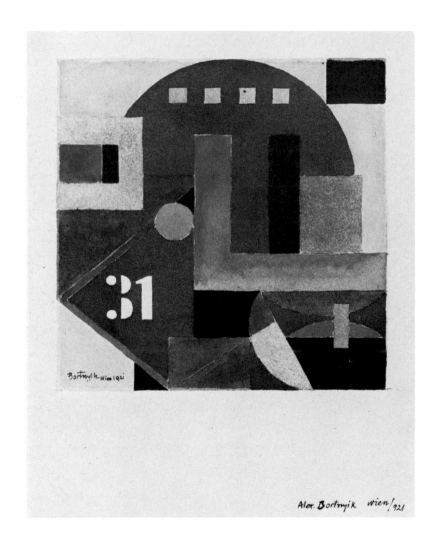

Buchheister, Carl
Composition No. 27. 1927
Oil and tempera on hardboard
19¼ × 25″ (49 × 63.5 cm)

Crotti, Jean
The Infinite Staircase. 1920
Gouache on paper
23¾ × 19¾″ (60 × 50 cm)

Dexel, Walter
Ioci. 1926
Collage on board
24¾ × 19¾″ (63 × 50 cm)

129

van Doesburg, Theo
Simultaneous Counter-Composition. 1929
Oil on canvas
19¾ × 19¾″ (50 × 50 cm)

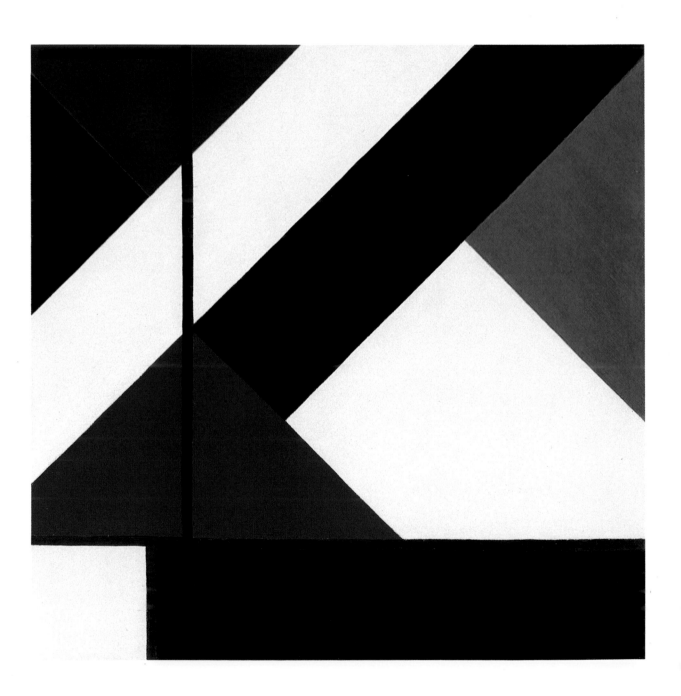

Herbin, Auguste
Composition. c. 1925
Gouache
6½ × 4¼″ (16.5 × 11 cm)

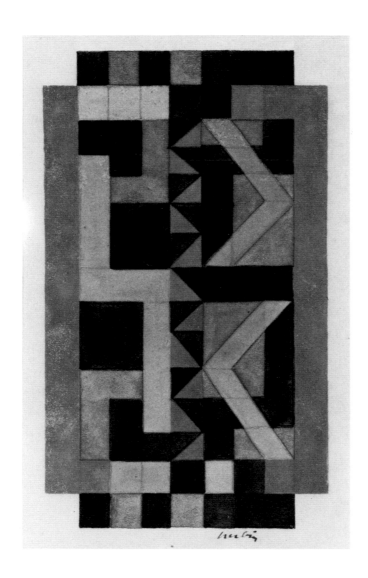

Kandinsky, Vasily
Soft Pressure. 1931
Oil on plywood panel
39⅜ × 39⅜″ (100 × 100 cm)

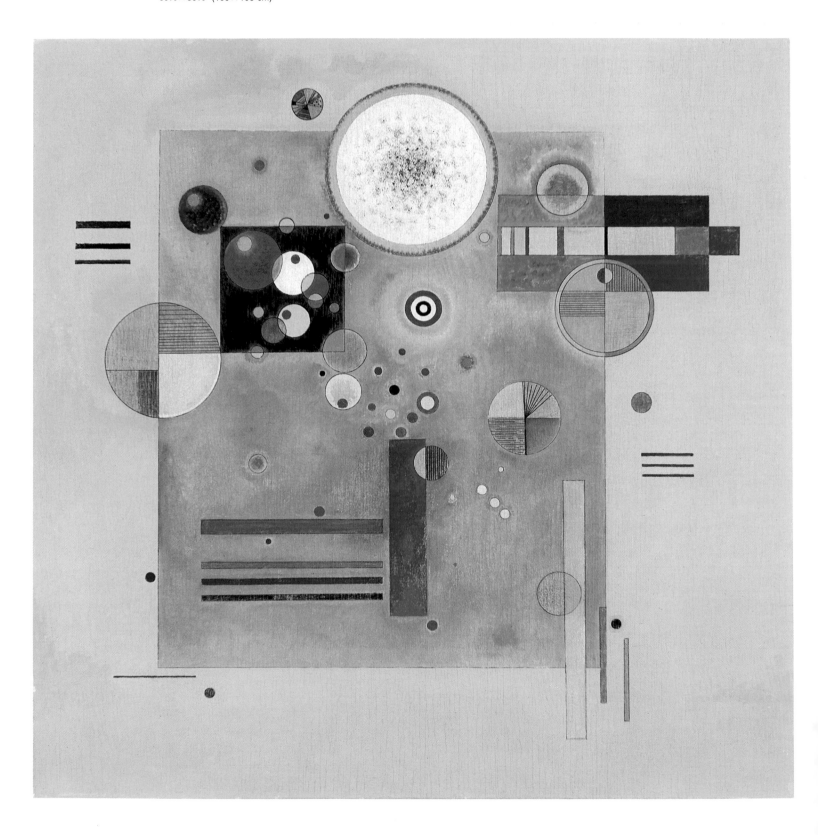

Kandinsky, Vasily
White—Soft and Hard. 1932
Oil and gouache on canvas
31½ × 39⅜″ (80 × 100 cm)

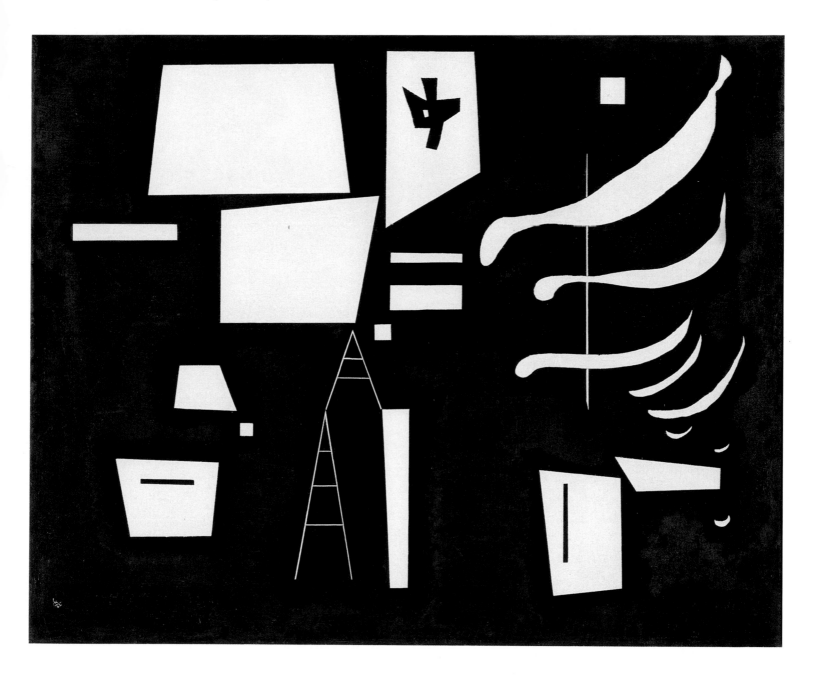

Kassak, Lajos
Untitled. 1921
Collage and mixed media
8 × 6¼″ (20 × 16 cm)

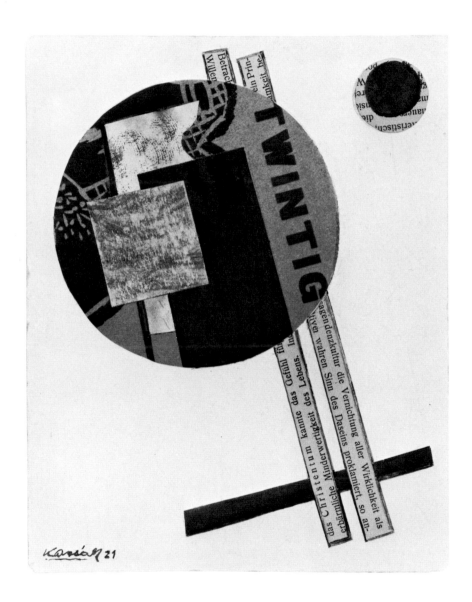

Klee, Paul

Fire in the Evening. 1929

Oil on cardboard

13⅜ × 13¼″ (33.8 × 33.4 cm)

Mr. and Mrs. Joachim Jean Aberbach Fund

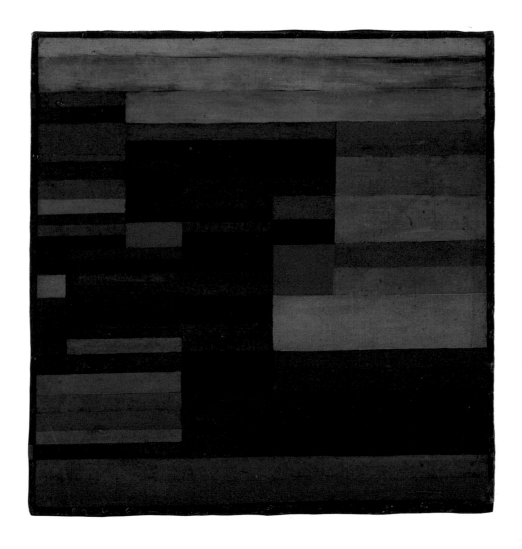

Kupka, František
Untitled. 1928
Gouache, watercolor, and pencil
7¾ × 12¼" (19.5 × 31 cm)

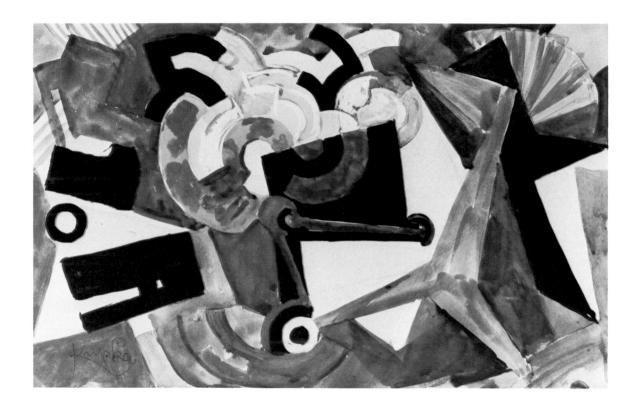

van der Leck, Bart
Abstract Composition. 1927
Oil on canvas
19¾ × 19″ (47.5 × 48 cm)

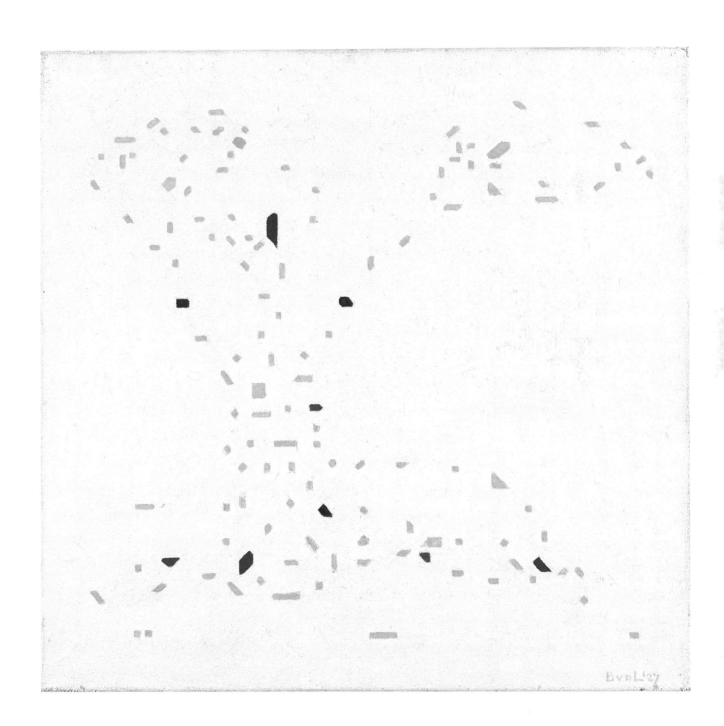

Léger, Fernand
Mural Painting. 1924
Oil on canvas
71 × 31¼″ (180.3 × 79.2 cm)
Given anonymously

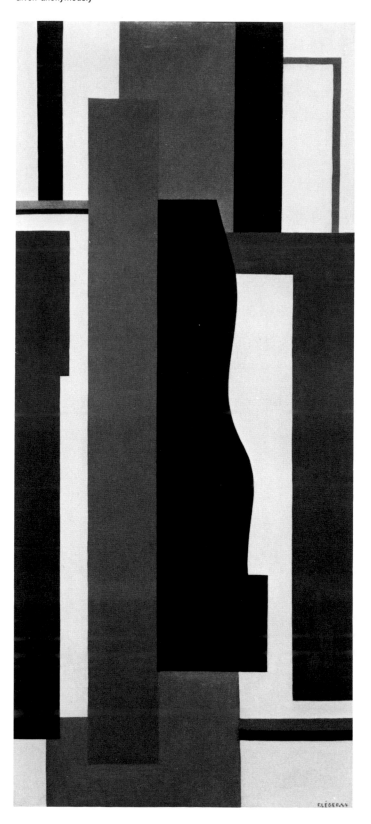

Lissitzky, El (Lazar)
Proun 19D. 1922
Gesso, oil, collage, etc., on plywood
38⅜ × 38¼" (97.5 × 97.2 cm)
Katherine S. Dreier Bequest

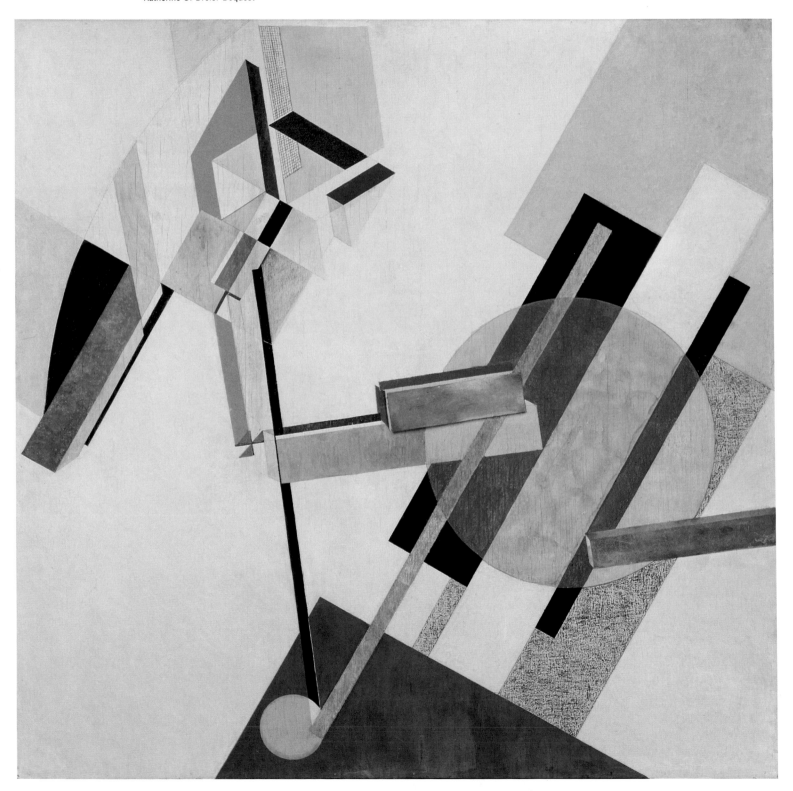

Moholy-Nagy, László
Yellow Circle. 1921
Oil wash on canvas
53⅛ × 45¼" (135 × 115 cm)

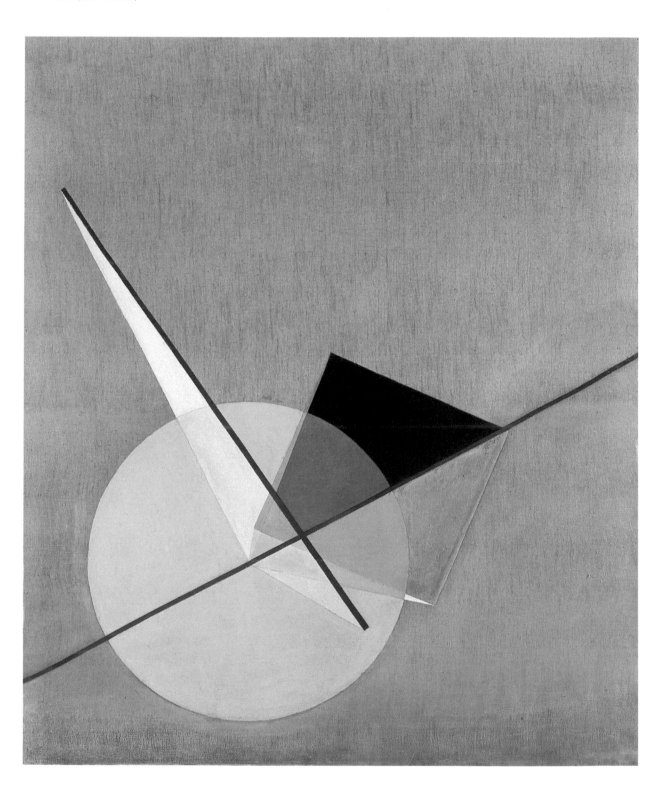

Moholy-Nagy, László
Nickel Construction. 1921
Nickel-plated iron, welded
14⅛ (35.6 cm) high; base 6⅞ × 9⅜″
(17.5 × 23.8 cm)
Gift of Mrs. Sibyl Moholy-Nagy

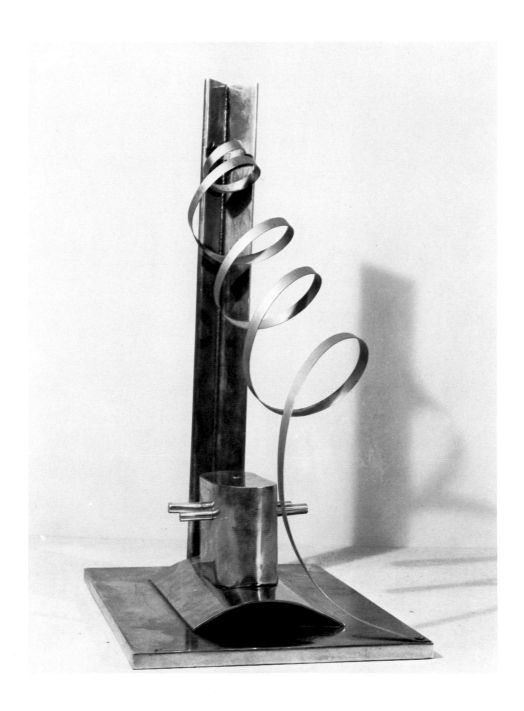

Moholy-Nagy, László
Q 1 Suprematistic. 1923
Oil on canvas
37½ × 37½" (95 × 95 cm)

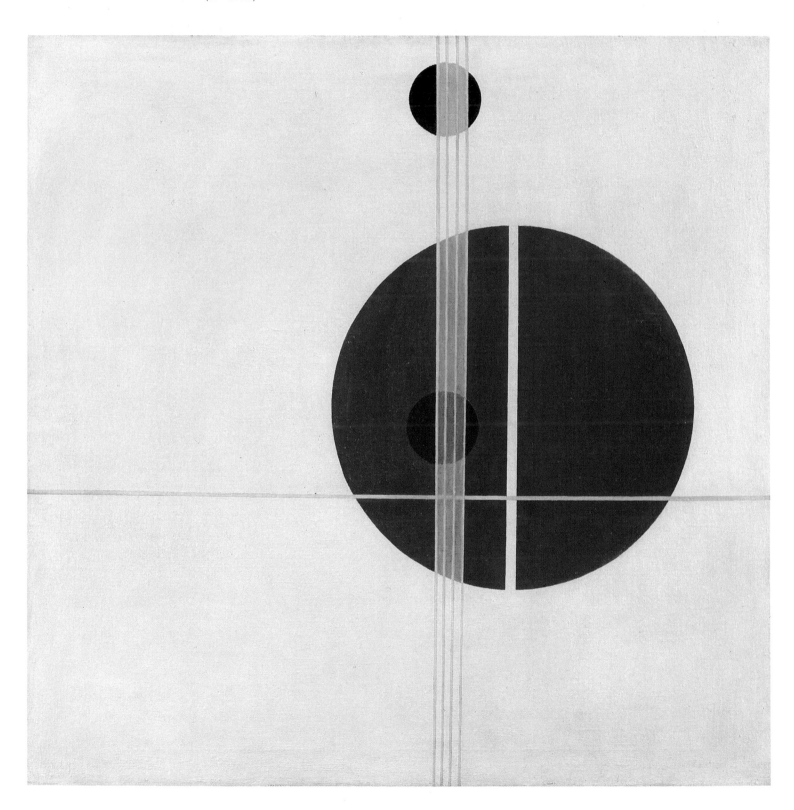

Schlemmer, Oskar
Abstract Figure (Relief H). 1919 (cast 1963)
Aluminum
26¼ × 10¾ × 1½″ (66.5 × 27.5 × 3.8 cm)

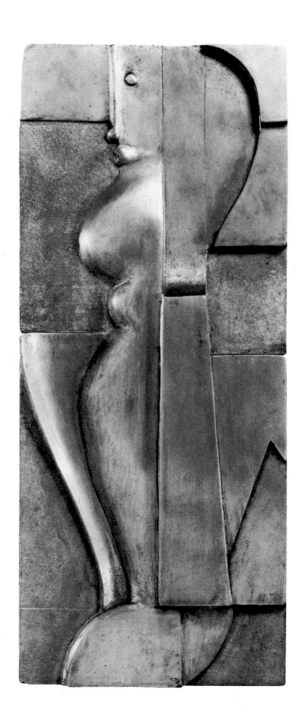

Schlemmer, Oskar
Bauhaus Stairway. 1932
Oil on canvas
63⅞ × 45″ (162.3 × 114.3 cm)
Gift of Philip Johnson

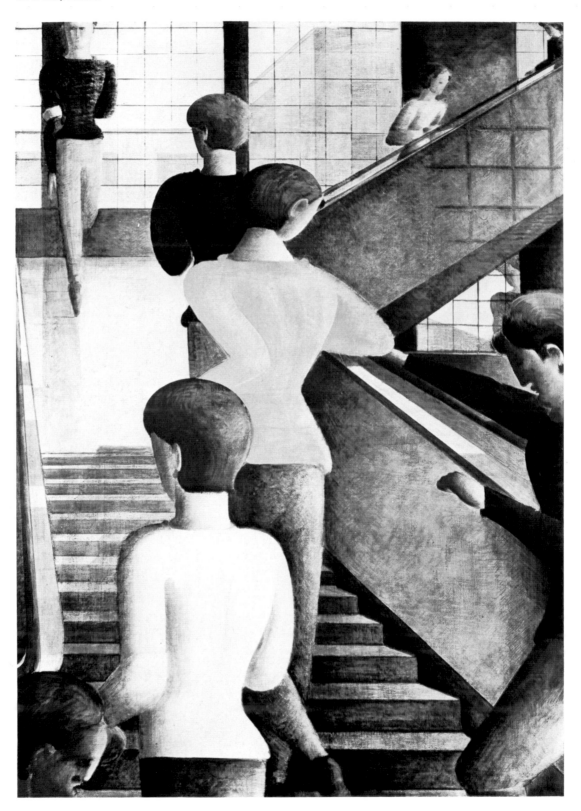

Schlemmer, Oskar
Figures in a Room. 1936
Pencil and crayon on graph paper
8⅝ × 11″ (22 × 28 cm)

Schwitters, Kurt

Karlsruhe. 1929

Found objects on board

11¼ × 7¾″ (28.5 × 19.5 cm)

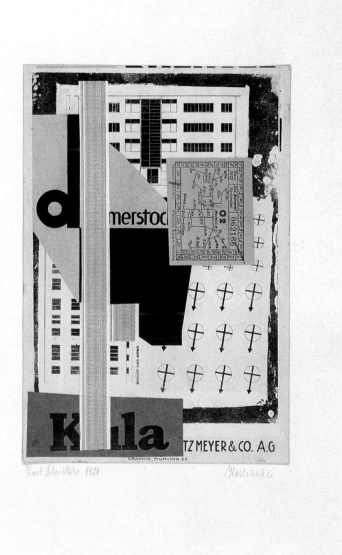

Servranckx, Victor
Opus 16. 1924
Oil on canvas
27½ × 17¾″ (70 × 45 cm)

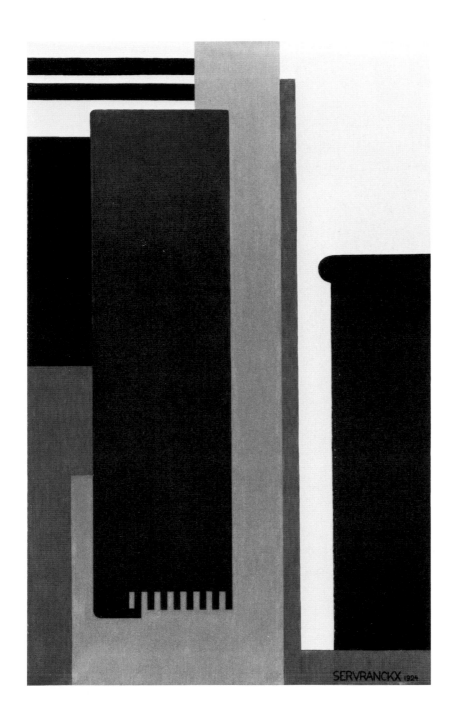

Storrs, John
Forms in Space. c. 1924
Brass, copper, steel on marble base
11¾″ (30 cm) high

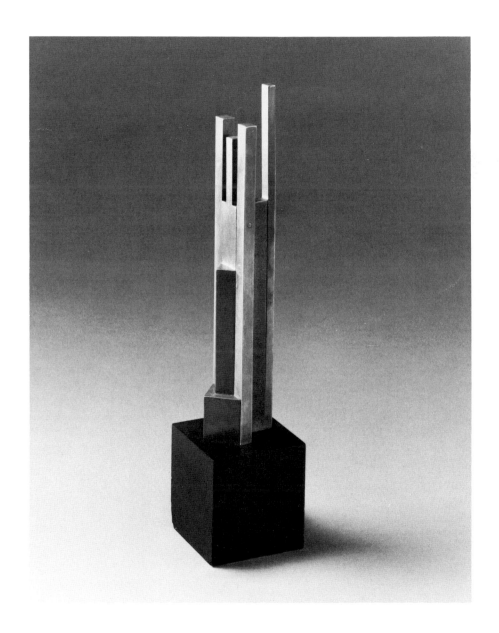

Vantongerloo, Georges
Construction of Volume Relations. 1921
Mahogany
16⅛″ (41 cm) high; base 4¾ × 4⅛″ (12.1 × 10.3 cm)
Gift of Silvia Pizitz

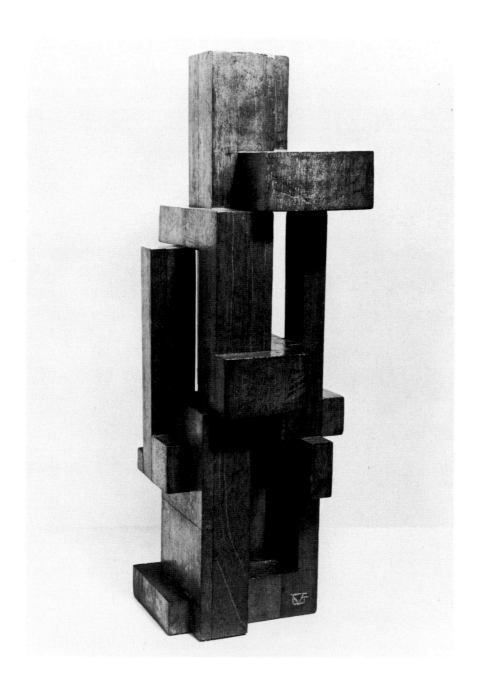

Vordemberge-Gildewart, Friedrich
Composition No. 23. 1926
Oil on canvas with mounted frame
94½ × 78¾" (240 × 200 cm)

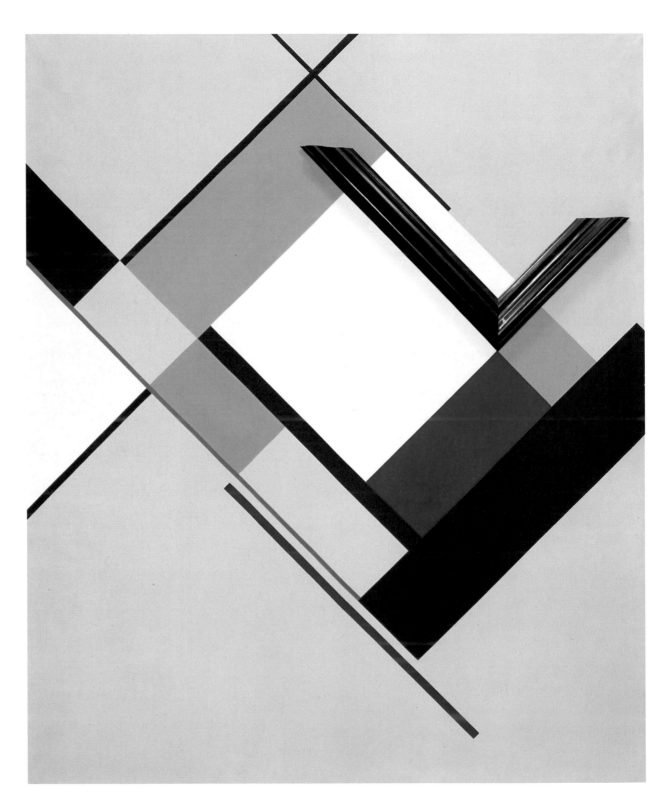

Vordemberge-Gildewart, Friedrich
Composition No. 37. 1927
Oil on canvas with mounted half-sphere
23¾ × 31½″ (60 × 80 cm)

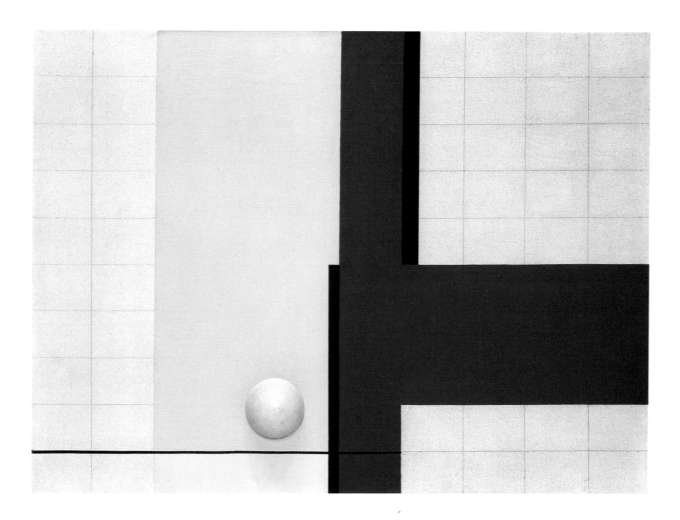

The Paris–New York Connection

1930–1959

Geometric abstraction from 1930 through the 1950s preserved for the most part its earlier formal and conceptual tradition, even though the locus of that tradition moved in the early 1940s from Europe to America. While many European artists continued to work within the established canons of the geometric-abstract tradition, that tradition was eventually to be significantly transformed in the American context. The shift along the Paris–New York axis occurred as a result of World War II, which had dramatically disrupted the regular course of life in Europe and caused many artists to move to the other side of the Atlantic. Because of this shift, art of the 1930s should be discussed in a European context, and the developments of the 1940s and 1950s in an American one.

By 1930 geometric abstraction had lost much of its uncompromising character, and the younger generation was beginning to produce what Theo van Doesurg mockingly called ''quadratic Baroque.'' In contrast to the pure, ascetic abstraction of the teens and twenties, a sensuous, romantic, and often decorative element made its appearance in many of the new works. The 1930s were essentially a turning point in the history of abstract art, because the earlier modes of expression were now synthesized, allowing an enrichment of formal vocabulary and a more personal interpretation of the geometric idiom. In retrospect, it is not a period of innovation or creation, of new philosophies, but rather a period of relaxation that blended earlier disciplines such as classic Cubism, de Stijl, Constructivism, the Bauhaus, the art of Mondrian and that of Kandinsky, as well as the biomorphic forms of Surrealism and the decorative aspects of Synthetic Cubism. For the generation of the 1930s geometric abstraction became a style rather than a philosophy. This may have happened either because the artists felt certain implicit contradictions in the theories of abstraction of the early ''utopian'' years, or because they simply did not feel any need for deeper philosophical justifications. The philosophy that supported the early visions of a new order could not withstand the pressure of events occurring in the 1930s—the Depression, the Moscow trials, the Spanish War, the rise of Nazism, and finally World War II. History as it unfolded undermined belief in absolute principles of art. The viability of nonobjective art as reflective of the new order became questionable in an era of social and political disenchantment.

Formally, geometric abstraction as a style passed on to the younger generation the traditions of the most advanced modernist art. The works of this younger generation were nonfigurative, often eclectic, incorporating a wide repertory of forms and images that opened up a new range of formal issues—issues eventually influential in the mainstream of modern art. The paintings of the period vary from the purest arrangements of lines on a white surface to flamboyant compositions involving complex relationships of geometric forms and colors. It should be stressed that while the developments in abstract art in the 1930s were a direct heritage from the nonobjective trends of the 1920s, they were at the same time a reaction against those trends—as well as a reaction against the continuing strength of Surrealism and the emergence of various realist styles such as Neue Sachlichkeit in Germany and Socialist Realism in Russia.

While in the 1920s the most advanced explorations in art had taken place in Germany, Holland, and Russia, during the 1930s Paris reasserted its position as the focus of modernist art. This was to a large degree due to the new impetus given to

geometric abstract art, from around 1927 on, by the presence in Paris of foreign artists of the older generation: Mondrian, Kandinsky, van Doesburg. New proponents of the style had come onto the scene: César Domela, Auguste Herbin, Sophie Taeuber-Arp, Joaquín Torres-García, Georges Vantongerloo. However, the public at large, more interested in Surrealism, was indifferent to geometric abstraction. The artists therefore felt it necessary to create a unified front that would add strength to the movement, bring it into public focus, and overcome the general apathy. This objective was realized in 1930 through formation of the group Cercle et Carré, initiated by the Belgian critic Michel Seuphor and the Uruguayan painter Torres-García. This group, committed to fostering communication among artists rather than debating artistic conceptions, provided the first tribune for artists sharing the principle of nonfiguration. It was succeeded in 1931 by a grouping of broader scope and impact, Abstraction-Création. The purpose of both groups was to organize exhibitions of the members' works and to publish magazines that would popularize the art and call attention to the theoretical issues relevant to it.

Central concepts of the philosophy of the short-lived Cercle et Carré were structure and abstraction. The discussions published in *Cercle et Carré* gained interest through Seuphor's extensive campaign by correspondence, which enlisted such diverse artistic personalities as Baumeister, Gropius, Kandinsky, Moholy-Nagy, Schwitters, Giedon, ex-Futurist Prampolini, and Pevsner, among others. Having published three issues (in March, April, and June 1930) and organized one exhibition in the spring of 1930, Cercle et Carré ceased its activity both as a group and as a publication.

The pluralism of attitudes among the proponents of geometric abstraction became more evident when, in response to the establishment of Cercle et Carré, van Doesburg created his own group, Art Concret, in April of 1930. Opposing the eclectic diversity of views prevailing in the Cercle et Carré group, van Doesburg and his followers—Hélion, Tutundjian, and Carlsrund —championed the hard-core utilitarian and objectivist theories of the previous decade. *Art concret*, their magazine, was destined to be the last theoretical manifestation of these ideas.

Van Doesburg was the last holdout for the doctrinaire approach. After his death in 1931, hard-and-fast attitudes were modified. A common ground for exchange between extreme positions in the geometric camp, and even between geometric and nongeometric trends, was provided within the framework of the new group, Abstraction-Création. Founded in 1931 by Georges Vantongerloo, Auguste Herbin, and Etienne Béothy, it included many members of the former Cercle et Carré group and continued the latter's internationalist policy, welcoming artists from France, Switzerland, America, Holland, Great Britain, Germany, Italy, and Poland. The main activity of the group centered on the annual yearbook *Abstraction-Création—Art non-figuratif,* which, beginning in early 1932, served as vehicle for the popularization of geometric abstraction during the next five years. It encompassed a large variety of abstract tendencies: de Stijl, endorsed by Domela, Gorin, Hélion, Moss, Vordemberge-Gildewart; Mondrian's ''constructive'' painting (eventually of crucial influence on the American Abstract Artists group); Kandinsky's ''abstract expressionism''; aspects of International Constructivism; the Synthetic Cubism of Gleizes, Prampolini, Villon, Kupka; even the biomorphic abstraction of Arp and the Surrealists. As a result of the interaction of these diverse expressions, the distinctions in pictorial styles became less rigid.

In England, the proponents of geometric abstraction comprised a diverse group of English artists—John Piper, Ben Nicholson, Arthur Jackson—as well as a number of Europeans who had previously worked in Russia and/or Germany and

Paris, such as Gabo. Their theories on art and architecture shared concepts of International Constructivism and were expounded in the publication *Circle*, which appeared in 1937 to accompany the exhibition "Constructive Art" at the London Gallery. In painting their work was characterized by shallow pictorial space and overlapping planar forms, descended from Synthetic Cubism. The three-dimensional works included such diverse forms as Nicholson's reliefs, built of overlapping planes, and Gabo's and Pevsner's complex freestanding constructions of interlocking circular and planar forms, executed often in transparent materials.

In 1936 the Abstraction-Création group collapsed, at the time of a general decline of interest in pure abstraction, caused by the political situation during these years. Another effort to support its cause came in the spring of 1937 with the publication of the review *Plastique,* sponsored by Arp, Domela, and the Americans G. L. K. Morris and A. E. Gallatin; but essentially the creative years of geometric abstraction in Europe were over. An attempt to revitalize it was made in Paris some ten years later, when Herbin, Gleizes, Gorin, Pevsner, and del Marle founded the Salon des Réalités Nouvelles, intended to take over as successor to the international groupings of the 1930s. But since Paris had now lost its position as the capital of art, the Réalités Nouvelles had only a limited impact.

After the outbreak of World War II many European artists went to America, and the center of interest in art shifted to New York. Here the American Abstract Artists, founded in 1937, carried on the tradition of European abstract art, augmented by influences from the earlier American abstract tradition of the 1910s. Stylistically, the American Abstract Artists represented a group as diverse as the ranks of Abstraction-Création. The influence of Cubist-derived styles is evident in the work of G. L. K. Morris and Byron Browne; Russian Constructivism can be perceived behind the work of Balcomb Greene and Irene Rice Pereira; Neoplasticism in that of Burgoyne Diller, Charles Biederman, Charmion von Wiegand, and Ilya Bolotowsky.

Meanwhile in Europe during the 1940s and 1950s, a number of artists—Herbin, Baljeu, Gorin, Mary Martin, and Sonia Delaunay-Terk, as well as Victor Pasmore in England—continued to work in a variety of idioms descended from Cubist-inspired styles. Concurrently, the search for new modes of artistic expression led away from direct continuation of the geometric tradition toward a diversity of experiments related to concepts that had preoccupied the pioneers, such as light and motion. This can be exemplified by the "spatial art" (Spazialismo) of Fontana in Italy, intended to transcend the limits of easel painting with new uses of science and technology. But essentially, in the post–World War II decades, European geometric abstraction was past its creative phase.

European geometric abstraction was disseminated in America largely through the activities of Katherine Dreier's Société Anonyme in the 1920s and 1930s. The Museum of Modern Art, established in 1929, exerted a strong influence, notably with its 1936 exhibition "Cubism and Abstract Art." The Museum of Non-Objective Art (now the Guggenheim) was founded in 1939. There were also the direct contacts of young Americans with geometric abstraction in Paris. For instance, in 1936 Charles Biederman made a trip to Paris, where he became acquainted firsthand with the European geometric tradition. However, dissatisfied with the flat decorative aspect of the work seen, he began to investigate the possibilities of the three-dimensional idiom and initiated a revival of interest in relief, which became a vehicle of expression for him and other geometric-abstract artists such as Theodore Roszak and Burgoyne Diller.

But close encounter with the European geometric tradition was now possible on American soil. In 1933, after the closing of the Bauhaus, Josef Albers had come to America. Other artists followed suit: Glarner in 1936, Moholy-Nagy in 1937, Ozenfant in 1938, Mondrian in 1940.

A number of the European artists were active as teachers during the 1940s and 1950s. They mediated the transition from the earlier stages of geometric abstraction to the abstract styles of the midcentury. Albers and Bolotowsky, who taught at Black Mountain College, served as catalysts in the creation of Kenneth Noland's and Frank Stella's hard-edge abstraction, at the time when Abstract Expressionism was in the ascendant. Vaclav Vytlacil and Carl Holty, teaching in New York, created a link between the styles of the 1930s and the 1950s.

An event that refocused the attention of American artists on Constructivist ideas was the publication in 1948 of Charles Biederman's *Art as the Evolution of Visual Knowledge,* a historical record of the development of abstraction and Constructivism, understood in a rather broad sense. The book formulated conceptual and formal issues involved and made available to the younger generation the often unappreciated antecedents of contemporary art.

In formal terms, the geometric abstraction of the 1940s and particularly of the 1950s differed considerably from earlier work. The dynamic asymmetry of the 1930s and early 1940s shifted toward symmetry and toward a stillness of the composition, obvious in the work of Albers and Diller. Fragmented forms were used less frequently than before. The structure of paintings changed from relational to overall symmetry; the composition became holistic, with the surface of the canvas treated as a unit. The structure, through emphasis on the wholeness of the pictorial field, became a tense frontal compositional plane. The works of the younger generation that matured artistically at the very end of the 1950s and in the 1960s bear witness to this trend.

Chronology

1930–1959

Berlin

July. Exhibition of Soviet painters, "Sowjetmalerei."

Dessau

Mies van der Rohe is appointed director of the Bauhaus to succeed Hannes Meyer, who is forced to resign.

Kiev

Malevich publishes his last essay, "Architecture, Studio Painting, and Sculpture" while preparing for an unrealized one-artist exhibition.

Leipzig

Lissitzky supervises the U.S.S.R. contribution to the International Fur Trade Fair.

Leningrad

Tatlin participates in the exhibition "War and Art."

Moscow

Publication of V. M. Lobanov's *Artistic Groups over the Last Twenty-five Years*.

June. The "Exhibition of Acquisitions by the State Commission for the Acquisition of Works of Visual Art" opens in Moscow; includes contributions by Malevich, Tatlin.

The October group holds its single exhibition with contributions by Rodchenko, Stepanova. Founded in 1928, the group encompasses various artistic activities, but concentrates on the industrial and applied arts.

New York

January–February. Exhibition of recent (Paris) works by Stuart Davis, at the Downtown Gallery.

April. De Hauke holds exhibition of Cubism, including work by Picasso, Léger, Gleizes, Gris, Duchamp, and Villon.

October. Exhibition of contemporary French art, including work of Léger and Braque, at the Reinhardt Galleries.

Paris

The group Cercle et Carré is founded by Michel Seuphor and Joaquín Torres-García. (Preliminary meetings had taken place in 1929 to invite "artists working in the constructive field.") The group publishes three issues of its magazine *Cercle et Carré*, from March to June.

April. Members of Cercle et Carré exhibit at Galerie 23. The second issue of *Cercle et Carré* includes catalog of the exhibition and a text by Mondrian, "L'Art réaliste et l'art superréaliste." The exhibition includes forty-six artists representing major abstract directions: Dadaism, Futurism, the Bauhaus, and Constructivism. Among artists are Arp, Schwitters, Richter, Moholy-Nagy, Kandinsky, Pevsner, Léger, Ozenfant, Le Corbusier, Mondrian, Vantongerloo, and Vordemberge-Gildewart.

Van Doesburg (who had refused to join Cercle et Carré), Jean Hélion, Otto Carlsund, Léon Tutundjian, and Wantz publish pamphlet *Art concret*, as founding document of a new group. Van Doesburg proposes an objective, impersonal art, mathematically precise and devoid of individualism.

Vienna

Publication of Lissitzky's *Russia: The Reconstruction of Architecture in the Soviet Union*.

Front page of the first issue of
Cercle et Carré, Paris, 1930

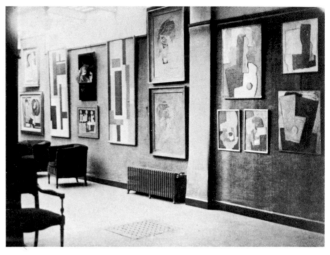

View of the exhibition "Cercle et
Carré" at Galerie 23, Paris, 1930,
showing works (from left to right)
by Marcelle Cahn, Fernand Léger,
Antoine Pevsner, Sophie Taeuber-
Arp, et al.

Members of the group Cercle et
Carré, Paris, 1930

Members of the group Art Con-
cret, Paris, 1930. Standing, left:
Jean Hélion; right: Otto Carlsrud.
Seated, center: van Doesburg;
right: Marcel Wantz. Photo taken
by Tutundjian

abstraction
création
art non
figuratif 1932

Cover of the first issue of *Abstraction-Création—Art non-figuratif*, Paris, 1932

October. An exhibition of contemporary Soviet art opens with, among others, contributions by Malevich.

1931

Davos, Switzerland

Van Doesburg dies.

Leningrad

The Construction of Architectural and Machine Forms by Jacov Tchernikhov published by the Society of Architects of Leningrad.

Moscow

Rejection of Le Corbusier's competition project for the Palace of the Soviets, which is replaced by a monumentlike "neoclassical structure"—important point of defeat for modernist and Constructivist architecture.

New York

New Year's Day, Dreier's exhibition of seventy contemporary works inaugurates the New School's new building. Works by John Graham, Gorky, Kandinsky, Klee, Léger, and Mondrian are included.

January–March. Dreier gives twelve lectures at the New School. The last program, "Art of the Future," features artistic uses of electricity: Duchamp's film *Anemic Cinema*, Wilfred's Clavilux, and Archipenko's motorized *Archipentura*.

Paris

Abstraction-Création group is founded by Herbin and Vantongerloo. Yearly exhibitions continue for five years.

1932

Leningrad

November. The exhibition "Artists of the U.S.S.R. over the Last Fifteen Years" opens with contributions by Drevin, Filonov, Malevich, Tatlin. This impressive exhibition of almost a thousand works stays open until May 1933.

Paris

January. *Abstraction-Création—Art non-figuratif,* organ of the Abstraction-Création group, begins to appear; four issues will be published yearly until 1936.

1933

Black Mountain College, North Carolina

Albers arrives and stays until 1950.

Dessau

Bauhaus closed by Hitler. Breuer moves to London, Kandinsky to Paris, Klee to Bern, Gabo to London.

1934

New York

Group A formed in West Redding and New York; includes Albers, Diller, Dreier, Drewes, Gorky, Graham, Harry Holtzman, and Paul Outerbridge.

Cover of the review *Axis*, London, 1935

Two installation views of the exhibition "Abstract and Concrete," at the Lefevre Gallery, London, 1936

North Carolina

Dreier lectures at Black Mountain College and joins Albers in panel discussions on "New Trends in Art."

Paris

Mondrian is visited by Holtzman and Ben Nicholson.

Philadelphia

December. The exhibition "The Art of Soviet Russia" opens, with contributions by Drevin, Shevchenko, Udaltsova, Vialov.

1935

Hartford

"Abstract Art" exhibition, Wadsworth Atheneum, includes Gabo, Pevsner, Mondrian, Domela.

London

The review *Axis*, edited by Myfanwy Evans, is founded; and throughout its existence until Winter 1937 it popularizes new modes of abstract art.

Gabo becomes active in Herbert Read's group Design Unit One.

New York

Lecture at MoMA by Léger; subsequently published as "The New Realism" in journal *Art Front,* December 1935.

Whitney Museum of American Art, exhibition "Abstract Painting in America," with contributions by Davis, Demuth, Sheeler, Stella, Weber.

Diller assumes position as supervisor of the Mural Division of the Federal Art Project of the Works Progress Administration.

Gorky begins ten-panel mural for Newark Airport under the auspices of the WPA: *Aviation: Evolution of Forms under Aerodynamic Limitations* (completed in 1937).

1936

London

Exhibition "Abstract and Concrete" at the Lefèvre Gallery; includes works by Domela, Gabo, Hélion, Kandinsky, Moholy-Nagy, Mondrian.

Exhibition "Modern Pictures in Modern Rooms" organized by Duncan Miller; introduces the work of Mondrian, Hélion, and Calder and demonstrates the close connection between abstract art and modern architecture.

New York

Meyer Schapiro addresses first American Artists' Congress. His paper is published as "The Social Bases of Art," *First American Artists' Congress.*

MoMA exhibition "Cubism and Abstract Art."

Federal Art Project invited to do extensive group of indoor and outdoor murals for lower-middle-income housing project in Brooklyn, the Williamsburg Houses, designed in modernist idiom by architect William Lescaze. The houses contain a generous number of murals, reliefs, free-standing works of sculpture by such artists as Bolotowsky, Stuart Davis, de Kooning, George McNeil, Jan Matulka.

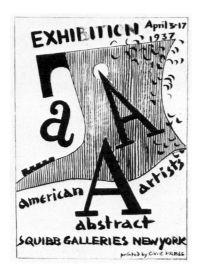

Cover of the catalog for the American Abstract Artists' first exhibition, New York, 1937

March. Gallatin organizes "Five Contemporary American Concretionists: Biederman, Calder, Ferren, Morris and Shaw," at Paul Reinhardt Galleries.

Paris

End of Abstraction-Création.

Charles Biederman travels to Paris, where he becomes acquainted with ideas and theories of de Stijl and Constructivism.

1937

Basel

Founding of the group Allianz.

Exhibition "Constructivism" held at the Kunsthalle.

Chicago

New Bauhaus in America, under the leadership of Moholy-Nagy, opens in Chicago and lasts one year. The school reopens in January 1939 as the Institute of Design.

London

Publication of *Circle: International Survey of Constructive Art* by Faber and Faber, with texts by J. L. Martin, Ben Nicholson, and Naum Gabo.

July. Exhibition of "Constructive Art" at the London Gallery includes works by the *Circle* contributors.

Munich

"Entartete Kunst" (Degenerate Art) organized by the Nazis as the last and most comprehensive in the series of exhibitions held since 1933 in various German provincial capitals and intended to discredit modern art.

New York

John Graham publishes *System and Dialectics of Art* (Paris and New York).

Journal *Plastique* founded (with Paris–New York letterhead). Sophie Taeuber-Arp, Domela, Arp, George L. K. Morris, and A. E. Gallatin direct the journal.

January. Founding of the American Abstract Artists group (still in existence).

April 3–17. First exhibition of American Abstracts Artists group. Includes Lassaw, Shaw, Albers, Browne, at Squibb Galleries.

October. American Abstract Artists exhibition at Columbia University.

1938

Amsterdam

Exhibition "Abstrakte Kunst" at the Stedelijk Museum.

Hartford

March. Gabo exhibition at Wadsworth Atheneum.

New York

Bauhaus exhibition at MoMA.

Léger visits New York.

American Abstract Artists send survey exhibition on tour of several Midwestern museums.

February. The second American Abstract Artists annual exhibition. Eighty-page yearbook published, containing eleven essays, forty-six illustrations of current work by members. Held at the Gallery of the American Fine Arts Society.

1939

New York

May 31. Guggenheim Museum opens as the Museum of Non-Objective Art. Director Hilla Rebay puts special emphasis on Kandinsky and Rudolf Bauer.

Springfield, Massachusetts

End of year. A large retrospective of the Société Anonyme; the exhibition is also shown in Hartford, Connecticut.

1940

New York

Fall. Mondrian arrives in New York.

The World's Fairgrounds accepts an exhibition by the American Abstract Artists; lectures given by Holtzman; also art demonstrations by Reinhardt and McNeil.

American Abstract Art exhibition at Galerie St. Etienne, with G. L. K. Morris writing the catalog introduction.

1941

New Haven

October 11. Yale accepts the collection of the Société Anonyme: total of 135 oils, 7 sculptures, 186 drawings, 180 prints, photos, and miscellaneous works; 141 artists represented, including 45 Germans, 27 Americans, 20 French, and 18 Russians.

New York

Mondrian delivers lecture "A New Realism" at the Nierendorf Gallery for the American Abstract Artists group. The lecture is later published in *American Abstract Artists Annual 1946* (reprinted in *American Abstract Artists, Three Yearbooks*).

1942

New Haven

January 14. "Modern Art from the Collection of the Société Anonyme" at Yale University Art Gallery—the inaugural exhibition of the collection, including works by Albers, Boccioni, Buchheister, Burliuk, Chagall, Gabo, Gris, Hartley, Schwitters, Stella. An abbreviated version is shown in February at Olin Library, Wesleyan University.

New York

"Artists in Exile" exhibition at Pierre Matisse Gallery includes Léger, Mondrian, Chagall, Ozenfant, Tanguy.

On nine alternate Friday evenings, lectures and demonstrations at Nierendorf Gallery by American Abstract Artists, including Mondrian, a showing of *Ballet Mécanique,* and slides by Glarner.

October. The opening of Peggy Guggenheim's Art of This Century Gallery presents a survey of her own collection, including work by Arp, Breton, Gabo, and Mondrian.

1943

New Haven

March. Selection from the Société Anonyme Collection at Saybrook College, Yale University.

New London, Connecticut

October. "Exhibition of Russian Art," Connecticut College, a selection from the Société Anonyme, includes Kandinsky, Lissitzky, Malevich, Udaltsova.

New York

Gallatin's Museum of Living Art ends long tenure at N.Y.U. and moves to permanent home at the Philadelphia Museum of Art.

American Abstract Artists exhibition at Riverside Museum.

1944

February. "Abstract and Surrealist Art in the U.S.," at Cincinnati Art Museum. Organized by Sidney Janis, traveling to Denver Art Museum, Seattle Art Museum, Santa Barbara Museum of Art, San Francisco Museum of Art.

New York

May. "Art in Progress: A Survey for the Fifteenth Anniversary of The Museum of Modern Art," with essay by James Thrall Soby. Includes works by Stella, Mondrian, Gabo.

J. B. Neumann ships a group of paintings to Cincinnati under the title "From Realism to Abstraction"; includes Albers, Holty.

1945

"Variety in Abstraction," exhibition coordinated by MoMA, circulates to institutions in Northeast and Midwest.

Paris

June. "Art Concret" exhibition at Galerie Drouin includes Arp, Delaunay, Kandinsky, Mondrian, Pevsner, van Doesburg.

South Hadley, Massachusetts

September. "Modern Art from the Collection of the Société Anonyme," at Mount Holyoke College, includes contributions by Burliuk, Gleizes, Gris, Kandinsky, Léger, Malevich, Metzinger, Mondrian, Schwitters, Udaltsova. (Similar exhibition from Société Anonyme presented at Smith College and Amherst College.)

1946

"Abstract and Cubist Art" at Duke University, Durham, N.C. Includes Boccioni, Gris, Léger, Malevich, Mondrian, Udaltsova, Klee, Ernst. Exhibition travels to five institutions in the South in 1946.

Gabo moves to the U.S. (Middlebury, Conn.).

Argentina

Fontana issues manifesto entitled *Spazialismo:* contains words reminiscent of Malevich and becomes known as the "White Manifesto."

New Haven

April 4. "Plastic Experience in the Twentieth Century: Contemporary Sculpture, Objects, Constructions" at the Yale University Art Gallery. Includes Arp, Medunetsky, Pevsner, Man Ray, Schwitters.

Paris

Salon des Réalités Nouvelles founded under the direction of Herbin, Gleizes, Gorin, Pevsner, del Marle. It attempted to establish itself as the successor to the international groupings of the 1930s, and its first exhibition (July 19–August 18, 1946) included "art abstrait/concret/constructiviste/non-figuratif" and was dedicated to the memory of Delaunay, van Doesburg, Duchamp-Villon, Eggeling, Freundlich, Kandinsky, Malevich, Mondrian, Lissitzky.

1947

Exhibition "Abstract and Cubist Art," shown previously at Duke University (1946), travels to university museums in the North.

Andover, Massachusetts

January. Exhibition "Seeing the Unseeable" at Addison Gallery of American Art: includes Lissitzky, Schwitters, among others.

New York

March. "The White Plane" exhibition at Pinacotheca gallery. Includes Albers, Buchheister, Mondrian, Schwitters.

Paris

Summer. "Automatisme" exhibition at Galerie du Luxembourg, with works of six Canadian painters.

July. Second Salon des Réalités Nouvelles.

1948

August. Selection from the Société Anonyme Collection at Norfolk Art School in Connecticut. Includes Albers, Bortnyik, Burliuk, Graham.

New Haven

March 6. "An Exhibition of Painting and Sculpture by the Directors of the Société Anonyme since Its Foundations: 1920–1949" at Yale University Art Gallery. Includes fifty-nine works by Duchamp, Gabo, Kandinsky, and others. Trowbridge lectures by Dreier, Gabo, James J. Sweeney published in 1949.

New York

"Gabo-Pevsner" exhibition at MoMA.

"Collage" exhibition at MoMA.

Publication of *Art as the Evolution of Visual Knowledge* by Charles Biederman written between 1938 and 1946); intended to present a historical record of the development of Constructivism and abstract art.

1949

Boston

June. "The Société Anonyme of Twentieth-Century Painting" is shown at the Institute of Contemporary Art; includes Glarner, Kandinsky, Klee, Lissitzky, Malevich, Mondrian, among others. A larger version of the show opens there in September with the addition of Baumeister, Chagall, Diller, Moholy-Nagy.

1950

New Haven

April 30. "An Exhibition Commemorating the Thirtieth Anniversary of the Société Anonyme" at Yale University Art Gallery. Includes Arp, Braque, van Doesburg, Gabo, Léger, Lissitzky, Malevich, Medunetsky, Mondrian, Pevsner.

New York

Dissolution of the Société Anonyme announced, April 30.

Saginaw, Michigan

October 5. "Collection of the Société Anonyme" at Art Museum; includes Boccioni, Gris, Léger, Malevich, Mondrian.

Springfield, Massachusetts

January 15. "In Freedom's Search" at the Museum of Fine Arts; includes Gris and Malevich among the "searchers."

1951

New York

January. "Abstract Painting and Sculpture in America," at MoMA, includes Morris, Diller, Glarner, Roszak, Greene.

November. "Revolution and Tradition: An Exhibition of the Chief Movements in American Painting from 1900 to the Present" at the Brooklyn Museum.

1952

Cambridge

January. "Gropius, Architect and Teacher: The Bauhaus Artists" at the Busch-Reisinger Museum, Harvard. Includes Albers, Moholy-Nagy.

Minneapolis

January. "Space in Painting" at University of Minnesota. Includes Buchheister, Mondrian, Puni.

New London, Connecticut

March. "Société Anonyme Collection" at Lyman Allyne Museum. Includes Albers, Arp, Barlach, Boccioni, Braque, Chagall, van Doesburg, Gris, Léger, Malevich, Mondrian.

1953

Minneapolis

April. "The Classic Tradition in Contemporary Art" at Walker Art Center includes van Doesburg, Gleizes, Gris, Malevich, Mondrian.

New York

"Gabo: Space and Kinetic Constructions" at the Pierre Matisse Gallery.

1955

Montreal

February. Canadian group Les Plasticiens issue manifesto against French Tachism and announce themselves as proponents of abstract geometric idiom and followers of the principles of Mondrian's Neoplasticism. Members of the group include Guido Molinari, Claude Toussignant, Jean-Paul Mousseau, Yves Gaucher, Fernand Leduc, Jean Goguen.

Paris

"Le Mouvement" exhibition at Galerie Denise René; concerned with kinetic concepts. Among the artists are Calder, Duchamp, Agam, Pol Bury, Tinguely, Klein.

Vasarely produces his "Yellow Manifesto" on the occasion of the "Mouvement" exhibition at Galerie Denise René.

1957

Yves Klein monochromes exhibited in Paris, Milan, and Düsseldorf; also a Klein exhibition at Gallery One, London.

New York

May. Ad Reinhardt publishes "Twelve Rules for the New Academy" in *Art News*.

Paris

The group Equipo 57, "inspired by Pevsner and Vasarely," founded by Spanish artists in Paris, including Juan Cuenca, Angel Duarte, José Duarte, Augustin Ibarrola, Juan Serrano. Their first exhibition held at Café du

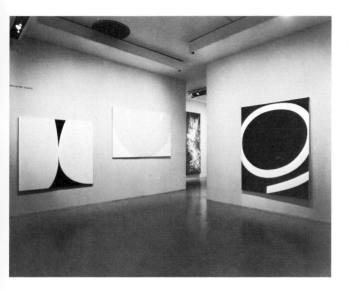

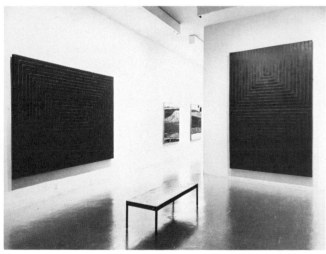

Two installation views of the "Sixteen Americans" exhibition at The Museum of Modern Art, New York, 1959, with works by Ellsworth Kelly (top) and Frank Stella (bottom)

Rond-Point de Montparnasse and Galerie Denise René. Subsequently they returned to Spain and settled in Córdoba. After a show in Bern in 1966 the group was dissolved.

1958

Joost Baljeu (teaching at the University of Saskatchewan) founds with Eli Bornstein the magazine *Structure*, published in Amsterdam and distributed in Canada, the United States, Great Britain, and the Netherlands; *Structure* continues publication until 1964.

Equipo 57 spends five months in Denmark.

Balla dies.

Düsseldorf

Otto Piene and Heinz Mack found Group Zero (dissolved in 1967) and publish the magazine *Zero*.

Houston

September. "The Trojan Horse: The Art of the Machine" at Contemporary Arts Museum.

Paris

April. Yves Klein exhibition at Galerie Iris Clert. It consisted of an empty white-walled gallery.

1959

Publication of the English translation of Malevich's *The Nonobjective World* (Paul Theobald and Co., Chicago).

Antwerp

Exhibition "Vision in Motion—Motion in Vision" includes Mack and Group Zero.

London

October–November. "Kasimir Malevich 1878–1935" at London Whitechapel Gallery.

Los Angeles

July. "Four Abstract Classicists" exhibition at Los Angeles County Museum of Art.

Milan

Gruppo T, comprising Giovanni Anceschi, David Boriani, Gianni Colombo, Gabriele Vecchi, and Crazio Varisco, pursues the aim of creating a reality under the aspects of change and perception. Gruppo T disbands in 1966.

New York

Exhibition "Sixteen Americans" held at The Museum of Modern Art; includes Ellsworth Kelly, Frank Stella, Jack Youngerman, Robert Rauschenberg, Jasper Johns.

Padua

Gruppo N formed in Padua (breaks up in 1964); includes Alberto Biasi, Enzio Chiggio, Toni Costa, Eduardo Landi, and Manfredo Massironi.

Rome

May: "Casimir Malevic," Galleria Nazionale d'Arte Moderna.

Washington, D.C.

Naum Gabo lectures "Of Divers Arts," at the National Gallery of Art (published 1962 in the Bollingen Series).

Albers, Josef
Structural Constellation "To Ferdinand Hodler." 1954
Incised resopal on wood
17¼ × 22½" (44 × 57 cm)

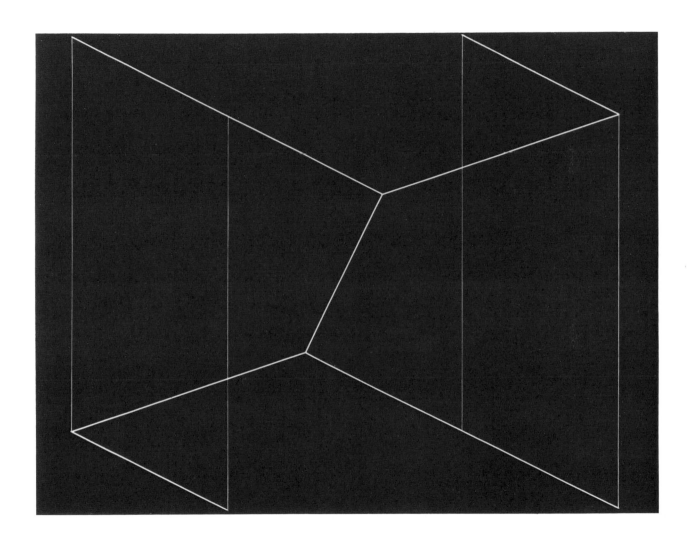

Arp, Jean
Helmet Head I. 1959
Bronze, 2/5
21¼ × 14¼ × 7½″ (54 × 36 × 19 cm)

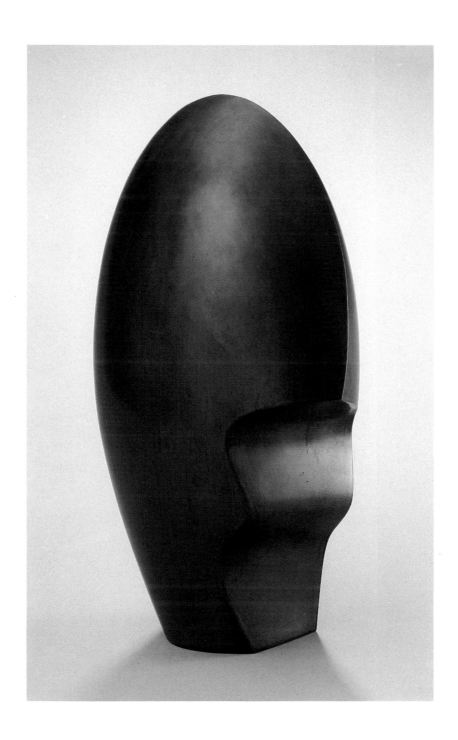

Baljeu, Joost
Synthesist Construction R4. 1955
Painted wood relief
27½ × 11½ × 1¾″ (70 × 29 × 3.5 cm)

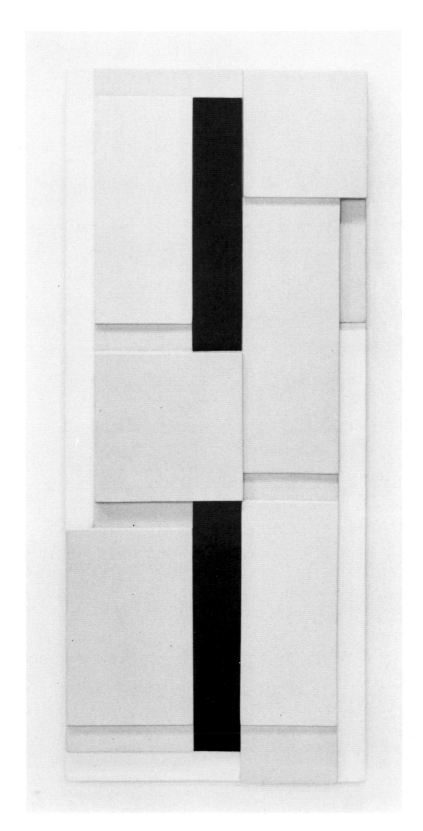

Biederman, Charles
Work No. 36, Aix. 1953–1972
Painted aluminum relief
36 × 30¼ × 5¹⁄₁₆″ (91.5 × 77 × 12.8 cm)

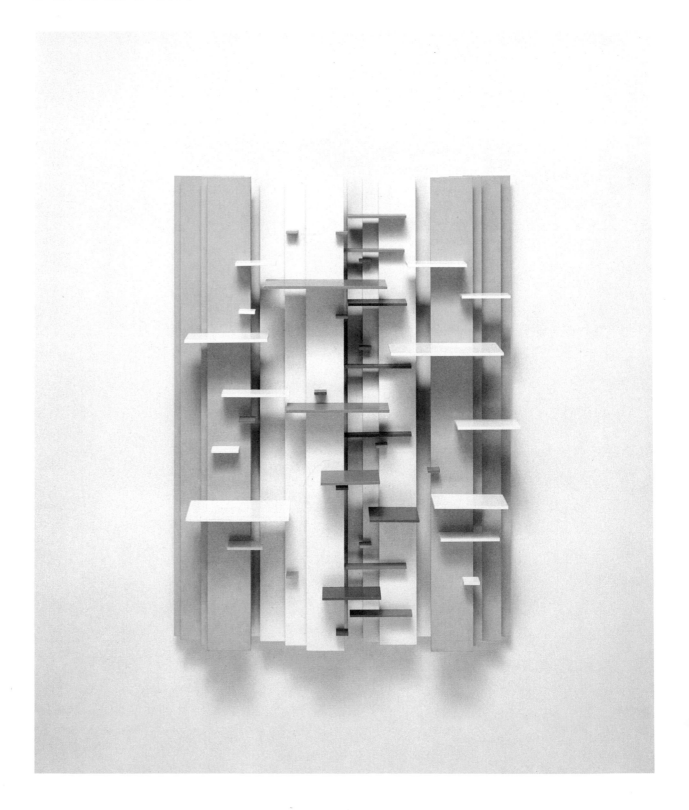

Bolotowsky, Ilya
Oval Painting. 1955
Oil on canvas
18¾ × 24½″ (47.5 × 62.5 cm)

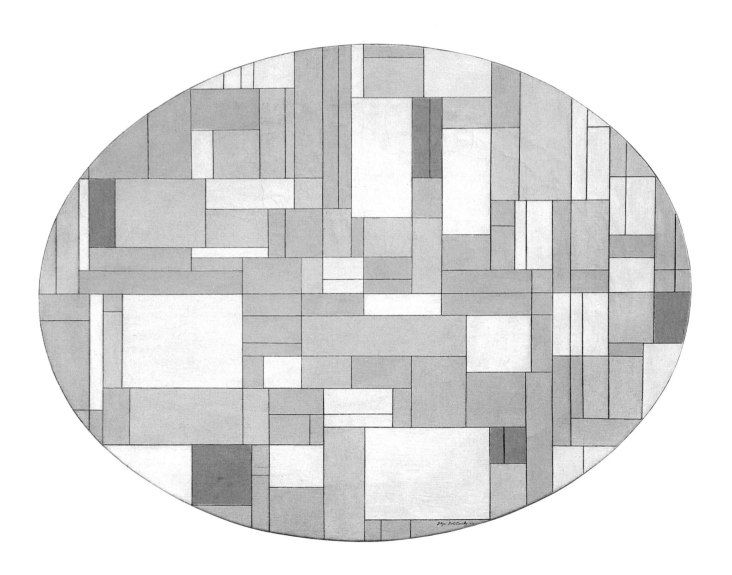

Delaunay-Terk, Sonia
Colored Rhythm. 1953
Gouache on paper
17¾ × 24¾″ (45 × 63 cm)

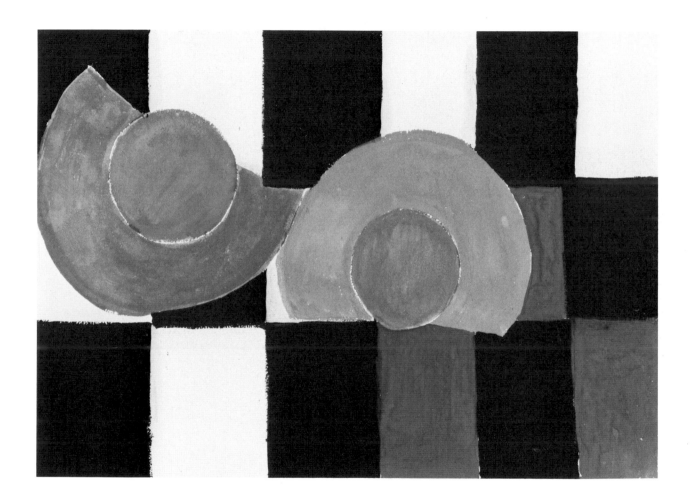

Diller, Burgoyne
Study, Construction. 1937
Oil on wood, mounted on plywood
12 × 8 × 1¼″ (30.5 × 20.5 × 3 cm)

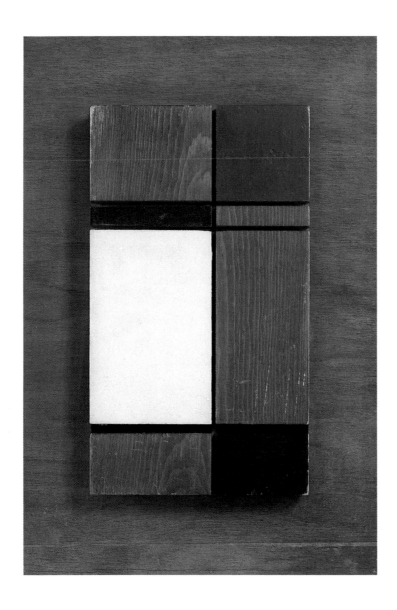

Diller, Burgoyne
Untitled. c. 1944
Oil on canvas
18 × 18″ (46 × 46 cm)

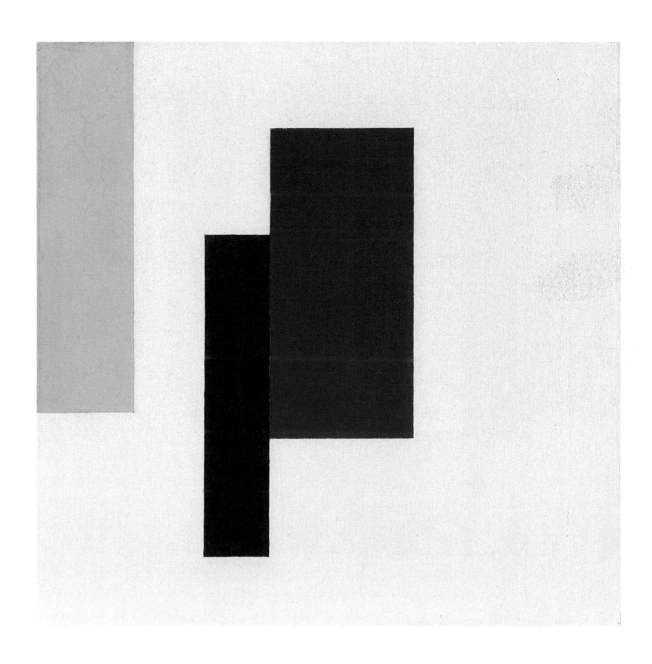

Fontana, Lucio
Concetto Spaziale, Attese. 1959
Mixed media on canvas
16¾ × 25¾″ (42.5 × 65.5 cm)

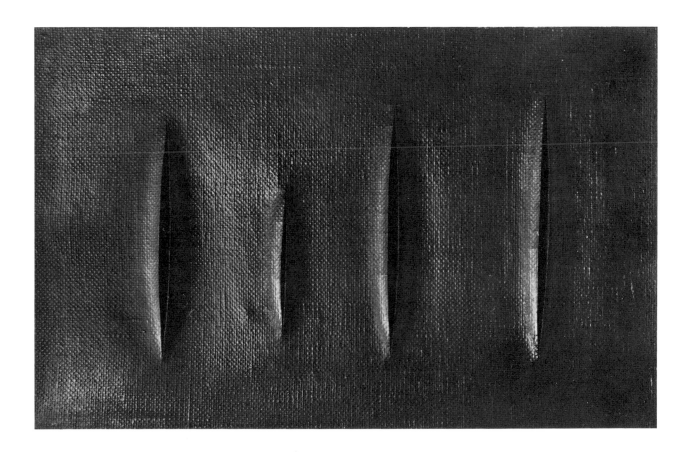

Freundlich, Otto
Abstract Composition. 1930
Pastel on paper
25¾ × 19¾″ (65.5 × 50 cm)

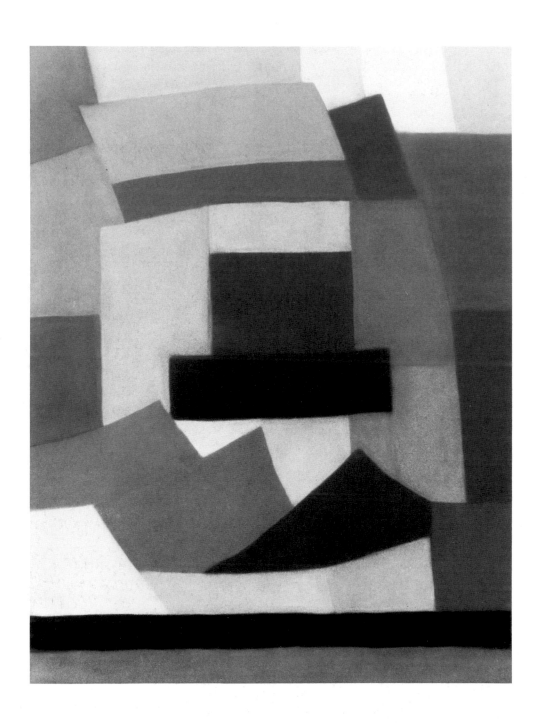

Freundlich, Otto
Composition. 1930
Oil on canvas
51¼ × 38″ (130 × 96.5 cm)

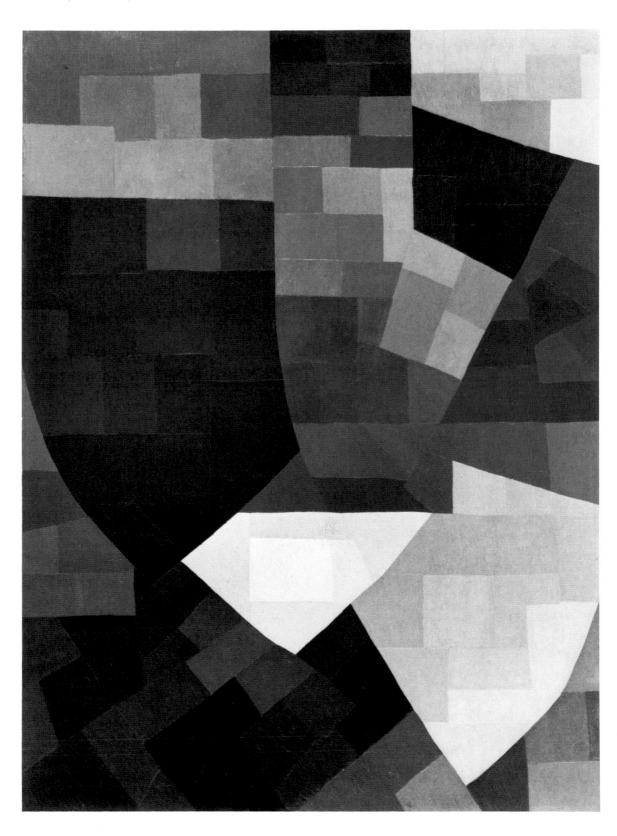

Gabo, Naum
Torsion—Bronze Variation. 1963
Gold-plated bronze and stainless-steel springs
24½ × 28″ (62 × 71 cm)

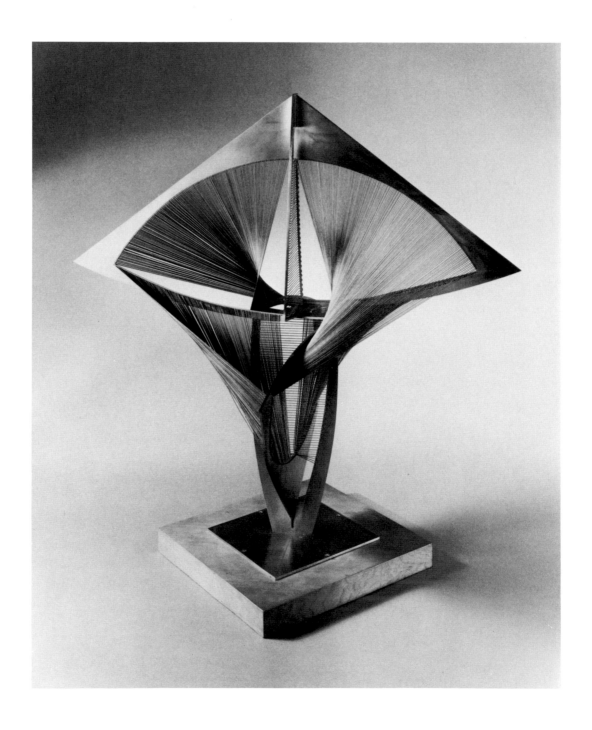

Glarner, Fritz
Relational Painting No. 60. 1952
Oil on canvas
58½ × 44½″ (149 × 108 cm)

Gorin, Jean
Relief-Composition. 1937
Painted wood
36 × 36 × 2″ (92 × 92 × 5 cm)

Gorin, Jean
Counterpoint No. 31. 1948
Painted wood relief
$23 \times 35\frac{1}{2} \times 3\frac{1}{4}''$ ($58 \times 90 \times 8.5$ cm)

Greene, Gertrude
Construction. 1935
Painted wood, composition board, and metal
16 × 24″ (40.5 × 61 cm)

Herbin, Auguste
The Nest. 1955
Oil on canvas
39⅜ × 31½" (100 × 80 cm)

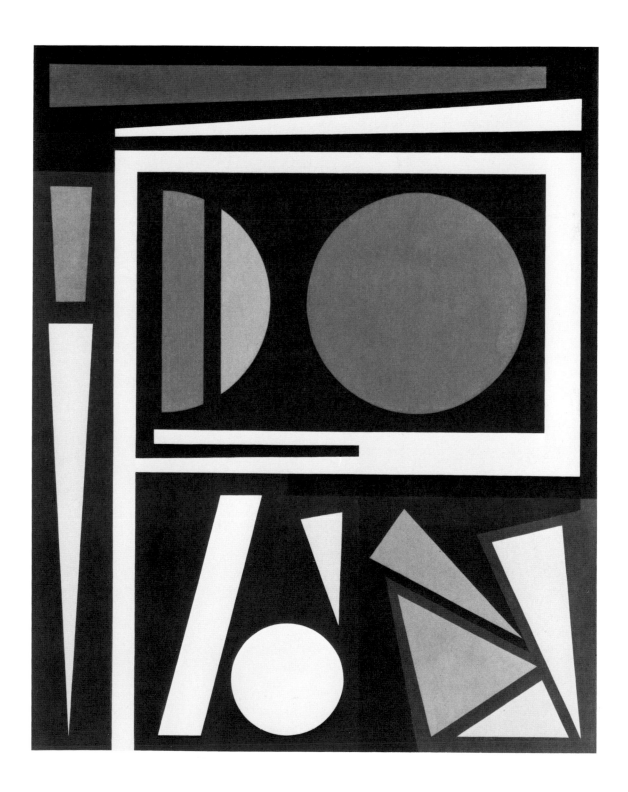

Herbin, Auguste
Hand. 1960
Oil on canvas
36¼ × 28¾″ (92 × 73 cm)

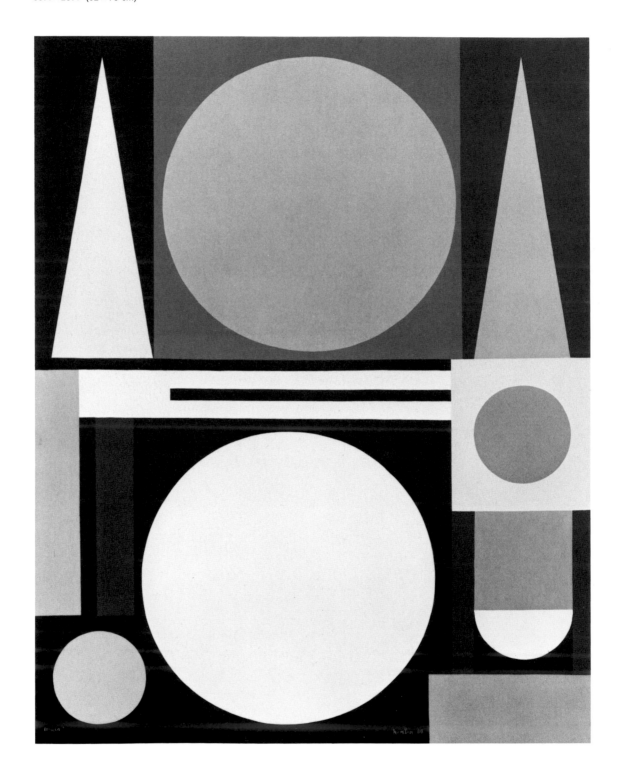

Itten, Johannes
Space Composition II. 1944
Oil on canvas
25½ × 19¾″ (65 × 50 cm)

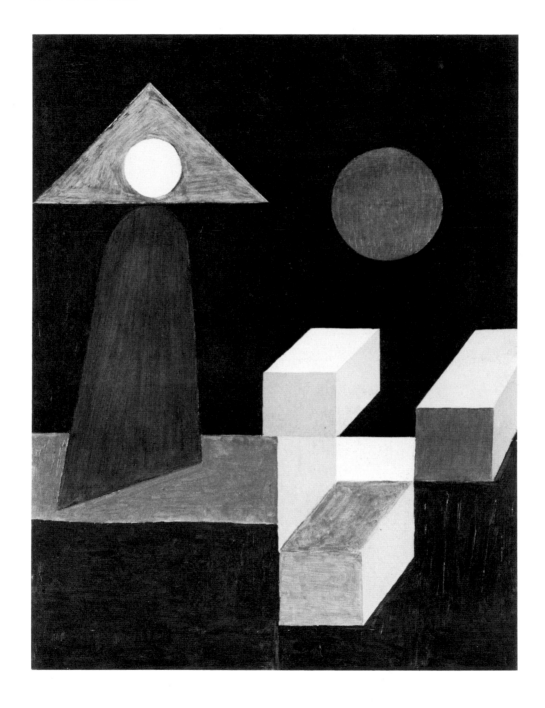

McLaughlin, John
Untitled. 1951
Oil on board
38 × 32″ (96.5 × 81 cm)

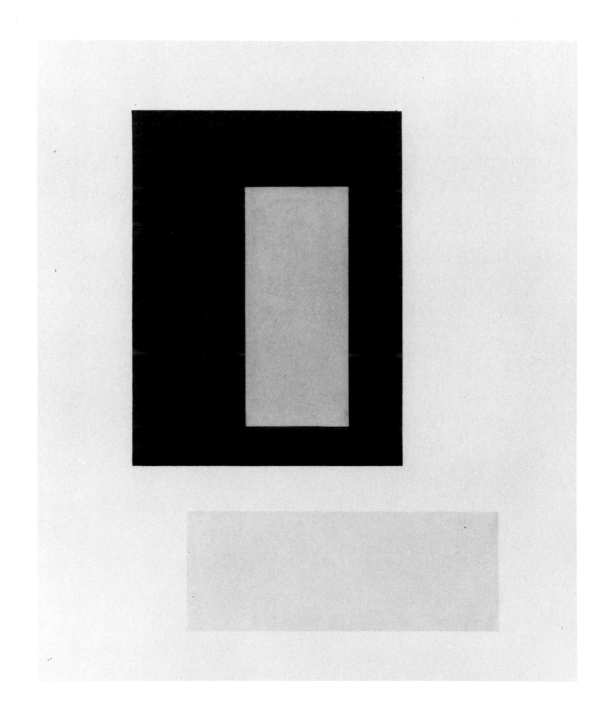

Martin, Mary
White Relief. 1952
White-painted wood
24 × 24 × 4¼" (61 × 61 × 11 cm)

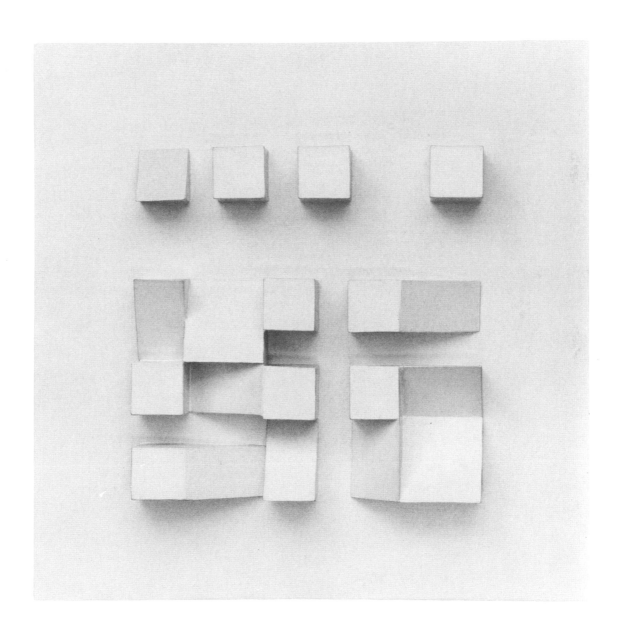

Moholy-Nagy, László
Space Modulator L3. 1936
Oil on perforated zinc and composition board, with
glass-headed pins
17¼ × 19⅛″ (43.8 × 48.6 cm)
Purchase

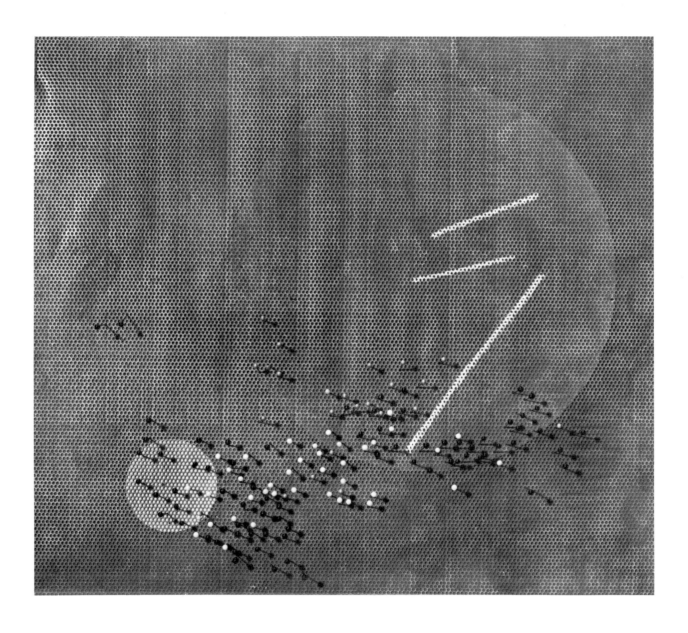

Mondrian, Piet
Composition. 1933
Oil on canvas
16¼ × 13⅛″ (41.2 × 33.3 cm)
The Sidney and Harriet Janis Collection

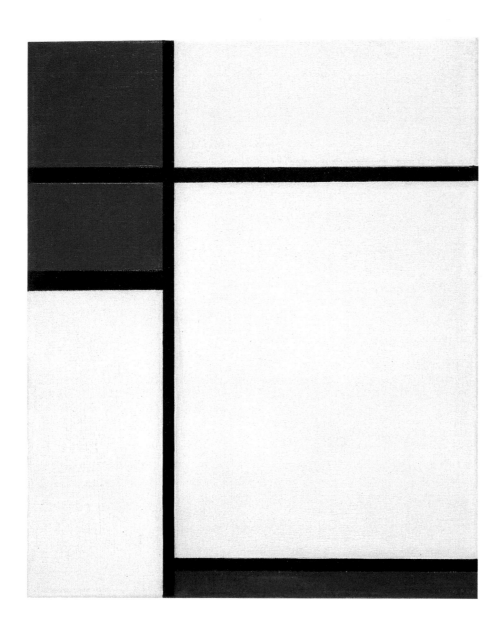

Morris, George L. K.
Rotary Motion. 1935
Oil on canvas
33⅝ × 30″ (85.5 × 76.3 cm)

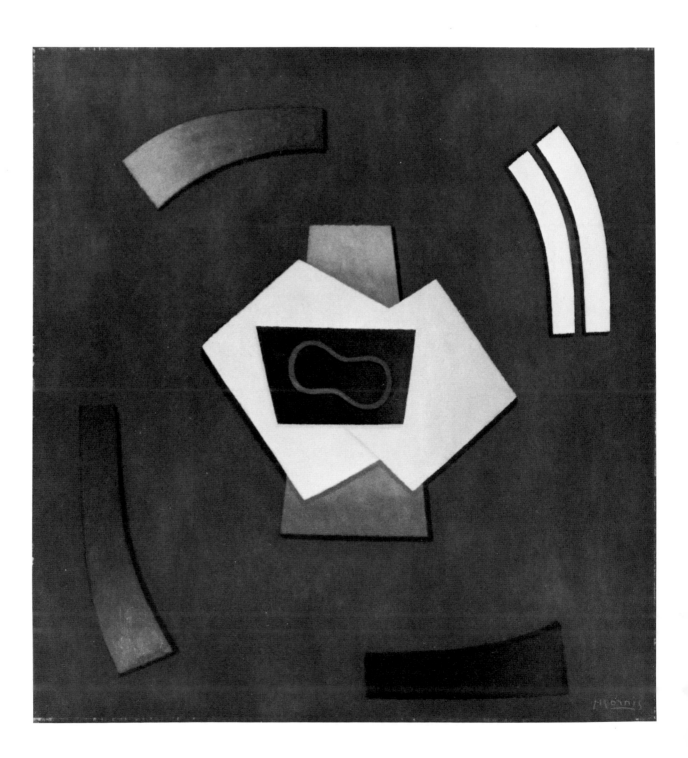

Moss, Marlow
White with Rope. 1940
Oil on canvas with rope
21¼ × 21¼" (54 × 54 cm)

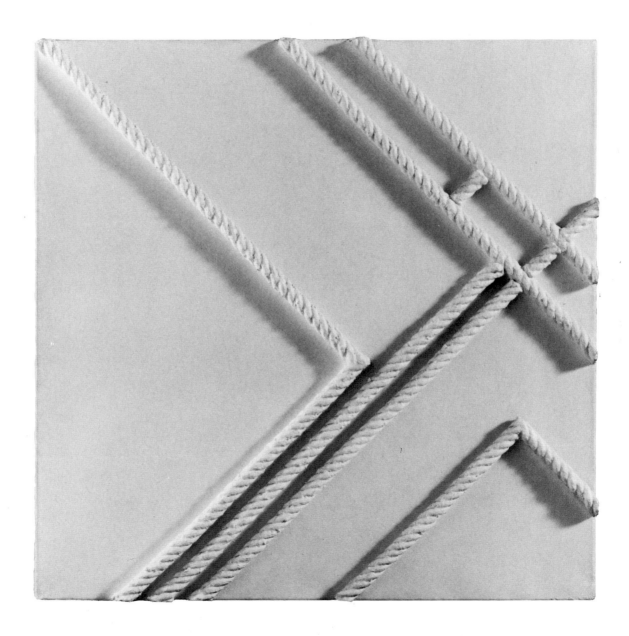

Nicholson, Ben
Abstract Composition. 1936
Oil wash and pencil on board
15¼ × 20¼″ (38.5 × 51.5 cm)

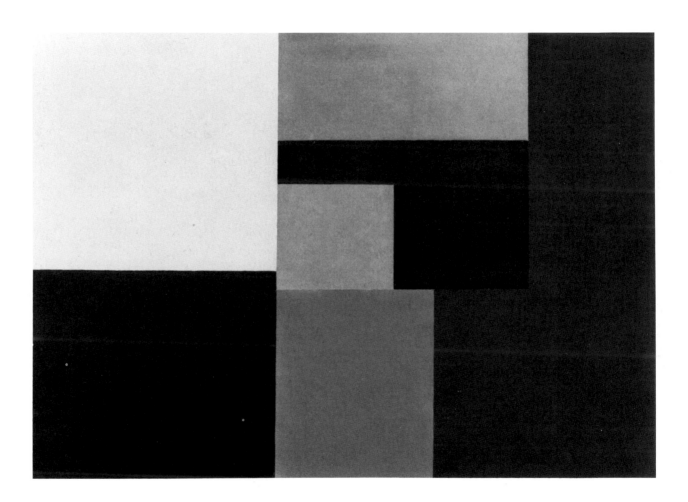

Pasmore, Victor

Transparent Construction in White, Black, and Ocher. 1959

Oil, painted wood, plexiglass

30 × 32 × 9″ (76 × 81 × 23 cm)

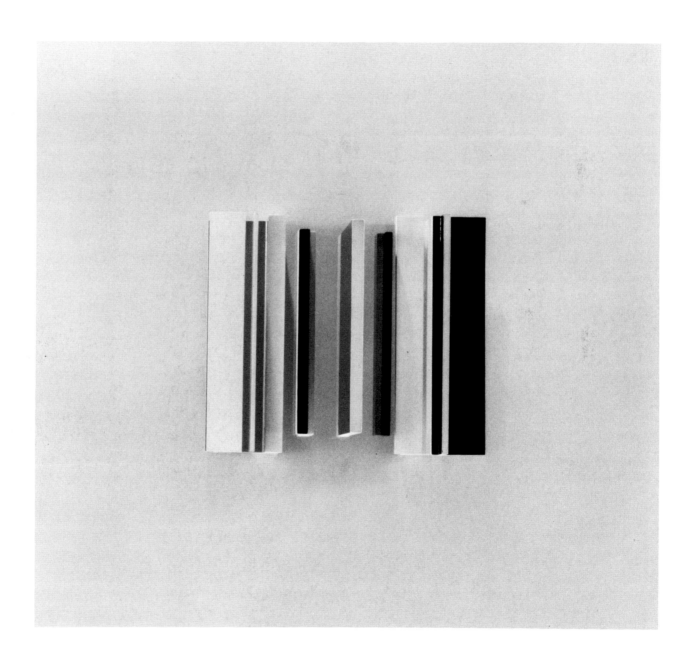

Pevsner, Antoine
Le Dernier Elan. 1962
Brass, wire, and bronze
27″ (68.5 cm) high

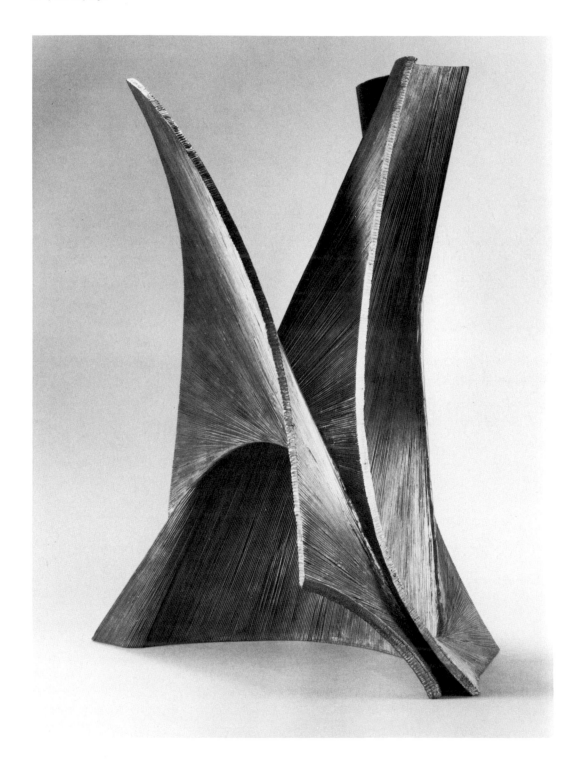

Roszak, Theodore

Pierced Circle. 1939

Painted wood, plexiglass, and wire

24 × 24 × 2½″ (61 × 61 × 6.5 cm)

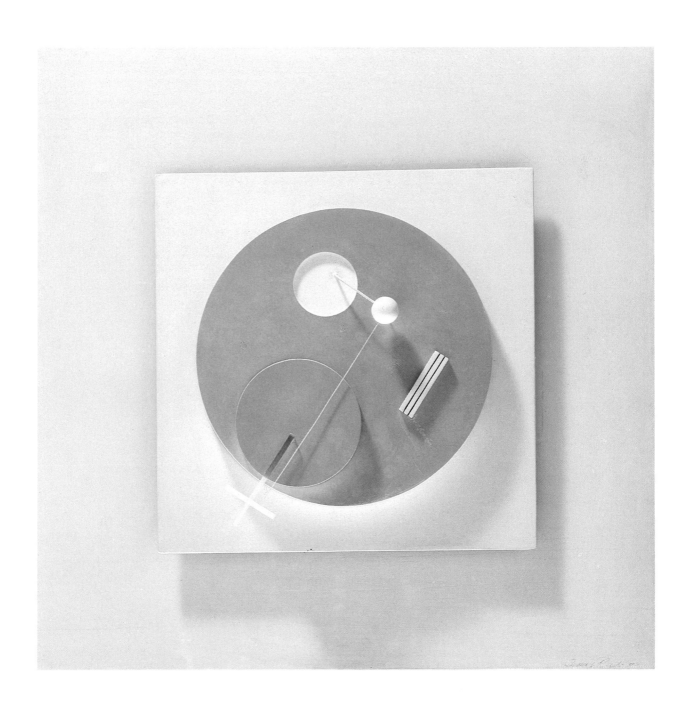

Schwitters, Kurt

Bild mit Korbring (Basket Ring). 1938

Assemblage on wood

8½ × 6¾″ (21.5 × 17 cm)

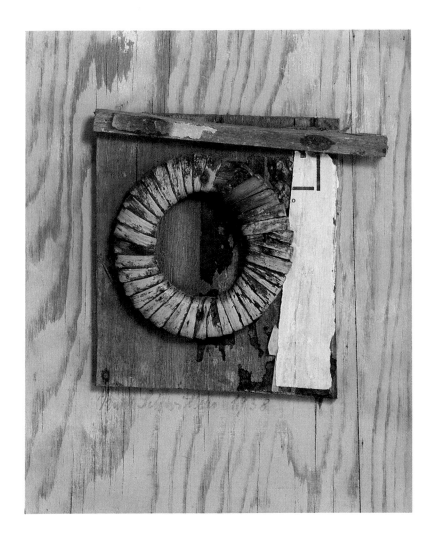

Sheeler, Charles
Industrial Architecture. 1949
Tempera on board
12½ × 9¼″ (32 × 23.5 cm)

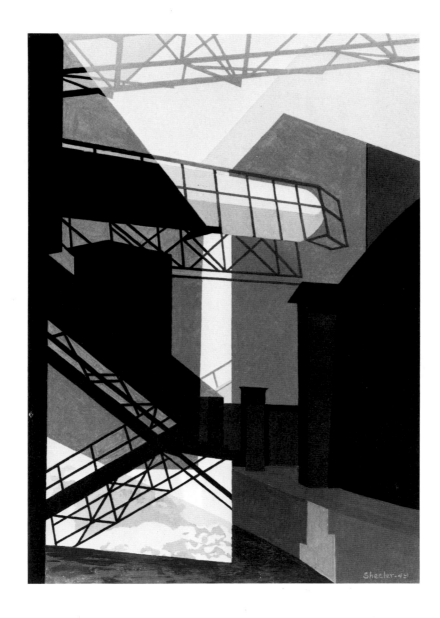

Spencer, Niles
Near Washington Square. c. 1928
Oil on canvas
16⅛ × 10¼″ (41 × 26 cm)

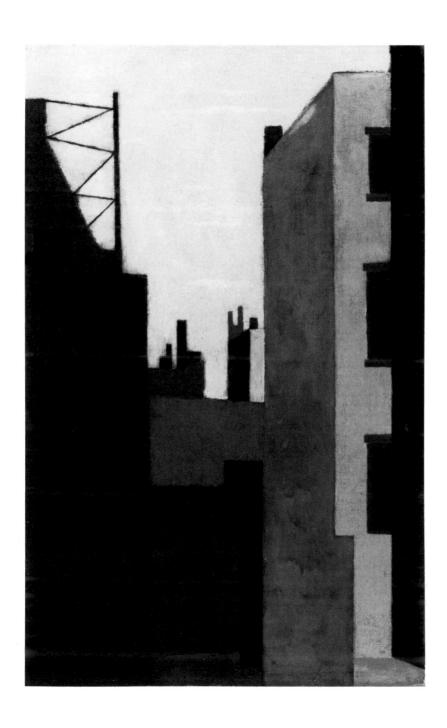

Strzeminski, Wladyslaw
Unistic Composition. 1932
Oil on gypsum
16 × 12″ (40.5 × 30.5 cm)

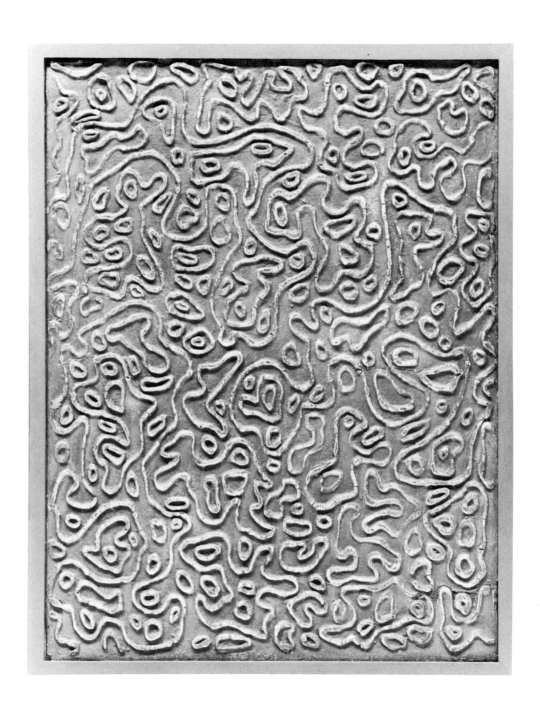

Taeuber-Arp, Sophie
Composition of Circles and Overlapping Angles. 1930
Oil on canvas
20 × 25½″ (50 × 65 cm)

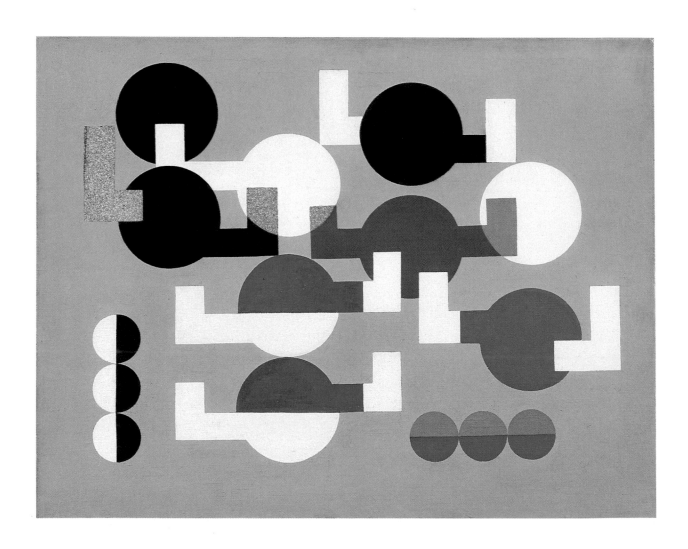

Taeuber-Arp, Sophie
Echelonnement Désaxé. 1934
Gouache on paper
13¾ × 10¼" (35 × 26 cm)

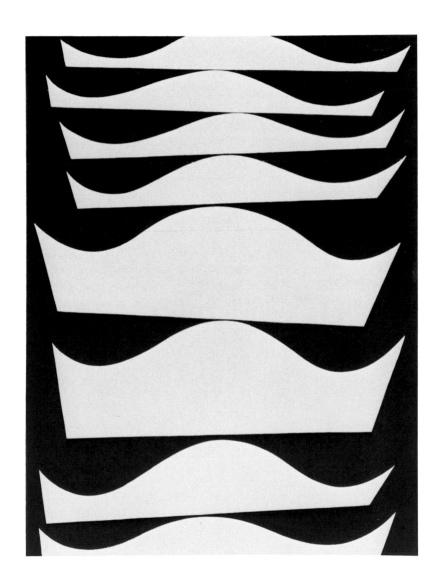

Vantongerloo, Georges
Relation of Lines and Colors. 1939
Oil on hardboard
28½ × 20¾″ (72.5 × 53 cm)

von Wiegand, Charmion
Sanctuary of the Four Directions. 1959
Oil on canvas
36 × 32″ (91.5 × 81 cm)

Recent Nonfigurative Tendencies

1960–1980

The post–World War II period, particularly the decade of the 1960s, has been dominated by the creative impetus of American art. Working outside the spotlight, European artists who matured in the tradition of geometric abstraction of the 1920s and 1930s pursued their own efforts to enrich the pictorial vocabulary handed down to them by the earlier styles. The Bauhaus tradition, especially the color theories of George Itten and his design system predicated on strict calculation, contributed to the exploration of color and its interrelations with modular geometric form in the work of the Swiss artists Richard Lohse and Max Bill, who also evolved sculptural concepts of spatial definition based on topological and mathematical principles. A further development of that tradition was the optical art (Op Art) of Vasarely and the color kinevisuality of Bridget Riley, which had been foreshadowed by Berlewi's experiments with "mechano-faktura" in the 1920s. Vasarely and Riley investigated space-color relations in connection with basic design patterns of geometric forms that set up a vibrant interaction of color and rhythm. This vibrant effect resulted from the tendency of the eye to produce afterimages when confronted with sharp black-and-white contrasts and/or juxtapositions of very brilliant hues. What can be regarded as an extension of optical painting is the work in relief and sculpture where in many cases optical kinevisuality was combined with the machine aesthetic (e.g., the work of Kenneth Martin in England and George Rickey in America), in a way reminiscent of the earlier experiments of Moholy-Nagy with his space modulators.

In America, through the 1940s and 1950s, the geometric tradition had existed as an offshoot of the European geometric styles of the 1930s, and was largely eclipsed by that first truly independent American idiom, Abstract Expressionism. During the 1950s, in fact, only a few important artists worked in geometric idioms: Albers, Diller, Reinhardt, Kelly, Leon Polk Smith, Myron Stout, Al Jensen, Ludwig Sander, among them. In the late 1950s, and attending marked changes in society, a shift of sensibility took place. This new sensibility rejected the premises and the emotional content of Abstract Expressionism and looked for alternative solutions. Important for this change were the works (and iconoclastic writings) of Ad Reinhardt, especially his series of black paintings in close chromatic scale, which set the stage for the reductive art of the 1960s artists: painters such as Frank Stella and Jo Baer and structure-makers such as Donald Judd, Sol LeWitt, and Carl Andre.

Around 1960 a geometric idiom appeared once again, though now in an essentially modified form, and by 1967 was a prevailing mode, producing a variety of conceptually based postgeometric styles. It was partly a reaction against the gestural, expressive paint texture of most Abstract Expressionist painting, against its spontaneity, complexity, and ambiguity. On the other hand, it was an extension of the color-field painting of Barnett Newman and Ad Reinhardt, which emphasized nonhierarchical, nonrelational arrangement of forms, eliminating form/field relationship and focusing on color and its spatial synthesis. It was also a reexamination and transposition of earlier modernist concepts of abstract art—the reductivism of de Stijl, Suprematist austerity, objectivism in Constructivist art, Bauhaus design—tempered by influences from other sources as diverse as Dada and Matisse.

Color-field painting, hard-edge painting, and Minimalism each seemed in turn to take up concerns tangent to those that had preoccupied the pioneers of geometric and constructivist art. Artists of the 1960s generation were acutely aware of previous

developments in Western art, and they could selectively seize upon elements that they found akin to their own way of thinking. For instance, the investigations of color and form and their equation with content and object that characterized the work of such pioneers of abstraction as Delaunay and Kupka had as one of their consequences the rise of the color-field painting of artists such as Kenneth Noland; also, certain aspects of these investigations were absorbed into the work of hard-edge painters Ellsworth Kelly and Al Held.

Hard-edge painting, exemplified by the work of Ellsworth Kelly, Leon Polk Smith, and Myron Stout, provided a fresh manner of geometric abstraction, and an alternative mode—away from the gestural painting that had dominated the 1950s. It highlighted clarity of design (usually there were only a few forms to a painting) and clarity of color, simplicity of form and immaculate pictorial surface devoid of any modulation; at the same time, there was no figure/ground effect, so that the entire picture presented itself as a single unit. While such painting had evolved out of Cubist-inspired geometric abstraction of the early years (such as the work of Mondrian), its course of development was transformed through various influences—Matisse, Miró, Arp, and Brancusi.

Further, Systemic painting embraced diverse idioms making use of geometry or geometric forms. "Systemic Painting" was so named by Lawrence Alloway in an exhibition he organized under that title at the Guggenheim Museum in 1966. The show included a variety of works sharing the reductive vocabulary of form, among them the bilateral symmetries of Frank Stella's early years, the diamond-shaped canvases of Kenneth Noland, and works by Agnes Martin and Robert Mangold. The paintings in question rely upon a balance of shapes and a harmony of color-space or a shape-volume unit recalling the work of Mondrian. Yet these works also share the essential concept of Malevich's philosophy, the principle which in fact formed the main premise of Clement Greenberg's formalist conception: the self-definition of the arts and their tendency toward "uniqueness" by virtue of the medium (in painting, this means preserving the flatness of the surface and eliminating representation and illusion).

Malevich, with his *Black Square on White Ground* of 1913, and Duchamp, with his ready-made *Bottle Rack* of 1914, defined the polar "icons" of Minimalism and Conceptualism, and the radicality of their decisions might be said to have defined the limits of the visual arts. The economy and reductivism of Malevich's and Mondrian's work and the introduction of a new Duchampian concept of what constitutes "art" and content in art became an inspiration for Minimal artists. In painting they focused on the objectlike quality of the work and on the surface of the canvas. The canvas was usually evenly brushed, devoid of perceptible texture and traces of paint-handling—except for the works of Robert Ryman, who made evenly applied brushwork the very subject of his art.

But the main practitioners of Minimalism were the artists who worked in three dimensions, such as Carl Andre, Dan Flavin, Donald Judd, Sol LeWitt, and Robert Morris, whose innovative constructions came to public attention in the exhibition "Primary Structures" at the Jewish Museum in New York in 1966. Also characterized by art historians and critics as "ABC Art," "Cool Art," "Art of the Real," or the "Third Stream," their works were intended to transgress the traditional boundaries of painting and sculpture and to incorporate elements of both. In fact, all of the five aforementioned artists had begun as painters. They made use of serial systems, geometric planes or forms, and smooth surfaces; they dispensed with pedestals or plinths and created bold, self-contained abstract structures. The Minimal object—whether two-dimensional painting (often

shaped) or three-dimensional structure—made active use of the viewer's space. Space was given a new definition and delineation through placement of the large-scale object with reference to the floor, walls, and ceiling. The scale of the object created an "aggressive" relationship between the work and the surrounding space, as witnessed in the case of works by LeWitt, Judd, Andre, Dorothea Rockburne, Mel Bochner. Minimal art introduced a noncompositional principle and an idea of "subversive content," that is, a lack of "true" art content, which was replaced by the concept of content as form, color, material, the interaction with space, or simply definition of space. In this respect, the Constructivists' removal of the pedestal and their interest in the use of ordinary materials and in the interaction of the object and the viewer's space had foreshadowed the preoccupations of the Minimal artists, even though the Minimalists rejected the relational structure of Constructivist works.

During the 1970s a number of artists reacted against the cool and detached approach of Minimalism and became increasingly interested in painterly work. There emerged a variety of art that presented geometric forms but introduced yet another transformation of geometric principles. In many cases—for instance, in Jake Berthot's *Yellow Bar with Red*, or in Joanne Pousette-Dart's *For Greg*, or in Diebenkorn's *Ocean Park 115*—the precision of geometric forms and surface was subverted in a painterly way, and geometry became not so much a pattern on a field as a way to structure the compositional field.

In recent years, art that focuses on structural components arranged according to a rational system has again claimed public attention, and a number of exhibitions have pointed up the continuation of the "constructive" tradition in the work of a younger generation of artists, born after World War II: James Biederman, Tony Robbins, Mel Kendrick, and Tom Holste, among others.

The interest in Russian avant-garde art—with special emphasis on Constructivist art—which has manifested itself during the past two decades in numerous exhibitions and publications in Europe as well as in the United States has undoubtedly stimulated a reevaluation of the formal and conceptual premises of that art and has presented additional questions and solutions for those artists whose sensibility tends toward geometric rigor.

Chronology
1960–1980

Cleveland

American group Anonima founded, including Ernest Benkert, Edwin Mieszkiewski, and Francis Hewitt.

Leverkusen

"Monochrome Malerei" exhibition in the Schloss Morsbroich. Includes Fontana, Rothko, Klein, Still, Newman.

Munich

The Op Art groups Effekt and Nota are formed. Artists in the Effekt group are Walter Zehringer, Dieter Hacker, Karl Reinharz, and Helge Sommerock. Some artists in the Nota group (named after a periodical) are von Graevenitz, Gotthart Müller, and Walter Zehringer.

New York

Jean Tinguely constructs his *Homage to New York* at MoMA.

March. Exhibition "Construction and Geometry in Painting: From Malevich to Tomorrow" at Galerie Chalette.

Al Held exhibition, Poindexter Gallery.

Paris

July. GRAV (Groupe de Recherche d'Art Visuel) founded. Includes de Marco, García-Miranda, García Rossi, Le Parc, Melnar Morelle, Moyano, Servanes Sobrino, Stein, Yvaral. Sponsored for some years by Galerie Denise René. Common element among members was the visualization of light, with primitive geometrical forms in mobile assemblages and ornamentation of several levels.

Zurich

"Kinetische Kunst" exhibition.

"Konkrete Kunst" exhibition.

NUL, a Dutch group, is formed; founding members are Henk Peeters, Armando, Jan Schoonhoven, and Herman de Vries.

Amsterdam

March–April. "Bewogen Beweging" (Eventful Movement) exhibition at the Stedelijk Museum. (Shown also at the Moderna Museet, Stockholm.)

Düsseldorf

Piene, Mack, and Günther Uecker hold first Group Zero "Demonstration," a kind of outdoor happening.

New York

Clement Greenberg's "Modernist Painting" published in *Arts Yearbook 4*.

October. "American Abstract Expressionists and Imagists" exhibition at the Guggenheim includes Held, Humphrey.

Pittsburgh

The International exhibition at Carnegie Institute includes Agnes Martin and Al Held.

1962

Amsterdam

"Experiment in Constructie" exhibition at the Stedelijk Museum; the first corporate expression of the group that had arisen around Joost Baljeu, Biederman, Gorin, Hill, and Mary Martin.

Moscow

Dvizjenje group formed in Moscow by Lev Nusberg. Group includes L. V. Nusberg, V. Akulinin, B. Diodorov, V. P. Galkin, F. A. Infante, A. Krivchikov, G. I. Iopakov, R. Sapgiry-Sanevskaja, V. V. Stepanov, and V. Skerbakov. They develop the principles established by Lissitzky, Gabo, and Mondrian.

New York

March. "Geometric Abstraction in America" at the Whitney Museum. Includes Albers, Diller, Glarner, Holtzman.

The Great Experiment: Russian Art 1863–1922 by Camilla Gray (published in New York by Abrams).

"Hard Edge Painting" exhibition at Fischbach Gallery.

Paris

Salons des Réalités Nouvelles; Paris group includes the American artist James Bishop.

1963

New York

MoMA exhibition "Americans 1963."

May. "Toward a New Abstraction" exhibition at the Jewish Museum. Texts on Al Held by Irving Sandler, on Ellsworth Kelly by Henry Geldzahler, on Kenneth Noland by Alan R. Solomon, on Frank Stella by Michael Fried.

Paris

GRAV exhibition "Labyrinth" at the Paris Biennale.

Washington, D.C.

"Formalists" exhibition, Gallery of Modern Art.

1964

Chicago

Annual Exhibition, Art Institute of Chicago, includes Held.

Los Angeles

"Post-Painterly Abstraction" at Los Angeles County Museum. Clement Greenberg writes essay for catalog.

Milan

M.I.D. group formed with Barese, A. Grassi, G. Laminarca, and A. Marangoni. Founded for the study of stroboscopic motion and programmed light.

September. "Il Contributo Russo alle Avanguardie Plastiche," Galleria del Levante.

New York

April. "Mondrian, de Stijl and Their Impact," Marlborough-Gerson Gallery.

"Black and White," Jewish Museum.

"Eleven Artists," Kaymar Gallery, includes Ryman, Baer.

February. In an interview on WBAI-FM, Judd and Stella discuss Constructivism and Bauhaus with Bruce Glaser: "New Nihilism or New Art?"

Paris

Nouvelle Tendance exhibition: Bridget Riley.

Poughkeepsie

"Directions 1964," Vassar College Art Gallery.

San Marino

San Marino Biennale. The Paduan Gruppo N (A. Biasi, E. Chiggio, A. Costa, E. Landi, and M. Massironi) win first prize. Interested in light interference and dynamo-optical effects.

Venice

Biennale. Kenneth Noland occupies half of the U.S. pavilion.

1965

Basel

"Signale" exhibition, Kunsthalle, includes Held.

Cambridge

April. "Three American Painters: Kenneth Noland, Jules Olitsky, Frank Stella" at Harvard's Fogg Art Museum.

Installation photograph of ''The
Responsive Eye'' exhibition, The
Museum of Modern Art, 1965,
with works by Ellsworth Kelly

Installation photograph of ''The
Responsive Eye'' exhibition, The
Museum of Modern Art, 1965,
with work by Frank Stella at back
center

Installation photograph from the
''Primary Structures'' exhibition,
Jewish Museum, 1966, with works
by Ron Bladen (front) and Walter
de Maria (back center)

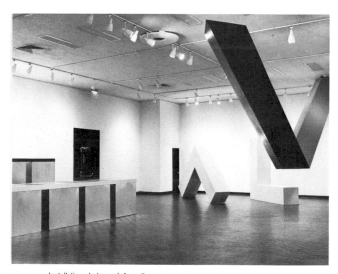

Installation photograph from the
''Primary Structures'' exhibition,
Jewish Museum, 1966, with works
by Donald Judd (left), Robert
Grosvenor (suspended, right), and
Robert Morris

New York

"The Responsive Eye," MoMA, includes Agnes Martin.

Exhibition by American Abstract Artists Association, Riverside Museum, includes Ryman.

Mangold exhibition, "Walls and Areas," at Fischbach Gallery.

February. Kenneth Noland retrospective at the Jewish Museum.

April. "Concrete Expressionism" at Loeb Student Center, N.Y.U. Text by Irving Sandler.

October. "Synchromism and Color Principles in American Painting" at Knoedler Gallery.

Paris

James Bishop exhibition "Promesses Tenues" at Museé Galliéra.

1966

Amsterdam

Al Held exhibition, Stedelijk Museum.

Bern

"White on White," Kunsthalle.

London

Frank Popper publishes his *Kinetic Art*.

New York

"Ad Reinhardt," Jewish Museum.

"Systemic Painting," Guggenheim Museum.

"Primary Structures," Jewish Museum.

"Kandinsky: The Bauhaus Years," Marlborough-Gerson Gallery.

Paris

James Bishop exhibition, Galerie Fournier.

1967

Berlin

October. "Avantgarde Osteuropa 1910–1930," Academie der Künste, Deutsche Gesellschaft für Bildende Kunst und Kunstverein.

Detroit

"Form, Color, Image" exhibition, Detroit Institute of Arts, includes Agnes Martin.

Frankfurt

"Konstruktive Malerei 1915–1930," Frankfurter Kunstverein.

New York

Annual Exhibition, Whitney Museum, includes Martin, Baer, Held, Mangold, Insley, Novros.

"Rejective Art," American Federation of Arts circulating exhibition, includes Marden, Ryman, Ohlson.

Ryman exhibition, Bianchini Gallery (first solo).

"Synchromism and Related American Color Painting 1910–1930," MoMA circulating exhibition, shown at State University College, Oswego, N.Y.; Santa Barbara Museum of Art, Cal.; California Institute of the Arts, Los Angeles; Oberlin College, Ohio; Brandeis University, Waltham, Mass.; Museum of Art, Providence, R.I.; Goucher College, Towson, Md.; Cummer Gallery of Art, Jacksonville, Fla.; San Francisco Museum of Modern Art.

Paris

Frank Popper's *Kinetic Art* published in French as *Naissance de la Cinétique*.

"Lumière et Mouvement" exhibition devoted to Nicolas Schöffer.

Philadelphia

"A Romantic Minimalism," Institute of Contemporary Art.

Trenton

"Focus on Light," New Jersey State Museum, includes Mangold.

1968

Buffalo

"Plus by Minus: Today's Half-Century," Albright-Knox Art Gallery, includes van Doesburg, Lissitzky, Malevich, Mondrian, Pevsner, Puni.

Düsseldorf

Ryman exhibition, Konrad Fischer Gallery.

Kassel

"Documenta IV" includes Al Held and Jo Baer.

New York

"The Art of the Real," MoMA, includes Carl Andre, Donald Judd, Ellsworth Kelly, Sol LeWitt, Agnes Martin, Kenneth Noland, Ad Reinhardt.

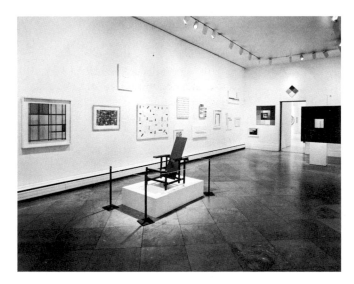

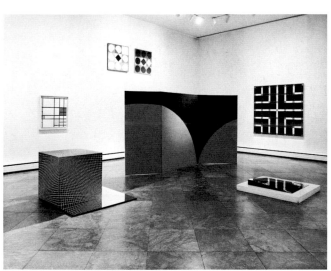

Two views of the installation of "Plus by Minus: Today's Half-Century" exhibition, Albright-Knox Art Gallery, Buffalo, 1968

November. "The Machine as Seen at the End of the Mechanical Age," MoMA; subsequently traveled to University of St. Thomas, Houston, and San Francisco Museum of Modern Art.

Stockholm

July–September. "Vladimir Tatlin" at Moderna Museet.

Venice

Bridget Riley awarded prize at Biennale.

1969

Illinois Institute of Technology presents "50 Years Bauhaus German Exhibition."

Munich

Ryman exhibition, Heiner Friedrich Gallery.

New York

Annual Exhibition, Whitney Museum, includes Baer, Held, Mangold, Marden.

"Anti-Illusion: Procedure/Materials," Whitney Museum, includes Ryman.

Nuremberg

First Nuremberg Biennale, on the theme "Constructive Art: Elements and Principles."

Poughkeepsie

"Concepts," Vassar College Art Gallery, includes Mangold, Novros, Marden, Ohlsen.

1970

Amsterdam

"Malevich." First important Malevich retrospective at the Stedelijk Museum (catalog includes catalogue raisonné of the Berlin exhibition, 1927, and the collection of the Stedelijk Museum).

Cologne

October. "Eastern European Avant-Garde (until 1930)," at Galerie Gmurzynska-Bargera.

London

"Kinetics" exhibition at Hayward Gallery.

1971

Le Renouveau de l'art pictural russe 1863-1914 by Valentine Marcadé published in Lausanne.

London

February. "Art in Revolution: Soviet Art and Design since 1917" at Hayward Gallery. (Traveled to New York Cultural Center in September and Art Gallery of Ontario, Toronto, January 1972.)

New York

June. "Russian Art of the Revolution," at Brooklyn Museum (organized and first shown in February at Andrew Dickson White Museum of Art, Ithaca).

San Diego

November. "Color and Form 1909–1914: The Origin and Evolution of Abstract Painting in Futurism, Orphism, Rayonism, Synchromism and The Blue Rider," at Fine Arts Gallery. Later travels to Oakland Museum, Seattle Art Museum.

1972

Cologne

September. "Constructivism: Development and Tendencies since 1913" at Galerie Gmurzynska-Bargera.

London

"Systems" exhibition at Whitechapel Gallery, organized by the Arts Council to present work of the British artists of the Systems group. (Travels throughout England, 1972–1973).

July. "The Non-Objective World 1939–1955," at Annely Juda Fine Art. (Travels to Galerie Liatowitsch, Basel, September; Galleria Milano, Milan, November.)

Paris

May. "Alexandra Exter," first important solo exhibition of her work in the West, at Galerie Jean Chauvelin.

1973

Essen

May. "Constructivism in Poland 1923–1936," at Museum Folkwang. (Travels to Rijksmuseum Kröller-Müller, Otterlo, July.)

London

July. "The Non-Objective World 1914–1955," at Annely Juda Fine Art. (Travels to University Art Museum, University of Texas, Austin, October.)

Newcastle-upon-Tyne

March. "Russian Constructivism Revisited," at Hatton Gallery.

1974

Cologne

March. "De Stijl, Cercle et Carré: Development of Constructivism in Europe from 1917," at Galerie Gmurzynska.

September. "From Surface to Space: Russia 1916–1924," at Galerie Gmurzynska.

Stuttgart

"Constructivism and Its Followers from the Collection of the Staatsgalerie Stuttgart and Its Graphic Holdings," at Staatsgalerie Stuttgart.

1975

Atlanta

"Bauhaus Color," at High Museum.

London

May. "Russian Constructivism: 'Laboratory Period' " (travels to Art Gallery of Ontario, Toronto, July), at Annely Juda Fine Art.

Paris

April. "2 Stenberg 2." (Travels to London, May, and Ontario, July.) First Western exhibition (since 1922) concerned with the works of the Stenberg brothers.

1976

Brussels

April. "Larinov, Gontcharova Retrospective," at Musée d'Ixelles.

Cologne

June. "The 1920s in Eastern Europe," at Galerie Gmurzynska.

Düsseldorf

October. "Pure Form: From Malevich to Albers," at the Kunstmuseum.

London

"Kasimir Malevich," at the Tate Gallery.

March. "Russian Suprematist and Constructivist Art 1910–1930," at Fischer Fine Art, Ltd.

May. "Russian Pioneers at the Origins of Non-Objective Art," at Annely Juda Fine Art.

1977

Cologne

May. "Art Isms in Russia 1907–1930," at Galerie Gmurzynska.

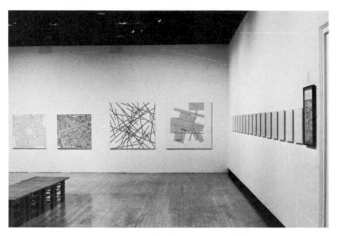

Installation photograph of "Pier and Ocean: Construction in the Art of the Seventies," Hayward Gallery, London, 1980

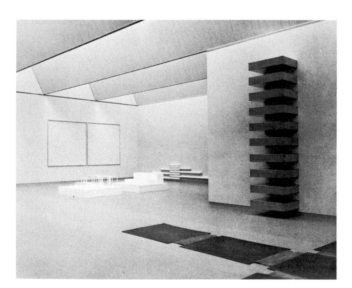

Installation photograph of "Pier and Ocean: Construction in the Art of the Seventies," Hayward Gallery, London, 1980, with works by Carl Andre, Donald Judd, Sol LeWitt

Edinburgh

August. "The Modern Spirit: American Painting 1908–1935," at Royal Scottish Academy; also shown at Hayward Gallery, London.

Hannover

March. "Malewitsch-Mondrian Konstruktion als Konzept," at the Kunstverein.

London

June. "Malevich, Suetin, Chashnik, Lissitzky: The Suprematist Straight Line," at Annely Juda Fine Art.

Paris

June. "Paris–New York," Centre Pompidou.

October. "Suprematism," at Galerie Jean Chauvelin.

1978

Cologne

June–July. "Kasimir Malevich," exhibition commemorating centennial of the artist's birth, at Galerie Gmurzynska.

Edinburgh

August. "Liberated Colour and Form: Russian Non-Objective Art 1915–1922," at the Scottish National Gallery of Modern Art.

Great Britain

"Constructive Context" put on by Arts Council of Great Britain.

New York

January. "Synchromism and Color Abstraction 1910–1925," Whitney Museum; also shown at Museum of Fine Arts, Houston; Des Moines Art Center; San Francisco Museum of Modern Art; Everson Museum of Art, Syracuse; Columbus (Ohio) Gallery of Fine Arts.

"Revolution: Russian Avant-Garde 1912–1930" at MoMA.

Paris

March. "Malevich," at Centre Pompidou.

1979

Cologne

May. "Mondrian and de Stijl," at Galerie Gmurzynska.

December. "Women Artists of the Russian Avant-Garde," Galerie Gmurzynska, includes Exter, Gontcharova, Popova, Rozanova, Stepanova, and others.

London

June. "Line and Movement," at Annely Juda Fine Art.

New Haven

October. "Mondrian and Neo-Plasticism in America," Yale University Art Gallery, including Bolotowsky, Diller, van Doesburg, Glarner, Holtzman, Mondrian.

New York

March. "The Planar Dimension: Europe, 1912–1932," Guggenheim Museum.

June. "The Language of Abstraction," put on by American Abstract Artists, opens at Betty Parsons Gallery and Marilyn Pearl Gallery.

Paris

Exhibition "Paris-Moscow 1900–1930," at Centre Pompidou. (Shown in Moscow in 1981.)

1980

London

May–June. "Pier and Ocean: Construction in the Art of the Seventies," at Hayward Gallery, included a wide range of international artists working in geometry-related three-dimensional idioms. (Traveled to the Rijksmuseum Kröller-Müller, Otterlo.)

Los Angeles

"The Avant-Garde in Russia 1910–1930: New Perspectives," at the Los Angeles County Museum of Art. A comprehensive survey of the explorations of all the major Russian artists of the period, it includes paintings, three-dimensional constructions, graphic works, and costumes and stage sets for the theater.

Paris

March–May. A comprehensive exhibition of paintings, drawings, and three-dimensional models by Malevich, at Centre Pompidou.

Philadelphia

"Futurism and the International Avant-Garde," at the Philadelphia Museum of Art, reevaluating the connection of Futurism to the early modernist avant-garde movements in England, France, Russia, and the United States.

Albers, Josef
Homage to the Square: Silent Hall. 1961
Oil on composition board
40 × 40″ (101.8 × 101.8 cm)
Dr. and Mrs. Frank Stanton Fund

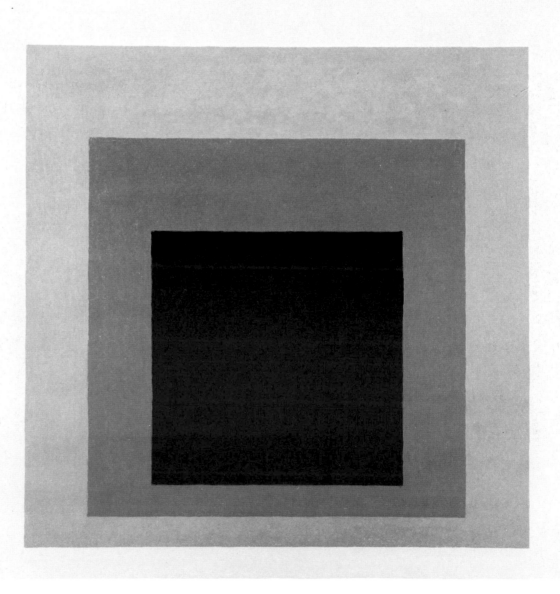

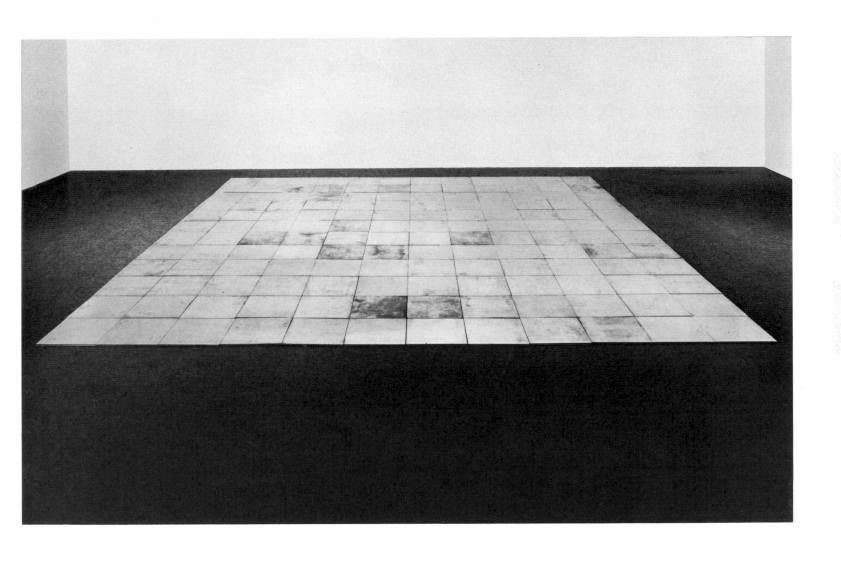

Berthot, Jake
Yellow Bar with Red. 1977
Oil on canvas
74 × 52″ (188 × 132 cm)

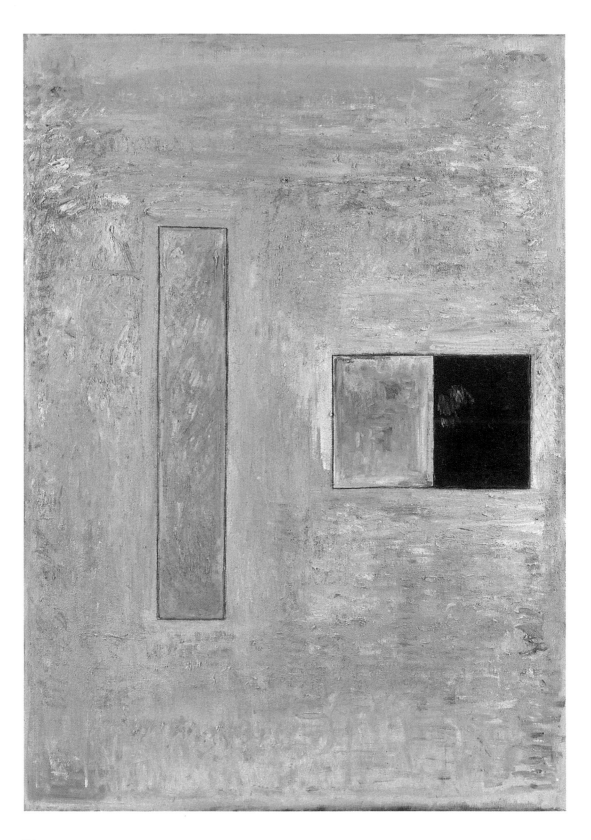

Bill, Max
Half-Sphere around Two Axes. 1966
Black marble
11¾ × 10¼″ (30 × 26 cm)

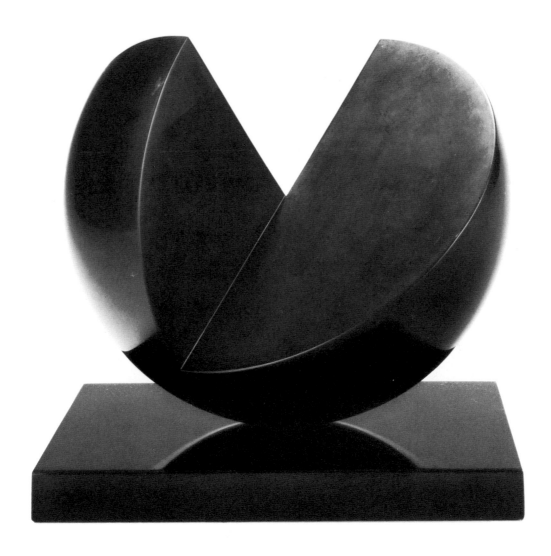

Dekkers, Ad

From Square to Circle. 1968

Relief on white hardboard

35½ × 35½ × 1¼" (90 × 90 × 3 cm)

Diebenkorn, Richard
Ocean Park 115. 1979
Oil on canvas
100 × 81″ (254 × 206 cm)
Mrs. Charles G. Stachelberg Fund

Graeser, Camille
Three Color-Groups against Black/White. 1969
Acrylic on canvas
47¼ × 47¼" (120 × 120 cm)

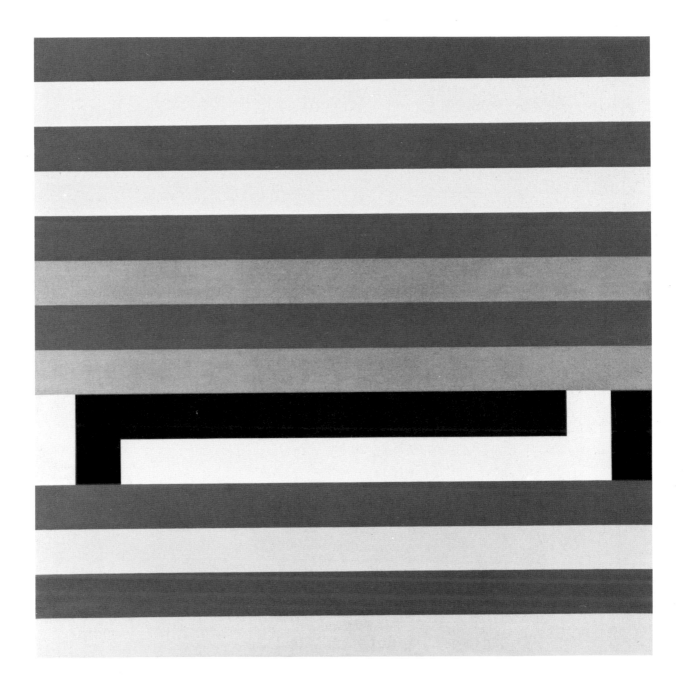

Held, Al
C-B-1. 1978
Acrylic on canvas
72 × 84″ (183 × 213.5 cm)

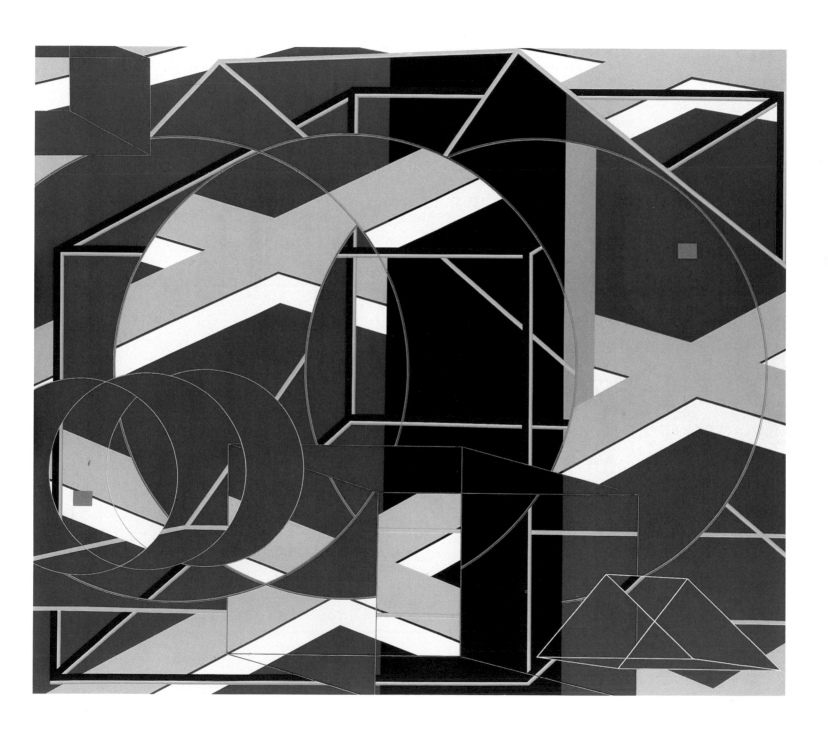

Jensen, Alfred
This Is It. 1966
Oil on canvas
42 × 36″ (106.5 × 91.5 cm)

Judd, Donald
Untitled (Progression). 1979
Galvanized steel and clear anodized aluminum
5¼ × 75 × 5¼″ (13.5 × 190.5 × 13.5 cm)

Kelly, Ellsworth
Two Panels: Yellow-Orange. 1968
Oil on canvas
62 × 62″ (157.5 × 157.5 cm)

LeWitt, Sol
Cubic Construction: Diagonal 4, Opposite Corners 1 and 4
Units. 1971
White-painted wood
24¼ × 24¼ × 24¼″ (61.5 × 61.5 × 61.5 cm)

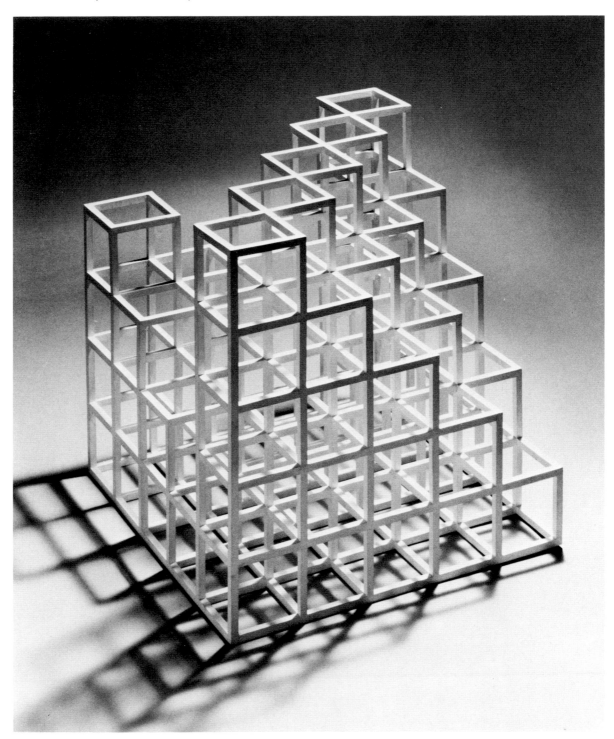

Lohse, Richard Paul
Fifteen Systematic Color Rows with Vertical Condensations.
1950–1968
Oil on canvas
59 × 59″ (150 × 150 cm)

Mangold, Robert
Distorted Circle within a Polygon I. 1972
Acrylic on shaped canvas
80 × 89″ (203 × 226 cm)

Martin, Agnes
The Tree. 1964
Oil and pencil on canvas
72 × 72″ (183 × 183 cm)
Larry Aldrich Foundation Fund

Martin, Kenneth
Rotary Rings, Second Version. 1967
Brass
21″ (53.5 cm) high

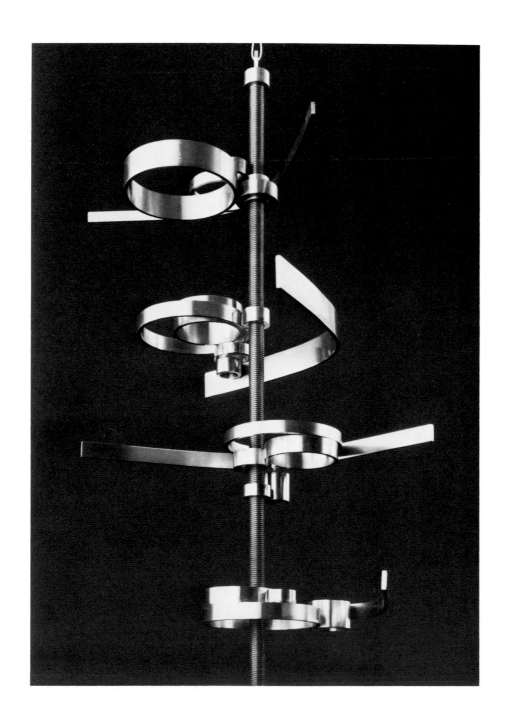

Nicholson, Ben

Locmariaquer 5. 1964

Oil and pencil on carved board

38⅝ × 55⅞″ (98 × 139.5 cm)

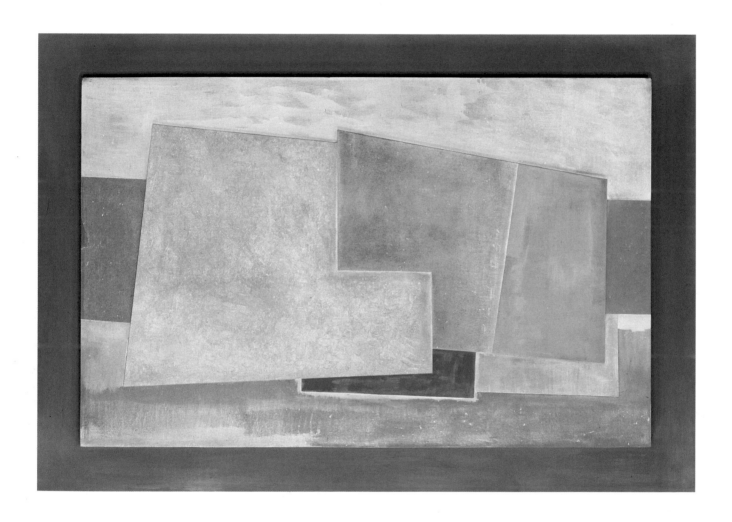

Noland, Kenneth
Blue Veil. 1963
Acrylic on canvas
69 × 69″ (175 × 175 cm)

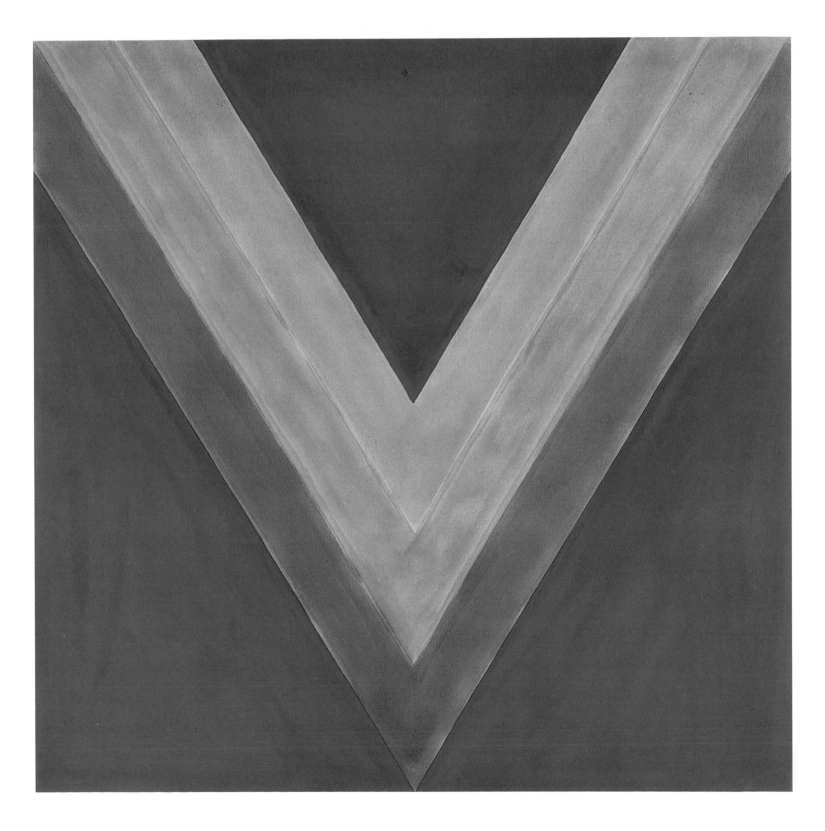

Novros, David
Untitled. 1972–1975
Oil on canvas
In two parts, overall: 7′5¾″ × 12′4½″ (227.7 × 346.3 cm)
Bernhill Fund and anonymous promised gift

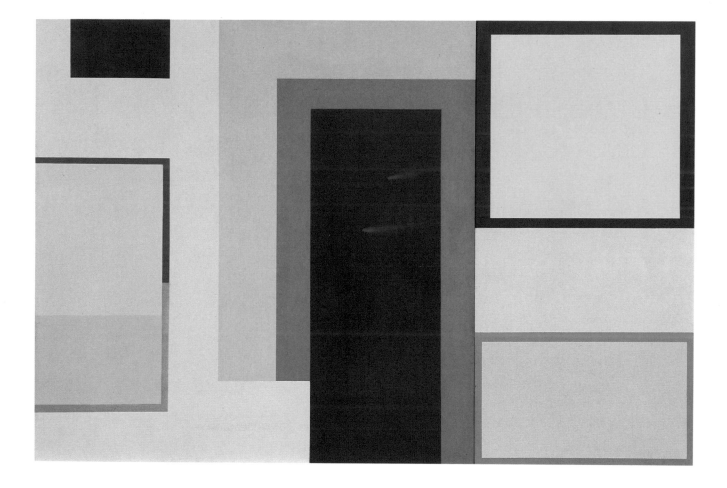

Pousette-Dart, Joanne
For Greg. 1977–1978
Oil on canvas
7′ × 14′ (213.2 × 426.4 cm)
Mrs. Alfred A. Knopf Fund

Reinhardt, Ad
Number 87. 1957
Oil on canvas
9′ × 40″ (274.3 × 101.5 cm)
Purchase

Riley, Bridget
Study for Painting, (12011-DG). 1965
Gouache and pencil on graph paper
41 × 29″ (104 × 71 cm)

Ryman, Robert
Twin. 1966
Oil on cotton
6'3¾" × 6'3⅞" (192.4 × 192.6 cm)
Charles and Anita Blatt Fund and Purchase

Sander, Ludwig
Tioga II. 1969
Oil on canvas
44 × 40″ (112 × 102 cm)

Schoonhoven, Jan J.
R-70. 28. 1970
Relief, papier mâché
13 × 13 × 1¾″ (33 × 33 × 3.5 cm)

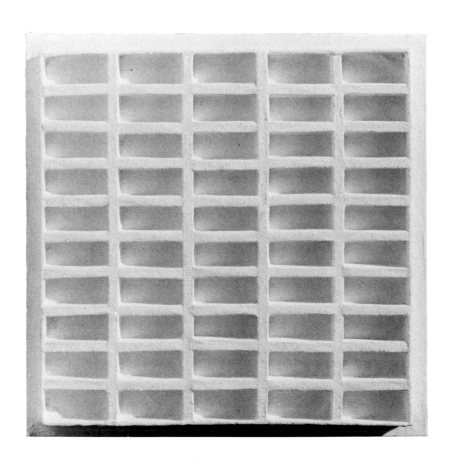

Stella, Frank
The Marriage of Reason and Squalor. 1959
Oil on canvas
7'6¾" × 11'¾" (230.5 × 337.2 cm)
Larry Aldrich Foundation Fund

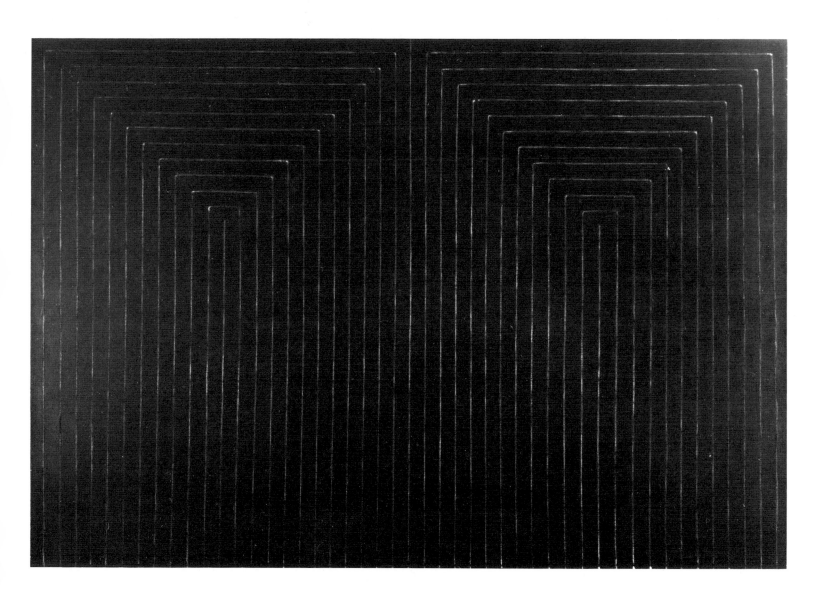

Vasarely, Victor
Capella 4 B. 1965
Tempera on composition board
50⅝ × 32¾″ (128.5 × 83.2 cm)
The Sidney and Harriet Janis Collection

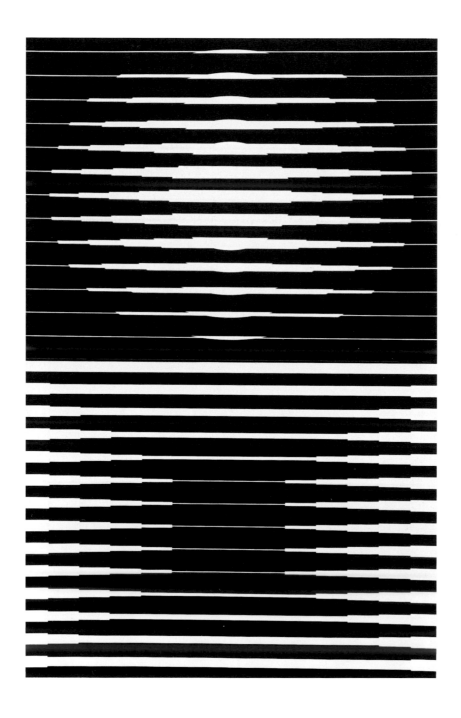

Biographical Notes

Albers, Josef

Born 1888, Bottrop, Germany.
Died 1976, New Haven, Connecticut.

Educated at the Royal Art School, Berlin (1913–1915), the School of Applied Arts, Essen (1916–1919), and the Art Academy, Munich (1919–1920). His earliest work (mostly representational prints and drawings) showed the influence of Cubism and German Expressionism. He continued his studies at the Bauhaus (1920–1923) and then remained there as a teacher until 1933, heading the glass and furniture workshops and teaching the influential preliminary course. There he became closely acquainted with the ideas of Klee and Kandinsky. In his own work he experimented with a variety of materials, exploring their intrinsic formal and structural possibilities. Preoccupied with the interrelationships between the fine and the applied arts, he designed stained-glass windows and furniture for mass production.

After the closing of the Bauhaus by the Nazis, Albers emigrated to the U.S. He taught at Black Mountain College in North Carolina (1933–1949), also teaching special courses at Harvard (1936, 1941, and 1950). He was a member of the Paris-based Abstraction-Création group and the American Abstract Artists in New York. From 1950 to 1961 he was chairman of the Department of Art at Yale University. His painting and graphic work focused on the investigation of color relationships, generally within a well-defined geometric form, and the creation of spatial illusion through compositional structure. The most famous of these explorations was his *Homage to the Square* series, begun around 1949. Here, with the ultimate simplification of formal language—superimposed squares of solid colors—he achieved the maximum effect of color performance through interaction of the lines, hues, and sizes.

Andre, Carl

Born 1935, Quincy, Massachusetts.

Studied at the Phillips Academy in Andover under Patrick Morgan during 1951–1953 with, among others, the painter Frank Stella. In 1954 worked for Boston Gear Works in Quincy and traveled to England and France. During 1955–1956 was an intelligence analyst with the army in North Carolina. Moved to New York in 1957, where he worked as an editorial assistant for a textbook publisher. In 1958–1959 made his first large wood sculpture as well as a number of small works in plexiglass and wood. They made use of strictly geometric forms: cubes, cylinders, spheres, and pyramids. Stylistically Andre's development was indebted at that time to the work of Frank Stella and that of Brancusi, the latter's particularly with respect to the vertical format and absence of pedestal. Subsequently, he eschewed both influences in the works in wood, metal, and plexiglass, exploring basic right-angle geometric principles such as the post-lintel structure. During 1960–1964 his artistic output was rather limited; he was working then as a freight brakeman and conductor for the Pennsylvania Railroad—an experience which he considers important for the further development of his sculpture.

In 1964 had his first public showing at Hudson River Museum, Yonkers, and Bennington College. Around 1965 his work underwent drastic change: he began to use modular (styrofoam) pieces in different configurations, first presented in his 1965 exhibition at the Tibor de Nagy gallery in New York; through their placement within the space he gave definition to the environment, creating positive and negative spatial relationships. His configurations relied on strict, modular, interchangeable units, which acquired their identity as art objects when they were set up as a work within a given space. After 1965 these arrangements of sand-lime or concrete bricks or metal plates were executed directly on the floor, creating ''a floor,'' the permutations of the arrangements resulting from the arithmetical combinations related to the size of the module unit. Andre's work, in its exploration of the inherent qualities of materials, its interrelationship with the environment, and its objectification of the process of creation, shows affinity with the works of the Constructivists. He continues to explore the possibilities of transforming the structure of the environment, and his work is widely exhibited both in the United States and in Europe.

Annenkov, Yuri Pavlovich

Born 1889, Petropavlovsk, Siberia.
Died 1974, Paris.

Educated in St. Petersburg, where in 1908 he entered the University and studied under Yan Tsionglinsky (a teacher of many members of the Russian avant-garde, among them Elena Guro and Mikhail Matiushin). He then lived in Paris for two years and frequented the studios of Maurice Denis and Félix Vallotton; he saw the Futurist exhibition at the Bernheim Jeune gallery in 1912. Upon his return to St. Petersburg in 1913 he was closely associated with the Russian avant-garde, members of the Union of Youth, and also collaborated on several projects in stage design and book illustration.

In 1915 he began to explore collage and subsequently produced works, such as *Relief-Collage* (1919), incorporating three-dimensional elements and combining abstract form and new ordinary materials. From 1917 on he was involved in a number of theatrical events for which he produced innovative designs (advocating sets and costumes based on mechanical movement). In 1918 he began to teach at the Free Studios (Svomas) at Petrograd and was also involved in decorating public places for mass spectacles and propaganda projects, of which the most celebrated was the 1920 re-creation of the Storming of the Winter Palace. He executed portraits of Communist leaders and artistic figures, among them Lenin, Lunacharsky, Trotsky, Akhmatova, Meyerhold. His work was included in the Erste Russische Kunstaus-

stellung at the Galerie van Diemen in Berlin in 1922 and at the Venice Biennale in 1924. He emigrated to Paris in 1924 and continued to paint portraits and still lifes, as well as collaborating on typographical, theater, and film designs.

Arp, Jean (Hans)
Born 1887, Strasbourg.
Died 1966, Paris.

Painter, poet, and sculptor, first studied at the Kunstgewerbe Schule in Strasbourg (1904), then at the Weimar Art School (1905–1907), and subsequently at the Académie Julian in Paris (1908). Following the year in Paris, Arp lived from 1909 to 1912 in Weggis, Switzerland, where he collaborated in the Moderner Bund group; at that time he also met Kandinsky (1911) and a year later contributed to the second Blaue Reiter exhibition in Munich. Following the meeting with Kandinsky he began to create abstract works. In 1913 he contributed to the Herbstsalon at Herwarth Walden's Der Sturm gallery in Berlin. In the summer of 1915 he moved to Zurich, where he helped found the Dada movement with Tristan Tzara, Hugo Ball, Richard Huelsenbeck in 1916. In 1920 he cofounded a Dada group in Cologne, in collaboration with Johannes Baader and Max Ernst. That year he moved to Paris and in 1926 settled in Meudon. Arp's early attention focused on collage, prints, and wood reliefs. Also, between 1910 and 1930, as a poet and artist, Arp contributed to important art periodicals: *Der blaue Reiter, Der Sturm, Dada, La Revue surréaliste*. In 1925 he and Lissitzky published a book on different aspects of abstract art: *Die Kunstismen* (Isms in Art). That same year he began closer association with the Surrealist movement, concurrently maintaining contacts with van Doesburg, with whom he and his wife Sophie Taeuber-Arp participated in redecoration of the Café de l'Aubette, Strasbourg (1927–1928).

He joined the group Cercle et Carré in 1930 and a year later was among the founding members of Abstraction-Création. Beginning in 1930 he devoted himself mostly to sculpture, working in bronze as well as stone and wood. His works of that period are characterized by smooth surfaces, natural forms reduced to basic shapes, sometimes undulating but always monumental regardless of scale, as *Helmet Head I* (1955). During World War II Arp lived in Switzerland and in 1945 returned to Meudon outside Paris. He worked on poems, drawings, and lithographs. He visited the U.S. in 1949 and had a retrospective at The Museum of Modern Art in 1958.

Baljeu, Joost
Born 1925, Middelburg, Netherlands.
Lives in The Hague.

Began painting in 1940. Studied at the Amsterdam Institute of Design from 1943 to 1945. His early abstract paintings date from the years 1952–1955. He then gave up painting and began to create geometric constructions that incorporated the influences of Cubism and de Stijl. Interested in geometric art and Constructivism, he founded in 1958 the magazine *Structure* (published until 1964), which became a forum for the exchange of Constructivist-related theories. Since 1957 he has been teaching at the Royal Academy of Fine Arts at The Hague. He continues to develop his theories in painting, sculpture, and construction.

Balla, Giacomo
Born 1871, Turin.
Died 1958, Rome.

Studied briefly in Turin, then around 1900 in Paris, but was mostly self-taught. In 1893 moved to Rome, where he lived and worked for the rest of his life. He was a teacher of Boccioni and Severini, with whom he signed the *Technical Manifesto of Futurist Painting* in 1910. Initially strongly influenced by French Neo-Impressionism, he evolved his own divisionist idiom, which he applied, in his Futurist works after 1910, to the concept of simultaneous movement of forms in space. His main pictorial interest focused on abstract elements of rhythm, light, and color as well as velocity, dynamics, and sound. Balla first exhibited with the Futurists in 1912 and worked in this style until the 1930s, designing the Futurist rooms for the 1925 International Exhibition of Decorative Arts in Paris. He was also responsible in the early 1950s for the efforts to revive Italian Futurism. Much of his work is characterized by an architectural structuring of color and form.

Baumeister, Willi
Born 1889, Stuttgart.
Died 1955, Stuttgart.

Educated in Stuttgart, where he studied at the Academy of Fine Arts under the noted color theorist Adolf Hölzel. In 1911 and 1914 made trips to Paris, second one with Schlemmer. Was associated with gallery Der Sturm in Berlin from 1912 and participated in its first Herbstsalon in 1913. His first abstract paintings, executed in 1919, showed architecturally geometric structure. As a result of that series (*Mauerbilder*), he came into contact with Le Corbusier, Ozenfant, and Léger, He evolved a personal idiom which incorporated geometric and machine forms into figurative and abstract compositions, where he also at times explored textural possibilities through the use of different materials added to the surface. At the time he showed interest in the Neoplastic and Constructivist theories. In 1928 he was appointed professor of graphic arts at the School of the Staedel Museum in Frankfurt am Main, where he remained until 1933. His work was first exhibited in the U.S. through the Société Anonyme in 1926 in its Brooklyn show; in 1927 he exhibited in Paris. He became a member of Cercle and Carré in 1930 and its successor Abstraction-Création in 1932. By 1937 his style had changed significantly. During the Hitler period his work was banned in Germany, but beginning in 1945 he again became active as artist and teacher.

Beekman, Chris Hendrik

Born 1887, The Hague.
Died 1964, Amsterdam.

In 1900 he began to study ceramics and painting and from 1907 on focused entirely on painting. His early work was influenced by the Hague school and—following his 1913 trip to Paris—by Neo-Impressionism. Upon his return to the Netherlands in 1914 he met Bart van der Leck and through him became associated with de Stijl. As a member of the Dutch Communist party he fostered a closer involvement of de Stijl in politics, promoting the idea of a link between nonfigurative art and proletarian revolution. In 1919–1920 he was active in the campaign to establish contacts with the avant-garde artists in the Soviet Union; in particular he was instrumental in beginning correspondence with Malevich. By 1923 Beekman had become dissatisfied with the strict geometries of de Stijl and returned to the figurative.

Béothy, Etienne (Istvan)

Born 1897, Heves, Hungary.
Died 1962, Paris.

Originally trained in Hungary, where in 1918 he began to study architecture at the Budapest School of Architecture. There he met Moholy-Nagy and joined the MA group founded by him. Developed interest in Constructivism. In 1920 gave up architecture and for four years studied fine arts at the Budapest Academy of Art. Traveled to Vienna, Italy, and Munich. In 1925 settled in Paris, where in 1931 he was one of the cofounders of the Abstraction-Création group. After World War II he participated in the efforts to revive geometric abstraction through active involvement with the Réalités Nouvelles. Beginning in 1952 was a professor at the Ecole des Beaux-Arts in Paris. His sculpture showed a strong Constructivist tendency.

Berlewi, Henryk

Born 1894, Warsaw.
Died 1967, Paris.

Studied at the Academy of Fine Arts in Warsaw 1906–1909; Académie des Beaux-Arts in Antwerp 1909–1910, and Ecole des Beaux-Arts in Paris 1911-1912. In Paris he became interested in Cubism and after his return to Warsaw in 1913 in Futurism and later Dada. His work underwent crucial change brought about by his meeting with Lissitzky in Warsaw in 1921 and the influences absorbed during a year's stay in Berlin, where he was an active participant in the international avant-garde movement. He was a member of the Novembergruppe, a participant in the International Congress of Progressive Artists in Düsseldorf in 1922, and subsequently his works were shown at the Grosse Berliner Kunstausstellung in 1923. At that time he formulated his concepts of "Mechano-Faktura"—an abstract idiom based on dynamically or statically arranged geometric figures (squares, rectangles, and circles) either in uniform color or with rows of white or black dots creating an optical illusion of vibrating forms. His tenets of "Mechano-Faktura"—first published in a booklet in Warsaw in 1924 and later in the *Der Sturm* magazine—originated in his fascination with the machine and principles of machine-production, as well as belief in objective values of geometric forms. His "Mechano-Faktura" compositions were first shown in March 1924 at his one-man show at the Austro-Daimler showroom in Warsaw, then at the first collective showing of the Polish Constructivist group Blok (with whom Berlewi collaborated closely), and later in Berlin in August 1924. During the next few years, through his advertising agency Reklama Mechano, he produced some of the most advanced examples of Constructivist graphic designs and pictorial typography. Around 1926 his involvement extended to theater design and small architectural forms. He settled in Paris in 1928 and abandoned his investigations of abstract form, to resume them again after 1947, when he began to

experiment with rhythmical forms resulting in optical illusion. This work was included in the "The Responsive Eye" exhibition, which introduced perceptual ("optical") art to the public in 1965 at The Museum of Modern Art, New York.

Berthot, Jake

Born 1939, Niagara Falls.
Lives in New York City and Maine.

Attended Pratt Institute in Brooklyn 1960–1962 and the New School for Social Research in Manhattan 1960–1961. His work has been widely exhibited in recent years in New York, Boston, San Francisco, and Philadelphia, and abroad in London, Paris, Hamburg, and Venice.

Biederman, Charles

Born 1906, Cleveland.
Lives in Red Wing, Minnesota.

At sixteen apprenticed in commercial art studio in Cleveland; attended the School of the Art Institute of Chicago from 1926 to 1929 and remained in Chicago until 1934. During that time his art was influenced by Cézanne and the Cubist works of Picasso and Gris. His first totally abstract works appeared in 1934; that year he moved to New York and met George L. K. Morris, A. E. Gallatin, Léger, and Pierre Matisse, at whose gallery he familiarized himself with the art of Léger, Mondrian, and Miró. At the end of 1935 he began wood reliefs, some with geometric designs. A year later he traveled to Paris, where he remained from October 1936 to June 1937, meeting Mondrian, Vantongerloo, Pevsner, Arp, Brancusi, Domela, and Miró and renewing contact with Léger. Pevsner's Constructivist ideas in particular had an important impact on Biederman's work. When he returned to New York (1937) he abandoned painting for construction, feeling dissatisfied with the traditional pictorial medium of the

European artists. His works of that time combined influences from Constructivism and de Stijl, translated into his Structuralist relief, and around 1939 a more pronounced relationship to the work of Mondrian is evident. In the early forties he distances himself from the Neoplasticist model and leans toward certain Constructivist ideas of Gabo and Pevsner. His most original work at that time became his explorations of color principles in his mature Structuralist reliefs. The concept of Structuralism was developed by Biederman as a method of presenting the transformations of the structural formations underlying natural forms, in terms of pure geometric forms. His theoretical concepts of the evolution in art were published in 1948 as *Art as the Evolution of Visual Knowledge,* a book begun in 1938 and inspired by a seminar he attended that year in Chicago.

Bill, Max
Born 1908, Winterthur.
Lives in Zurich.

Architect, painter, sculptor, printmaker, and industrial designer, originally trained as silversmith at the School of Applied Arts in Zurich and then at the Bauhaus (1927–1929). He was particularly influenced by the works and ideas of Albers and Moholy-Nagy. In 1929 he established himself in Zurich, where he has been active since. He was a member of the Abstraction-Création group from its beginnings in 1931 until its dissolution in 1936, contributing both to its exhibitions and publications. In 1944 he organized the first international exhibition of "Concrete Art" in Basel. He taught at the School of Applied Arts in Zurich (1944–1945), at the Department of Architecture of the Technische Hochschule in Darmstadt (1948), and later helped found the Hochschule für Gestaltung in Ulm (1951). In 1957 he established his design and architecture office in Zurich. In his multidisciplinary work he has always pursued the Bauhaus ideal of the unification of fine and applied

arts. His sculpture, which he began making in 1932, has always been concerned with spatial definition and characterized by clarity of form. During the late 1930s and early 1940s his mathematical interests led him to develop sculptural concepts based on topological and mathematical principles that resulted in repetition and variation of forms in different materials.

Bolotowsky, Ilya
Born 1907, St. Petersburg.
Died 1981, New York.

Educated at St. Joseph College in Istanbul, where his family moved from Baku (in the Caucasus) after the Russian Revolution. Arrived in the U.S. in 1923 and studied at the National Academy of Design in New York (1924–1930). The first major influences that changed the course of his idiom toward abstraction were those of Russian Constructivist works, with which he became familiar around 1929, and those of Mondrian and Miró a few years later. In 1932 he traveled in Europe. After returning to the U.S. worked first in the Public Works of Art Project and from 1936 to 1941 in the Mural Division at the Federal Art Project of the WPA, under the supervision of Burgoyne Diller, painting numerous murals. His work for the Williamsburg Housing Project was among the first abstract murals in the U.S. Bolotowsky joined the exhibition group The Ten in 1935 and the next year helped organize the American Abstract Artists association.

The years 1927–1944 were the period of greatest diversity and change in his work. His early figurative and semiabstract style, showing influences of Klee, Braque, and Arp, evolved into abstract compositions combining biomorphic forms and then into increasingly severe configurations of strict geometric forms in pure colors clearly indebted to the influence of Mondrian, whose work first came to Bolotowsky's attention in 1933. His personal Neoplastic idiom developed throughout the next fifteen years. Mondrian's impact on

his style was enhanced by Mondrian's arrival in the U.S. in 1940. Bolotowsky's work of the mid-1930's and 1940's was also influenced by the Suprematism of Malevich, whose planar structure and dry precision and austerity of form attracted Bolotowsky. Toward the end of the 1940s he began experimenting with unusually shaped canvases: tondos, ellipses, trapezoids. Besides painting, Bolotowsky also devoted himself to teaching and in 1946 replaced Albers for two years at Black Mountain College in North Carolina; from 1948 to 1957 he taught at the University of Wyoming, and later in colleges and art schools in the New York area. In the 1950s his distinctive idiom became painted columns. His personal version of geometric abstraction containing elements of Neoplasticism and Constructivism was also translated into three-dimensional form in the sculptures conceived after 1961.

Bortnyik, Alexander (Sandor)
Born 1893, Marsvasarhely, Hungary.
Died 1976, Budapest.

Settled in Budapest in 1910 and around 1912 studied at the private school directed by Josef Rippl-Ronai and Karol Kernstok. Exhibited his first painting at the Budapest National Salon in 1916. Belonged to a circle of Hungarian Constructivists grouped around Moholy-Nagy, Kassak (whom he met in 1916), Laszlo Peri, and the journal *MA* (Today). His early works were done in a Cubo-Futurist style and in subject matter related to his political ideals of social revolution, which he pursued as an ardent Communist. In 1920, following the overthrow of the socialist government in Hungary, Bortnyik moved to Vienna and joined Kassak and his revived *MA* journal. Remained there until 1922, then settling for three years in Weimar (where he came in contact with the Bauhaus), and returning to Budapest in 1925. In 1922 he exhibited with Der Sturm in Berlin and later in other German galleries. His work of that period shows

influences of International Constructivism, best exemplified in his almost abstract *Painting Architecture* series (1921–1923). His work was shown in the U.S. through Katherine Dreier's Société Anonyme. After his return to Budapest Bortnyik was active in painting, theater design, graphic design, art criticism, and teaching, founding in 1928 a private school Mühely (Studio), which lasted ten years and was considered to be the Hungarian Bauhaus. After World War II until his death he continued to play an active part in the artistic life of Budapest, as artist, critic, and educator.

Braque, Georges
Born 1882, Argenteuil-sur-Seine.
Died 1963, Paris.

Began first drawing lessons around 1897 in the evening classes of the Ecole des Beaux-Arts at Le Havre (where the family had moved in 1890). Two years later became an apprentice to a house painter at Le Havre, continuing evening classes in painting. In 1900 moved to Paris to continue his apprenticeship as *peintre-décorateur* and attended art classes at the Cours Municipal at Les Batignolles. At that time learned the techniques of painting simulated textures and surfaces as well as hand-lettering and sign painting. In 1901–1902 fulfilled his military service at Le Havre. Settling in Paris, he enrolled at the Académie Humbert and in 1903 was briefly at the Ecole des Beaux-Arts (under Léon Bonnat).

At the 1905 Salon d'Automne he was introduced to the work of the Fauves, and in summer 1906 he painted his first Fauve works, continuing to paint in Fauve manner for two years. His early Cubist period developed under the influence of Cézanne (whose posthumous retrospective took place in 1907). In 1909 his friendship with Picasso strengthened; their collaboration during 1910–1912 resulted in formulation of the new conception of Analytic Cubism. In 1911 began to use stenciled letters and numbers. Spent summer in Ceret with Picasso, painting in close collaboration. At Sorgues in 1912 in-

vented "papiers collés" and introduced imitation textures—innovations that precipitated Synthetic Cubism (1912–1914). Fought in World War I; wounded, discharged in 1916. Settled in Sorgues and Paris.

From 1917 to early 1920s his style became flatter and more variegated in color. From mid-1920s he worked in an idiom based on figurative elements. He continued to paint actively until the end of his life, refining his composition, drawing, texture, and color. His work was subject of many retrospectives and was included in numerous international exhibitions. Recently, a major exhibition of his papiers collés was held at the National Gallery of Art in Washington, D.C. (1982); organized in collaboration with the Musée National d'Art Moderne in Paris, it was accompanied by a catalog containing extensive biographical material and in-depth discussion of Braque's important contribution to the development of Cubism.

Buchheister, Carl
Born 1890, Hannover.
Died 1964, Hannover.

Essentially self-taught, except for a six-month period at the Berlin Academy of Applied Arts in 1918; in 1919 turned to painting full time. Renouncing formal instruction in Berlin, returned to Hannover, where he remained for the rest of his life. In 1921 met Kurt Schwitters, whose work, along with that of Lissitzky, van Doesburg, Kandinsky, and Moholy-Nagy (associated with the Kestner-Gesellschaft), had an important impact on his development. By 1923, he was working in a lyrical abstract style; in 1926 he embraced the geometric style. Also in 1926, he had his first one-man show at Der Sturm Gallery in Berlin and participated in the International Exhibition of Modern Art at the Brooklyn Museum organized by Katherine Dreier. He founded Die Abstrakten-Hannover with Schwitters, Rudolf Jahns, and César Domela as a branch of the Berlin-based international Vereinigung der

Expressionisten, Futuristen, Cubisten and Konstruktivisten. He was also a member of the Novembergruppe in Berlin and the Parisian group Abstraction-Création. With the 1933 Nazi ban on abstract art and the inclusion of his work in their "Degenerate Art" exhibition in Berlin in 1937, Buchheister withdrew from the public scene and worked in isolation, painting landscapes and portraits. He participated in World War II and returned to Hannover in 1945. He continued to paint, exhibit, and teach.

His early Constructivist works of the mid-1920s show balance of forms and mathematically calculated proportions, with the rigidity of the system modified by different manipulations of color planes and rhythmic variations of lines. After 1928 he introduced into his works greater variety of texture, through the use of three-dimensional materials (in the manner of the Russian Constructivists, Moholy-Nagy, and Schwitters) and by creating more complex spatial relationships, often employing a diagonal.

Chashnik, Ilya Grigorievich
Born 1902, Lyucite, Latvia.
Died 1929, Leningrad.

Lived in Vitebsk from 1903; there he studied art with Yurii Pen from 1917 to 1919. Began to attend Vkhutemas in Moscow in 1919 but soon returned to the Vitebsk Practical Art Institute to study with Chagall, then head of the Institute. Became a pupil and follower of Malevich and his Suprematist style when Malevich took over control of the Institute from Chagall in the winter of 1919–1920. Was one of the organizers of Malevich-headed Posnovis group (Followers of the New Art), later renamed Unovis (Affirmers of the New Art). Chashnik's work was included in all Unovis exhibitions. Worked closely with many avant-garde artists: Ermilov, Klucis, Lissitzky, Khidekel, Ermolaeva, Suetin. When in 1922 Malevich, forced out of Vitebsk, moved to Petrograd, Chashnik (along with Suetin, Ermolaeva, and Yudin) joined him and from

1924 assisted at the Petrograd Ginkhuk with developing his Suprematist architectural models, Arkhitektons, at the same time evolving his own architectural ideas. He also worked with Suetin at the Lomonosov State Porcelain Factory, making Suprematist china designs, and executed numerous ceramic, textile, and book-cover designs. In 1923 he was a researcher at the Museum of Painterly Culture, and that year he participated in the "Exhibition of Paintings of Petrograd Artists of All Tendencies." In 1925 he became a research associate at the Decorative Institute and during 1925–1926 collaborated with Suetin and the architect Alexandr Nikolsky. Chashnik's Suprematist paintings and watercolors, although clearly under the influence of Malevich's Surpematist works, indicate personal understanding of the Suprematist principles and, compared with Malevich's work, show greater concentration of forms in the center of the composition and stronger adherence to vertical-horizontal positioning, sometimes developing into overall abstract designs.

Crotti, Jean
Born 1878, Bulle, Switzerland.
Died 1958, Paris.

Began to study painting in 1896 in Munich. In 1901 moved to Paris and studied for a year at the Académie Julian (under Jules Lefebvre); after that abandoned formal instruction. Traveled to Italy in 1905 and 1912. Started to exhibit regularly at the Salon des Indépendants in 1908 and at the Salon d'Automne in 1910. Maintained contacts with the Cubists and the group around Jacques Villon. An important influence for his artistic development was his trip in 1915 to New York, where he joined the Dada group including Picabia and Man Ray and worked closely with Duchamp. As a result produced mechanical drawings, collages on glass and metal, and wire constructions. In 1919 he visited Vienna. He made two other trips to New York, in 1921 and 1938. By 1923 his interest in Cubism had

diminished, and he turned to a more sculptural, less abstract style. Also invented a new technique of painting on glass—"Gemmaux" —which he used during the 1930s and 1940s to reproduce the works of the leading French modern artists.

Dekkers, Ad
Born 1938, Nieuwport, Netherlands.
Died 1974, Gorcum, Netherlands.

From 1954 to 1958 studied at the Art Academy in Rotterdam. He was influenced by the work of Ben Nicholson and Mondrian. His early precise renderings of objects evolved into nonobjective all-white paintings and reliefs, wherein he experimented with the interrelations of light, form, and space. He was also interested in systematization of sensation in both drawing and sculpture.

Delaunay, Robert
Born 1885, Paris.
Died 1941, Montpellier.

At seventeen apprenticed in a set designer's studio at Belleville, where he remained for two years. He then devoted himself entirely to painting and exhibited his first landscapes, done in the Impressionist manner, at the Salon des Indépendants of 1904. During 1905–1909 he worked in the Neo-Impressionist idiom. Strongly influenced by Seurat, he also studied the painting of Cézanne and in 1907 "discovered" the laws of simultaneous contrasts of colors through the famous book of Chevreul (of 1839). His brief involvement with Cubism (1909–1911) is marked by his St. Severin and Eiffel Tower paintings. In 1910 married the artist Sonia Terk, with whom he later collaborated on various decorative projects. The "destructive" Cubist phase was followed by the "Constructive" phase of investigations of chromatic and spatial relationships of color contrasts and their perception in time—concepts philosophically related

to the Bergsonian notion of continuity of movement through time and space. They resulted in the creation of his first abstract paintings, baptized "Orphism" by Apollinaire. These color abstractions, begun with the *Windows* series (1912) and the *Disks: Circular Forms* series (1913), were composed by juxtaposing diverse colored geometric forms that energized the canvas through their interaction. The concern of the work was color, rhythm, light, and motion—which remained the theme of Delaunay's work throughout his career and became particularly important with his *Rhythm without End* series of 1930–1935.

From his early years Delaunay was actively involved with the French and international avant-garde. He exhibited with the Blaue Reiter group in Munich at the invitation of Kandinsky (1911) and had a one-man show at Der Sturm gallery in Berlin in 1913. During World War I he lived in Spain and Portugal, returning to Paris in 1921. He temporarily abandoned abstract style, became involved with the theater and decorative design, and painted numerous portraits. Around 1930 he returned to the abstract idiom and also made his first abstract reliefs in plaster, later experimenting with materials like casein and cement. During the 1930s he participated with other artists and architects in various decorative projects such as pavilions for the Exposition Universelle (1937) and the Hall of Sculpture for the Salon des Tuileries (1938).

Delaunay-Terk, Sonia
Born 1885, Ukraine.
Died 1979, Paris.

A great colorist, versatile painter, gifted designer, and above all an active contributor to different areas of modern art during the most creative period of the School of Paris, and a close collaborator of her husband, Robert Delaunay, she began to study painting and drawing in Karlsruhe (Germany) in 1903. In 1905 arrived in Paris and enrolled at the Académie de la Palette, meeting there among others Ozenfant, Segonzac. There became acquainted with Fauvism and particularly

studied the work of van Gogh and Gauguin, whose influence is evident in her paintings of that period. She married Robert Delaunay in 1910 and shortly after, under his influence, abandoned the Fauve-Expressionist figurative style and turned to abstraction, showing particular feeling for vibrant color. In 1912 she became involved wth design, collaborating with Blaise Cendrars on the first "simultaneous" book, *La Prose du Transsibérien et de la Petite Jehanne de France,* and showed great originality in decorative and applied arts (textile, poster, and costume designs). From 1913 on her work was characterized by geometric form and vivid color. Many of her decorative works related in motif to her painted works. After the death of Robert Delaunay in 1941 until her return to Paris in 1945 at the end of World War II, she was closely associated with Arp, Sophie Taeuber-Arp, and V. Magnelli—the "Groupe de Grasse." At that time her vivid palette was modified by the addition of black. Upon her return to Paris she exhibited with the Art Concret group and also helped to found the Salon des Réalités Nouvelles. She continued to paint and publish her graphic works until her death, continuing the early themes of "colored rhythm" and "endless rhythm" expressive of her concerns with movement, light, and pure color.

Dexel, Walter
Born 1890, Munich.
Died 1973, Braunschweig.

Initially trained as art historian in Munich, where he studied 1910–1914 with Heinrich Wölfflin. After his graduation in Jena in 1916 acted as Director of the Jena Kunstverein. Executed his first paintings around 1912. Developed contacts, 1919–1925, with the Bauhaus and the avant-garde members in Weimar; also from 1918 on maintained relations and exhibited with Der Sturm gallery in Berlin. Met Theo van Doesburg in 1921 and with him initiated the Weimar Dada-Con-

structivist Congress in the autumn of 1922. His art evolved along the principles of Neoplasticism and Constructivism, making use of geometric forms and flat colors in rigorously organized compositions. From his early years he also worked on stage design; throughout the 1920s executed numerous typographical designs and worked as advertising consultant for the city of Frankfurt. After his art was banned by the Nazis in 1933, he devoted himself mostly to art education, teaching in Berlin from 1936 to 1942. From 1942 to 1955 he was director of the Historical Form collection in Braunschweig. Remaining in Braunschweig, he resumed painting in 1961.

Diebenkorn, Richard
Born 1922, Portland, Oregon.
Lives in California.

Studied at Stanford University and University of California at Berkeley from 1940–1943, and in 1946 (after two years of service in the Marine Corps) at the California School of Fine Arts, where he began teaching a year later (continuing until 1950). In 1948 had his first one-man show at California Palace of the Legion of Honor in San Francisco. Received in 1952 a master's degree in art from University of New Mexico, where studied for two years. In 1952–1953 taught at the University of Illinois in Urbana; at California College of Arts and Crafts 1955–1957; and at San Francisco Art Institute 1959–1963. He had a retrospective at the Pasadena Art Museum in 1960 and received an award from the National Institute of Arts and Letters in 1962. A year later was artist-in-residence at Stanford University (1963–1964). His work was subject of a retrospective in 1964 at the Washington Gallery of Modern Art in Washington, D.C. In 1966 became professor of art at the University of California in Los Angeles. For the last two decades he has shown in innumerable exhibitions in the U.S. and Europe, and his work is included in many public and private collections.

Diebenkorn's early work (1943 on) grew out of the American tradition of Hopper and the vernacular American townscape subjects of Sheeler and O'Keeffe in the 1920s; his later work of the 1940s and until 1955 was associated with the Abstract Expressionist movement and was based on landscape motifs. His style was formed under the influences of the modernist tradition from Manet to Matisse to Mondrian, absorbed from the works he studied at the Phillips Collection in Washington during his military service. Around 1956 he began to paint figure subjects. His work revealed the lessons he had learned from Hopper and Matisse; the sculptural qualities of the figure were offset by an emphasis on the flatness of the picture surface, achieved through a spatial organization exploiting horizontal bands of pure color. He stopped painting figurative works around 1966 and began to work in an abstract idiom, invoking feeling through color, space, and proportion and structural integration of all visual elements. In 1967 he began his famous Ocean Park series of paintings, characterized by a vertical format, large scale, sensuous color, internal linear elements, and often rectangular grid within a planar flatness, stressed through the tensions of geometric divisions which form the basic structure. He continues to explore the subject, searching for new possibilities both in painting and in works on paper.

Diller, Burgoyne
Born 1906, New York.
Died 1965, New York.

One of the first purely abstract American artists and a leading American exponent of Neoplasticism, Diller grew up in Michigan and attended Michigan State University in East Lansing. He began to draw and paint in 1920 and while in college frequently visited the Art Institute of Chicago to study the Impressionist and Post-Impressionist paintings, of which at first Seurat's and then Cézanne's works were of particular influence on his development. He

moved to New York in 1928 and enrolled at the Art Students League in 1929, studying there for five years under different teachers: Jan Matulka, George Grosz, Hans Hofmann.

His early works clearly indicated the influences of Analytic and Synthetic Cubism combined with those of German Expressionism and Kandinsky, mostly known to him through book and magazine reproductions. By 1933 Diller had evolved his geometric abstract style, informed by the Neoplasticism of Mondrian and van Doesburg and the nonfigurative idiom of the Russian Suprematists and Constructivists, especially Malevich and Lissitzky. He also made his first relief constructions around 1934, using materials such as wood and masonite to project into real space (a practice reminiscent of Russian Constructivism). From 1935 to 1940 he was supervisor of the Mural Division of the Federal Art Project of the WPA for the New York region and was thus able to secure mural commissions for Bolotowsky, Davis, Gorky, Matulka, and Byron Browne, among others. He was a member of the American Abstract Artists from their beginning in 1937 and showed with them until 1939. After the war, in 1945, he became an instructor of design at Brooklyn College (remaining until 1964), and had studio in Atlantic Highlands, New York.

In his later years he seemed to divide his paintings into three groups: "First Theme," where the mostly rectangular elements in pure color are anchored to a monochromatic background (white in the early works); "Second Theme" (1943), where the rectangular elements of pure color are tied together by a grid; and the "Third Theme" (begun around 1945), based on a complex grid structure developed through the use of tape (clearly an influence of late Mondrian, "Boogie Woogie" works of 1942–1944) into compositions of elements and colors in flux.

van Doesburg, Theo
Born 1883, Utrecht.
Died 1931, Davos, Switzerland.

A self-taught artist, began painting in 1889 and in his early work was influenced by the old masters, Impressionism, Fauvism, German Expressionism, and the work of Kandinsky. He painted his first abstract works in 1916 (developed as geometric abstractions of landscape and still-life subjects). In 1915 he began correspondence with Piet Mondrian and in 1917 cofounded with him, the architects J. J. P. Oud and Jan Wils, and poet Anton Kok the magazine *De Stijl,* which appeared until 1932. Beginning in 1912 he was also a prolific art critic, writer, and lecturer on subjects related to painting, sculpture, architecture, city planning, music, literature, typography, and applied arts. After World War I he actively disseminated the precepts of de Stijl through his frequent trips to Belgium, Germany, Italy. In 1921–1922 he established close ties with the Bauhaus and in the course of 1922, attracted by the ideas and ideals of Russian Constructivists, attempted, in collaboration with Lissitzky and Richter, to establish Constructivism as a formal international movement, first at the Düsseldorf Congress of Progressive Artists (May 1922) and then at Weimar Congress (September 1922). He moved to Paris in 1923 to help organize an exhibition of de Stijl architecture at the Léonce Rosenberg gallery L'Effort Moderne. Under the influence of his architectural work he developed in 1924–1925 the concept of Elementarism in painting—the style which introduced a diagonal into the rectilinear Neoplastic composition to permit the temporal and dynamic perception of the composition. As a result of this Mondrian withdrew from de Stijl in 1925. The principles of Elementarism were soon after applied by van Doesburg in his project for the reconstruction of the Café de l'Aubette in Strasbourg, executed in collaboration with Jean Arp and Sophie Taeuber-Arp in 1926–1928. This involvement with architecture again affected his pictorial work, result-

ing in his Counter-Constructions. To reaffirm his doctrinaire stand regarding the principles of geometric art and in response to the creation of the group of abstract artists Cercle and Carré (1930), van Doesburg founded, in collaboration with Hélion, Carlsund, and Tutundjian, the review *Art concret* (1930), in which they stressed the importance of mathematics and measurement as concrete elements of art.

Ermilov, Vasily Dimitrievich
Born 1894, Kharkov.
Died 1968, Kharkov.

Studied at the School of Decorative Arts during 1905–1909, then at the School of Painting in Kharkov 1910–1911. In 1913 worked with the Russian "Fauve" painter Ilya Mashkov in the latter's studio in Moscow. His first Cubo-Futurist compositions were executed in 1914, and early that year he became an active participant in avant-garde events (e.g., discussions with Marinetti during his visit to Russia). After the interruption of artistic activity caused by World War I, he returned to Kharkov in 1917 and two years later exhibited his first Suprematist canvases. He remained in Kharkov for the rest of his life and was instrumental in making that city the last outpost of Constructivism in the Soviet Union, where the last progressive art reviews were published—*Avant-Garde* and *New Generation*—with articles by such artists as Malevich and Matiushin and with information about Western art developments, the Bauhaus, etc. From 1918 to 1922 Ermilov was in charge of the Studio of the Decoration of the City and executed posters and other propagandistic displays such as the "Red Ukraine" propaganda train. He became an instructor at the Kharkov Technikum of Art in 1922. By that time he was producing Constructivist works, often experimenting with different materials (wood, metal, etc.) and different textures, and at times using a diagonal to introduce a dynamic quality into

the composition. His activities were largely focused on designing constructions for public use (kiosks, public platforms, propaganda billboards), typography, and theater design. In the Khrushchev era, as one of the very few avant-garde artists active in the Soviet Union, Ermilov was given a retrospective—in Kharkov in 1963.

Exter, Aleksandra Aleksandrovna

Born 1882, near Kiev.
Died 1949, Fontenay-aux-Roses, France.

One of the more important and active members of the Russian avant-garde, who through her Western contacts contributed to the dissemination of Cubism and Futurism in Russia as well as to the elaboration of Cubo-Futurist and Constructivist ideas. She graduated from the Kiev Art School in 1906 and first exhibited in Moscow in 1907 with the Blue Rose group. In 1908 Exter made her first trip to Paris; until 1914 she spent part of every year there, also traveling extensively in Europe, particularly Italy. In Paris she first studied at the Académie de la Grande Chaumière and in 1909 set up her own studio. She became acquainted with Braque, Picasso, Apollinaire, Marinetti and in the spring of 1914 shared a studio with the Italian Futurist Ardengo Soffici. She also frequented the Academy Vasiliev, where Léger gave two important lectures on modern art. On her trips to Russia she visited Moscow and Kiev and from 1908 to 1914 participated in most of the important Russian avant-garde exhibitions: "New Trends" (St. Petersburg, 1908), "Link" (Kiev, 1908), the first Izdebsky Salon (Odessa and Kiev, 1909–1910), the second Izdebsky Salon (St. Petersburg and Riga, 1910–1911), Union of Youth (Riga, 1910, and St. Petersburg, 1913–1914), The Ring (Kiev, 1914), "No. 4" (Moscow, 1914), and also all of the Jack of Diamonds exhibitions from 1910 to 1916. In Paris she exhibited at the Salon des Indépendants (1912) and the Section d'Or (1912), and in Rome at the

"Esposizione Libera Futurista Internazionale" at the Galleria Sprovieri (1914). Her work at that time showed an assimilation of Cubist and certain Futurist principles with an added interest in decorative color and rhythm, all fused into a personal Cubo-Futurist idiom.

After 1914 she developed a more fully abstract style, often making use of large planes of color. In 1916 she began her experiments in theatrical design, which continued until 1924. Her sets, based on movable three-dimensional geometric forms and complemented by the dynamic action of the lights, constitute some of the best examples of Constructivist theatrical design. Between 1914 and 1924 Exter further participated in the activities of the avant-garde, showing her work at "Tramway V" (Petrograd, 1915), "Magazin" (Moscow, 1916), and the allegedly last exhibition of painting, "5 × 5 = 25" (Moscow, 1921). Although she taught at the Vkhutemas from 1920 to 1922 and actively participated in developing Constructivist ideas and pictorial experiments in "Construction," she never supported the extreme Constructivist stance of rejecting easel painting as artistic expression. Her works of that period combined flat color planes with linear elements, exploring different structural possibilities to achieve a dynamic construction.

During 1917–1918 in Odessa and 1918–1921 in Kiev she also taught at her own studio, and among her pupils in Kiev were Pavel Tchelitchew, Isaak Rabinovich, Anatolii Petritsky, who later became known for their outstanding stage designs. Exter's studio also executed abstract designs for propagandistic and decorative purposes (e.g., for the first anniversary of the Revolution, and for the pavilions at the All Russian Agricultural Exhibition in Moscow, 1923). In 1923 Exter worked on perhaps her best-known film project: the scenery and costumes for Yakov Protozanov's science-fiction film *Aelita*. Exter emigrated to France in 1924 and continued to be active as theatrical designer.

Fontana, Lucio

Born 1899, Rosario de Santa Fe, Argentina.
Died 1968, Comabbio, Varese, Italy.

Arrived in Milan in 1905 and later became a stoneworker. Studied painting at the Brera Academy 1927–1929. From the beginning created abstract works. In 1934 joined the Paris-based group Abstraction-Création. From 1939 to 1947 Fontana lived in Argentina, where in 1946 he published his famous *White Manifesto* calling for a new form of art, "Spazialismo," which was to explore new materials and their expressive possibilities to convey "motion, evolution, and development." His works explored voids of space and through the use of slashes and punched holes in the surface created spatial ambiguity. After 1951 he added new elements—strokes of paint, or colored stones—to increase these spatial ambiguities. Subsequently expanded his works into sculptures and environments.

Freundlich, Otto

Born 1878, Pomerania, Germany.
Died 1943, Lublin, Poland.

Originally studied art history with Wölfflin in Munich, then sculpture in Munich, Florence, and Paris. His first works were done in Florence around 1905. He settled in Paris in 1909 at the "Bateau-Lavoir," along with Picasso and Herbin; also met Braque, Gris, and Max Jacob. He lived in Cologne during World War I and in Berlin from 1918 to 1924, during that time exhibiting there as well as in France and Amsterdam. His first nonfigurative works date from 1919. Returned to Paris from Germany in 1924, where he became a member of the Cercle et Carré group (1930) and Abstraction-Création (1932–1935). He had his first one-man show in 1931 at the Galerie de la Renaissance and a retrospective at the Galerie Jeanne Bucher in Paris in 1938. Stylistically his work showed an assimilation of Cubism and Constructivism. Following the outbreak of World War II he was arrested and deported to Poland, where he died in a concentration camp.

Gabo, Naum (Naum Neemia Borisovich Pevsner)

Born 1890, Briansk, Russia.
Died 1977, Waterbury, Connecticut.

After his graduation from the Gymnasium in Kursk in 1910, went to study medicine at the University of Munich, but in 1912 transferred to the Munich Polytechnicum to study engineering. Attracted to art, he attended the art-history lectures of Wölfflin. In 1913 and 1914 he traveled to Paris to visit his older brother Antoine Pevsner (to avoid confusion with him, took the surname Gabo). While there met Archipenko and studied Cubist painting. At the outbreak of World War I he went with his younger brother Aleksei to Copenhagen and then to Norway, where in 1915 he executed his first open constructions made of planar elements assembled in a way to reveal internal structure and to dynamically integrate the interior and exterior space (e.g., *Head*, 1920, The Museum of Modern Art). He returned to Moscow in 1917, taking an active part in avant-garde events and debates. His brother Antoine was teaching at the State Free Art Studios, Vkhutemas, and Gabo worked in his studio. In 1920 he formulated his artistic ideas in the *Realist Manifesto* (cosigned by his brother Antoine), published on the occasion of their open-air exhibition on Tverskoi Boulevard in Moscow. The manifesto renounced the traditional forms of sculpture in favor of dynamic construction based on interaction of new materials, elemental forms, and space, but defended purely artistic creation in opposition to the highly utilitarian imperatives championed by Tatlin and Rodchenko. As a result of his disagreements with the artistic left, Gabo went to Berlin and remained there until 1932. There he was associated with the Novembergruppe and maintained contact with the Bauhaus. He lectured in Germany and Holland and exhibited in France (Galerie Percier, Paris, 1924) and the U.S. (Little Review Gallery, New York, 1926). In 1927 he and Antoine created Constructivist sets for Diaghilev's ballet *La Chatte,* thus introducing audiences in Monte Carlo, London, Paris, and Berlin to the new principles and materials in set design. Gabo continued to work on his spatial constructions, exploring new materials such as transparent plastics and also metal and glass. His recent constructions were shown in his one-man exhibition at the Kestner Gesellschaft in Hannover in 1930. Gabo left Berlin for Paris in 1932; he joined the group Abstraction-Création and in 1935 moved to London. There he participated in the activities of Herbert Read's Design Unit One, and with J. L. Martin and Ben Nicholson published in 1937 an important volume, *Circle: International Survey of Constructive Art.* He remained in London until 1946, when he moved to the U.S., settling in Middlebury, Connecticut; he continued, however, to spend much time in London. His work was largely known in America from the early 1920s through Katherine Dreier's Société Anonyme collection and later through his sculpture at The Museum of Modern Art.

Glarner, Fritz

Born 1889, Zurich.
Died 1972, Locarno, Switzerland.

Spent much of his youth in France and Italy, where his family moved in 1904. There he studied, from 1914 to 1920, at the Regio Istituto di Belle Arti in Naples. He moved to Paris in 1923 and became acquainted with contemporary progressive movements, frequenting a circle of modern artists including the Arps, the Delaunays, Hélion, Léger, van Doesburg, Mondrian. His early paintings were influenced by Impressionism; gradually, during the late 1920s and 1930s, his work evolved into abstract compositions that focused on the interrelationship of form and space. In 1930–1931 Glarner lived for several months in New York (with his American wife), had a one-man show, and contributed to the international exhibition of abstract art of the Société Anonyme at the Albright-Knox Gallery in Buffalo. In 1931 he returned to Europe, became a member of the Abstraction-Création group and the Allianz (Association of Swiss Constructivists). At the outbreak of the Spanish Civil War, Glarner emigrated to New York, where from 1938 to 1944 he participated in annual exhibitions of the American Abstract Artists, while forced to support himself as a portrait photographer. His painting matured in the mid-1940s essentially under the influence of Mondrian, with whom he formed a close friendship after Mondrian's arrival in New York in 1940. He also maintained friendly relations with artists such as Gabo, Moholy-Nagy, and Duchamp.

Glarner's mature idiom explored relations of forms in space, often employing diagonal elements and overlapping planes of primary colors, black, and variations of gray to create dynamic, vibrant compositions, called by him "relational paintings."

Gontcharova, Natalia Sergeievna

Born 1881, Ladyzhino, Tula Province, Russia.
Died 1962, Paris.

Educated at the Moscow Institute of Painting, Sculpture, and Architecture, where in 1898 she began to study sculpture with Pavel Trubetskoi, a disciple of Rodin, but in 1900 abandoned it for painting. At that time met her future lifelong companion Mikhail Larionov. After finishing school she first exhibited at the Literary and Artistic Circle in Moscow in 1904; in 1905–1907 participated in the exhibitions of the Moscow Association of Artists and in 1906 contributed to the Russian exhibition organized by Diaghilev at the Salon d'Automne in Paris. From 1907 to 1910 Gontcharova participated in three exhibitions of the "Golden Fleece" and in the "Wreath" (Moscow, 1908) and the "Link" (Kiev, 1908). She collaborated with Larionov and Lentulov in organizing the first Jack of Diamonds exhibition (1910), showed in the first and second Izdebsky salons in Odessa (1909–1910 and 1910–1911), participated in the exhibition of the World of Art group, as

well as the Union of Youth (1911–1912) and Larionov's exhibition "The Donkey's Tail" (1912), and was included in the Second Post-Impressionist Exhibition at the Grafton Galleries in London (1912). Through Kandinsky she exhibited with the Blaue Reiter in Munich. During 1912–1914 she collaborated with the Futurist writers Velimir Khlebnikov and Alexei Kruchenykh on several futurist booklets, for which she executed illustrations in Rayonist and Cubo-Futurist styles. She participated in various activities and debates of the Cubo-Futurist avant-garde, strongly promoted the national heritage—icons and folk painting—as the only proper source for developing a new national idiom, and was violently outspoken against Cubism and Western art.

In 1913 she organized with Larionov the exhibition "Target" and consigned with him and several others the "Manifesto of Rayonists and Futurists," published in the almanach *The Donkey's Tail and the Target*. That same year she sent her works to the First German Autumn Salon at Der Sturm Gallery in Berlin and also had a large one-person show (760 works) that first opened in Moscow and in 1914, in an abridged version, traveled to St. Petersburg. She participated in Larionov's "No. 4" exhibition in Moscow in 1914, and that year she and Larionov were given a joint exhibition at the Galerie Paul Guillaume in Paris.

Gontcharova was also involved with the theater, designing scenery for Diaghilev's *Le Coq d'or* Paris production (1914) and Tairov's Kamernyi Theater productions in Moscow. She left Moscow for Switzerland in 1915 at Diaghilev's invitation to design sets and costumes for his Ballets Russes and in 1917 settled permanently in Paris. She continued painting, but mostly designed theater decors and exhibited little.

Her most important pictorial works were done between 1908 and 1914, when she worked in a variety of styles: Neoprimitivism (1908–1910), characterized by boldly outlined flat forms in vivid colors, influenced by icons and folk broadsheets; Cubo-Futurism (1910–1912), which prompted some of her best works, highly personal interpretations of speed, motion, the machine and urban imagery; and finally Rayonism, responsible for almost purely abstract works (1913–1914).

Gorin, Jean
Born 1899, Saint-Emilion-de-Blain, France.
Lives in France.

Attended Académie de la Grande Chaumière in Paris 1916–1917; two years later moved to Nantes, where he studied at the Ecole des Beaux-Arts. His first paintings were executed around 1922 and until about 1924 showed the influence of Albert Gleizes. From 1925 on he developed an abstract idiom and became increasingly influenced by de Stijl. At that time he also began his earliest sculpture. He maintained correspondence with Mondrian and Vantongerloo and in 1927 visited Mondrian in Paris. In 1928 Gorin realized his first Neoplastic interiors, at Nantes and Nort-sur-Erdre. A year later he executed his first constructed wall reliefs, in primary colors with geometric forms. Gorin exhibited with the group Vouloir (founded by del Marle at Lille), the Cercle et Carré group in Paris (1930), Abstraction-Création (1932–1936), the group Renaissance Plastique (1939), and the Salon des Réalités Nouvelles (1946 on). In 1953 he cosigned a manifesto of the group Espace founded by del Marle. Major exhibitions of his work included a retrospective at the Musée des Beaux-Arts in Nantes (1965) and another retrospective at the Centre National d'Art Contemporain in Paris (1969).

Graeser, Camille
Born 1892, Geneva, Switzerland.
Died 1980, Switzerland.

Studied at the School of Applied Arts in Stuttgart from 1913 to 1915 and later worked in that city in an architect's studio (where for a time he was assigned to the Weissenhof Settlement, Stuttgart, designed by Mies van der Rohe). He returned to Switzerland in 1933 and developed interest in Constructivist art. Exhibited in international exhibitions from the mid-1920s on; Landesgewerbe Museum, Stuttgart (1926); Kunsthalle, Basel (1938); Réalités Nouvelles, Paris (1948, 1950); Kunstmuseum Winterthur (1958); Metropolitan Art Gallery, Tokyo (1959); "Art Abstrait Constructif International," Galerie Denise René, Paris (1961); Kunstverein Ulm (1964); and many others.

Greene, Gertrude
Born 1904, New York.
Died 1956, New York.

Self-taught, except for a two-year period (1924–1926) of formal instruction at the Leonardo da Vinci School in New York, under the sculptor Cesare Stea. In 1931 spent a year in Paris (with her husband, the painter Balcomb Greene) and came into contact with the concepts of Suprematism, Neoplasticism, Constructivism, and the biomorphism of the Surrealists, propagated by the Abstraction-Création group. She was among the founding members of the American Abstract Artists (1937) and a close friend of such geometric abstractionists as Bolotowsky, Byron Browne, G. L. K. Morris.

Greene's earliest works were figurative and three-dimensional; her style eventually evolved from Expressionist-Cubist toward relief constructions with an increasingly geometric framework. During the early 1930s she started to work in metal and wood, exploring the spatial interrelationships of forms and their implied movement. Among the diverse influences that shaped her personal style, the strongest stemmed from the African-inspired pieces in Brancusi's oeuvre, as well as ideas of Gabo and Mondrian. She was also especially affected by The Museum of Modern Art's 1936 exhibition "Cubism and Abstract Art," which included Suprematist canvases by Malevich and Constructivist works by Rodchenko and Lissitzky. In 1937 Greene's style underwent a change, combining geometric and free forms and developing toward

the box-motif configurations which continued until 1942 and were composed of flat rectangles and squares connected to diagonal projections. After 1942 she simplified her structures and worked within shallower space; this development paralleled her experiments in collage, begun around 1939. Mondrian remained an important influence on her work; his arrival in New York in 1940 strengthened her interest in his concepts and pictorial solutions.

In 1942 Greene moved to Pittsburgh and until her death divided her time between her studio there and New York. She also slowly abandoned constructions, turning to the investigation of architectonically built canvas compositions.

Held, Al
Born 1928, New York.
Lives in New York.

In 1948 enrolled at the Art Students League under the G.I. Bill after serving for two years in the U. S. Navy. At this time he was painting figurative works with political and social overtones. In 1949 went to Paris to study drawing at the Académie de la Grande Chaumière. Also studied sculpture with Zadkine. While in Paris, he saw Jackson Pollock paintings for the first time. Held wanted to incorporate Pollock's ideas and Mondrian's geometric forms in his work. In 1951 had his first exhibition in Gallery Eight, a gallery organized by American students in Paris. After this exhibition he decided that he was not pleased with these paintings (only one survives from the exhibiton), and did not paint again for a year.

When he returned to New York in 1953, he started painting with patterns and then leaned toward more structured shapes. In 1956 he was a founding member of the Brata Gallery on 10th Street, along with other artists including Bladen and Sugarman. A member of the New York School of Painting, he broke away from the ideas of Abstract Expressionism through the geometric simplification

of forms. Held, who has been linked with the color-field painters, did not eliminate texture. In the 1950s, he used heavy impastos to add to the power of his paintings. In the early 1960s he started to sand down the painted surfaces. In the summer of 1959 studied The Museum of Modern Art's exhibition "The New American Painting" and decided that he had to clarify the forms and edges in his paintings.

His work was included in exhibition "Systemic Painting" at the Guggenheim Museum. He based his paintings on the letters of the alphabet, such as *The Big N* (1965), at The Museum of Modern Art, where the "N," not really discernible in this nine-foot painting, is seen at its minimum on the top and bottom edge of the canvas—a device that helps to expand this painting to its largest scale. Beginning in 1967 and continuing for the next twelve years, Held painted only in black and white. He stated that he had hung his color paintings low because he wanted them to be related to the floor and to have a gravitational pull, whereas his black-and-white paintings lacked a gravitational relationship; the forms themselves interacted and produced their own gravity and their own space, which could be read in many different ways by the viewer.

Now Held has returned to painting in color; the forms and space are no longer ambiguous, and the viewer is drawn into the space. Although his style has changed throughout the years, it always retains a monumental quality.

Herbin, Auguste
Born 1882, Quiévy-à-la-Motte, France.
Died 1960, Paris.

Attended Ecole des Beaux-Arts at Lille from 1898 to 1901. Moved to Paris in 1901, where in 1904 he befriended the dealer Wilhelm Uhde, with whom in 1907 he traveled to Corsica and Hamburg. His early works were executed in Impressionist and later Fauve idiom. In 1909 he took a studio at the "Bateau-Lavoir" and became a friend of Picasso, Braque, and Gris. A Cubist period

followed in his work. His first geometric abstractions appeared around 1917, succeeded in 1923–1925 by a figurative idiom and then a return to the geometric style. His geometric style was based on investigation of the relationships of basic forms and pure colors as well as analogies of sound, letter, and color which formed his "plastic alphabet." Around 1920 Herbin belonged to the circle of artists associated with Léonce Rosenberg's gallery L'Effort Moderne, a circle that included Léger, Gris, Mondrian, and van Doesburg. He was a cofounder (with Vantongerloo) of the Abstraction-Création group in 1931 and from 1947 to 1955 was a member of the directing committee of the Salon des Réalités Nouvelles. He exhibited from 1946 at the Galerie Denise René in Paris and during his lifetime had a retrospective at the Palais des Beaux-Arts in Brussels in 1956 and in 1959 at the Galerie Simone Heller, Paris. These were followed by posthumous retrospectives at the Kunsthalle Berne and the Stedelijk Museum, Amsterdam (1963), and the Kestner Gesellschaft, Hannover (1967). Herbin was also the author of *L'Art non-figuratif non-objectif*, published in 1949, in which he expounded his color system.

Huszar, Vilmos
Born 1884, Budapest.
Died 1960, Hierden, Netherlands.

Studied art in Munich around 1900 at the Studio Hollosy, and after 1900 at the School of Decorative Arts in Budapest. Moved to Holland in 1905 and settled in Voorburg. In 1917 was cofounder of de Stijl with Mondrian, van Doesburg, and others and designed the cover for *De Stijl*, the magazine. Was deeply involved with the application of de Stijl principles to interior-decoration projects, furniture, and stained-glass designs. In 1923 collaborated with Rietveld on the exhibition interior for the Greater Berlin Art Exhibition. Left de Stijl group in 1923 and later pursued his career in graphic design and figurative painting.

His de Stijl works showed less rigid structure than those of Mondrian and van Doesburg, often making use of diamond, triangular, and trapezoid forms, which deflect the strong horizontal-vertical grid. Also, frequently the human figure appears to be the original motif of the abstract compositions.

Itten, Johannes

Born 1888, Südern-Linden, Switzerland.
Died 1967, Zurich.

Gifted in both art and science, he first studied at the teachers' training college at Berne-Hofwil from 1904 to 1908; in 1909 attended (for one term) Ecole des Beaux-Arts in Geneva and during 1910–12 studied mathematics and natural sciences at Berne University. He visited Munich and Paris and became acquainted with the art of the Blaue Reiter group and Cubism. From 1913 to 1916 attended the Stuttgart Academy of Art as a pupil of Adolf Hölzel, a theoretician of art. There met Oskar Schlemmer and Willi Baumeister, with whom he shared many artistic ideas. Itten's first nonfigurative paintings date from 1915. Interested in the career of art teacher he went to Vienna in 1916 and organized an art school; in 1919, on an invitation from Gropius, Itten joined the Bauhaus faculty and moved to Weimar. There Itten developed the famous "Vorkurs" (the basic course) compulsory for all first-year students, which introduced them to the problems of form, the construction of the picture as a two-dimensional organization of elements, and the theory of color. He was also interested in music and investigated the possibilities of translating musical structures into visual terms. Itten remained at the Bauhaus until 1923, then moved to Switzerland, and from 1926 to 1931 directed his own school in Berlin. Later taught at Krefeld School of Textile Design (1932), Amsterdam (1938), and School of Applied Arts in Zurich (1938). Became director of College of Textile Design in Zurich in 1943 and remained there until his death.

Jensen, Alfred

Born 1903, Guatemala.
Died 1981, New Jersey.

Grew up in Guatemala and Denmark. In 1924 he received a scholarship to the San Diego Fine Arts School; then decided to go to Munich to study under Hans Hofmann. After Jensen withdrew from Hofmann's classes in 1927, Saidie Adler May, a fellow student and wealthy art patron, offered him financial support. In 1929, Jensen enrolled at the Académie Scandinave in Paris. He studied painting with Othon Friesz and Charles Dufresne and sculpture with Charles Despiau. Traveled to Africa and Spain, where he copied works in the Prado. Through Mrs. May's collection of artists such as Miró, Matisse, and Giacometti, Jensen was exposed to the modern French masters. In the late thirties he visited André Masson and was introduced to Auguste Herbin's interest in Goethe's color theory. In the forties, influenced by Gabo, Jensen tried his hand at Constructivist sculpture. In 1951, after Saidie May's death, Jensen settled in New York. At this time, he was painting landscapes, figures, and still lifes in an Abstract Expressionist style. In 1952 Jensen had his first one-man show at the John Heller Gallery in New York. The work in this show explored Goethe's color theory. In the mid to late fifties Jensen participated in many New York exhibitions, including those at the Stable Gallery. Using prismatic colors and checkerboards together, Jensen began to paint murals. Calligraphy also began to appear in his work. After reading books on physics, hieroglyphics, and astronomy, he incorporated related themes into his paintings. He was also influenced by Oriental philosophy, Peruvian calendars, ancient number systems, and Islamic decorations. Jensen used grid systems to harmonize his work. Through surface handling and repetitive patterns, his works evoked mysticism and were hypnotic and illusionistic.

Judd, Donald

Born 1928, Excelsior Springs, Missouri.
Lives in New York and Texas.

In 1953 attended Columbia University in New York, where he received his B.A. in philosophy. While in College he also studied at the Art Students League in New York. In 1962 he received his M.A. in art history from Columbia University, studying under Rudolf Wittkower and Meyer Schapiro. Judd wrote criticism and reviews for several art magazines, including *Arts*, *Art News*, and *Art in America*. In "The Specific Object," an important statement from the early 1960s, he described the aim of his art. He was one of the founders of the Minimal art movement. He started off as a painter in the late 1950s and early 1960s. Many of his works of this period were relief constructions of paint, plywood, and metal. Finding the two-dimensionality of painting too limited, he turned to sculpture. In 1965 he traveled to Sweden on a grant from the Swedish Institute, and he was visiting artist at Dartmouth College in the summer of 1966. He taught a sculpture seminar at Yale University in 1967.

In 1962 and 1963 his sculptures were structured and direct, like the paintings of New York School artists such as Kenneth Noland. His first freestanding sculptures were box forms, some constructed of metal and some painted with industrial pigments. Sometimes these sculptures included two sides of plexiglass in order to make their inner surfaces visible. Some sculptures rested against the floor, while others were stacked in series along the wall with primary emphasis on shape and color. Judd was given a one-man show at the Whitney Museum, New York, in 1968. He has also designed pieces to relate to the space in which they are to be exhibited. In 1971 at the Guggenheim International, he took a large galvanized iron ring and put a slightly smaller one inside at a tilt, thus echoing the structure of the Guggenheim Museum. His outdoor sculptures, done in large geometric shapes, rest together in such a way that they reflect the surrounding landscape. Judd

creates a design, and it is then carried out by skilled craftsmen. He wants each of his works to be perceived immediately as a whole structure, at a single glance. His art is based on true proportions, repetitive geometric elements which have structured themselves in series.

Kandinsky, Vasily

Born 1866, Moscow.
Died 1944, Paris.

Grew up in Moscow and Odessa. Originally studied economics and law at the University of Moscow (1886–1892), where in 1893 assumed position of teaching assistant at the Faculty of Law. Three years later abandoned the legal career, declined a teaching offer at the University of Dorpat (Estonia), and moved to Munich to study painting. From 1897 to 1899 studied at the School of Anton d'Azbé, met Jawlensky, von Werefkin, and other Russian artists. In 1900 became a student of Franz von Stuck at the Munich Academy. That year he also showed for the first time with the Moscow Association of Artists, with whom he exhibited yearly until 1908. Cofounded in 1901 the Munich Phalanx exhibition society and later the Phalanx School, where he taught painting and drawing; Gabrielle Münter was among his pupils. Maintained contact with Russia, participating in exhibitions and acting as an art correspondent for the journal *World of Art* and later *Apollon*. From 1903 to 1906 traveled extensively in Europe and also visited Russia regularly. From early 1906 to June 1907 he lived in Paris, participating in several exhibitions there and in Germany, and later in 1907 moved to Berlin, remaining there until mid-1908. In 1909 cofounded Neue Künstlervereinigung and later in the year settled in Murnau, where he lived until the outbreak of World War I. Was instrumental in creating the influential Blaue Reiter group in 1911 and together with Franz Marc edited the *Blaue Reiter Almanach*, published in May 1912. In the Almanach he expounded his theories regarding representational and abstract art,

reaffirming the ideas developed in his first theoretical essay, *Concerning the Spiritual in Art,* which was begun in 1910, presented in Russia in excerpts in December 1911 at the All-Russian Congress of Artists in St. Petersburg, and published concurrently by Piper in Munich. Throughout his years in Germany, Kandinsky was deeply involved with Russian artistic life, participating in the Izdebsky Salons (1909 and 1910) in Odessa, the first Jack of Diamonds exhibition (1910) in Moscow, and the "Permanent Exhibition of Contemporary Art" (1913) and Exhibition of Graphic Art (1913), both in St. Petersburg. He also maintained correspondence with various members of the Russian avant-garde— Larionov, Gontcharova, whom he invited to participate in the second Blaue Reiter exhibition.

After the outbreak of World War I Kandinsky left Munich for Switzerland and in December 1914 returned to Russia, to remain there until the end of 1921 (except for a period from December 1915 to March 1916 spent in Stockholm). Beginning in 1918 he was very actively involved in the reorganization of cultural and artistic life in Russia: as a member of the collegium of IZO Narkompros, professor at the Moscow University and at Vkhutemas (from 1920 on), an initiator of proposals for a network of provincial museums of contemporary art, one of the organizers of the Museum of Artistic Culture in Moscow, author of the initial program for the Inkhuk (1920), a member of the founding committee of the Academy (RAkhN, 1921) and head of its physical and psychological section. He was in close contact with Rodchenko, Stepanova, and other members of the Inkhuk and Vkhutemas. Also between 1918 and 1921 he contributed to several exhibitions in Moscow, Petrograd, and Vitebsk. At the end of 1921, when his program for the Inkhuk had been rejected and the Constructivist imperative of utilitarian art became the dominant philosophy, Kandinsky left Russia for Germany and accepted a teaching position at the Bauhaus in Weimar. His experience, both theoretical and pedagogical, in Russia provided the basis for his Bauhaus activities during his years with the

school. He was among the artists included in the First Russian Exhibition at the Galerie van Diemen in Berlin in 1922. His second important theoretical book, *Point and Line to Plane*, was published in 1926. He moved with the Bauhaus to Dessau and Berlin, and upon the closing of the Bauhuas (1933) he settled in France. There he was a member of Cercle et Carré (1930) and Abstraction-Création (1934–1935).

Kandinsky's work underwent a significant change as a result of his contact with the Russian avant-garde, moving toward greater use of geometric forms and greater austerity of composition. That trend continued during the Bauhaus years, while later the works of the Paris period introduced biomorphic forms and a less rigid compositional structure.

Kassak, Lajos

Born 1887, Ersekujvar, Hungary.
Died 1967, Budapest.

From 1899 to 1907 apprenticed as a craftsman and began to paint and draw. Left for Paris in 1909 and while there met Apollinaire, Blaise Cendrars, Picasso, and Modigliani; became interested in Cubism. In 1915, back in Budapest, began the publication of an avant-garde journal, *MA* (Today), which for eleven years was an important platform for European avant-garde movements, with particular interest in Constructivist ideas. In 1921 he had his first one-man show in Vienna and in 1922 a show at Der Sturm gallery in Berlin. That year he also published, in collaboration with Moholy-Nagy, a *Book of New Artists* in Vienna. In 1960 his work was the subject of an important exhibition in Paris.

Kelly, Ellsworth

Born 1923, Newburgh, New York.
Lives in New York.

Studied at the Boston Museum School 1946–1948. Subsequently went to France on the G.I. Bill; came under the influence of the

work of Matisse and Arp and the rigorous geometric style of the members of the Réalités Nouvelles group. Also traveled extensively in France and other European countries, meeting important European artists and visiting private and public collections. In 1954 returned to New York, where he has been living and working since. His works of the mid to late 1940s were mostly portraits, abstractions of the human figure, drawings of plants. In 1949 completed his first abstract painting and shortly after became acquainted with the technique of "automatic drawing," characteristic of the work of the Surrealists. Made his first relief objects in the autumn of that year and in 1950 his first cut-out objects, followed by numerous collages and drawings. In April of 1951 had his first one-man exhibition of paintings and reliefs at the Galerie Arnaud in Paris.

In late autumn 1951 made his first attached single-color panel paintings, inspired in color by the Mediterranean environment of his summer months. From then until the present he has been working in a hard-edge abstract idiom characterized by plain surface and limited color. He has developed in his mature work a highly purified and reductive language of precisely delineated adjacent rectilinear or curvilinear shapes in strong spectral contrasts placed in an extremely simple format. The similarities in shape of the adjacent areas point up the dynamics of the interrelation and interaction of color. Progressively, he has developed large-scale geometric-shaped forms—flat expanses of intense saturated color, often executed in series. He has also been working in sculpture since the late 1950s, having had his first sculpture show in 1959 at Betty Parsons' in New York.

He continues to refine all the aspects of his work both in painting and sculpture, concerned always with flatness, straightforward execution, precision of shape, and finely calibrated proportions as well as material finesse. His works are always geometric, frontal, planar, thin; generally mounted on the wall, they are considered by him as wall pieces, whether done on canvas or in metal.

For the past twenty-five years his work has been widely exhibited both in the U.S. and Europe. Among his shows were a retrospective at The Museum of Modern Art, New York, in 1973; a major one-man exhibition at the Stedelijk Museum, Amsterdam, in 1979; and one at the Centre Pompidou in Paris in 1981.

Klee, Paul

Born 1879, Münchenbuchsee n/Berne.
Died 1940, Locarno.

Studied art at the Munich Academy in the studio of Franz von Stuck, where he met Kandinsky as fellow student. In 1901–1902 made his first trip to Italy and in 1905 to Paris. In 1906 exhibited ten etchings in the Munich Sezession exhibition. Betweeen 1910 and 1912 participated in exhibitions in Bern, Zurich, Winterthur, and Basel, and in both "Der Blaue Reiter" shows in Munich. In 1911 met Louis Moilliet and August Macke; traveled with the latter to Tunis in 1914. At that time began to work in watercolor. Befriended Rilke in 1915. Spent 1916–1918 in military service, afterward returning to Munich.

In 1920 invited by Gropius to join the Bauhaus in Weimar. Three years later became acquainted with the work of Schwitters and Lissitzky in Hannover. Also exposed to the Russian works of Kandinsky, who joined the Bauhaus faculty in 1922. In 1924 cofounded with Kandinsky, Feininger, and Jawlensky the group The Blue Four, and had his first exhibition in the U.S.A. Moved to Dessau with the Bauhaus in 1925 and that year participated in the first Surrealist group exhibition in Paris. Traveled to Egypt in 1928; journey inspired a series of paintings that showed geometric divisions and strict organization of compositional field. Left the Bauhaus in 1931 and joined the Düsseldorf Academy of Art, two years later emigrating to Bern. He had a retrospective in Bonn and Basel in 1935; in 1937 his art was included in the exhibition of "Degenerate Art" organized in Munich by the Nazis. In 1939 an exhibition of over two hundred of his works was held at the Kunsthaus in Zurich.

Kliun, Ivan Vasilievich (Kliunkov)

Born 1873, near Kiev.
Died 1942, Moscow.

Studied art in Moscow and Kiev and in the early 1900s moved to Moscow, where he frequented the studios of Fedor Rerberg and Ilya Mashkov. In 1907 met Malevich. Began contacts with the Union of Youth in 1910, later contributing to their last exhibition (St. Petersburg, winter 1913–1914); also in 1910 cofounded the Moscow Salon. In 1913 developed closer contacts with Malevich, Matiushin, and Krutchenykh and started his three-dimensional Cubo-Futurist painted reliefs and spatial sculpture, which continued through 1916. In 1915 began to work in Suprematist style and joined the group Supremus (1916), organized to publish a magazine.

In 1915–1916 contributed to all major avant-garde exhibitions: "Tramway V: The First Futurist Exhibition of Paintings," Petrograd (1915); "The Last Futurist Exhibition, 0.10," Petrograd (1915); "Magazin," Moscow (1916); Jack of Diamonds, Moscow (1916). After the Revolution was appointed Director of Central Exhibition Bureau of Narkompros and from 1918 to 1921 taught painting at Svomas and then Moscow Vkhutemas; in 1921 became a member of the Inkhuk.

His works were included in the Fifth and Tenth State Exhibitions in 1919 in Moscow and the 1922 Galerie van Diemen exhibition of Russian Art in Berlin. In 1923 Kliun designed a series of Futurist publications and a year later became a member of the Four Arts' Association, which grouped figuratively inclined artists. Around that time his work underwent change from the Suprematist idiom to a representational style related to Ozenfant's and Le Corbusier's Purism.

Klucis, Gustav Gustavovich

Born 1895, Volmar, Latvia.
Died 1944 (in a labor camp).

Attended teacher's seminary in Volmar (1911–1913) and the Riga Art Institute (1913–1915). In 1915 moved to Petrograd and until 1917 studied at the School of the Society for the Encouragement of the Arts. Concurrently worked as a scenery painter for the Okhta Workers' Theater. In 1917 Klucis participated in the Revolution and in the civil war. Beginning in 1918 he studied in Moscow, first with Ilya Mashkov, then at the Svomas (later Vkhutemas) with Malevich, and after Malevich's departure for Vitebsk (summer 1919) with Pevsner. In 1920, together with Gabo and Pevsner, he showed his works in the open-air exhibition on Tverskoi Boulevard in Moscow. That year he also visited Malevich in Vitebsk and exhibited with Malevich's Unovis group there (1920) and in Moscow (1921). In 1921 he graduated from Vkhutemas and also joined the Inkhuk, where he remained as a member until 1925.

Until 1921, under the influence of Suprematism, he produced mostly abstract works, composed of flat and stereometric forms floating in neutral, unstructured space. In 1922 he was among the contributors to the First Russian Art Exhibition at the Galerie van Diemen in Berlin. In the early 1920s he adopted the Constructivist attitude to form and material (experimenting with the materiality of space and volume) and the ideal of utilitarian art. An active member of the Productivist group (along with Popova, Rodchenko, Stepanova, Vesnin), he produced prints, book designs, photomontages, posters, exhibition installations, stands, kiosks, and other utilitarian constructions such as loudspeakers for the celebration of the fifth anniversary of the Revolution in 1922. All of his utilitarian constructions displayed simple geometric forms connected by tension cables, with the elements interacting according to principles analogous to those of the Constructivist architectural structures by Leonidov and Melnikov. Between 1923 and 1925 Klucis

was involved with the journal *LEF*. From 1924 to 1930 he taught a course on color in the Wood and Metal department at the Vkhutemas. He was among the organizers of the Russian section for the Exposition Internationale des Arts Décoratifs et Industriels Modernes in Paris in 1925 and a founding member of the October group in 1928.

His commitment to the Revolution and the new art expressed itself in his proposal to create at Vkhutemas the Workshop of the Revolution—a training program for propaganda artists and Productivists—whose work would fulfill contemporary artistic and propagandistic requirements. Only a small number of Klucis's nonobjective compositions are extant. Much of his subsequent oeuvre was destroyed after 1938; most of the remaining works (besides those in the Costakis collection) are at the Riga Museum of Art, where a Klucis retrospective was organized in 1970.

Kudriashev, Ivan Alexeievich

Born 1896, Kaluga, Russia.
Died 1972, Moscow.

Studied at the School of Painting, Sculpture, and Architecture in Moscow 1913–1917. After the Revolution attended the Free State Art Studios (Svomas) in Moscow, studying with Malevich. Met Kliun, Gabo, and Pevsner. In 1919 transferred to Orenburg to establish a branch of Svomas there and remained in correspondence with Malevich, organizing in 1920 the Orenburg section of Unovis committed to the dissemination of Suprematist ideas. Kudriashev's most important project was the Suprematist designs for the interior decoration of the First Soviet Theater in Orenburg (1920).

In 1921 traveled to Smolensk (as a supervisor of the train evacuating starving children) and there met two Polish followers of Malevich: Katarzyna Kobro and Wladyslaw Strzeminski. After his return to Moscow continued to work as a designer. In 1922 was

among the contributors to the Erste Russische Kunstausstellung at the Galerie van Diemen in Berlin, and from 1925 to 1928 showed in the OST (Society of Easel Artists) exhibitions. Ceased exhibiting after 1928.

Kupka, František

Born 1871, Opocno, Bohemia.
Died 1957, Puteaux, France.

Studied at the Prague Academy (1889–1892) and the Academy of Fine Arts in Vienna (1892–1894). Around 1893–1894 developed interest in theosophy and Oriental philosophy. Settled permanently in Paris in 1896; briefly attended Académie Julian in 1897 and began to work as illustrator. In 1906 moved to Puteaux and in 1911–1912 participated in meetings of the Puteaux Cubist group including Duchamp-Villon, Villon, Gleizes, Metzinger, La Fresnaye, Le Fauconnier, Léger, et al. Strongly interested in subjects discussed there: art of Cézanne and Seurat, divine proportions, the golden section, Bergson, non-Euclidian geometry and the fourth dimension, theories of correspondence between music and painting, new conceptions of depicting motion, and dynamics of color. His work evolved from figurative to abstract. Started to work on the Amorpha Fugue series, which explored the analogy between the abstract nature of painting and music, inspired by the orchestration principle of a fugue. His first abstractions, *Planes by Colors,* were shown at the Salon d'Automne of 1911, and at the Salon d'Automne of 1912 he presented two entirely abstract works: *Amorpha: Fugue in Two Colors* and *Amorpha: Warm Chromatics,* based on simplified formal patterns organized into rotational cosmic configurations and exploring the interaction of color and refraction of light, as well as the chromatic and linear dynamics of natural phenomena. In 1912 withdrew from the Puteaux group; in 1913 his abstract works were briefly identified with Orphism. Took part in World War I. In 1921 had his first one-man exhibition at Galerie Povolozky in Paris,

followed in 1924 by a retrospective at the Galerie La Boétie.

His oeuvre essentially developed two major themes: dynamic circular shapes (mainly in the works before 1920) and the thrusting vertical planes of colors used sporadically before 1920 and prevalent in subsequent years. Stopped painting temporarily in 1930. Beginning in 1931 was a member of Abstraction-Création group. Throughout the 1930s and 1940s his work was shown in numerous exhibitions in France, Prague, and New York. His painting of the late period was characterized by austere geometric shapes in simple compositional configurations. A major retrospective of his work was held in 1975 at the Guggenheim Museum in New York.

Larionov, Mikhail Fedorovich

Born 1881, Tiraspol, Russia.
Died 1964, Fontenay-aux-Roses, France.

Attended the Moscow Institute of Painting, Sculpture, and Architecture 1898–1908. There around 1900 met his lifelong companion Natalia Gontcharova. His early works showed the influence of Impressionism. Began exhibiting in 1906, participating in the exhibitions of the World of Art, St. Petersburg; the Union of Russian Artists, Moscow; the Moscow Association of Artists; and in the Russian section at the Salon d'Automne in Paris (organized by Diaghilev)—on which occasion he made his first trip to Paris. From 1907 until 1914, when he was mobilized at the outbreak of the war, Larionov was among the most active members of the avant-garde, organizing exhibitions and debates on contemporary art, collaborating with poets on the publication of Futurist books and almanachs, and contributing to all major avant-garde exhibitions in Russia and in Europe.

He showed his work in 1907–1908 in the "Wreath-Stephanos" exhibition in Moscow, the "Wreath" in St. Petersburg, the "Link" in Kiev. He was also, from 1907 to 1910, associated with the founder and editor of the art publication *The Golden Fleece*—the col-

lector Nikolai Ryabushinsky—and helped organize the three Golden Fleece exhibitions (1908–1909). Beginning in 1907 Larionov developed a new style—Neoprimitivism, a result of his interest in the folk-art woodcut, the icon, and children's art. He continued to work in this manner until 1912, producing works characterized by crudely drawn forms and the use of vivid, flat colors, depicting mundane subjects such as the life of provincial people, soldiers and barracks scenes (executed during his military service in 1908), seasons, still lifes, etc. During this period his works appeared at the Union of Youth exhibitions in St. Petersburg (1910, 1911, 1912), the two Izdebsky Salons organized in Odessa (1909–1910 and 1910–1911), and the first exhibition of the Jack of Diamonds group, Moscow (1910), which he helped organize with, among others, Gontcharova and Aristarkh Lentulov. In 1911 Larionov and Gontcharova separated from Jack of Diamonds following dissension within the group over its artistic objectives and the resulting division into Russian and French factions. Formed the Donkey's Tail group, which held one exhibition (March 1912) of the works of Larionov, Gontcharova, Malevich, and Tatlin. In 1912 Larionov's paintings were included in Roger Fry's Second Post-Impressionist Exhibition at the Grafton Galleries in London, and in 1913 in the First German Autumn Salon at Der Sturm gallery in Berlin.

Toward the end of 1912 Larionov began to evolve a new style, Rayonism, first presented to the public at his exhibition "Target" in April 1913 in Moscow, accompanied by an almanach, *The Donkey's Tail and Target,* containing the text "Rayonists and Futurists: A Manifesto" (countersigned by ten other artists)—the first theoretical explanation of Rayonism. His mature Rayonist paintings—the purely nonobjective works composed of intersecting lines of color interacting dynamically, and generally characterized by heavy surface texture—date from 1913–1914. He also applied his Rayonist style in the illustrations for the Futurist books of Khlebnikov and Krutchenykh, mostly done in 1912–1913. During 1914 Larionov organized the "No. 4"

exhibition in Moscow and in June had a joint exhibition (with Gontcharova) at the Galerie Paul Guillaume in Paris. Mobilized in 1914, he was discharged for health reasons in 1915 and at the invitation of Diaghilev left for Switzerland (with Gontcharova), in 1917 settling in Paris. His activities focused on theater designs for Diaghilev's productions, such as *Le Renard* by Stravinsky (1922); he also did some book illustrations. He had numerous exhibitions in France, Germany, Belgium, England, and Italy but painted little.

van der Leck, Bart

Born 1876, Utrecht.
Died 1958, Blaricum, Netherlands.

Studied at the State School for Decorative Arts and at the Academy in Amsterdam. Worked as illustrator, painter, designer, and interior decorator. In 1905 came in contact with the architect H. P. Berlage. His early figurative style changed around 1912 when he began to stylize forms and use flat planes of pure color. Progressively his style developed into an abstract idiom based on purely geometric forms. In 1916 moved to Laren and there met Mondrian, van Doesburg, Huszar, and Dr. M. H. J. Schoenmakers. Participated with Mondrian, van Doesburg, and Huszar in founding de Stijl in 1917 and remained associated with it until mid-1918, painting nonobjective works composed of rectangular forms in primary colors on a white ground, often introducing the diagonal element into the compositional structure (through placement of rectangles on a diagonal axis and use of trapezoidal shapes). After leaving de Stijl returned to painting abstract works derived from observed subjects and also to realism. In June 1918 moved from Laren to Blaricum and was active as designer for interiors, furnishings, and carpets.

Le Corbusier (Charles-Edouard Jeanneret-Gris)

Born 1887, La Chaux-de-Fonds, Switzerland.
Died 1965, Cap-Martin, France.

Studied engraving at the Art School of La Chaux-de-Fonds around 1900, under painter L'Eplattenier. Interested in Art Nouveau stylizations. In 1905 came his first architectural projects. In 1907 traveled to northern Italy, Tuscany, Ravenna, Budapest, and Vienna, where he worked for six months under Josef Hoffmann, leader of the Vienna Sezession. Made first trip to Paris in 1908. Received in 1910 a fellowship from the Art School of La Chaux-de-Fonds to study arts-and-crafts movement in Germany and remained there until mid-1911, visiting Berlin and Dresden. In 1911 traveled widely in Central Europe and the Balkans, Greece, Italy. Exhibited a number of watercolors from the 1907–1912 period at the 1912 Salon d'Automne in Paris. In 1912 placed in charge of courses on architecture and furniture in the "New Section" at the Art School of La Chaux-de-Fonds. Subsequently headed their "Ateliers d'Art Réunis" (1914). In 1917 settled in Paris and worked at the office of the architect Auguste Perret, where he met Amédée Ozenfant. Began to paint in 1918 and that year exhibited with Ozenfant, concurrently publishing the manifesto of Purism, *Après le cubisme*. In 1920 together with Ozenfant and Paul Dermée founded a magazine, *L'Esprit nouveau*. Continued his activity as architect and painter and in 1923 had an exhibition of his paintings at L'Effort Moderne, the gallery of Léonce Rosenberg. His paintings evolved out of Synthetic Cubist forms into sharply delineated geometric shapes, and in 1928 began the period of "objects of poetic reaction." Later, in 1930, a human figure made its appearance in his compositions. That year he joined the Cercle et Carré group. Continued to paint and execute murals throughout his very active architectural career.

Léger, Fernand

Born 1881, Argentan, France.
Died 1955, Gif-sur-Yvette, France.

An important figure in the development of Cubism, Léger grew up in Normandy and from 1897 to 1902 worked for architects in Caen and Paris. Studied in Paris at the Ecole des Arts Décoratifs, Académie Julian, and the ateliers of Jean-Léon Gérôme and Gabriel Ferrier. Settled definitively in Paris in 1908 and before 1910 became acquainted with Braque, Picasso, Matisse, and writers, Apollinaire, Max Jacob, Maurice Raynal, André Salmon. He befriended the Delaunays and the Cubist artists of the Section d'Or circle. His early Cubist idiom of 1909–1911 was influenced by Cézanne, Braque, and Picasso. He exhibited at the gallery of Daniel-Henri Kahnweiler and with the Section d'Or group at the Galerie la Boétie in Paris in 1912 and in the First German Autumn Salon at Der Sturm gallery in Berlin in 1913. His personal Cubist idiom of 1912–1914 incorporated powerfully modeled truncated conical shapes, implying mechanical movement through the repetitions of form and exploring contrasts of flat versus volumetric, straight versus curved, bright color versus black and white. The almost abstract compositions that resulted are exemplified in the Contrast of Forms series (1912–1913). After serving in the war he resumed painting in 1918, focusing on urban subjects and using tubular, machinelike forms. In the early 1920s he was involved with the Purism of Le Corbusier and Ozenfant. He collaborated on films (with Blaise Cendrars), designed costumes and stage sets for the Ballets Suédois, and produced his experimental film *Ballet mecanique* (1924). He also executed various decorative commissions—for the Exposition des Arts Décoratifs in Paris (1925), for Le Corbusier's Pavillon de l'Esprit Nouveau, etc. Became influential as educator, founding in 1924 with Amédée Ozenfant the Académie Moderne (active until 1931), teaching at the Académie de l'Art Contemporain (1933–1939) and the Atelier Fernand Léger (1946–1955). Made several trips to the U.S.: 1931, 1935–1936,

1938–1939, and a prolonged stay, 1940–1945. Stylistically, in the 1930s and 1940s his work vacillated between abstract and figurative, exploring differentiation of scale (easel painting versus mural) and searching for a monumental dynamic idiom, often making use of flat patterns of vivid color and bold linear patterns. After his return to France in 1946 his activities concentrated on decorative commissions, murals and stained-glass windows for churches and public buildings, as well as theater designs.

van Leusden, Willem

Born 1886, Utrecht.
Died 1974, Maarssen, Netherlands.

For a short time tangentially associated with de Stijl and van Doesburg, with whom he exhibited in Paris in 1923 at Léonce Rosenberg's Galerie de L'Effort Moderne in the exhibition of de Stijl architecture. That year his work was also included in the Novembergruppe section of the Grosse Berliner Kunstausstellung. Subsequently, he underwent the influence of the art of Lissitzky and other Constructivists.

LeWitt, Sol

Born 1928, Hartford, Connecticut.
Lives in New York.

Attended Syracuse University 1945–1949. In 1953, after two years in the army in Japan and Korea, where he studied shrines, temples, and gardens, he moved to New York and studied at the Cartoonists and Illustrators School (now School of Visual Arts). In 1962–1963 his paintings developed into reliefs based on the right angle and the basic diminishing square construction telescoped to a central rod. His first three-dimensional works, shown at St. Mark's Church, New York, in 1963, revealed the influences of de Stijl, Constructivism, and the Bauhaus. A year later he contributed to a group show at the

Kaymar Gallery, showing geometric reliefs, box forms, and wall structures already executed in a personal style making use of squares and cube shapes. In 1965 made his first modular pieces, built of open cubic forms and eventually combined into his serial works. In May of that year had his first one-man show at the Daniels Gallery, New York, where he exhibited his painted constructions, and in 1966 showed at the Park Place Gallery, New York, as well as at the Dwan Gallery, exhibiting there the modules in serial form. From 1967 to 1970 his work was included in major group shows of Minimal art, such as "Primary Structures" at the Jewish Museum, New York (1966); "Minimal Art," Gemeentemuseum, The Hague (1968); and "The Art of the Real," Museum of Modern Art, New York (1968). Taught at several art schools: Cooper Union (1967–1968), School of Visual Arts (1969–1970), N.Y.U. (1970–1971). In 1967 and 1969 published his important statements on Conceptual Art. In 1968 evolved the basic principle of his highly innovative wall drawings: "lines in four directions—vertical, horizontal and 2 diagonals." He presented the resultant work for the first time at the Paula Cooper Gallery, New York. He continues to explore this premise in numerous and varied series, both in black-and-white and color, which have been widely exhibited in the U.S. and abroad. His works were included in the important group shows of conceptual art: "When Attitude Becomes Form," Kunsthalle, Bern (1969); "Konzeption/Conception," Städtisch Museum, Leverkusen, West Germany (1969); "Information," Museum of Modern Art, New York (1970). A retrospective of his work was held at The Museum of Modern Art, New York, in 1978. He founded (with the critic Lucy Lippard) the group Printed Matter to publish and distribute artists' books.

His work uses as its fundamental component the geometric grid, arrived at through the manipulation of the modular unit. This basic vocabulary affords multiplicational possibilities of infinite complexity.

Lissitzky, El (Lazar Markovich)

Born 1890, Polschinok near Smolensk, Russia.
Died 1941, Moscow.

One of the major figures of the Russian Constructivist avant-garde, initially trained as an architect at the Technische Hochschule in Darmstadt in Germany (1909–1914). In 1912 and 1913 made summer trips to Paris (met Zadkine) and visited Italy: Venice, Pisa, and Ravenna. Returned to Russia at the outbreak of the war. In 1915–1917 studied at the Riga Polytechnical Institute. An active supporter of the Revolution, became in 1918 a member of IZO Narkompros. In May 1919 at Chagall's invitation joined the faculty of the Vitebsk Art School as professor of graphics and architecture. After Malevich's arrival at Vitebsk Art School in autumn 1919, embraced Malevich's Suprematism and under its influence developed in 1919–1920 his own idiom, the "Prouns" (acronym for the Projects for the Affirmations of the New)—abstract compositions combining flat and three-dimensional geometric forms in flat colors interacting spatially and dynamically in a neutral space. Considered them an intermediate stage between painting and architecture, in effect combining Suprematist and Constructivist principles—which he was to develop further in his work of the 1920s, including illustrations, typography, exhibition and interior design, architectural projects, decorations for revolutionary festivals and events, posters, and structures such as Lenin's Podium. During the 1920s, through his numerous trips to Europe, was an important link between the Russian Constructivists and Western avant-garde artists and was instrumental in the dissemination of Russian Constructivist ideas in the West.

In 1921 was appointed to the faculty at the Vkhutemas. In 1922 in Berlin cofounded with his compatriot writer Ilya Ehrenburg the important Constructivist journal *Veshch/Gegenstand/Objet*. Participated in the

First Russian Art Exhibition at the Galerie van Diemen in Berlin (1922) and designed the cover for its catalog. Maintained contacts with de Stijl (van Doesburg), Dada (Schwitters), and the Bauhaus in Weimar. Was actively involved with the Congress of Progressive Artists in Düsseldorf (1922) and the Dada-Constructivist Congress in Weimar (1922). His "Proun" concepts were carried into architecture and environment in the "Proun Room" designed for the Grosse Berliner Kunstaustellung in 1923; the 1926 exhibition space (Raum der Abstrakten) at the International Kunstausstellung in Dresden; the Soviet pavilion at the Pressa exhibition in Cologne (1928) ; the Kabinett der Abstrakten (1927–1928) at the Landesmuseum in Hannover; and numerous other exhibition spaces executed between 1927 and 1930 in Russia and Germany. He was active as a book designer, the most famous works being the *Story of 2 Squares* (1922) and Mayakovsky's *For the Voice* (1923); published two portfolios of lithographs, *Proun* and *Victory over the Sun* (1920–1923), through the Kestnergesellschaft in Hannover; collaborated with Mies van der Rohe on the magazine *G* (1923) and with Schwitters on *Merz* (1924); and in 1925 coedited with Jean Arp *The Isms of Art (Die Kunstismen)*, a brief survey of the twentieth-century avant-garde movements. After 1925 he lived mostly in Moscow. During 1925–1930 taught architectural interior design and furniture design in the Wood and Metal department at the Vkhutemas in Moscow. He was strongly aligned with the Constructivists promoting the concept of utilitarianism in art and designed several architectural projects and interiors for communal housing blocks. In the 1930s began experimenting with photography and photomontage, often applying them in his typographical designs, which along with exhibition designs remained one of the main areas of his activity until his death. He was also the author of the important treatise on Soviet architecture, *Russia: The Reconstruction of Architecture in the Soviet Union*, published in Vienna in 1930.

Lohse, Richard

Born 1902, Zurich.
Lives in Zurich.

Studied at the School of Applied Arts in Zurich from 1918 to 1922 and for the next five years worked for an advertising studio. During that period became acquainted with the works and publications of the European avant-garde and began to paint still lifes and landscapes in a belated Cubist idiom. Subsequently his painting style evolved from the Cubist phase into a geometric idiom making use of grids of equal rectangular elements, rendered with mathematical precision, where the overall pattern is enhanced by the gradations of colors. His works are developed on serial and modular principles.

Lohse was a cofounder of Allianz (1937), an association of modern Swiss artists, and in 1938 developed close contacts with Sophie Taeuber-Arp, Jean Arp, and Friedrich Vordemberge-Gildewart. At that time he also began to explore the possibilities of introducing dynamic quality into the composition through the addition of a diagonal to the horizontal-vertical progression of elements. He continues to explore the interrelations of modular geometric form and color in their limitless combinations. Over the last twenty-five years, he has had numerous one-man exhibitions in Germany, Holland, Italy, and Switzerland and has also participated in group exhibitions in France, Germany, Austria, and the U.S.

McLaughlin, John

Born 1898, Sharon, Massachusetts.
Died 1976, Dana Point, California.

Self-taught; began painting in 1938 and after 1946 devoted himself entirely to art. His main sources of inspiration were Zen Buddhism (in which he developed an interest while living in the Orient for a few years beginning in 1935, studying the Japanese language and dealing in Japanese prints), Mondrian's Neo-plasticism, and the work of Malevich. His

abstract style developed around 1946 as a result of his search for the simplicity of form that would in an objective way convey the unity of the human experience of the relationhips existing in nature. In order to arrive at such a neutral form McLaughlin from 1948 on restricted his palette to basic colors and his forms to rectangles (with the few exceptions of the 1948 and 1952 circle paintings and the 1949 grid paintings). His hard-edge color forms, through their changing relationships, created variable space where the spatial field was perceived temporally. He also eliminated any suggestion of brushwork. His reductive aesthetic culminated in the early 1970s in works based on strict black-and-white contrasts.

Malevich, Kasimir Severinovich

Born 1878, near Kiev.
Died 1935, Leningrad.

One of the most important figures of the Russian avant-garde and founder of the first truly nonobjective movement, Suprematism. First studied at the Drawing School in Kiev (1895–1896), the Moscow School of Painting, Sculpture, and Architecture (1904–1905), and with the painter Fedor Rerberg (1905–1910). Around 1910 became associated with Larionov and Gontcharova and with them exhibited in the first Jack of Diamonds exhibition (1910), "The Donkey's Tail" (1912), and the "Target" (1913). From 1911 was also a member of the St. Petersburg group The Union of Youth and contributed to their exhibitions in 1911 and 1914. His early work developed under the influence of Cézanne, Matisse, Derain, and Picasso and was followed by a Neoprimitivist phase stylistically indebted to the Russian icon and native folk art. In 1912–1915 evolved his Cubo-Futurist style, making use of repeating forms, truncated cones and cylinders—reflecting his thorough study of French Cubism and Italian Futurism. In its final stage produced his

"alogic" pictures, such as *An Englishman in Moscow* (1914, Stedelijk Museum, Amsterdam), which combined objects irrationally juxtaposed, with added elements of collage and ordinary objects applied to the surface and contrasting flat and volumetric forms. In 1913 designed costumes and scenery for the Futurist opera *Victory over the Sun,* with libretto by the poet Aleksei Krutchenykh and music by Mikhail Matiushin. The costumes, made up of geometric forms, and the almost abstract backdrop designs, also based on geometric shapes, were the most radical example of innovative theater design at the time. In 1914 met the Italian Futurist Filippo Tommaso Marinetti on his tour in Russia. In 1915 participated in two important avant-garde exhibitions in Petrograd, "Tramway V: The First Futurist Exhibition of Paintings" and "The Last Futurist Exhibition of Paintings: 0.10," where he launched Suprematism—a nonobjective idiom based on the use of flat geometric forms in pure colors organized in dynamic configurations against a white background. Accompanied his contributions with a manifesto and a small leaflet, "From Cubism and Futurism to Suprematism: The New Realism in Painting," which explained his evolution of abstract form and was his first major theoretical essay (reissued with amendments three times). In 1916 participated in the exhibition "The Store" in Moscow and during 1916–1917 organized Supremus, a group of supporters of Suprematism, including Popova, Rozanova, Kliun, Pestel, and Udaltsova, to prepare the publication of the Suprematist journal *Supremus* (never realized). After the Revolution, became actively involved, as a member of IZO Narkompros and of the International Bureau and as professor at the Moscow Free Studios (Svomas, from autumn 1918). In 1919 wrote his important essay *On New Systems in Art* and also designed sets and costumes for Mayakovsky's play about revolution, *Mystery-Bouffe,* produced by Meyerhold in Petrograd. At the invitation of Chagall, then head of the Vitebsk Art Institute, joined its faculty in the autumn of 1919 and in the winter of 1919–1920 replaced Chagall as director. Dur-

ing that time had a one-man show in Moscow including 153 works—"The Sixteenth State Exhibition: K. S. Malevich, His Path from Impressionism to Suprematism." While at Vitebsk Malevich in 1920 founded Unovis, a group of followers including Lissitzky, Chashnik, Suetin. After the ousting of Unovis from Vitebsk in 1922, moved to Petrograd (followed by some of his students) and joined the faculty of the reinstated Academy of Arts and the Ginkhuk (a branch of the Inkhuk headed by Tatlin), directing the Formal and Technical Department of the Section of Painterly Culture (1923–1926). He was among the contributors to the First Russian Art Exhibition at the Galerie van Diemen in Berlin in 1922.

Beginning in 1919 and throughout his period at the Ginkhuk, Malevich's interests focused on the theoretical research and design of architectural and urban projects, which developed in his drawings and architectural models known as Planits and Architektons. In 1927 had a one-man exhibition in Warsaw; also traveled to Berlin, where his work was included in the Great Berlin Art Exhibition. Visited the Bauhaus, which published his theoretical essays as one of the Bauhaus books: *The Nonobjective World* (1927). Returned to Russia, leaving in Germany the works shown in Berlin (future collection of the Stedelijk Museum, Amsterdam). Had his one-man exhibition at the Tretiakov Gallery in Moscow in 1929, but his works at that time became mostly figurative, often exploring peasant themes of the 1910s. Worked in the figurative style until his death (1935).

Mangold, Robert
Born 1937, North Tonawanda, New York.
Lives in Washingtonville, New York.

From 1956 to 1959 studied at Cleveland Art Institute and from 1960 to 1962 at Yale University. His early work was included in such exhibitions as "Hard-Edge Painting" at the Fischbach Gallery, New York (1962–1963),

and "Systemic Painting" at the Guggenheim Museum in New York (1966). His work, characterized by great severity of means, with large-scale monochrome painted surfaces sectioned by linear elements, is among the most important contributions of the Minimal artists. The radical reduction of means began in his painting around the mid-1960s, when the largely biomorphic forms of his first works were replaced by sharply contoured basic geometric shapes. These remained the essence of his subsequent work exploring textural surfaces (on masonite) and shaped canvases to emphasize the "object" quality of the paintings. Around 1966 he introduced the curve and circle, which along with the square became the preferred geometric forms. In 1968–1969 explored seriality in painting, fascinated with the complexities of permutations in structural relationships among the components of the work arrived at by dividing and subtracting and as a result multiplying expressive possibilities. The serial concept allowed for the investigation of subtle variations resulting from sequential changes in the relationships of the drawn line and the color-surface. Around 1971 he began his Distorted Square Circle group of paintings, concentrating on the two basic shapes that he continues to explore. His work has been widely exhibited since 1964 in the U.S. and in various European countries—West Germany, Switzerland, Italy, England, France.

Mansurov, Pavel
Born 1896, St. Petersburg.
Died 1984, France.

Studied from 1909 at the Stieglitz School in St. Petersburg and then the school of the Society for the Encouragement of the Arts. During 1915–1917 completed military service, designing airplane equipment for the Ministry of Aviation in St. Petersburg. After the October Revolution worked for some time with Lunacharsky in the People's Commissariat of Enlightenment. Also developed contacts with Tatlin, Malevich, and Matiushin.

His first abstract drawings and paintings evolved around 1917. In 1919 participated in the First State Free Exhibition of Works of Art in Petrograd, which included contributions representative of both leftist and rightist artistic trends. He was among the organizers of the Petrograd Inkhuk (Ginkhuk) in 1922 together with Malevich, Matiushin, Nikolai Punin, Tatlin, and others, and became head of their experimental section. In 1922 he contributed to the First Russian Art Exhibition at the Galerie von Diemen in Berlin, and in 1923 his work was included in the Exhibition of Paintings of Petrograd Artists of All Tendencies. He defined his theoretical artistic position in two statements published in 1923 in the journal *Zhizn iskusstva* (Life of Art). In 1924 participated in the XIV Venice Biennale and in 1927 in the exhibition at the Leningrad Academy of Arts commemorating the tenth anniversary of the October Revolution.

Left Soviet Union in 1928 for Italy, where in 1929 had an exhibition at the theater of the Bragaglia brothers, Bragaglia fuori Commercio, in Rome. That same year emigrated to Paris, continuing to work in the abstract style of his earlier years, based on his interest in line and form and great economy of composition. He explored in particular the possibilities offered by the vertical format (usually of wooden board as support) and by monochromatic planes organized with a limited number of lines.

Marinetti, Filippo Tommaso
Born 1876, Alexandria, Egypt.
Died 1944, Bellagio, Italy.

Founder, theoretician, and chief popularizer of Italian Futurism, Marinetti spent his early years in Alexandria, then briefly attended the Sorbonne in Paris in 1894, and from 1895 to 1899 studied law at the University of Genoa. In 1898 he made his literary debut publishing in *Anthology Review* in Milan his first poem, "L'Echanson." In 1904 founded with Sem Benelli and Vitaliano Ponti the review *Poesia*, the first issue of which, intended for Novem-

ber of that year, finally appeared in February of 1905. In 1909 Marinetti published his *Founding Manifesto of Futurism*, the first of numerous Futurist manifestos written between 1910 and 1932. He met the painters Boccioni, Russolo, and Carrà in 1910 and that year also began the first Futurist evenings, which continued through 1915. In early 1914 he made a trip to Russia, where he gave several lectures and met Russian avant-garde artists, poets, and writers. Among his most important manifestos were the *Technical Manifesto of Futurist Literature* (1912), *Free Words* (1913), and *The Synthetic Futurist Theater* (1915).

In 1918 he created the Futurist party, which in 1919 joined forces with Mussolini and the Fascist party. Subsequently, in 1924 and 1925, published manifestos promoting Futurism and Fascism. From 1924 on lived in Rome. In 1942 volunteered for the Russian front. He was active as a painter mostly during the "heroic years" of Futurism (1910–1915), painting abstract compositions, often making use of freely applied words, and creating collages and *objets-tableaux*, some of which were exhibited in the Futurist gallery, Galleria Sprovieri, in Rome in 1914.

del Marle, Félix
Born 1889, Pont-sur-Sambre, France.
Died 1952, Paris.

First arrived in Paris in 1911 and was influenced by Cubism and Futurism, the latter familiar to him through his studies under Severini (in 1913). In 1920 met František Kupka and was introduced by him to "pure painting." Two years later met Mondrian and van Doesburg and for a brief time was associated with de Stijl, seeing in their geometries new artistic possibilities. In 1924 settled in Lille and founded the monthly *Vouloir*, subtitled "Organe constructif de littérature et d'art moderne," which in 1927 became "Mensuelle d'esthétique néoplastique," propagating the ideas of de Stijl

and Russian Constructivism, with contributions by Mondrian, van Doesburg, Vantongerloo, and others. In 1926 undertook several projects designed to apply Neoplastic principles to furnishings and interior design and architecture. He organized in 1928 the exhibition "Stuca" in Lille, intended to present the achievements of Neoplasticism in theoretical and practical areas and including works by Gorin, Domela, Vantongerloo. His early idiom, progressively geometric, evolved in the 1930s into a nonobjective style, inspired by ideas related to Constructivism. He was a regular exhibitor in Paris at the Salon des Indépendants and the Salon des Réalités Nouvelles after World War II. He had an important exhibition of his late work in 1949 at the Galerie Colette Allendy, and his oeuvre began to attract attention in England and the U.S. In 1950 founded with André Bloch the group Espace. An exhibition of his work was held at the Carus Gallery in New York in 1982.

Martin, Agnes
Born 1912, Maklin, Saskatchewan.
Lives in Glasteo, New Mexico.

Came to the U.S. in 1932 and attended various American universities, graduating from Columbia University, New York. From early 1940s until mid-1950s lived in Portland, Oregon, and New Mexico, teaching at Eastern Oregon College and the University of New Mexico. Returned to New York in 1957 and remained there for a decade, moving in 1967 to Cuba, New Mexico.

Her seemingly austere compositions are based on systemic-grid patterns which in multiple variations explore irregularities of lines and differentiation in sizes of the basic linear elements organized in modular configurations. These carefully laid out compositions with minute divisions of the surfaces open up for the spectator diverse possibilities of interpretation and elicit different responses. Her characteristic personal idiom crystallized around 1957 after a period of landscape and

figure paintings as well as the Surrealist compositions of the 1940s and early 1950s. She became increasingly preoccupied with the regularity of certain forms, their symmetries, and steady rhythms underlying natural relationships and universal harmony. After 1961 she made the system of horizontal and vertical lines the sole means of expression, perfecting and refining over the years their compositional syntax. Her works are embodiments of holistic structure, where parts are subordinate to the larger module and become expressive of infinite spaces (since the marks of the grid do not reach the edges of the support, leaving the patterned structure hovering like a veil).

Martin, Kenneth
Born 1905, Sheffield, England.
Lives in London.

In 1921–1923 and again 1927–1929 studied at the Sheffield School of Art, working from 1923 to 1929 in Sheffield as a designer. Attended the Royal College of Art in London from 1929 to 1932. Until 1943 worked directly from nature. Executed his first abstract paintings in 1948, creating by 1951 his first kinetic constructions. From 1946 to 1967 was a visiting teacher at Goldsmith's College of Art and Design, University of London. Was also an active participant and organizer of exhibitions of abstract art in London. Along with Victor Pasmore he has been one of the main proponents of Constructivist concepts in British art. Since 1951 he has continued both his abstract paintings and kinetic constructions. His work has been included in numerous exhibitions in England, Holland, and the U.S. He has also carried out various architectural commissions and published critical writings in art and architecture magazines.

Martin, Mary

Born 1907, Folkestone, England.
Died 1969, London.

Studied at Goldsmith's College of Art and Design of the University of London and the Royal College of Art 1925–1932. Her first abstract paintings date from 1949 and the first geometric abstract reliefs in painted wood from 1951. Afterward she concentrated on the reliefs and executed a number of commissions, such as a wall construction for the University of Stirling. She also contributed critical writings to art publications, among them Joost Baljeu's *Structure*. Had a one-man exhibition at Molton and Lords Gallery in London in 1964. In 1969 she was named (jointly with Richard Hamilton) the first-prize winner of the John Moores exhibition in Liverpool. Her works are included in the collection of the Tate Gallery, London, and the Calouste Gulbenkian Foundation, Lisbon.

Matiushin, Mikhail Vasilievich

Born 1861, Nizhni Novgorod, Russia.
Died 1934, Leningrad.

Artist, composer, writer, and active sponsor of the avant-garde, Matiushin studied at the Moscow Conservatory of Music 1878–1881 and from 1881 to 1913 was a violinist in the Court Orchestra in St. Petersburg. Began to study art at the School of the Society for the Encouragement of the Arts and from 1898 to 1906 attended the private studio of Yan Tsionglinsky (where he met his future wife, painter and poet Elena Guro). Subsequently (1906–1908) studied with the World of Art artists Leon Bakst and Mstislav Dobuzhinsky at the Zvantseva School of Art.

A friend of Nikolai Kulbin, he briefly belonged to the group organized by him, The Impressionists, and showed with them in 1909. In late 1909, after breaking away from Kulbin, he cofounded the Union of Youth, occasionally contributing to their St. Pe-

tersburg exhibitions (1911, 1913–1914). Also contributed to the Futurist almanach *Trap for Judges I* and published the *Trap for Judges II*.

Befriended Malevich and Aleksei Krutchenykh in 1912 and a year later collaborated with them on the first Futurist opera, *Victory over the Sun,* for which he wrote the musical score (Krutchenykh, libretto; Malevich, costume and stage designs). Set up his own imprint, Crane, and published several books, among them a translation of *Du cubisme* by Gleizes and Metzinger (1913) and Malevich's treatise *From Cubism and Futurism to Suprematism* (1915). Was also the author of a text on the fourth dimension.

In 1918–1922, at the Free Studios (Svomas) in Petrograd, taught a course in "Spatial Realism." Also became involved with theatrical productions (1920–1922). In 1922 was placed in charge of a laboratory at the Museum of Painterly Culture and in 1924 of the Department of Organic Culture at Ginkhuk. His handbook, *The Rules of the Variability of Color Combinations: A Color Manual,* was published in 1932 in Moscow and Leningrad. In 1934, when he died, he was preparing its second volume. Matiushin developed an independent nonobjective style based on his color studies.

Moholy-Nagy, László

Born 1895, Bacsbarsod, Hungary.
Died 1946, Chicago.

Originally studied law in Budapest; began drawing around 1915 in a manner influenced by German Expressionism. Became involved with the literary and musical avant-garde and in 1917 helped found with Kassak the avant-garde group MA (Today) and its radical journal fostering the cause of modern art (until 1925). In 1919 went to Vienna, where MA resettled, and in 1920 moved to Berlin. Became associated with the Dada movement (met Schwitters) and also Herwarth Walden's Der Sturm gallery, where in 1922 he was given a one-man show. When in Berlin

developed interest in the ideas and nonobjective works of Malevich and of Lissitzky, then one of the important transmitters of Russian Constructivist ideas to the West. Began to introduce Suprematist and Constructivist principles into his own style. His work embraced painting, sculpture, graphic design, photography, photomontage, and experiments with light and film related to his fascination with the machine and machine aesthetic. In 1923 was invited by Gropius to join the faculty of the Bauhaus in Weimar, where he remained until Gropius's resignation in 1928. His teaching strongly influenced the Bauhaus toward Constructivist ideas. Lived in Berlin until 1933, designing sets for the State Opera, advertisements, and documentary films. Left Germany in 1934 for Amsterdam and, in 1935, London, concentrating on exhibition design, also making documentary films and creating three-dimensional works, "space-modulators," that investigated the interaction of light and transparent materials (plastics). In 1937 moved to Chicago and directed the New Bauhaus, and a year later founded his own school of design. He divided his energies between teaching, theoretical writing (*Vision and Motion,* 1946), and his own creative work. From 1941 on was a member of American Abstract Artists.

Mondrian, Piet

Born 1872, Amersfoort, Holland.
Died 1944, New York.

Began to paint under the guidance of his uncle. From 1892 to 1894 attended the Academy of Fine Arts in Amsterdam. Painted naturalistic landscape scenes until around 1908. At that time became influenced by Post-Impressionism and Symbolism (particularly the linear stylizations of Jan Toorop). From 1908 to 1910 lived at Domburg, simplifying his means of expression and lightening his palette. Interested in modern French art, traveled to Paris in 1911 and lived there until mid-1914. Absorbed the influence of French Cubism into his own idiom, between 1912 and

1914 producing a personal style that eventually evolved into a nonobjective expression based on the vertical-horizontal grid and reduced palette. From summer 1914 until 1919 remained in Holland (Laren from 1915); met Theo van Doesburg and Bart van der Leck, with whom he founded in 1917 the magazine *De Stijl*. His style became increasingly abstract, characterized by the use of flat rectangular planes in limited primary colors and a vertical-horizontal grid pattern in black or gray. Such compositional structure was the essence of the ''new plasticism in painting,'' his Neoplastic idiom intended as a theory that would organize not only pictorial composition but provide a modus vivendi for the new man and new order and whose principles would be best expressed in concepts of architecture and environment. In 1919 returned to Paris, and in 1920 his first theoretical essay on the new style, *Le Néoplasticisme,* was published by the dealer Léonce Rosenberg, whose gallery, L'Effort Moderne, was for some time associated with de Stijl. Mondrian's palette lightened, the black connecting lines increased in size, and the grid became less regular. Around 1922 he began his ''classical period,'' using a reductive language based on the use of a few planes of color limited to blue, yellow, and red, organized into centrifugal compositions with the help of assymetrically used white planes and black vertical and horizontal lines. In 1925 Mondrian withdrew from de Stijl following the philosophical disagreement with van Doesburg regarding the latter's Elementarist theory that postulated introduction of a diagonal into pictorial compositions to achieve elements of dynamism and temporal perception. Mondrian's work was first shown in America through the 1926 exhibition of Katherine Dreier's Société Anonyme at the Brooklyn Museum and in 1936 through the ''Cubism and Abstract Art'' exhibition at The Museum of Modern Art. He lived in Paris until 1938 and was a member of the Abstraction-Création group. In 1938 moved to London (Hampstead), became associated with the group around Herbert Read and the *Circle*

publication (Gabo, Nicholson), and in the fall of 1940 emigrated to New York, where he had his first one-man show at the Dudensing Gallery in 1942 and a posthumous retrospective at The Museum of Modern Art in 1945. After his arrival in New York, Mondrian's style underwent a change, eliminating black lines and using small rectilinear geometric forms in bright colors arranged in bands, with the interaction of forms and colors against white activating the compositional field. His work was an important influence on the development of the geometric abstract idiom of the younger generation of painters in the U.S., such as Bolotowsky, Holtzman, Glarner, Diller, Charmion von Wiegand.

Morris, George L. K.
Born 1905, New York.
Died 1975, Stockbridge, Massachusetts.

Attended Yale University (1924–1928), the Art Students League in New York (fall 1928, fall 1929), and the Académie Moderne in Paris (spring 1929, spring 1930), where he studied under Léger and Ozenfant and developed appreciation of Cubism. He was particularly interested in the work of Picasso, Gris, Léger, and later Mondrian. While studying with Léger met Arp, Mondrian, Hélion, and other members of the abstract movement. The influence of Léger's work and teaching was crucial for Morris's development during 1929–1935; he represented the structural order of Cubism and a simplified formal vocabulary containing elements of primitivism. Other European artists—Matisse, Delaunay, Gris, and Hélion—were also of consequence for that phase of Morris's stylistic evolution. By 1935 Morris had developed a personal style and began his first sculpture. His work became fully abstract, dominated by angular geometric forms (although at the same time he was experimenting with the biomorphic forms of Miró and Arp). Subsequently integrated the geometric and biomorphic elements and during 1938–1942 produced works incorporating linear grids

stylistically indebted to such influences as the work of Stuart Davis, Ben Nicholson, Mondrian in addition to that of Léger. Between 1942 and 1945 his style underwent change toward more explicit figuration. Besides his work as an artist, Morris pursued critical writing and was a spokesman for American abstract art, cofounding in 1937 the association of American Abstract Artists. During the 1930s and 1940s he maintained close ties with European modernists and collaborated with them on the abstract art magazine *Plastique* (1937), supporting the cause of geometric abstraction and Constructivist traditions. In New York he was an editor and financial supporter of *Partisan Review* (1937–1943). He was influential in popularizing American art through the 1940s and 1950s. He had his first one-man show in 1944 at the Downtown Gallery. He continued to pursue his artistic goals set out in the 1930s throughout the 1960s until his death. He had retrospectives at the Corcoran Gallery of Art, Washington, D.C., in 1965 and at Hirschl and Adler Galleries in New York in 1971.

Moss, Marlow
Born 1890, Richmond, Surrey, England.
Died 1958, Penzance, Cornwall, England.

Before becoming an artist she studied music and ballet. Studied art at Slade School of Art in London; left school in 1919 and moved to Cornwall, returning to London in 1926 and taking up painting. In 1927 went to Paris and remained there until 1939. There met Mondrian (in 1929) and maintained contact with him until his departure for England in 1938. Also became pupil of Léger and Ozenfant. Through contacts with Mondrian embraced theory of Neoplasticism and in 1929 painted her first Neoplastic compositions. In 1931 was among cofounders of Abstraction-Création. Returned to England in 1940 (via Holland) and settled in Cornwall. After 1940 developed interest in three-dimensional work and constructed metal and wood reliefs.

Visited Paris in 1946 and participated in the Salon des Réalités Nouvelles. She had one-man exhibitions in 1953 and 1958 at the Hanover Gallery, London, and her work was also included posthumously in exhibitions at the Stedelijk Museum, Amsterdam (1962), and Town Hall of Middleburg (1972), followed by a retrospective in 1974 at the Gimpel & Hanover gallery in Zurich.

Nicholson, Ben

Born 1894, Denham, England.
Died 1982, England.

Essentially self-taught except for a brief period at the Slade School in London (1911–1912). After leaving school traveled extensively and studied different aspects of modern art. Developed particular appreciation for the work of Cézanne, Rousseau, and the Cubists, and these became an essential influence on the evolution of his own art. His work during the 1920s showed stylistic variety related to his exploration of different modernist expressions, particularly Cubism and primitivism; however, it consistently revealed a tendency toward geometric form and an interest in the textural quality of the pictorial surface. His first abstract paintings date from 1924 and his first geometric abstract reliefs from 1933–1934. During the 1930s, as a result of his closer ties with Parisian modernists such as Mondrian, Miró, and Calder as well as the English artist Barbara Hepworth (his future wife), Nicholson's style evolved into a rigorously purified, totally abstract idiom, exemplified in his famous white reliefs (carved and painted). He was a member of the 7 and 5 Society from 1924, Unit One (1933–1935), and the Parisian Abstraction-Création (1933–1935). His work was exhibited at the Bloomsbury Gallery (1931), the 7 and 5 Society (1934), and the Lefevre Gallery in London (1933, 1935, 1939). Throughout the 1930s lived in Hampstead, maintaining close contact with Henry Moore, Herbert Read,

Naum Gabo, and Mondrian. In 1937, in collaboration with Gabo and architect J. L. Martin, edited an important publication, *Circle: International Survey of Constructivist Art.* At the outbreak of World War II moved to St. Ives, Cornwall, where he lived until 1958, changing his style under the impact of new environment to painting landscapes and still lifes in less abstract mode; subsequently, in the late 1950s, returned to his painted and carved reliefs. From 1958 to 1971 lived in Switzerland; then returned to Hampstead. He had a retrospective at the Venice Biennale in 1954 and the Tate Gallery in London in 1955.

Noland, Kenneth

Born 1924, Asheville, North Carolina.
Lives in New York.

Studied art (and music) at Black Mountain College, North Carolina, in 1946–1948, primarily under the guidance of Ilya Bolotowsky, but also for brief periods with Albers (1947), John Cage, and Peter Grippe (summer 1948). Through Bolotowsky he was exposed to the European geometric abstract tradition, particularly the work of Mondrian. Also developed an interest in the painting of Paul Klee. Albers introduced him to his color theories and the Bauhaus principles. In 1948–1949 lived in Paris, where he studied with sculptor Ossip Zadkine. At that time studied the work of Matisse, Miró, and Picasso, and their influences began to appear in his work. In Paris in 1949 had his first one-man show, of his Parisian Klee-influenced paintings. Returned to the U.S. in the summer of 1949, settled in Washington, D.C., and worked as student-teacher at Institute of Contemporary Arts, subsequently teaching painting there until 1951; from 1951 to 1960 taught figure drawing and basic design at Catholic University in Washington.

In 1950 met Helen Frankenthaler and in 1952 became friend of Morris Louis; their work was of importance for Noland's stylistic development. In 1953, through Clement Greenberg (whom he met in 1950), first saw

Frankenthaler's poured stain work in New York, and upon his return to Washington began, together with Louis, to experiment with stain technique. Began producing allover abstractions influenced by Pollock, Frankenthaler, de Kooning, Clyfford Still, and experimenting with forms, imagery, and methods of application (alternating the thick Abstract Expressionist manner with staining or pouring in thin washes). By 1956 painted centered pictures and began to focus on a circle as central image. During 1957–1958 his work became increasingly geometric, hard-edged, characterized by the use of centered motifs; disks, lozenges, cruciforms. His concentric-circle canvases were first exhibited in 1959 in his one-man exhibition at French and Co. in New York. The concentric color-ring works were followed by the off-center, elliptical "tiger's eye" motifs, then around 1963 by the chevron motifs, suspended from top edge of the canvas, which through modifications to the assymetrical engendered the transition to diamond-shaped canvases with diagonal stripes. During 1964–1965 attenuated the diamond shape, reduced number of color bands, and introduced neutral color.

In the late 1960s developed the horizontal stripe motif. Also began making sculpure, which he first exhibited in 1971 in the Whitney Annual. Around 1971 began vertical plaid paintings with overlapping forms and colors, which later developed also into horizontal format. In 1975 started to paint irregularly shaped canvases, in which he experimented with new colors and techniques. His work shows a continuing preoccupation with the problem of color, relationships of different colors and hues, and the flatness of the pictorial surface. His work has been widely exhibited in the U.S. and abroad.

Novros, David

Born 1941, Los Angeles.
Lives in New York.

Graduated from University of Southern California in 1963. Then traveled in Europe and in

1964 settled in New York. He had his first exhibition, together with the sculptor Mark di Suvero, at the Park Place Gallery in New York in 1965, and a year later his work was included in the important exhibition "Systemic Painting" at the Guggenheim Museum in New York. Since then his work has been shown yearly in innumerable exhibitions in the United States, Germany, Italy, and England. His early works—often made up of multiple units—were shaped canvases, based on geometric forms, which through their compositional organization often implied a diagonal movement. Later he introduced L-shaped forms that relied upon vertical-horizontal relationships and a broader range of color. Although essentially objectlike, these works retained their two-dimensional identity. Whether fiberglass panels, L-shaped or rectangular canvases, his works always relate to the rectangular space of the wall plane to which they are attached. The compositions are based on geometric divisions and the interplay of subtle combinations of luminous color. He has also been one of the few prominent modern painters to execute murals (e.g., for the Gooch Auditorium at the University of Texas Health Science Center in Dallas, 1977).

Pasmore, Victor

Born 1908, Chelsham, Surrey, England.
Lives in Malta.

Moved to London in 1927; for ten years worked for Local Government Service, attending evening classes at L.C.C. Central School of Arts and Crafts in London (1927–1931). In 1937, with Claude Rogers and William Coldstream, opened a teaching studio, The School of Drawing and Painting in Euston Road (known as the Euston Rd. School), which closed after the outbreak of World War II. Beginning in 1938 devoted himself entirely to painting, working in the English and French Impressionist landscape tradition. Although he turned to an abstract idiom shortly after

his contact in London with Fauvism, Cubism, and early European abstraction, he pursued it consistently only from 1947 on. During the early 1950s he worked out, under the influence of Ben Nicholson, various collage ideas that developed into relief concepts. These were also related to his discovery in 1951 of Charles Biederman's book, *Art as the Evolution of Visual Knowledge,* which considered painting to be obsolete and saw its only future in the development of relief.

After 1954 he also produced free three-dimensional constructions, composed of planar elements in geometric shapes, often related to architectural spaces. His contacts with architecture became closer in 1955 when he was appointed as an architectural and environmental designer for the development project in Peterlee New Town. He also executed mural paintings and mural constructions in various public buildings. From 1954 to 1961 he pursued in addition a teaching career as a Master of Painting at Durham University. Toward 1960 he again returned to painting, dividing his energies between painting and relief-making. A large retrospective of his work was presented in the British pavilion at the Venice Biennale in 1960, later traveling to Paris, Amsterdam, Brussels. Among other numerous exhibitions he had a large retrospective at the Tate Gallery in London in 1965 and at the Arts Club of Chicago in 1971.

Pevsner, Antoine

Born 1886, Orel, Russia.
Died 1962, Paris.

The older brother of the sculptor Naum Gabo, Pevsner studied painting at the School of Fine Arts in Kiev from 1902 to 1909 and then for a year attended the St. Petersburg Academy of Fine Arts. During his studies in Kiev his work was influenced by that of Vrubel and Levitan. In 1910 Pevsner toured old Russian monuments and in 1911 went to Paris, where he remained until the outbreak of World War I. While there he met many vanguard artists and became friendly with Archipenko and

Modigliani. During 1913 he began to introduce into his work the elements of Cubism combined with Futurist inflections. He returned to Russia in 1914, working in Moscow during 1914–1915 and studying the works in the Shchukin collection, especially those of Matisse. In 1915 he joined his brothers Naum Gabo and Aleksei Pevsner in Norway, remaining there until April 1917, when they returned to Russia and settled in Moscow. In 1918 Pevsner began to teach at the State Free Art Studios (Svomas) and later Vkhutemas. In 1920 he cosigned Gabo's *Realist Manifesto,* published on occasion of their open-air exhibition on Tverskoi Boulevard in Moscow, in which he included his two-dimensional pictorial investigations of structural aspects of composition. He participated in the First Russian Art Exhibition at the Galerie van Diemen in Berlin in 1922. Left Moscow for Germany in 1923 and later settled permanently in Paris. He began his explorations in plastic sculpture in the 1920s, investigating the techniques of transparent and translucent materials. But only after 1924 did his work show a clearer break with the painter's way of thinking, away from flat surfaces, yet still conceived in terms of planar organization of forms. After 1927 he turned mostly to work in metal, exploring various possibilities of surface texture and emphasizing voids rather than mass. He was a cofounder of the Abstraction-Création group in 1931 and of the Salon des Réalités Nouvelles in 1946.

Picasso, Pablo (Ruiz)

Born 1881, Málaga, Spain.
Died 1973, Mougins, France.

Learned to draw from his father, a painter and art teacher. Studied at Provincial School of Fine Arts, Barcelona, and joined group of Bohemian artists in Barcelona. In 1900 made his first trip to Paris, where he settled definitively in 1904. The work of his Blue Period (1901–1904) was characterized by melancholy mood and predominantly blue

tonality. In 1904–1905 met Apollinaire, Gris, Derain, Léger, Rousseau, Vlaminck, Gertrude and Leo Stein. Began his Rose Period, depicting mostly lyrical circus themes. In 1906 he developed interest in pre-Roman Iberian sculpture and assimilated its influence into his own idiom; met Matisse. In 1907 painted the seminal canvas *Les Demoiselles d'Avignon;* discovered African sculpture in the Musée de l'Homme at the Trocadéro. In 1907 met the dealer Daniel-Henry Kahnweiler and Braque. Collaboration with Braque produced Cubism, which entered its High Analytic phase in 1910. In 1912 he created *Guitar,* the first open relief construction; made first collages. Late 1912 marks the transition to Synthetic Cubism, which will be modified in 1915 and will culminate in the *Three Musicians* paintings of 1921. The early 1920s were his so-called classical period. From mid-1920s he was associated with the Surrealists, and until mid-1930s his work showed Surrealist overtones. In 1937 he painted his monumental *Guernica* in response to bombing of that town during the Spanish Civil War.

He continued his painting and sculpture throughout his life, in the late 1960s producing also large series of drawings, etchings, and lithographs. His work has been subject of innumerable exhibitions in Europe and in the U.S. His significance in the history of art as one of the major contributors to the development of twentieth-century movements has also made him one of the most frequently discussed masters. Extensive documentation of his life and work is in the catalog of the Picasso retrospective held at The Museum of Modern Art, New York, in 1980.

Popova, Liubov Sergeievna
Born 1889, Ivanovskoe, near Moscow.
Died 1924, Moscow.

Educated at the Yalta Women's Gymnasium and in 1907–1908 at the Arsenieva Gymnasium in Moscow. Popova studied art with Stanislav Zhukovsky and the Impressionist Konstantin Yuon in Moscow. Between 1908 and 1911 traveled widely in Europe and Russia, visiting Kiev (where she saw the painting of Vrubel), Italy (where she was particularly impressed by Early Renaissance art, especially Giotto), and numerous Russian towns known for their masterpieces of architecture and art—Novgorod, Pskov, Rostov, Suzdal, Yaroslavl. During the winter of 1912–1913 lived in Paris, where together with Udaltsova studied at the studio La Palette under the guidance of Le Fauconnier and Metzinger. While there met Zadkine and Archipenko and also became acquainted with Futurist ideas. Again traveled to Italy and France in the summer of 1914. Sometime between 1913 and 1915 attended the Tatlin-organized teaching studio The Tower in Moscow, where she worked with Aleksandr Vesnin. Her works of 1912–1915 show an assimilation of Cubist analysis of form and the Futurist preoccupation with dynamics of color and movement. Her works after mid-1914 show influences of Tatlin and Boccioni. Around 1915 Popova developed a nonrepresentational idiom based on the use of overlapping color planes, dynamically interacting. At that time she also began exploring collage and created three-dimensional reliefs (only three still extant) and some nonobjective arrangements of Cubist-inspired colored planes. Popova was an active participant in the important avant-garde exhibitions: in 1914 her Cubist paintings were included in the Jack of Diamonds exhibition (Moscow); she showed at the "Tramway V" (1915, Petrograd); "The Last Futurist Exhibition of Paintings: 0:10" (1915, Petrograd); and "The Store" (1916, Moscow), at which she first presented her reliefs. Her first nonobjective paintings were included in the Jack of Diamonds exhibition in 1916 in Moscow. At that time Popova worked closely with Malevich and was influenced by his Suprematist concepts; she was a member of a group organized by him to prepare publication of the journal "Supremus" (never published). In 1917–1918 she executed a group of canvases designated as "Painterly Architectonics," composed of large geometric planes of flat bright colors placed at different angles and characterized by a strongly architectural structure, enhanced by the linear element provided by the sharp delineation of edges of color planes, which anticipated her future interest in the role of line as a dynamic device.

In 1918–1919 Popova showed her compositions in Moscow in the Fifth State Exhibition, "From Impressionism to Nonobjective Art," and the Tenth State Exhibition, "Nonobjective Creation and Suprematism." In 1918 she joined the faculty of the Svomas, then Vkhutemas in Moscow, and from 1920 on was an active member of the Inkhuk, participating in all of their debates regarding the new artistic philosophy and the practical instruction of future artists. She helped define theoretical concepts of Constructivism and highly favored the active involvement of artists with industry and the production of utilitarian objects known as Productivism. She contributed to the "last" exhibition of paintings "5 × 5 = 25" in 1921 in Moscow and also to the First Russian Art Exhibition at the Galerie van Diemen in Berlin in 1922. She introduced innovative concepts of Constructivism into stage design in her scenery designs for Vsevolod Meyerhold's productions of *The Magnanimous Cuckold* by Fernand Crommelynck (1922) and *Earth in Turmoil* by Sergei Tretiakov (1923). Following the Constructivist tenet of "art into life," she turned to textile and clothing design, working together with Varvara Stepanova for the First State Textile Print Factory in Moscow. She was posthumously given a retrospective in Moscow in 1924.

Pousette-Dart, Joanna
Born 1947, New York.
Lives in New York.

Graduated in 1968 from Bennington College. From 1972 to 1976 taught at Ramapo College, New Jersey. Began exhibiting in 1970, contributing to gallery and museum exhibitions in

New York, Santa Barbara, Boston, Houston, Los Angeles. Also had three solo exhibitions (1976, 1978, 1979) at the Susan Caldwell Gallery in New York. Her works were abstract geometric structures based on a freely drawn grid underlying the colored rectangles painted over it, in various sizes and in iridescent color. But the grid essentially served to organize the surface in terms of color. The works became expressive through well-orchestrated manipulation of color, texture, format, and size. They continued a tradition of Mondrian's 1918 works and related to the more recent explorations of David Novros, while in the use of color they bring to mind certain effects in the paintings of Mark Rothko. Her present work tends toward a more painterly expressive idiom.

Puni, Ivan Albertovich

Born 1892, Kouokkala, Finland.
Died 1956, Paris.

Began to study painting on the advice of the Russian realist painter Ilya Repin and in 1909, after attending the Military College in St. Petersburg (1900–1908), set up a studio in St. Petersburg. In 1911–1912, attracted by French art, made his first trip to Paris, where he studied at the Académie Julian and stayed with the Russian painter Yuri Annenkov. Became deeply interested in Fauvism and Cubism. In 1912 traveled to Italy and upon his return to St. Petersburg became closely associated with the avant-garde through his friend Nikolai Kulbin. Began participating in the Union of Youth exhibitions in St. Petersburg. In 1913 married the artist Ksenia Boguslavskaia, and their atelier became a center of activity of the literary and artistic avant-garde. In 1914 made another trip to Paris, where he exhibited at the Salon des Indépendants. At the outbreak of World War I returned to St. Petersburg, where he was instrumental in organizing the exhibition "Tramway V: The First Futurist Exhibition of Paintings" and the "Last Futurist Exhibition of

Pictures: 0.10" (both in 1915 in Petrograd). On occasion of "0.10" exhibition, published a Suprematist manifesto along with Malevich, Boguslavskaia, Kliun, and Menkov. Puni's work at that time included his first three-dimensional works exploring Cubist principles of composition and textural and spatial possibilities afforded by collage. In 1916 Puni developed his three-dimensional abstract works—arrangements of planar elements according to Malevich's Suprematist principles of dynamic interaction of forms.

In 1918 executed various propagandistic decorations for the celebrations of May 1 and the anniversary of the Revolution. Left Petrograd for Vitebsk in January 1919, invited by Chagall to teach at the Art Institute, but in the autumn returned to Petrograd and with the worsening economic stituation there escaped to Finland. Emigrated to Berlin in the autumn of 1920. There met members of the international avant-garde: Richter, Eggeling, van Doesburg, Belling, and his Russian compatriots. Also came into contact with Herwarth Walden's Der Sturm gallery, where in February 1921 he had a one-man show. In 1922 contributed to the First Russian Art Exhibition at the Galerie van Diemen in Berlin and the First International Art exhibition in Düsseldorf. Settled in Paris in 1924 and continued to paint and work as a graphic artist and critic.

Reinhardt, Ad

Born 1913, New York.
Died 1967, New York.

Studied at Columbia University under Meyer Schapiro 1931–1935, then in 1936 at National Academy of Design with Karl Anderson, and during 1936–1937 with Carl Holty and Francis Criss. Also from 1936 to 1939 worked on Federal Arts Project under Burgoyne Diller. Joined the American Abstract Artists and the Artists Union in 1937 and remained a member until 1947. In 1938 began a series of bright-colored paintings. Took up studies of art history in 1944 under Alfred Salmony, focus-

ing on Chinese and Japanese painting and Islamic architectural decoration; that year had his first solo exhibition at the Artists Gallery in New York. Worked for the newspaper *PM* (1944–1946).

In 1946 began to exhibit at the Betty Parsons Gallery. Taught at Brooklyn College (1947–1967), also at the California School of Fine Arts, San Francisco (1950); University of Wyoming, Laramie (1952); School of Fine Arts, Yale University (1952–1953); Syracuse University (1957). In 1952 made his first trip to Europe. Continued to paint in bright colors until 1953, when besides giving up color also gave up the principles of assymetry and irregularity of composition. That year traveled to Greece; in 1958 to Japan, India, Persia, and Egypt; in 1961 to Turkey, Syria, and Jordan. From 1959 to 1967 taught at Hunter College in New York. In 1960 an exhibition at the Betty Parsons Gallery showed his paintings of the previous twenty-five years. A large retrospective of his work was presented at the Jewish Museum in 1966–1967.

Reinhardt's early paintings and collages—from the late 1930s—grew out of his studies of Cubism and the spatial problems he encountered in that discipline. Compositionally his work showed a tendency to fill up the space, evolving a structure that was neither truly vertical nor horizontal. From 1953 until his death in 1967, he single-mindedly worked at his black paintings. He was a great admirer of Oriental art and thought, a writer and lecturer on the interrelations between Eastern and Western art. The geometric forms he used in his paintings—the mandala, the circled square, the squared circle, the cross, and the interlace—held a fascination for him because of their associative meaning with elements of Eastern art.

Riley, Bridget

Born 1931, London.
Lives in London.

A major figure of the British Op Art movement of the 1960s, Riley studied in London at the

Goldsmith's School of Art (1949–1952) and at the Royal College of Art (1952–1955). In 1958–1959 she taught art to children and in 1959–1960 was a lecturer in Basic Course at Loughborough School of Art. She worked part-time as an illustrator and book-cover designer for the J. Walter Thompson advertising agency from 1959 to 1964, while teaching at the Hornsey School of Art and then the Croydon School of Art. In 1963 was awarded a prize in open section of John Moores Liverpool Exhibition and AICA critics' prize.

Riley's art evolved out of the dynamic pictorial effects present in the work of Seurat, as well as the sensory experience of the Futurist works, which she studied in Milan in 1959, taking special interest in Boccioni's theories on the interaction of light and form. Her first entirely abstract paintings date from 1961, and were primarily concerned with the contrasts of black and white. At that time she became aware of the optical explorations of Victor Vasarely and the experiments of the Groupe de Recherche d'Art Visuel in France. Her personal style first manifested itself in her second solo show in London in 1963 at Gallery One. Eventually, stark oppositions of black and white were modified through the introduction of tonal gradations (of gray) and then subtle color variations (from around 1968 on). All her works show strict pictorial organization based on rhythmical multiplication, serial progression, repetition, and counterpoint. Her work has been widely exhibited in Europe, the United States, and Canada.

Rodchenko, Aleksandr Mikhailovich

Born 1891, St. Petersburg.
Died 1956, Moscow.

Began art education at the Kazan Art School 1910–1914. There met the artist Varvara Stepanova, whom he later married. Having graduated from Kazan, briefly attended the Stroganov School of Applied Art in Moscow. His early style was influenced by Art

Nouveau, Beardsley, and the World of Art group. In 1915–1916 came into contact with the Moscow avant-garde artists Malevich, Tatlin, Popova and in 1916 participated in the exhibition "The Store," organized by Tatlin in Moscow. His works of that period included a series of compass-and-ruler drawings that showed his originality of thought and anticipated in a way his preoccupation with the line as expressive vehicle, carried to its ultimate in his three-dimensional linear hanging constructions (1920). In his pictorial research, among the influences that helped form his style were Suprematist works of Malevich and Rozanova, the counter-reliefs of Tatlin, and possibly even theories of Kandinsky. In 1917 Rodchenko collaborated with Georges Yakulov and Tatlin on the decoration of the Café Pittoresque in Moscow, designing the structures composed of planar elements, overlapping and intersecting. After the Revolution, in 1918 became a member of IZO Narkompros and participated in organizing new artistic and pedagogical life in Moscow. That year, in response to Malevich's seminal painting *White on White*, he painted his *Black on Black*, shown at the Tenth State Exhibition, "Nonobjective Creation and Suprematism," in Moscow in 1919. Also began work on three-dimensional constructions around 1918. In 1920 was among the founding members of the Inkhuk, whose artistic philosophy he strongly influenced; became also professor at the Vkhutemas/Vkhutein (remaining for the next ten years). Cofounded in March 1921 with Gan and Stepanova the First Working Group of Constructivists, whose name officially initiated the designation "Constructivism." That year also contributed to the Moscow exhibition "5 × 5 = 25," showing three paintings in monochrome pure primary colors: red, yellow, and blue. Afterward gave up easel painting and turned to areas better suited to his principles of utilitarian art: posters, book and textile designs, film and theater designs, photography and photomontage. In 1920 met Mayakovsky and from 1923 to 1925 was associated with the leftist art journal *LEF,* for which he produced many excellent typographical designs and photo-

graphs; also contributed numerous articles. His utilitarian designs included the 1925 Workers' Club project, exhibited at the Soviet pavilion at the Exposition International des Arts Décoratifs et Industriels Modernes in Paris. He resumed painting in the 1930s.

Roszak, Theodore

Born 1907, Poznan, Poland.
Died 1981, New York.

Arrived in the United States in 1909. Studied during 1922–1926 and 1927–1929 at the Art Institute of Chicago and in 1926 at the National Academy of Design in New York. He first became aware of abstract art, particularly the Constructivist trend, while traveling and studying in Europe on a two-year fellowship between 1929 and 1931. Although he spent most of his stay in Czechoslovakia, also visited Paris, where familiarized himself with the work of Picasso, Miró, de Chirico, whose work made an impact on his own paintings. While in Czechoslovakia he maintained contacts with the Czech Constructivists and also became aware of the innovative concepts of the Bauhaus. These he further studied through the book by the Bauhaus master Moholy-Nagy, *The New Vision,* acquired in its first English edition before his return to the U.S. After his return Roszak continued to paint under the influence of the European artists and concurrently began to experiment with sculpture, first in plaster and clay, then in metal. His early works in the three-dimensional idiom showed asymmetrical composition of intersecting planes and linear elements indicative of his interest in the Bauhaus-inspired machine aesthetic, and conveyed great technical mastery of the medium. After freestanding objects came painted wall reliefs, in bright colors, executed with help of hand tools and power tools. His fascination with the machine made it also one of the sources of new imagery for his painted constructions, dating from 1936–1945, in which he sometimes introduced a playful

element, echoing the forms of Miró and Arp and even Schlemmer. In 1938 Roszak met Moholy-Nagy and began to teach composition and design at the Moholy-founded school, the Design Laboratory in New York, which was to foster the theories and ideals of the Bauhaus. He was the first American artist to assimilate Constructivist principles and the Bauhaus machine aesthetic into a coherent personal idiom. But by mid–1940s his geometric abstract mode gave way to organic forms of expressionistic nature. From 1940 to 1956 he was a teacher at Sarah Lawrence College and from 1970 to 1972 at Columbia University.

Rozanova, Olga Vladimirovna

Born 1886, Malenki, Vladimir Province.
Died 1918, Moscow.

Educated at the Bolshakov Art School and the Stroganov Art Institute in Moscow. Moved to St. Petersburg in 1911 and there attended the Zvantseva School of Art (1912–1913). Became an active member of the Union of Youth group, contributing to their exhibitions during 1911–1914. Between 1912 and 1916 illustrated various publications of Futurist poets Velimir Khlebnikov and Aleksei Kruchenykh (whom she married in 1916): *Game in Hell* (1913), *Let's Grumble* (1914), *Futurists: Roaring Parnassus* (1914), *Transrational Book* (1916). She also collaborated with Kruchenykh on two portfolios, *War* and *Universal War* (both 1916), for which she executed nonobjective collages of cut-and-pasted geometric forms of colored paper floating against a monochrome background, structured in a manner reminiscent of Malevich's Suprematist paintings. Malevich exerted an important influence upon her work from 1916 on, while her painting style prior to that had developed on the basis of Cubism and Futurism. She contributed to all major avant-garde exhibitions during 1915–1916: "Tramway V: The First Futurist Exhibition of Paintings" and "The Last Futurist exhibition of Pictures: 0.10" (both Pe-

trograd, 1915), "The Store" and the Jack of Diamonds exhibition (both Moscow, 1916). She joined Malevich's group Supremus (1916) and acted as the editorial secretary for its journal (never published). After the Revolution was a member of Proletkult and IZO Narkompros, heading (with Rodchenko) the Subsection of Applied Art of IZO; also was instrumental in founding branches of Svomas in provincial towns. She was active as textile and applied-arts designer. A posthumous retrospective of her work was organized in Moscow in 1919; her work was also represented that year in the Tenth State Exhibition, "Nonobjective Creation and Suprematism," in Moscow and the First Russian Art Exhibition at the Galerie van Diemen in Berlin in 1922.

Ryman, Robert

Born 1930, Nashville, Tennessee.
Lives and works in New York.

Attended the Tennessee Polytechnic Institute in Cookville and the Peabody College for Teachers in Nashville. He was in the army from 1950 to 1952 and after being discharged moved to New York. He came to New York as a jazz musician, but started to paint in 1954. He worked as a guard in The Museum of Modern Art, where he was exposed to all of the modern masters. In the late 1960s he was one of the leading American Minimal artists. His own painting style developed early in his career with variations of monochromatic square paintings. Through extreme simplification of the canvas, his art became characterized by a reduction of forms to primary, simple, repetitive means which created a powerful presence with no figurative imitation of nature. He took every aspect of painting into account—the paint itself on the canvas, or cotton, steel, cardboard, fiberglass, wood. Each of these materials has its own characteristics, which interact differently with oils, tempera, acrylics. Ryman takes into account all the elements that condition perception of the work: the size of the wall, the height at which the painting is to be hung, the depth of

the stretcher, the size of the signature and date. The sides of the paintings perpendicular to the wall are significantly important for the work. Every element is crucial in the creation of a painting. Ryman's work has been included in numerous exhibitions in the United States and Europe and is represented in various public and private collections.

Sander, Ludwig

Born 1906, New York.
Died 1975, New York.

Began to paint in 1925 and two years later attended Art Students League, where he studied with Alexander Archipenko. That year also traveled to Germany and Switzerland. In 1931 spent some time in Paris with the sculptor Reuben Nakian and other American artists and also in Munich, where he studied under Hans Hofmann. From there traveled to Italy and Paris before returning to the U.S. During 1942–1945 served in the military. After his return to New York in 1945 developed closer contacts with the artists of the New York School; his closest friends included Nakian and Arshile Gorky. In 1946 studied art history at New York University. In 1950 cofounded the Club, the association of New York artists which included de Kooning, Franz Kline, Ad Reinhardt, Conrad Marca-Relli, among others; was particularly a friend of de Kooning and Kline. Despite his close association with the Abstract Expressionists, his own work always remained under the influence of Mondrian and the de Stijl tradition. His works are characterized by a strong structure of vertical and horizontal lines dividing the monochrome or close-value field into geometric divisions.

Schlemmer, Oskar

Born 1888, Stuttgart.
Died 1943, Baden-Baden.

Attended School of Applied Art in Stuttgart in 1905 and, beginning in 1906, the Stuttgart Academy of Art, where studied under Adolf Hölzel. In 1910 lived in Berlin and became acquainted with the European avant-garde movement and the work of Cézanne. His first outstanding paintings date from 1911–1912 and were done in a Cubist style reminiscent of Braque. Later works, of 1915–1919, began to establish his formal canon, dominated by flat and linear elements devoid of any illusion of space. His only totally abstract painting was executed in 1915. Around 1919 he began to work in sculpture and relief. In 1920 at Gropius's invitation joined the Bauhaus faculty; in charge first of a mural and sculpture workshop, then, between 1923 and 1929, of a theater-design workshop. His best-known work was done in the field of theatre design: he aspired to revitalize the art of the dance and to create a new theoretical foundation for the spectator's experience of the human figure moving in space. These investigations led him to develop the sets and costumes for the 1922 performance of the *Triadic Ballet*. The forms in his paintings related to his experiments with the theater, and the figures depicted, always imaginary, were rigid, puppetlike, flat, abstracted natural forms, reduced to the basic geometric forms of cone, sphere, and cylinder set in an ideal abstracted space. Schlemmer left the Bauhaus in 1929 (when the new director, Hannes Meyer, dissolved the Bauhaus theater) and accepted a teaching position at the State Academy of Art in Breslau, where he remained until 1932; after that became a professor at the Berlin Academy, where he was dismissed by the Nazis in 1933. He moved to Eichberg in South Baden in 1935 and then lived at Sehringen near Badenweiler (1937–1943), maintaining friendship with Muche and Baumeister.

Schoonhoven, Jan

Born 1914, Delft.
Lives in Delft.

Studied from 1932 to 1936 at the Royal Academy of Fine Arts in The Hague. During the 1940s and 1950s did mostly gouaches, pastels, and pencil drawings on paper. Stylistically influenced by the work of Paul Klee. In 1957 created his first reliefs in papier-mâché. His work—both in painting and relief—became concerned with complex, yet strongly ordered patterns of linear and geometric forms, used repetitively. In 1957–1959 he was a member of the Nederlandse Informele Group, which he had helped to found. His first white reliefs evolved around 1960, and that year he was also an organizer of the Gruppe Nul (Group Zero), together with Armando, Henderikse and Henk Peeters (the group lasted until 1965). Subsequently he concentrated on the white relief, characterized by a regular grid structure that through an emphasis on rhythmic repetition of vertical and horizontal lines resulted in three-dimensional compositions that look as if they were built of modular, serial elements. Schoonhoven's work has been frequently exhibited in Germany, Holland, England, Italy, Switzerland, and the United States.

Schwitters, Kurt

Born 1887, Hannover.
Died 1948, Ambleside, England.

Studied at Kunstgewerbeschule in Hannover in 1908–1909 and at the Dresden Academy of Art 1909–1914. During 1917–1918 worked as mechanical draftsman at ironworks near Hannover. Began experimenting with abstraction and made his first collages (Merzzeichnungen) late in 1918; the medium was to be his foremost personal idiom, explored and modified throughout his life. That year became friend of Hans Arp and Raoul Hausmann. His first Merz-pictures appeared in 1919. Also in 1919 had his first exhibition at the Der Sturm gallery in Berlin (together with Klee and Molzahn), and the first edition of his poems in prose, *Anna Blume*, was published in the magazine *Der Sturm*.

His Merz-pictures, collage-assemblage compositions, were arrangements of ordinary objects, scraps of paper and wood. He applied the Merz principles to his other art activities, such as the Merzbau, a three-dimensional structure, begun in 1923 in Hannover. In 1923 he also founded the magazine *Merz*, published until 1932. His artistic activities encompassed typography and advertising and graphic design as well as phonetic poetry. He was a member of the Paris-based groups Cercle et Carré (1930) and Abstraction-Création (1932). He developed an interest in de Stijl and Constructivist ideas around 1922, and his collages of that period and after show stricter composition and more regular geometric forms. From 1937 to 1940 Schwitters lived in Norway, where he began his second Merzbau (destroyed 1951), and in 1940 moved to England.

Servranckx, Victor

Born 1897, Dieghem, Belgium.
Died 1965, Elewijt, Belgium.

Studied at the Brussels Academy of Fine Arts from 1912 to 1917. Had his first one-man exhibition in Brussels in 1917, then showed regularly at the Salon des Indépendants in Paris between 1924 and 1927. In 1925 participated in the Exposition Internationale des Arts Décoratifs in Paris, where he received a gold medal; that year also exhibited with the Novembergruppe in Berlin. His work was included in the international exhibition of abstract art organized by Katherine Dreier's Société Anonyme at the Brooklyn Museum in 1926. He was active as a designer of modern furniture and was associated with the Léonce Rosenberg gallery L'Effort Moderne in Paris. In 1935 he executed murals for the Brussels Exposition. He was given a retrospective in 1947 at the Palais des Beaux-Arts in Brussels. Beginning in the 1920s his work was characterized by flat geometricized forms in pure, unmodulated bright colors organized into complex compositions reminiscent of the work of Léger and Ozenfant.

Severini, Gino

Born 1883, Cortona, Italy.
Died 1966, Meudon, France.

Moved to Rome in 1899 and studied at the studio of Giacomo Balla under Umberto Boccioni. In 1906 settled in Paris, where he met Braque, Modigliani, and the writer Max Jacob, also, in 1910, Picasso. Was a cosigner in 1910 of the *Technical Manifesto of Futurist Painting* and together with Marinetti served as link in the exchanges between the Parisian Cubist vanguard and the Italian Futurist painters. In February 1912 his work was included in the first exhibition of the Italian Futurists at the Bernheim-Jeune Gallery in Paris. His idiom at the time combined stylistic elements of early French Cubism, in its mosaiclike structure, with the interest in dynamic movement characteristic of Futurism. Through color, form, and lines used to represent force and speed, he conveyed in his canvases the impression of figures moving in the moving world. After 1914 his main themes revolved around the experiences of war, and in 1916 these works were presented in the exhibition "The Plastic Art of War," in Paris. Subsequently his style changed drastically toward a classicizing monumental idiom, expounded in his theoretical treatise of 1921, *Du cubisme au classicisme*, in which he vigorously defended the classical tradition. Continued to work in this classicizing style for the next two decades and subsequently returned to his pre–1918 Futurist expression.

Sheeler, Charles

Born 1883, Philadelphia.
Died 1965, Dobbs Ferry, New York.

Charles Sheeler, painter and photographer, studied at the School of Industrial Art in Philadelphia and at the Pennsylvania Academy of Fine Arts under William Merritt Chase. In Philadelphia, Sheeler was introduced to the Joseph Widener and John G. Johnson collections. During the summers of 1904 and 1905, Sheeler went with Chase and his class to study the old masters in England, Holland, and Spain. He began photography in 1912 to subsidize his painting. He used a clear, sharp-focus technique that revealed his interest in texture and design. He became a leading photographer and was asked to photograph Marius de Zayas's African sculpture collection in 1918. He also photographed the Ford Plant, Chartres Cathedral, and in 1942–1945 works in the collection of the Metropolitan Museum of Art, New York. In 1921 he collaborated with Paul Strand on an avant-garde film called *Mannahatta*.

Sheeler's early style, from 1903–1910, revealed Chase's influence of strong brush-strokes and tonal harmony. After his 1909 trip to Europe, the direct influence of Cézanne, the Fauves, and the Cubists was apparent in his work. Sheeler reconciled Cubism and photography in a well-defined, unprejudiced style, and his paintings of machinery and industrial architecture grew out of his love for geometric designs. He was interested in the structure of things and the patterns they formed. He never abstracted his works beyond recognition. In the early 1920s he used a technique of isolation, painting things in space with no background. In the mid–1920s and until around 1945, Sheeler painted more realistically, his works showing a direct relationship to photography. Falling into the category of Precisionism or Cubist Realism, his paintings of this period harmonized the geometry of Cubism with everyday surroundings. In the mid–1940s, his paintings became more abstract, and color masses were defined by line. It was now more difficult to discern Sheeler's subject, because objects were becoming even more geometrically simplified. In the 1950s he no longer used line to define edges, and objects were superimposed on one another, suggesting the photographic method of double exposure. By treating the subject matter in a purely objective and mechanical manner, he directly influenced the look of certain varieties of Pop and then Minimalist art.

Spencer, Niles

Born 1893, Pawtucket, Rhode Island.
Died 1952, Dingman's Ferry, Pennsylvania.

Studied at the Rhode Island School of Design 1913–1915. During summers he painted with a fellow student, Charles Woodbury, in Ogunquit, Maine. His early works already show an understanding of form and color. During these summers he met Yasuo Kuniyoshi, Katherine Schmidt, Bernard Karfiol, Marsden Hartley, Louis Bouché, and Robert Laurent. He went to New York in 1914 to study briefly with Kenneth Hays Miller at the Art Students League. Disturbed by the techniques and formulas of Miller, he enrolled briefly at the Ferrer School to study under George Bellows and Robert Henri. Subsequently returned to the Rhode Island School of Design as a student, but also taught an evening class. In 1916 he moved to New York.

In 1921, took his first trip to Europe, where in Paris he was exposed to the art of the Cubists and became especially interested in Juan Gris and Georges Braque. His response to Cubism was evident shortly thereafter in the structural pattern of his works. From France he traveled to Italy and then back to Aix-en-Provence, where he was influenced by Cézanne. In 1923, returned to New York and was invited to join the Whitney Studio Club, where he exhibited annually until it closed in 1930. In 1925 Spencer had his first one-man show in New York at the Daniel Gallery. His second one-man show was held at the same gallery in 1928. That year he took another trip to Europe. Spencer was a member of the Precisionist group who interpreted American subject matter such as industry and urban life in simplified geometric forms and patterns.

Stella, Frank

Born 1936, Malden, Massachusetts.
Lives in New York.

First studied painting at the Phillips Academy in Andover (1950–1954) under the abstract painter Patrick Morgan. While there developed interest in the art of Mondrian. He graduated from Phillips in 1954 and entered Princeton University, studying painting with William Seitz and Stephen Greene. Received his B.A. in 1958 and moved to New York. Stella's early works from the Andover years were small geometric compositions, most frequently arrangements of rectangular shapes. Around 1958 he began to work in a transitional style characterized by the use of simple or multiple boxlike forms arranged in bands of stripes. Then followed austere semigeometric works executed in commercial colors. Toward the end of 1958 started his innovative black-stripe paintings, the so-called Black series, compositions of unmodulated black stripe-patterns, with the black stripes separated by stripes of unpainted canvas, symmetrically arranged into allover configurations. They totally eliminated the boxlike forms and any suggestion of three-dimensional image, emphasizing through the allover pattern the two-dimensionality of pictorial surface and ultimate flatness of the composition. Yet they had an objectlike quality by virtue of the thick stretcher, which made them protrude from the wall. In 1959 his Black paintings were included in the "16 Americans" exhibition at The Museum of Modern Art in New York.

In 1960 emerged his first shaped canvases in the Aluminum series (which followed the Black series and was done in aluminum paint). Here, with the cutting away of the "unnecessary" space, articulation of the pattern conformed to the shape of the support. The shaped-canvas concept was further developed in the Copper series, characterized by mostly L- or V-shaped supports. He had his first one-man show at the Leo Castelli Gallery in New York in the autumn of 1960, and his austere, self-referential works made him a major figure in the early 1960s in establishing

Minimal art as a leading trend of the New York School. His first European one-man show was held in Paris at the Galerie Lawrence, in November 1961. In 1962–1963 he executed a series of Concentric Squares and Mitered Mazes. In the summer of 1963 he began his chevron-shaped works. In 1964 his work was included in the Venice Biennale. During 1964–1965 produced Notched-V series and the Moroccan series, the latter done in Day Glo colors on a square format. His first solo museum show was held in 1966 at the Pasadena Art Museum. In 1967 his work underwent change; in his Protractor series he introduced curved and concentric forms done in vivid fluorescent colors. That year he won the first prize in the International Biennale Exhibition of Paintings in Tokyo. In 1970 had a major one-man exhibition at The Museum of Modern Art, New York.

From 1970 on he experimented with new materials and gradually started moving away from the flat surface, beginning with the Polish Village series (1970–1974), which included three-dimensional constructions of paper, paint, cardboard, felt, and canvas, mounted on cardboard. In 1974–1975 there followed the Brazilian series of three-dimensional works in honeycombed aluminum, featuring shiny metal surface and high-hued lacquer. In 1975 executed the Exotic Bird series, where each configuration was presented in three different sizes. In the late 1970s another dramatic change occurred in Stella's style—toward a baroque expressionist idiom—the three-dimensional constructions composed of geometry-related forms seemingly organized in a chaotic way and exploring textural possibilities of (often) aluminum surfaces, painted in high-hued colors, incised, scribbled, which interact in a multiple-view space. In 1983 was invited by Harvard University to deliver the Charles Eliot Norton lecture series, in which he discussed the work of Caravaggio, Picasso, and Kandinsky.

Stepanova, Varvara Fedorovna

Born 1894, Kovno, Lithuania.
Died 1958, Moscow.

Attended the Kazan Art School 1910–1911 where she met Aleksandr Rodchenko (her future husband). Moved to Moscow in 1912 and studied with Konstantin Yuon and Ilya Mashkov, then in 1913 entered the Stroganov School of Applied Art in Moscow. After the Revolution she was an active member of the Constructivist avant-garde. Participated in a number of important exhibitions in Moscow: the Fifth State Exhibition, "From Impressionism to Nonobjective Art" (1918–1919); the Tenth State Exhibition, "Nonobjective Creation and Suprematism" (1919); "Exhibition of Four" (including Kandinsky, Rodchenko, and Sinezubov, 1920); and "$5 \times 5 = 25$" (1921). Her work was also included in the Erste Russische Kunstausstellung in 1922 at the Galerie van Diemen in Berlin. She also collaborated with the Futurist poets (1919), wrote poetry in Krutchenykh's transrational language "Zaoum," made nonobjective collages and calligraphic books. In 1918 she became a member of IZO Narkompros and in 1920–1923 was a member of Inkhuk, participating actively in debates and helping shape its artistic objectives. Together with Rodchenko and Gan formed the First Working Group of Constructivists (1921) and in December 1922 delivered an important lecture, "On Constructivism." Her artistic activities extended also to theater design, where she introduced innovative concepts of structural systems applying Constructivist principles to stage sets and introducing nonobjective forms in costume designs, as exemplified by the sets and costumes for the Meyerhold production of the *Death of Tarelkin* (1922). In 1923 she became closely involved with the vanguard journal *LEF* (1923–1925) and *Novyi LEF* (1927–1928), edited by Mayakovsky. She embraced the tenets of the Productivist group and in 1924 began to work (with Popova) as textile designer for the First State Textile Print Factory in Moscow. She taught at the Textile

Department of Vkhutemas from 1924, implementing Constructivist principles of design. In 1925 began to work on poster designs, an activity that continued through the next decade. In 1925 also participated in the Exposition des Arts Décoratifs et Industriels Modernes in Paris. Her later work, from the 1930s onward, was mainly in graphic and typographical design.

Storrs, John
Born 1885, Chicago.
Died 1956, Mer, Loir-et-Cher, France.

The son of a wealthy architect and real estate developer, Storrs studied art with Arthur Bock in Germany and at the Académie Julian in Paris in 1906; at the Académie Franklin, Paris, 1907; Chicago Academy of Fine Arts and the School of the Art Institute of Chicago, 1908–1909; School of the Museum of Fine Arts, Boston (with Bela Pratt), 1909–1910; Pennsylvania Academy of Fine Arts, with Thomas Anshutz and Charles Grafly, 1910–1911; Académie Colorossi, Paris, with Paul Bartlett and Jean-Antoine Injalbert, and Académie de la Grande Chaumière, Paris, 1911–1912; with Auguste Rodin, 1912–1914; and finally the Académie Julian, Paris, 1919. Storrs was an academic artist at this time, copying classical art. He exhibited at the Salon d'Automne in 1913 and 1920. After Rodin's death in 1917 he did his first abstract work and had his first one-man exhibition at the Folsom Galleries in New York in 1920. He was probably influenced by Boccioni's *Technical Manifesto of Futurist Sculpture* of 1912, which called for sculpture to be treated geometrically in terms of volume and form. His works were influenced by Lipchitz and Maillol, and there is an obvious influence of the segmented geometric forms of Cubism. He was also interested in the styles of Egyptian, pre-Columbian, and medieval sculpture. Storrs received many public commissions in the late twenties and thirties, including a monument to Wilbur Wright for the Aero Group of France in 1924 and a thirty-

foot-high aluminum statue of Ceres, for the Board of Trade Building in Chicago in 1929. Storrs's tall metal sculptures were reminiscent of the tall skyscrapers in the United States. From the late twenties to the late thirties, in order to satisfy the conditions of his father's will, Storrs lived for six months in Chicago and for the rest of the year in his French château. His style changed again at this time. Tall architectural forms were abandoned; his works became smaller, simplistically pure, with shapes evolving from machinery and technology. This style linked him with the Precisionists. In 1931 Storrs began painting; he had his first exhibitions of paintings at the Chester Johnson Galleries in Chicago. His paintings in the thirties became more painterly and dreamlike. He was arrested as an enemy in France and was placed in concentration camps twice by the occupation forces. Storrs produced little work after World War II.

Strzeminski, Wladyslaw
Born 1893, Minsk, Russia.
Died 1952, Lódź, Poland.

Polish painter, theoretician, and teacher, Strzeminski graduated in 1914 from the Engineering School in St. Petersburg. Close friend of Malevich, whom he probably met during his years in St. Petersburg. Possibly studied art at the Svomas in Moscow, in 1918–1919, and was an important member of IZO and the Russian Central Office of Exhibitions, becoming a member of the Moscow Council of Arts and Art Industry in 1919. His works at that time, including Constructivist paintings and reliefs composed of ordinary ready-made elements were exhibited at the Museum of Artistic Culture in Moscow and Petrograd. In his work he was influenced by Malevich, with whom he collaborated in his Vitebsk Unovis group. Together with his wife, the Polish sculptor Katarzyna Kobro, he subsequently headed the Smolensk Svomas. Moved to Poland in 1922 and became leader of the Polish avant-garde, being instrumental in organizing the "Exhibition of New Art" in Vilno, and cofounding the group of Polish

Constructivists Blok (1922) and its journal of the same name, devoted to the cause of Constructivism. Two years later also collaborated with the group Praesens—an association of vanguard architects postulating unification of architecture and painting. In 1927 he formulated his theory of Unism—a nonobjective painting based on the unification of all the pictorial components: texture, monochrome color, and composition—and during 1928–1934 produced about a dozen Unistic paintings. He also worked on a series of architectural paintings (1926–1929), developed as a reductive system of elementary geometric forms arranged according to strict mathematical relations toward each other and executed in color schemes limited to two or three colors. After 1929 his Unistic canvases with painstakingly executed monochrome surfaces became the focal point of his work. He actively carried on his theoretical writings and typographical experiments and was particularly preoccupied with the social problems of art. His work and especially his theoretical writings were an important influence on the development of nonobjective art in Poland. His work was included in many international exhibitions during his lifetime, and more recently in "Pioneers of Abstract Art in Poland," Galerie Denise René, Paris, 1958; "Polish Constructivism," MoMA, New York, 1976; "Constructivism in Poland 1923–1936," Kettle Yard Gallery, London, 1984.

Taeuber-Arp, Sophie
Born 1889, Davos, Switzerland.
Died 1943, Zurich.

She initially studied applied arts at the Kunstgewerbeschule in Hamburg in the textile section (1908–1910), at W. Debschitz's experimental school of arts and crafts in Munich (1911, 1913), and the Hamburg Kunstgewerbeschule (1912). In 1915 she met Hans Arp (whom she married in 1922), while studying in Rudolf von Laban's dance school in Zurich, and with Arp was a member of the Zurich Dada group (1916–1920). Her first

geometric compositions were done around 1916. Between 1916 and 1929 she taught weaving and embroidery at the Zurich Kunstgewerbeschule. Both her paintings and her textile designs of that period show extreme attention to order and balance among the vertical and horizontal elements, between line and color, and are always strongly two-dimensional. In 1927–1928 she collaborated with Arp and Theo van Doesburg in the interior decoration of the Café de l'Aubette in Strasbourg—one of the few abstract interiors effectively realized, highlighting the integration of art and architecture (destroyed in the early 1940s). Moved with Arp to Meudon near Paris around 1929; was a member of the Paris Abstraction-Création group (1931–1936), the Zurich Allianz association (1937), and co-edited the art magazine *Plastique* (1937–1939). Her work during the 1930s became less rigid, with the circle and curve becoming dominant elements, organized into compositions often exploring the diagonal, but always stressing the equilibrium of the arrangement. Returned to live in Zurich in 1942 (two months before her death). Her work was shown in a retrospective at the Musée National d'Art Moderne in Paris in 1964 and again at The Museum of Modern Art, New York, 1981.

Tatlin, Vladimir Evgrafovich

Born 1885, Kharkov.
Died 1953, Moscow.

Grew up in Kharkov and in 1902 traveled as a merchant seaman to Bulgaria, North Africa, Near East, Greece, and Turkey. Began his artistic education around 1904 at the art school in Penza. In 1907 or 1908 visited Larionov at Tiraspol and on his advice entered in 1909 the Moscow School of Painting, Sculpture, and Architecture (from which he was subsequently expelled). He remained in close contact with Larionov and Gontcharova and exhibited with them at the second Izdebzky Salon in Odessa (1910–1911) and later in their "Donkey's Tail" (spring 1912),

beginning also to participate in the Union of Youth exhibitions from 1911. In the winter of 1911 Tatlin organized a teaching studio in Moscow, The Tower, which was attended at times by Vesnin, Popova, Udaltsova. He also designed his first stage sets, continuing this activity during 1912–1914. After separating from Larionov's group in 1912, began to exhibit with the French-influenced Jack of Diamonds group. In 1913 Tatlin traveled to Berlin with a Russian dance group and then to Paris, where he visited Picasso's studio and must have seen Picasso's Cubist constructions. Upon his return to Russia he began to evolve his new idiom, the three-dimensional painterly reliefs (1913–1914) and counter-reliefs (1914–1915), and in May 1914 had in his Moscow studio the first showing of these new works: "synthetic-static compositions." While working on his reliefs he developed his theory of the "culture of materials," eventually of great importance for the evolution of Constructivist concepts. He lived in Moscow but often visited Petrograd and there grouped around himself young artists and critics such as Lev Bruni, Petr Miturich, and Nikolai Punin (author of first monograph on Tatlin in 1920).

Tatlin's work was included in major avant-garde exhibitions, such as "Tramway V: The First Futurist Exhibition of Paintings" and "The Last Futurist Exhibition of Pictures: 0.10" (both Petrograd, 1915), "Exhibition of Painting: 1915" (Moscow), and "The Store" (Moscow, 1916)—this last organized by Tatlin himself. He participated with Yakulov and Rodchenko in the decorating of the interior of the Café Pittoresque in Moscow. After the Revolution, from mid-1918 headed IZO Narkompros and in January 1919 was placed in charge of the Department of Painting at the Moscow Free Art Studios (Svomas). Also, from mid-1919 to 1921, taught at the Petro-svomas in the Studio for Volumes, Materials, and Construction. Because of his ideological commitment was commissioned to execute a monument for the new state, the future Monument to the Third International, the famous "Tatlin's Tower," the model of which

was exhibited in 1920 in Petrograd and Moscow. In 1921 was appointed head of the Department of Sculpture of the restructured Academy of Arts, Petrograd. Exhibited his work in 1922 show of the Association of New Trends in Art (Petrograd), the First Russian Art Exhibition at the Galerie van Diemen in Berlin (1922), and "Exhibition of Paintings of Petrograd Artists of All Tendencies" (1923). In 1923 became involved with the Inkhuk, and was active in creating the Ginkhuk in Petrograd (1924). His philosophy of the exploration of the inherent nature of materials and his conviction as to the crucial importance of utilitarianism in art led him to experiments with designs for workers' clothing and furnishings, and from mid-1920s he was strongly preoccupied with applied arts. In 1925 contributed to the Exposition Internationale des Arts Décoratifs et Industriels Modernes in Paris. From 1925 to 1927 headed the Department of Theater, Cinema, and Photography at the Kiev Art School and began to teach his "culture of materials" course. Returned to Moscow in 1927, teaching at Vkhutemas, and from 1930 worked on his project for a flying machine, "Letatlin," which was exhibited in Moscow in 1932 at the Russian Museum of Fine Arts. In the 1930s returned to painting, working in the figurative idiom; also continued to work on theatrical designs.

Udaltsova, Nadezhda Andreievna

Born 1886, Orel, Russia.
Died 1961, Moscow.

Began her art education in 1905 at the Moscow School of Painting, Sculpture, and Architecture; in 1906 worked in private school of Konstantin Yuon, in 1909 worked with Simon Hollosy's students on study of space. In the winter of 1911–1912 went to Paris, where she studied with Popova at the studio La Palette under Le Fauconnier, Metzinger, and de Segonzac. There she came in close

contact with French Cubism, which she assimilated into her own idiom. Was deeply interested in the work of Picasso, as well as Poussin, Dutch masters, and medieval stained-glass windows. After her return to Moscow in 1913 became an active member of the Russian avant-garde: worked in Tatlin's studio, The Tower (1913), with Popova and Aleksandr Vesnin, among others; exhibited with the Jack of Diamonds group (Moscow, 1914), "Tramway V: The First Futurist Exhibition of Paintings" (Petrograd, 1915), the "Last Futurist Exhibition of Pictures: 0.10" (Petrograd, 1915), "The Store" (Moscow, 1916). During 1916–1917 was a member of Malevich's group, Supremus. Participated with Yakulov, Rodchenko, Tatlin in decorating the interior of the Café Pittoresque in Moscow in 1917. After the Revolution, in 1918 taught at the Moscow Svomas. Was a member of IZO Narkompros and during 1920–1921 the Inkhuk. From 1921 to 1934 taught at the Moscow Vkhutemas/Vkhutein. Her works were included in the First Russian Art Exhibition at the Galerie van Diemen in Berlin in 1922. In the late 1920s reverted to painting in a naturalistic idiom.

Vantongerloo, Georges

Born 1886, Antwerp.
Died 1965, Paris.

Attended the art academies at Brussels and Antwerp. In 1915 met van Doesburg and subsequently joined de Stijl in 1917; that year executed his first abstract sculptures. Remained associated with de Stijl until 1921. From 1919 to 1927 lived in Menton, France. His sculpture of 1919–1924 was focused on the exploration of interrelation of masses. In 1924 began making sculptures and paintings based on mathematical formulas that govern proportional progression of rectangular forms or cubic volumes. That year also published his book *L'Art et son avenir,* discussing the relation of art to modern society. He was represented in the 1925 exhibition "L'Art d'Aujourd'hui" in Paris and in 1926 at the

"International Exhibition of Modern Art" organized by the Société Anonyme at the Brooklyn Museum. In 1927 Vantongerloo moved to Paris, joined Cercle et Carré in 1930, and in 1931 became a cofounder of the Abstraction-Création group (and its vice-president). His work lost the strict rectilinearity characteristic of the early period, and he began to introduce a curve in his paintings (1937) and curving glass and plastic tubing in sculpture. After 1950 experimented with plexiglass sculpture, concentrating on problems of color and transparency of form in space. A retrospective of his work took place at the Marlborough New London Gallery in London in 1962.

Vasarely, Victor

Born 1908, Pecs, Hungary.
Lives in France.

Initially studied medicine in Budapest, but abandoned it to enroll at the Budapest Bauhaus in 1928. There studied under Alexander Bortnyik and became acquainted with the theories of abstract art and the work of Malevich, Mondrian, Kandinsky, and the Dessau Bauhaus. Settled in Paris in 1930, working as commercial artist; there, in 1931–1932, he made his first optical works—geometric drawings for textile prints, which in many ways anticipated his later Op Art works. Between 1933 and 1938 created his figurative works, which showed strong optical kineticism through their aggressive structure. Beginning in 1947 the natural shapes in his paintings became translated into simplified geometric signs organized into totally abstract geometric compositions. His interest in pictorial space and the three-dimensional interaction of two-dimensional forms led him to experiments with trompe l'oeil and optical illusion. In 1951 he began experimenting with grids and networks of lines that created an impression of movement, enhanced by the sharp black-and-white contrasts and rhythmic structure. In 1955 he published his *Yellow Manifesto,* a treatise on kinetic art.

In the early sixties his work underwent transition from black and white to color and also from the two-dimensional form to three-dimensional solid objects, such as pyramids and columns, composed of units of geometric forms. He has executed numerous public commissions and environmental works—murals, screens, etc.—always searching for "plastic unity of form and color." His introduction of the concept of movement into pure art was closely related to his belief that modern technique has altered the concept of a work of art from that of a "unique" example to that of a machine-related object reproduced in multiple copies. Kineticism and multidimensionality are the principal goals of his art.

Vesnin, Aleksandr Aleksandrovich

Born 1883, Yurevets, Volga Province, Russia.
Died 1959, Moscow.

Russian Constructivist painter, designer, architect, and, after 1923, the main stage designer for the Meyerhold and Tairov productions at the Kamerny Theater in Moscow. The youngest of the three Vesnin brothers, he studied painting from 1907 to 1911 in Moscow under the Impressionist painters Tsionglinski and Yuon; also attended the Institute of Civil Engineering (graduating in 1912) and from 1912 to 1914 worked in Tatlin's studio The Tower, where he met Popova and Udaltsova, among others. He was an active member of the avant-garde, a friend of Kasimir Malevich, and a close collaborator of Exter, Tatlin, Popova, Rodchenko. He exhibited with them in the important exhibition "5 × 5 = 25" in Moscow in 1921, showing such works as *Structures of Colored Space by Means of Lines of Force.* Began to collaborate on propagandistic decorative commissions in 1918, with the May Day decorations for the Moscow Red Square; worked on the 1921 Red Square decorations for the Third Congress of the Communist International, for which he proposed a monument composed of

several superimposed platforms. Beginning in 1921, Vesnin taught the color-construction part of the Basic Course and drawing and color in the Woodworking Department at the Moscow Vkhutemas; also taught in the Architecture Department. He was a member of the Moscow Inkhuk and one of the more active believers in Ossip Brik's principle of the artist's practical involvement in production. In 1922 he postulated the application of Constructivist principles to architecture and during the 1920s executed numerous architectural projects (in collaboration with his brothers), such as the Palace of Labor (1923) in Moscow and the competition for the Moscow office of the Leningrad *Pravda*. In 1922–1923 designed his famous Constructivist sets for *The Man Who Was Thursday* at the Kamerny Theater. In 1925 he, his brothers Leonid and Victor, and Moisei Ginzburg formed the group of architectural Constructivists OSA (Society of Contemporary Architecture) and in 1926 began to publish the journal *SA* (Contemporary Architecture). Joined the October group in 1928 and during the 1930s taught at the Moscow Architectural Institute.

Vordemberge-Gildewart, Friedrich

Born 1899, Osnabrück, Germany.
Died 1962, Ulm, West Germany.

Trained at the Applied Arts School and Technical Institute in Hannover. Started to paint in 1919, from the very beginning working in a nonfigurative idiom. Settled in Hannover, where he came into close contact with Schwitters and also met Hans Arp and Theo van Doesburg. Cofounded with Hans Nitschke the group K in Hannover in 1924; that year van Doesburg invited him to join de Stijl. Participated in 1925 in the exhibition "L'Art d'Aujourdhui" in Paris, and in the Société Anonyme "International Exhibition of Modern Art" at the Brooklyn Museum in 1926. Founded with Schwitters, Hans Nitschke, and Carl Buchheister the group Die Abstrakten Hannover in 1927 (within the International Association of Futurists, Cubists, and Constructivists of Berlin). In 1929 had his first one-man exhibition at the Galerie Povolozky in Paris; was a member of the Cercle et Carré (1930) and Abstraction-Création (1931) groups in Paris. Moved to Berlin in 1936 and in 1937–1938 worked in Switzerland; from 1938 to 1954 lived in Amsterdam. Beginning in 1954 taught at the Hochschule für Neue Gestaltung at Ulm. He was also active in typographical design and wrote poetry.

His work from the 1920s on displayed frequent application of relief elements and free-floating linear and triangular elements, exploring at times a diagonal as a compositional device.

von Wiegand, Charmion

Born 1900, Chicago.
Died 1983, New York.

Grew up in San Francisco and Berlin, Germany. After return to the U.S. attended Barnard College and Columbia University, where she first studied journalism and then history of art and archaeology. She focused on her painting career only in the late 1930s, having devoted herself previously to journalism. She was a foreign correspondent in Moscow from 1929 to 1932 for the Hearst newspapers. In the mid and late 1930s she published articles in *New Masses* (cofounded by her husband, the novelist Joseph Freeman, who also later founded *Partisan Review*) and worked as editor of *Art Front*. In 1941 she befriended Mondrian (then living in New York) and became his close follower, also helping to edit and translate his essays into English. In 1943 she wrote the first critical article on Mondrian to be published in America. Her other activities extended to involvement in organizing exhibitions, such as "Masters of Abstract Art" at the New Art Circle in 1942 and a number of shows for the Rose Fried Pinakotheca Gallery in the late 1940s.

Her own mature work is characterized by the use of flat planes, geometric forms, and grid structure. Initially a landscape painter in an Expressionist-like mode, she turned to abstraction inspired by the work of Mondrian. In the 1950s, admiring Schwitters's work in collage, she began to explore that medium, and also started to incorporate Oriental themes, particularly from Egyptian, Indian, and Tibetan cultures.

Selected Bibliography

This bibliography includes selected major sources: general books and exhibition catalogs. Articles in periodicals and artists' monographs have been excluded, except for a few recent monographs that are crucial to an understanding of the period and are the most comprehensive studies on important artists. Bibliographies including periodical literature and monographs will be found in the books by Bowlt and Lodder listed in section 2 and by Bann and Rickey in section 3. The first five sections of the bibliography correspond to the five chapters of this book; a sixth section has been added, listing selected major periodicals of the time, since they provide an exceptionally important insight into the art and culture of the period.

Clive Phillpot

1.

Origins of the Nonobjective —Cubism, Futurism, Cubo-Futurism: 1910–1914

Abstraction: Towards a New Art, Painting 1910–20. (Exhibition catalog.) London: Tate Gallery, 1980.

Ades, Dawn. *Photomontage*. New York: Pantheon, 1976.

Agee, William C. *Synchromism and Color Principles in American Painting, 1910–1930.* (Exhibition catalog.) New York: Knoedler & Company, 1965.

Apollonio, Umbro, ed. *Futurist Manifestos*. New York: Viking, 1973. Translation of *Futurismo*. Milan: Mazzotta, 1970. (2nd ed. 1976.)

Barr, Alfred, H., Jr. *Cubism and Abstract Art*. (Exhibition catalog.) New York: Museum of Modern Art, 1936. Reprint, Arno, 1966; 1st paperbound ed., Museum of Modern Art, 1974.

Breeskin, Adelyn D. *Roots of Abstract Art in America, 1910–1930.* (Exhibition catalog.) Washington: National Collection of Fine Arts, 1965.

Cachin-Nora, Françoise, ed. *Le Futurisme, 1909–1916.* (Exhibition catalog.) Paris: Musée National d'Art Moderne, 1973.

Carrieri, Raffaele. *Futurism*. Milan: Edizioni del Milione, 1963. Translation of *Il Futurismo*. Milan: Edizioni del Milione, 1961.

Color and Form 1909–1914: The Origin and Evolution of Abstract Painting in Futurism, Orphism, Rayonnism, Synchromism and the Blue Rider. (Exhibition catalog.) San Diego: Fine Arts Gallery, 1971.

Constructivism and Futurism: Russian and Other. New York: Ex Libris, 1977. (Bookseller's list with detailed annotations.)

Cooper, Douglas. *The Cubist Epoch*. (Exhibition catalog.) London: Phaidon, 1970.

Cooper, Douglas, and Gary Tinterow. *The Essential Cubism: Braque, Picasso and Their Friends, 1907–1920.* (Exhibition catalog.) London: Tate Gallery, 1983.

Cork, Richard. *Vorticism and Abstract Art in the First Machine Age*. Berkeley: University of California Press, 1976. 2 vols.

Daix, Pierre. *Cubists and Cubism*. New York: Rizzoli, 1982.

Drudi Gambillo, Maria, and Teresa Fiori. *Archivi del futurismo*. Rome: De Luca, 1958–1962. 2 vols.

Fry, Edward F. *Cubism*. London: Thames & Hudson, 1966. Reprint, New York: Oxford University Press, 1978.

Gleizes, Albert, and Jean Metzinger. *Cubism*. London: T. Fisher Unwin, 1913. Translation of *Du cubisme*. Paris: Figuière, 1912. Reprint, Sisteron, France: Editions Présence, 1980.

Golding, John. *Cubism: A History and an Analysis, 1907–1914.* New York: Wittenborn, 1959; 2nd ed., New York: Harper & Row, 1968.

Gray, Christopher. *Cubist Aesthetic Theories*. Baltimore: Johns Hopkins Press, 1953.

Habasque, Guy. *Cubism: Biographical and Critical Study*. New York: Skira, 1959.

d'Harnoncourt, Anne. *Futurism and the International Avant-Garde*. (Exhibition catalog.) Philadelphia: Philadelphia Museum of Art, 1980.

Henderson, Linda Dalrymple. *The Fourth Dimension and Non-Euclidean Geometry in Modern Art*. Princeton: Princeton University Press, 1983.

Homer, William Innes. *Alfred Stieglitz and the American Avant-Garde*. Boston: New York Graphic Society, 1977.

Janis, Harriet, and Rudi Blesh. *Collage: Personalities, Concepts, Techniques*. Philadelphia: Chilton, 1961. Rev. ed., 1967.

Kahnweiler, Daniel-Henry. *The Rise of Cubism*. New York: Wittenborn, Schultz, 1949. Translation of *Der Weg zum Kubismus*. Munich: Delphin-Verlag, 1920.

Kandinsky, Wassily. *Kandinsky: Complete Writings on Art*. Lindsay, Kenneth C., and Peter Vergo, eds. Boston: G. K. Hall, 1982. 2 vols.

Levin, Gail. *Synchromism and American Color Abstraction, 1910–1925.* (Exhibition catalog.) New York: Braziller, in Association with The Whitney Museum of American Art, 1978.

Lista, Giovanni. *Futurisme: Manifestes, proclamations, documents*. Lausanne: L'Age d'Homme, 1973.

Marcadé, Valentine. *Le Renouveau de l'art pictural russe, 1863–1914.* Lausanne: L'Age d'Homme, 1971.

Marinetti: Selected Writings. R. W. Flint, ed. New York: Farrar, Straus & Giroux, 1972.

Markov, Vladimir. *Russian Futurism: A History*. Berkeley: University of California Press, 1968.

Martin, Marianne W. *Futurist Art and Theory, 1909–1915.* Oxford: Clarendon Press, 1968. Reprint, New York: Hacker, 1978.

Rosenblum, Robert. *Cubism and Twentieth-Century Art*. New York: Abrams, 1960. Rev. ed., 1976.

Seuphor, Michel. *L'Art abstrait: Ses origines, ses premiers maîtres*. (Exhibition catalog.) Paris: Maeght, 1949. Nouvelle ed., 1950. Reprinted in vol. 1 of his *L'Art abstrait*. Paris: Maeght, 1971.

Spate, Virginia. *Orphism: The Evolution of Non-Figurative Painting in Paris, 1910–1914*. Oxford: Clarendon Press, 1979.

Taylor, Joshua C. *Futurism*. (Exhibition catalog.) New York: Museum of Modern Art, 1961.

Tisdall, Caroline, and Angelo Bozzolla. *Futurism*. New York: Oxford University Press, 1978.

Wees, William C. *Vorticism and the English Avant-Garde*. Toronto: University of Toronto Press, 1972.

Wescher, Herta. *Collage*. New York: Abrams, 1971. Translation of *Die Collage*. Cologne: DuMont Schauberg, 1968.

2.

From Surface to Space—Suprematism, de Stijl, Russian Constructivism: 1915–1921

Alexander Rodtschenko und Warwara Stepanova. (Exhibition catalog.) Duisburg: Wilhelm-Lehmbruck Museum, 1982.

Andersen, Troels. *Malevich: Catalogue Raisonné of the Berlin Exhibition 1927, Including the Collection in the Stedelijk Museum Amsterdam, with a General Introduction to His Work*. Amsterdam: Stedelijk Museum, 1970.

Andersen, Troels. *Moderne Russisk Kunst, 1910–1930*. Copenhagen: Borgen, 1967.

Art in Revolution: Soviet Art and Design since 1917. (Exhibition catalog.) London: Arts Council of Great Britain, Hayward Gallery, 1971.

Avantgarde Osteuropa, 1910–1930. Berlin: Kunstverein & Akademie der Künste, 1967.

Baljeu, Joost. *Theo van Doesburg*. New York: Macmillan, 1974.

Barooshian, Vahan D. *Russian Cubo-Futurism 1910–1930: A Study in Avant-Gardism*. The Hague: Mouton, 1974.

Barr, Alfred H., Jr. *De Stijl 1917–1928*. (Exhibition catalog.) New York: Museum of Modern Art, 1961. Text adapted from *Cubism and Abstract Art*. New York: Museum of Modern Art, 1936.

Barron, Stephanie, and Maurice Tuchman, eds. *The Avant-Garde in Russia, 1910–1930: New Perspectives*. (Exhibition catalog.) Los Angeles: Los Angeles County Museum of Art, 1980.

Belloli, Carlo. *Il Contributo russo alle avanguardie plastiche*. Milan: Galleria del Levante, 1964.

Berninger, Herman, and Jean-Albert Cartier. *Pougny: Jean Pougny (Iwan Puni), 1892–1956: Catalogue de l'oeuvre*. Tübingen: Wasmuth, 1972. (Includes reprints and translations of documents of the early Russian avant-garde.)

Blotkamp, Carel, et al. *De Beginjaren van De Stijl 1917–1922*. Utrecht: Reflex, 1982.

Bowlt, John E., ed. *Russian Art of the Avant-Garde: Theory and Criticism 1910–1934*. New York: Viking, 1976. (Includes comprehensive bibliography.)

Configuration 1910–1940 and Seven Tatlin Reconstructions. (Exhibition catalog.) London: Annely Juda Fine Art, 1981.

De Stijl. (Exhibition catalog.) Amsterdam: Stedelijk Museum, 1951.

van Doesburg, Theo. *Principles of Neo-Plastic Art*. Greenwich: New York Graphic Society, 1968. Translation of *Grundbegriffe der Neuen Gestaltenden Kunst*. Munich: Langen, 1925. (Originally published in *Het Tijdschrift voor Wijsbegeerte*, 1919.)

Elliot, David, ed. *Alexander Rodchenko*. (Exhibition catalog.) Oxford: Museum of Modern Art, 1979. Reprinted as *Rodchenko and the Arts of Revolutionary Russia*. New York: Pantheon, 1979.

Erste Russische Kunstausstellung. (Exhibition catalog.) Berlin: Galerie van Diemen; Internationale Arbeiterhilfe, 1922.

The First Russian Show: A Commemoration of the van Diemen Exhibition, Berlin, 1922. (Exhibition catalog.) London: Annely Juda Fine Art, 1983.

Friedman, Mildred, ed. *De Stijl, 1917–1931: Visions of Utopia*. (Exhibition catalog.) Minneapolis: Walker Art Center; New York: Abbeville, 1982.

Fülop-Miller, René. *The Mind and Face of Bolshevism: An Examination of Cultural Life in Soviet Russia*. London & New York: Putnams, 1927. Rev. ed., New York: Harper & Row, 1965.

Gan, Aleksei. *Konstruktivizm*. Tver: Tverskoe Izdatel'stvo, 1922. Reprint, Milan: Edizioni dello Scorpione, 1977.

Gibian, George, and H. W. Tjalsma, eds. *Russian Modernism: Culture and the Avant-Garde, 1900–1930*. Ithaca, Cornell University Press, 1976.

Gray, Camilla. *The Great Experiment: Russian Art, 1863–1922*. New York: Abrams, 1962. Reprinted as *The Russian Experiment in Art, 1863–1922*. New York: Abrams, 1971.

Guerman, Mikhail, ed. *Art of the October Revolution*. New York: Abrams, 1979.

Jaffé, Hans L.C., ed. *De Stijl*. New York: Abrams, 1970. Translation of *Mondrian und De Stijl*. Cologne: DuMont Schauberg, 1967.

Jaffé, Hans L.C. *De Stijl 1917–1931: The Dutch Contribution to Modern Art*. Amsterdam: Meulenhoff, 1956.

Karginov, German. *Rodchenko*. London: Thames and Hudson, 1979.

Kasimir Malevich zum 100. Geburtstag. (Exhibition catalog.) Cologne: Galerie Gmurzynska, 1978. (Text also in English.)

Die Kunstismen in Russland/The Isms of Art in Russia 1907–1930. (Exhibition catalog.) Cologne: Galerie Gmurzynska, 1977.

Künstlerinnen der Russischen Avantgarde/Russian Women-Artists of the Avantgarde, 1910–1930. (Exhibition catalog.) Cologne: Galerie Gmurzynska, 1979.

Liberated Colour and Form: Russian Non-Objective Art, 1915–1922. (Exhibition catalog.) Edinburgh: Scottish National Gallery of Modern Art, 1978.

Lissitzky-Küppers, Sophie. *El Lissitzky: Life, Letters, Texts*. London: Thames and Hudson, 1968. Reprinted with revisions, 1980. Translation of *El Lissitzky: Maler, Architekt, Typograf, Fotograf*. Dresden: Verlag der Kunst, 1967.

Lodder, Christina. *Russian Constructivism*. New Haven: Yale University Press, 1983. (Includes detailed ''selected bibliography.'')

Lozowick, Louis. *Modern Russian Art*. New York: Société Anonyme, 1925.

Malevich, Kasimir. *Essays on Art*. Troels Andersen, ed. Copenhagen: Borgen, 1968–78. 4 vols. Includes appendices, letters, and bibliographical notes in each volume. Vol. 1: *Essays on Art, 1915–1928*. Vol. 2: *Essays on Art, 1928–1933*. Vol. 3: *The World as Non-Objectivity: Unpublished Writings; 1922–25*. Vol. 4: *The Artist, Infinity, Suprematism: Unpublished Writings, 1913–1933*.

Malewitsch-Mondrian: Konstruktion als Konzept, Alexander Dorner Gewidmet. (Exhibition catalog.) Hannover: Kunstverein, 1977. A slightly different version published under title *Malewitsch-Mondrian und ihre Kreise, aus der Sammlung Wilhelm Hack*. (Exhibition catalog.) Cologne: Kölnischer Kunstverein, 1976.

Marcadé, Jean-Claude, and Valentine Marcadé. *L'Avant-Garde au feminin: Moscou–Saint-Petersbourg–Paris 1907–1930.* (Exhibition catalog.) Paris: Artcurial, 1983.

Milner, John. *Vladimir Tatlin and the Russian Avant-Garde.* New Haven: Yale University Press, 1983. (Only English-language monograph on the artist; at times inaccurate.)

Mondrian und De Stijl. (Exhibition catalog.) Cologne: Galerie Gmurzynska, 1979.

Mondrian, Piet. *Le Neo-plasticisme.* Paris: Editions de l'Effort Moderne, Léonce Rosenberg, 1920.

Nakov, Andrei B. *Abstrait/Concret: Art non-objectif russe et polonais.* Paris: Transédition, 1981.

Nakov, Andrei B. *Russian Constructivism: "Laboratory Period."* (Exhibition catalog.) London: Annely Juda Fine Art, 1975.

Nakov, Andrei B. *Russian Pioneers: At the Origins of Non-Objective Art.* (Exhibition catalog.) London: Annely Juda Fine Art, 1976.

Nakov, Andrei B. *Tatlin's Dream: Russian Suprematist and Constructivist Art, 1910–1923.* (Exhibition catalog.) London: Fischer Fine Art, 1973.

Nakov, Andrei B. *2 Stenberg 2: The "Laboratory" Period (1919–1921) of Russian Constructivism.* (Exhibition catalog.) Paris: Galerie Jean Chauvelin, 1975.

The Non-Objective World, 1914–1924. (Exhibition catalog.) London: Annely Juda Fine Art, 1970.

Paris–Moscou, 1900–1930. (Exhibition catalog.) Paris: Centre Georges Pompidou, 1979.

Poesin Måste Göras av Alla!/Poetry Must Be Made by All!: Förändra Världen!/Transform the World! (Exhibition catalog.) Stockholm: Moderna Museet, 1969.

Punin, Nikolai. *Tatlin. (Protiv Kubisma).* Petrograd, 1921.

Quilici, Vieri. *L'Architettura del costruttivismo.* Bari: Laterza, 1969. Rev. ed., Rome: Laterza, 1978.

Rathke, Ewald. *Konstruktive Malerei, 1915–1930.* (Exhibition catalog.) Frankfurt am Main: Frankfurter Kunstverein. Also Hanau: Peters, 1967.

Rowell, Margit, and Angelica Zander Rudenstine. *Art of the Avant-Garde in Russia: Selections from the George Costakis Collection.* (Exhibition

catalog.) New York: Solomon R. Guggenheim Museum, 1981.

Rudenstine, Angelica Zander, ed. *Russian Avant-Garde Art: The George Costakis Collection.* New York: Abrams, 1981.

Russian Art of the Revolution. (Exhibition catalog.) Ithaca: Andrew Dickson White Museum of Art, Cornell University, 1971.

Russian Avant-Garde 1908–1922. (Exhibition catalog.) New York: Leonard Hutton Galleries, 1971.

Russian Constructivism Revisited. (Exhibition catalog.) Newcastle upon Tyne: Hatton Gallery, University of Newcastle upon Tyne, 1973.

Salmon, André. *Art russe moderne.* Paris: Editions Laville, 1928.

Sieben Moskauer Künstler/Seven Moscow Artists 1910–1930. (Exhibition catalog.) Cologne: Galerie Gmurzynska, 1984.

Steneberg, Eberhard. *Russische Kunst: Berlin 1919–1932.* Berlin: Mann, 1969.

Suprematisme. (Exhibition catalog.) Paris: Galerie Jean Chauvelin, 1977.

The Suprematist Straight Line: Malevich, Suetin, Chashnik, Lissitzky. (Exhibition catalog.) London: Annely Juda Fine Art, 1977.

Taraboukine, Nikolai. *Le Dernier Tableau: Ecrits sur l'art et l'histoire de l'art à l'époque du constructivisme russe.* Paris: Editions Champ Libre, 1972.

Umanskij, Konstantin. *Neue Kunst in Russland, 1914–1919.* Potsdam: Kiepenheuer, 1920.

Vladimir Tatlin. (Exhibition catalog.) Stockholm: Moderna Museet, 1968.

Von der Fläche zum Raum/From Surface to Space: Russland/Russia 1916–24. (Exhibition catalog.) Cologne: Galerie Gmurzynska, 1974.

Weyergraf, Clara. *Piet Mondrian und Theo van Doesburg: Deutung von Werk und Theorie.* Munich: Fink, 1979.

Williams, Robert C. *Artists in Revolution: Portraits of the Russian Avant-Garde, 1905–1925.* Bloomington: Indiana University Press, 1977.

Zhadova, Larissa A. *Malevich, Suprematism and Revolution in Russian Art 1910.* New York: Thames & Hudson, 1982. Translation of: *Suche und Experiment: Aus der Geschichte der Russischen und Sowjetischen Kunst Zwischen 1910 und 1930.* Dresden: VEB Verlag der Kunst, 1978.

Zygas, Kestutis Paul. *Form Follows Form: Source Imagery of Constructivist Architecture, 1917–1925.* Ann Arbor: UMI Research Press, 1981.

3.

International Constructivism: 1922–1929

Bann, Stephen, ed. *The Tradition of Constructivism.* New York: Viking, 1974. (Includes "Selected Bibliography by Bernard Karpel.")

Bayer, Herbert, Walter Gropius, and Ise Gropius, eds. *Bauhaus 1919–1928.* (Exhibition catalog.) New York: Museum of Modern Art, 1938. Reprinted, Boston: Branford, 1952; New York: Arno, 1972; Museum of Modern Art, 1975.

Bohan, Ruth L. *The Société Anonyme's Brooklyn Exhibition: Katherine Dreier and Modernism in America.* Ann Arbor: UMI Research Press, 1982.

Constructivism in Poland 1923–1936. (Exhibition catalog.) Cambridge: Kettle's Yard Gallery, 1984.

Constructivism in Poland 1923–36: Blok, Praesens, a.r. (Exhibition catalog.) Essen: Museum Folkwang, 1973.

Dada-Constructivism: The Janus Face of the Twenties. (Exhibition catalog.) London: Annely Juda Fine Art, 1984.

De Stijl, Cercle et Carré: Entwicklungen des Konstruktivismus in Europa ab 1917. (Exhibition catalog.) Cologne: Galerie Gmurzynska, 1974.

Dreier, Katherine S. *Modern Art.* New York: Société Anonyme, 1926.

Green, Christopher. *Léger and the Avant-Garde.* New Haven: Yale University Press, 1976.

Herbert, Robert L., Eleanor S. Apter, and Elise K. Kenney, eds. *The Société Anonyme and the Dreier Bequest at Yale University: A Catalogue Raisonné.* New Haven: Yale University Press, 1984.

An International Exhibition of Modern Art Assembled by the Société Anonyme. (Exhibition catalog.) New York: Brooklyn Museum, 1926.

The International Exhibition of Modern Art Assembled by the Société Anonyme. (Exhibition catalog.) New York: Anderson Galleries, 1927.

Kassak, Ludwig, and László Moholy-Nagy, eds. *Buch Neuer Künstler.* Vienna: MA, 1922. Reprint, Budapest: Corvina, 1977.

Konstruktive Kunst 1915–45. (Exhibition catalog.) Winterthur: Kunstmuseum, 1981.

Kunst aus der Revolution: Sowjetische Kunst Während der Phase der Kollektivierung und Industrialisierung, 1927–1933. (Exhibition catalog.) Berlin: Akademie der Künste, 1977.

"Kunst in die Produktion!" Sowjetische Kunst Während der Phase der Kollektivierung und Industrialisierung, 1927–1933. (Exhibition catalog.) Berlin: Akademie der Künste, 1977.

Léger et l'esprit moderne: Une alternative d'avant-garde à l'art non-objectif (1918–1931)/ Léger and the Modern Spirit: An Avant-Garde Alternative to Non-Objective Art (1918–1931). (Exhibition catalog.) Paris: Musée d'Art Moderne de la Ville de Paris, 1982.

Line + Movement. (Exhibition catalog.) London: Annely Juda Fine Art, 1979.

Machine-Age Exposition. (Exhibition catalog.) New York: Little Review, 1927.

Neumann, Eckhard, ed. Bauhaus and Bauhaus People. New York: Van Nostrand Reinhold, 1970.

The Non-Objective World, 1924–1939/La Peinture non-objective, 1924–1939. (Catalog of an exhibition first held at Annely Juda Fine Art, London.) Milan: Electa, 1971.

Poling, Clark V. Bauhaus Color. (Exhibition catalog.) Atlanta: High Museum of Art, 1975.

Précurseurs de l'art abstrait en Pologne. (Exhibition catalog.) Paris: Galerie Denise René, 1957.

Présences polonaises: L'Art vivant autour du Musée de Lódź; Witkiewicz, constructivisme, les contemporains. (Exhibition catalog.) Paris: Centre Georges Pompidou, 1983.

Rickey, George. Constructivism: Origins and Evolution. New York: Braziller, 1967.

Roters, Eberhard. Painters of the Bauhaus. New York: Praeger, 1969. Translation of Maler am Bauhaus. Berlin: Rembrandt, 1965.

Rotzler, Willy. Constructive Concepts: A History of Constructive Art from Cubism to the Present; Collection McCrory Corporation. New York: Rizzoli, 1977. Translation of Konstruktive Konzepte. Zurich: ABC, 1977.

Rowell, Margit. The Planar Dimension: Europe, 1912–1932. (Exhibition catalog.) New York: Solomon R. Guggenheim Museum, 1979.

Société Anonyme (The First Museum of Modern Art 1920–1944): Selected Publications. New York: Arno, 1972. 3 vols.

Tendenzen der Zwanziger Jahre: Europäische Kunstausstellung, Berlin, 1977. (Exhibition catalog.) Berlin: Reimer, 1977.

Troy, Nancy J. The De Stijl Environment. Cambridge, MA: MIT Press, 1983.

Turowski, Andrzej. Konstruktywizm Polski: Próba Rekonstrukcji Nurtu, 1921–1934. Wroclaw: Zaklad Narodowy im. Ossolínskich, 1981.

Von der Malerei zum Design: Russische Konstruktivistische Kunst der Zwanziger Jahre/ From Painting to Design: Russian Constructivist Art oi the Twenties. (Exhibition catalog.) Cologne: Galerie Gmurzynska, 1981.

Whitford, Frank. Bauhaus. London & New York: Thames & Hudson, 1984.

Wijk, Kees van. Internationale Revue i10. Utrecht: Reflex, 1980.

Wingler, Hans M. The Bauhaus: Weimar, Dessau, Berlin, Chicago. Cambridge, MA, & London: MIT Press, 1969. Translation of Das Bauhaus. 2nd ed., 1968; 3rd ed., 1976; paperback ed., 1984.

Zevi, Bruno. Poetica dell'architettura neoplastica. Milan: Tamburini, 1953. 2nd ed., Turin: Einaudi, 1974.

Die Zwanziger Jahre in Hannover: Bildende Kunst, Literatur, Theater, Tanz, Architektur 1916–1933. (Exhibition catalog.) Hannover: Kunstverein, 1962.

Die Zwanziger Jahre in Osteuropa/The 1920s in Eastern Europe. (Exhibition catalog.) Cologne: Galerie Gmurzynska, 1975.

4.

The Paris–New York Connection: 1930–1959

Abstract and Concrete. (Exhibition catalog.) London: Lefèvre Gallery, 1936.

Abstraction-Création, 1931–1936. (Exhibition catalog.) Münster: Westfälisches Landesmuseum für Kunst und Kulturgeschichte, & Paris: Musée d'Art Moderne de la Ville de Paris, 1978.

Abstract Painting and Sculpture in America, 1927–1944. (Exhibition catalog.) Pittsburgh: Museum of Art, Carnegie Institute, 1983.

Alloway, Lawrence. Nine Abstract Artists: Their Work and Theory. London: Tiranti, 1954.

Alvard, Julien, ed. Témoignages pour l'art abstrait 1952. Paris: Editions "Art d'Aujourd'hui," 1952.

American Abstract Artists. (Exhibition catalog.) New York: Fine Art Galleries, 1938.

American Abstract Artists, eds. American Abstract Artists. New York: Ram Press, 1946.

American Abstract Artists, eds. The World of Abstract Art. New York: Wittenborn, 1957.

American Abstract Artists Exhibition. (Exhibition catalog.) New York: Squibb Galleries, 1937.

Baljeu, Joost. Mondrian or Miró. Amsterdam: De Beuk, 1958.

Beyond the Plane: American Constructions 1930–1965. (Exhibition catalog.) Trenton: New Jersey State Museum, 1983.

Biederman, Charles. Art as the Evolution of Visual Knowledge. Red Wing, MN: Biederman, 1948.

Biederman, Charles. Letters on the New Art. Red Wing, MN: Art History, 1951.

Biederman, Charles. The New Cézanne: From Monet to Mondrian. Red Wing, MN: Art History, 1958.

British Constructivist Art. (Exhibition catalog.) New York: American Federation of Arts, 1962.

Cercle et Carré. (Exhibition catalog.) Paris: Galerie 23, 1930.

The Classic Tradition in Contemporary Art. (Exhibition catalog.) Minneapolis: Walker Art Center, 1953.

Construction and Geometry in Painting: From Malevich to "Tomorrow." (Exhibition catalog.) New York: Galerie Chalette, 1960.

Construction: England 1950–1960. (Exhibition catalog.) London: Drian Galleries, 1961.

Construction England. (Exhibition catalog.) London: Arts Council of Great Britain, 1963.

Constructive Art. (Exhibition catalog.) London: London Gallery, 1937.

Equipo 57. (Exhibition catalog.) Madrid: Galeria Darro, 1960.

Five Contemporary American Concretionists. (Exhibition catalog.) New York: Reinhardt Galleries, 1936.

Gallatin, A.E. Museum of Living Art: A.E. Gallatin Collection. New York: New York University, 1940. First published 1936.

Geometric Abstraction 1926–1942. (Exhibition catalog.) Dallas: Dallas Museum of Fine Arts, 1972.

Geometric Abstraction in America. (Exhibition catalog.) New York: Whitney Museum of American Art, 1962.

Gerstner, Karl. Kalte Kunst? Zum Standort der Heutigen Malerei. Teufen: Niggli, 1957. Reprinted 1963.

Jeune Art constructif allemand. (Exhibition catalog.) Paris: Galerie Denise René, 1958.

Konkrete Kunst. (Exhibition catalog.) Basel: Kunsthalle, 1944.

Konkrete Kunst: 50 Jahre Entwicklung. (Exhibition catalog.) Zurich: Helmhaus, 1960.

Konstruktivisten. (Exhibition catalog.) Basel: Kunsthalle, 1937. Reprint, Redding, CT: Silver Fox Press, 1974.

Lewison, Jeremy. *Circle: Constructive Art in Britain, 1934–40*. (Exhibition catalog.) Cambridge: Kettle's Yard Gallery, 1982.

Lion, Stephen C., ed. *Masters of Abstract Art*. (Exhibition catalog.) New York: Helena Rubenstein's New Art Center, 1942.

Martin, J. L., Ben Nicholson, and Naum Gabo, eds. *Circle: International Survey of Constructive Art*. New York: Weyhe, 1937. Reprint, New York: Praeger, 1971.

Moholy-Nagy, László. *The New Vision: Fundamentals of Design, Painting, Sculpture, Architecture*. New York: Norton, 1938.

Mondrian, Piet. *Plastic Art and Pure Plastic Art, 1937, and Other Essays, 1941–1943*. New York: Wittenborn, Schultz, 1945. 2nd ed., 1947; 3rd ed., 1951.

Mondrian, De Stijl, and Their Impact. (Exhibition catalog.) New York: Marlborough-Gerson Gallery, 1964.

Le Mouvement. (Exhibition catalog.) Paris: Galerie Denise René, 1955.

The Non-Objective World, 1914–1955/Die Gegenstandslose Welt, 1914–1955. (Exhibition catalog.) London: Annely Juda Fine Art, 1973.

The Non-Objective World, 1939–1955/Die Gegenstandslose Welt, 1939–1955. (Exhibition catalog.) London: Annely Juda Fine Art, 1972.

Perucchi-Petri, Ursula. *Zero, Bildvorstellungen einer Europäischen Avantgarde, 1958–1964*. (Exhibition catalog.) Zurich: Kunsthaus, 1979.

Petersen, Vilhelm Bjerke. *Konkret Konst*. Stockholm: Raben & Sjogren, 1956. (Includes English summary: *Nonobjective Art*.)

Prinzip Vertikal: Europa nach 1945/Vertical Principle: Europe after 1945. (Exhibition catalog.) Cologne: Galerie Teufel, 1979.

Punkt, Linie, Form, Fläche, Raum, Farbe: Zeitpunkt Paris 1950–1959. (Exhibition catalog.) Cologne: Galerie Teufel, 1983.

Ritchie, Andrew Carnduff. *Abstract Painting and Sculpture in America*. (Exhibition catalog.) New York: Museum of Modern Art, 1951. Reprint, New York: Arno, 1969.

Staber, Margit. *Masters of Early Constructive Abstract Art*. (Exhibition catalog.) New York: Galerie Denise René, 1971.

Tentoonstelling Abstracte Kunst. (Exhibition catalog.) Amsterdam: Stedelijk Museum, 1938. Reprint, Redding, CT: Silver Fox Press, 1974.

Troy, Nancy J. *Mondrian and Neo-Plasticism in America*. (Exhibition catalog.) New Haven: Yale University Art Gallery, 1979.

Vantongerloo, Georges. *Paintings, Sculptures, Reflections*. New York: Wittenborn, Schultz, 1948.

5.

Recent Nonfigurative Tendencies: 1960–1980

Albrecht, Hans Joachim. *Farbe als Sprache: Robert Delaunay, Josef Albers, Richard Paul Lohse*. Cologne: DuMont Schauberg, 1974.

Alloway, Lawrence. *Systemic Painting*. (Exhibition catalog.) New York: Solomon R. Guggenheim Museum, 1966.

Baljeu, Joost. *Attempt at a Theory of Synthesist Plastic Expression*. London: Tiranti, 1963.

Bann, Stephen. *Experimental Painting: Construction, Abstraction, Destruction, Reduction*. New York: Universe Books, 1970.

Bann, Stephen. *Constructive Context: An Exhibition Selected from the Arts Council Collection by Stephen Bann*. (Exhibition catalog.) London: Arts Council of Great Britain, 1978.

Bann, Stephen, Reg Gadney, Frank Popper, and Philip Steadman. *Four Essays on Kinetic Art*. St. Albans: Motion Books, 1966.

Barrett, Cyril. *Op Art*. New York: Viking, 1970.

Basically White. (Exhibition catalog.) London: Institute of Contemporary Arts, 1974.

Battcock, Gregory, ed. *Minimal Art: A Critical Anthology*. New York: Dutton, 1968.

Bewogen Beweging. (Exhibition catalog.) Amsterdam: Stedelijk Museum, 1961.

Brett, Guy. *Kinetic Art*. London: Studio-Vista, 1968.

Burnham, Jack. *Beyond Modern Sculpture: The Effects of Science and Technology on the Sculpture of this Century*. New York: Braziller, 1968.

Caramel, Luciano. *GRAV: Groupe de Recherche d'Art Visuel 1960–1968*. Milan: Electa, 1975.

Color and Field 1890–1970. (Exhibition catalog.) Buffalo: Albright-Knox Art Gallery, 1970.

Concrete Expressionism. (Exhibition catalog.) New York: Loeb Student Center, New York University, 1965.

Constructivist Tendencies: From the Collection of Mr. and Mrs. George Rickey. (Exhibition catalog.) Santa Barbara: Art Galleries, University of California, 1970.

Experiment in Constructie. (Exhibition catalog.) Amsterdam: Stedelijk Museum, 1962.

Experiment in Fläche und Raum. (Exhibition catalog.) Zurich: Kunstgewerbemuseum, 1962.

Formalists. (Exhibition catalog.) Washington: Washington Gallery of Modern Art, 1963.

Formen der Farbe/Shapes of Colour. (Exhibition catalog.) Berne: Kunsthalle, 1967.

Fuchs, R. H. *Varianten: Abstrakt-Geometrische Kunst in Nederland*. Amsterdam: Nederlandse Kunststichting, 1973.

Goosen, E. C. *The Art of the Real: USA 1948–1968*. (Exhibition catalog.) New York: Museum of Modern Art, 1968.

Group Zero. (Exhibition catalog.) Philadelphia: Institute of Contemporary Art, University of Pennsylvania, 1964.

Güse, Ernst-Gerhard, ed. *Reliefs: Formprobleme Zwischen Malerei und Skulptur im 20 Jahrhundert*. (Exhibition catalog.) Münster: Westfälisches Landesmuseum für Kunst und Kulturgeschicte, 1980.

Hard-Edge. (Exhibition catalog.) Paris: Galerie Denise René, 1964.

Hill, Anthony, ed. *DATA: Directions in Art, Theory and Aesthetics*. London: Faber, 1968.

Den Inre och den Yttre Rymden/The Inner and the Outer Space: An Exhibition Devoted to Universal Art. (Exhibition catalog.) Stockholm: Moderna Museet, 1965.

Kepes, Gyorgy, ed. *Module, Proportion, Symmetry, Rhythm*. New York: Braziller, 1966.

Kinetics. (Exhibition catalog.) London: Arts Council of Great Britain, Hayward Gallery, 1970.

Konstruktive Kunst: Elemente und Prinzipien: Biennale Nürnberg. (Exhibition catalog.) 2 vols. Nuremberg: Institut für Moderne Kunst, 1969.

Konstruktivism 1974/Konstruktiivinen 1974. (Exhibition catalog.) Stockholm: Moderna Museet, and Helsinki: Amos Andersons Konstmuseum, 1974.

Kostyniuk, Ron. *The Evolution of the Constructed Relief, 1913–1979*. Calgary: Kostyniuk, 1979.

Kunst-Licht-Kunst. (Exhibition catalog.) Eindhoven: Stedelijk Van Abbemuseum, 1966.

Larson, Susan. *American Abstract Artists: The Language of Abstraction*. (Exhibition catalog.) New York: American Abstract Artists, Betty Parsons Gallery, and Marilyn Pearl Gallery, 1979.

Less Is More: The Influence of the Bauhaus on American Art. (Exhibition catalog.) Coral Gables: Lowe Art Museum, University of Miami, 1974.

Light, Motion, Space. (Exhibition catalog.) Minneapolis: Walker Art Center, 1967.

McShine, Kynaston. *Primary Structures: Younger American and British Sculptors*. (Exhibition catalog.) New York: Jewish Museum, 1966.

Miller, Dorothy C., ed. *Sixteen Americans*. New York: Museum of Modern Art, 1959.

Minimal Art. (Exhibition catalog.) The Hague: Gemeentemuseum, 1968.

New Shapes of Colour/Vormen van de Kleur. (Exhibition catalog.) Amsterdam: Stedelijk Museum, 1966.

Pier & Ocean: Construction in the Art of the Seventies. (Exhibition catalog.) London: Arts Council of Great Britain, Hayward Gallery, 1980.

Plus by Minus: Today's Half-Century. (Exhibition catalog.) Buffalo: Albright-Knox Art Gallery, 1968.

Popper, Frank. *Origins and Development of Kinetic Art*. Greenwich, CT: New York Graphic Society, 1968. Translation of *Naissance de l'art cinétique*. Paris: Gauthier-Villars, 1967.

Post Painterly Abstraction. (Exhibition catalog.) Los Angeles: Los Angeles County Museum of Art, 1964

Relief/Construction/Relief. (Exhibition catalog.) Chicago: Museum of Contemporary Art, 1968.

Riese, Hans-Peter. *Konstruktive Tendenzen in der BRD*. Offenbach: Werkkunstschule, 1970.

A Romantic Minimalism. (Exhibition catalog.) Philadelphia: Institute of Contemporary Art, University of Pennsylvania, 1967.

Sandler, Irving. *Concepts in Construction 1910–1980*. (Exhibition catalog.) New York: Independent Curators Incorporated, 1982.

Seitz, William C. *The Responsive Eye*. (Exhibition catalog.) New York: Museum of Modern Art, 1965.

Sul Concetto di Serie. (Exhibition catalog.) Varese: Museo Civico di Villa Mirabello, 1977.

Systeemi—System: An Exhibition of Syntactic Art from Britain. (Exhibition catalog.) Helsinki: Amos Andersons Konstmuseum, 1969.

Systems. (Exhibition catalog.) London: Arts Council of Great Britain, Whitechapel Art Gallery, 1972.

Systems II. (Exhibition catalog.) London: Polytechnic of Central London, 1973.

Tendenzen Strukturaler Kunst. (Exhibition catalog.) Münster: Westfälischer Kunstverein, 1966.

Toward a New Abstraction. (Exhibition catalog.) New York: Jewish Museum, 1963.

Tuchman, Maurice. *American Sculpture of the Sixties*. (Exhibition catalog.) Los Angeles: Los Angeles County Museum of Art, 1967.

Unit, Series, Progression: An Exhibition of Constructions. (Exhibition catalog.) Cambridge: Arts Council Gallery, 1967.

Unitary Forms: Minimal Sculpture. (Exhibition catalog.) San Francisco: San Francisco Museum of Art, 1970.

Vitt, Walter. *Von Strengen Gestaltern: Texte, Reden, Interviews und Briefe zur Konstruktiven und Konkreten Kunst*. Cologne: Vitt, 1982.

Weintraub, Linda. *The Maximal Implications of the Minimal Line*. (Exhibition catalog.) Annandale-on-Hudson, New York: Edith C. Blum Art Institute, Bard College, 1985.

Weiss auf Weiss. (Exhibition catalog.) Berne: Kunsthalle, 1966.

Wember, Paul. *Bewegte Bereiche der Kunst: Kinetik, Objecte, Plastik*. Krefeld: Scherpe Verlag, 1963.

Zero/Nul. (Exhibition catalog.) The Hague: Gemeentemuseum, 1964.

6.

Periodicals

Abstraction, création, art non-figuratif. Paris: 1932–1936. (Issued yearly.)

Abstrakt/Konkret: Bulletin der Galerie des Eaux Vives. Zurich: 1944.

Art concret. Paris: 1930. (Only 1 issue appeared.)

Axis. London: 1935–1937.

Bauhaus. Dessau: 1927–1931. (Suspended 1930.)

Blok. Warsaw: 1924–1926. (Issued monthly, 1924; irregular, 1925–1926.)

Cercle et carré. Paris: 1930. (3 issues appeared, Mar.–June.)

L'Esprit nouveau. Paris: Oct. 1920–Jan. 1925.

Form. Cambridge, England: Summer 1966–Oct. 1969. (Published quarterly.)

G. Berlin: July 1923–1926.

Lef. Moscow: 1923–1925. (Superseded by *Novyi Lef*.)

MA. Budapest: 1916–1919; Vienna: 1919–1925.

Mécano. Leiden: 1922–1923 (irregular). (Text in Dutch, English, French or German. Reprint editions: Liechtenstein: Quarto, 1979; Amsterdam: Van Gennep, 1982.)

Merz. Hannover: 1923–1932.

De Nieuwe stijl. Amsterdam: 1965. (Texts in English; excerpts in French and German.)

Novyi Lef. Moscow: 1927–1928. (Supersedes *Lef*.)

Het Overzicht. Antwerp: 1921–1925.

Plastique. Paris: 1937–1939.

Praesens: Awartalnik Modernistow. Warsaw: 1926–1930.

Signals. London: 1964–1966.

Spirale: Internationale Zeitschrift für junge Kunst. Bern: 1953–1964.

De Stijl. Leiden, Delft: 1917–1932. (Not published Nov.–Dec. 1920, Jan.–Feb. 1923, 1929–1931; reprint edition, Amsterdam: Atheneum and Polaic & van Gennep; The Hague: Bakker, 1968.)

Structure. Amsterdam: 1958–1964. (Published in Amsterdam; edited in Dept. of Art, Univ. of Saskatchewan.)

The Structurist. Saskatoon: 1960–to date.

Veshch/Gegenstand/Objet. Berlin: 1922.

Zero. Düsseldorf, 1958, 1961. (3 vols. in one published by Otto Piene and Heinz Mack; reprint edition, MIT Press, 1958–1961.)

Index of Artists

Page numbers refer the reader to illustrations, except for the last number in each entry, which indicates a biographical note.

Photograph Credits

The majority of the works of art reproduced in the plate sections were specially photographed for this volume by Malcolm Varon, New York. Other photography in the plate sections is credited in the following list, which is keyed to page numbers.

Kate Keller (staff photographer, MoMA): 32, 46, 49, 76, 77, 83, 85, 101, 104, 107, 224, 234, 235; James Mathews, New York: 99, 217, 241, 242; Herbert Matter, New York: 188; Mali Olatunji (staff photographer, MoMA): 221, 238; Rolf Peterson, New York: 89, 138, 216, 230; Eric Pollitzer, New York: 236; Soichi Sunami, New York: 37, 41–45, 48, 90, 96, 141, 144, 149; Charles Uht, New York: 31